COUSIN CLARE

The Tempestuous Career of Clare Sheridan

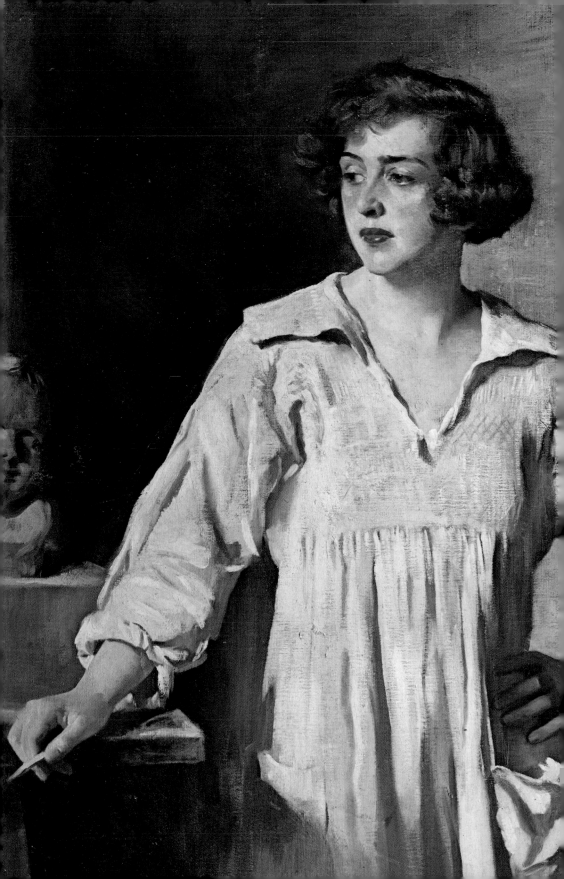

Cousin Clare

THE TEMPESTUOUS CAREER OF
CLARE SHERIDAN

ANITA LESLIE

HUTCHINSON OF LONDON

Hutchinson & Co (Publishers) Ltd
3 Fitzroy Square, London W1

London Melbourne Sydney Auckland
Wellington Johannesburg and agencies
throughout the world

First published 1976
© Anita Leslie 1976

Set in Monotype Bembo
Printed in Great Britain by
The Anchor Press Ltd and bound by
Wm Brendon & Son Ltd
both of Tiptree, Essex

ISBN 0 09 127940 2

Contents

CONTENTS

Illustrations

To
MARGARET
in memory of the
golden years

Acknowledgements

The author wishes to express gratitude to the authors, owners of copyright material, and publishers noted below for permission to reproduce extracts from correspondence and books, and especially to the Comtesse Guy de Renéville for permission to quote from the letters of her mother Clare Sheridan, from Clare Sheridan's books, and from her own *Morning Glory* (Longmans) written under the name of Mary Motley.

Acknowledgements are also due to the following for permission to quote from unpublished letters: C & T Publications Limited (letters from Winston S. Churchill) and to Mary Duchess of Roxburghe, Mr Jonathan Frewen and Mr Seymour Leslie, owners of the letters; Mr Seymour Leslie (Leonie Leslie), Lady Leslie (Shane Leslie), Mr Jonathan Frewen (Moreton Frewen and Hugh Frewen), and Mrs Oswald Frewen (Oswald Frewen).

Special thanks are due to Mr David Arbuthnot who made available his Saharan diary and to Mrs Oswald Frewen for permission to quote from the many volumes of her late husband's diaries.

The author also wishes to express thanks to those who have helped with reminiscences and in other ways: Lady Birley, Mrs Marigold Crook, Mr and Mrs Frederick Holt, Mr H. Montgomery Hyde, Patricia, Countess Jellicoe the Comtesse de Lalaing, Mr Desmond Leslie, Sir John Leslie, Mrs Alice Longworth, and the Hon. Mrs Alexandra Roche.

Very special thanks are due to Mrs Hilda Scott who watched Clare with a child's keen eye during the years 1917–1919 and who, along with countless stories, has volunteered this description: 'She was

generous, impetuous, artistic, very beautiful, kind and loyal to her friends, and with a wonderful sense of humour. She loved to shock people. I think it was her American blood in her that despised the then very stuffy attitude in this country as to what bed you happened to be born into.'

Last of all, I must thank Lord Kinross who said, 'But Clare's whole life was one long anecdote!'

A.L.

INTRODUCTION
Rebel daughter

By the time King Edward VII died in 1910, most of his lady friends had grown-up daughters, nearly all of whom were by that time safely married with children of their own.

This generation, too young to interest the King, had grown more independent than their mothers. In fact, family letters reveal that a ripple of rebellion had sometimes upset family conferences. Since the new century, since indeed the old Queen had died, an occasional murmur of dissent arose among these strictly brought-up girls being ushered into Society in the time-honoured way by their mamas. Some sulked, until they realized how dreary would be their lives un-married; quite a few talked about careers and several insisted on taking their own talents seriously. Genius is hard to smother beneath even the heaviest blankets of convention and, therefore, Vita Sackville-West and Ethel Smyth and Edith Sitwell and Dorothy Brett emerged from the battle for self-expression as they might have done in any century – glinting dragon-flies with wings a little damaged by the unyielding cocoons out of which they had bitten their way.

Maybe, as the bells tolled for King Edward, those ladies who had enjoyed the special amorality of his court felt that the pleasures of life would diminish under that virtuous sailor King George V and his astringent spouse. But during the next four years no alteration of social routine became perceptible. The etiquette of the London rounds continued to make sense. Girls were whisked, fresh and virginal, in white dresses, to their first balls, placed at dinner beside suitable young men, and went well-chaperoned to country house parties where they could ride and walk and consider the proposals engineered by their

[1]

parents. Many of them made happy marriages in this way. If a girl was not sufficiently attractive to catch a mate of proper vintage, she might have a wretched time, not because of her inability to lead an independent life, but because Mama would feel humiliated and irritated. It was a feather in the mother's cap to marry a daughter off during her first Season. No one ever called it a feather in the girl's cap!

Tiresome as these cages were, the birds within could live an entertaining existence owing to the activity of life as arranged by the English upper classes. That taste for country pursuits and delight in nature inherited by most English women kept them cheerful. The girl galloping her hunter over hedges and ditches of the shires could forget Mama's anger because some wretched young peer had not proposed. Sooner or later they all seemed to get married and the babies arrived who would ensure the continuance of the land-owning hierarchy. Then, so the older mothers thought, their girls might enter the zone of disciplined permissiveness which it had been their own luck to enjoy for several decades. If a whisper of disaffection stirred in the younger generation, it soon faded, for what could any girl do in the end but accept a husband to give her rank and status and freedom? Apart from two or three exceptional characters who dedicated themselves to nursing, no well-born spinsters could find anything to do.

The fetters which held fashionable women in subjection would be broken in 1914, but no one immediately realized this, for the whole country was bubbling with the excitement of the war itself. Within weeks the exuberance had turned to horror and grief, and as the agonies of loss swept across England, the social structure collapsed and the confident aristocratic way of life was irredeemably broken. Except for some ancient Norman and Scottish lines, titles were inherited by males only, and the estates were usually entailed to accompany the title. Now, as the men were wiped out on the Western Front, their wives, who had not yet borne sons, could find names and homes slipping away to distant cousins, maybe to little boys or babies. The result of this strict form of male primogeniture was family upheaval superimposed on the sadness of actual loss. Many young women reared in the stiff Edwardian traditions, realized their freedom in the debris and found a catharsis in flouting every rule. The alacrity with which some broke the iron bands of custom reveals their previous repression, but this violent breakaway from the traditional behaviour

patterns of aristocratic society was only made possible by the anguish of losing a whole generation of men.

During four bloody years the rain of desolation fell over England in the form of small yellow envelopes each containing a brief message starting with the words, 'The War Office regrets . . .' As this hail of golden arrows tipped with the poison of never-ending pain showered down on cottage and castle, the classes were drawn together in sorrow. The great lady went out to hold the hands of bereaved tenants while the old groom brushed horses with tear-filled eyes, knowing the young master would never come laughing into the stableyard again. As husbands, sons, brothers and lovers disappeared, the more perceptive women hit by this slaughter realized that their way of life was melting. The patterns they had been brought up to respect could never be reconstructed and although dazed by crashing values, the stronger personalities felt themselves individually magnified in loneliness. Out of the inferno many extraordinary women would evolve, but none more romantic and unexpected and none more typical of a new adventurous generation than Clare Sheridan.

She was born Clare Frewen, the only girl produced by that famous trio of Jerome sisters who had for so long bedecked Edwardian society. Mrs Moreton Frewen, her mother, dangled an earl's son, whom Clare did not like, as a prospective husband; Aunt Jennie Churchill provided a host of other young gentlemen – eldest sons, second sons, even third and fourth sons; but Clare chose the penniless Wilfred Sheridan, often called 'the best-looking man in England', to marry. For a time her artistic inclinations were smothered. Aunt Leonie Leslie, always close to her in time of trouble, and cousin Winston Churchill counselled patience. Child-bearing was supposed to have a settling effect. But Wilfred Sheridan was killed in 1915, seven days after the birth of his son, and Clare found herself a penniless widow with small children to support.

Her in-laws, living in old-fashioned grandeur at eighteenth-century Frampton Court, would allow her to live with them and hunt, which she hated, but they said it was impossible to give her any allowance. Winston proved generous and affectionate and helpful when she essayed to earn her living as a sculptor. In spite of the scarcity, more earls were produced (a few, unable to pass medical tests, had survived the war) but Clare would have none of them. Over-paraded on the marriage market as a girl, and deeply injured by death, she now broke

her bonds with a roar of rage, and set forth in search of dangerous adventures, interesting men and artistic fulfilment. Her astonishing career represented the epitome of all that was most shocking to those Edwardian mothers who were lamenting what they called the new generation of 'rebel daughters'.

I came to know her intimately over her last twenty-five years. As a child I was spellbound by her magnetic personality. Later, when the age gap did not matter, she became one of my closest friends. Even now I have only to look out of the window to see the stone figures which she hewed for my garden beside Galway Bay, and the sound of her deep laughter still fills the air. She never grew old. She lost her looks in that she became more powerful with age, but the sparkle of her personality remained. Never was anyone more stimulating; in affection and in anger alike her comments hit like a shower-bath. She was instinctive, emotional, devoid of logic, uncontrollable, blazing with love and indignation in turn.

A few crusty mortals found her exasperating; to all the rest she was vitalizing and inspiring. On the west coast of Ireland she is remembered as an artist who could drive a stonemason to work until he dropped, dragging out blocks of stone for her to carve; in the oasis of Biskra she must be remembered by the Arabs who lived around that famous date garden where she built her house of alabaster pillars; and on the Bosphorus a few ancient Turks surely remember with wonder the great lady who for a time planted tulips by the shore. Beyond that her ghost may sometimes stroll through the Kremlin and beyond that again to Sussex dells and the woods of County Cork where the vision of a golden-headed girl, tearful and tempestuous, may ruffle the evening breezes. It is hard to describe the integrity of her constant metamorphoses, but she was the frankest, bravest person and consistently true to herself.

This biography is based chiefly on her own recollections as we sat together by a log fire while the gales roared up from the Atlantic. Her own books give dates and hold the narrative together, but like her voluminous diaries they do not reveal her special quality. The letters and reminiscences of friends add variations, and the thirty volumes of diary kept by her brother Oswald Frewen light up the family views on her doings. From Bernard M. Baruch, Herbert Swope and Vladimir Korestovetz, I heard their own versions of certain dramas which Clare related from a very different angle, but however much people dis-

approved of her, they were unable to dislike her. Winston was furious when she went to Moscow in 1920 to do the busts of Lenin and Trotsky, but he forgave her and said to my father, 'It is easy to get angry with Clare but you have to forgive whatever she does. Anyway, she's the nearest thing to a sister you or I have ever known . . .'

I

Background

CLARE suffered an astonishing and unhappy childhood. Her father, Moreton Frewen, was the third son of a great Sussex landowner, so sixteenth-century Brickwall, the black-and-white timbered mansion in which his family had lived for three centuries, would never be his. A splendid horseman, a first-class shot, and a keen naturalist, he had, in the eighteen-seventies, allowed himself to become a man-about-town and a much sought-after guest in the country houses of England. One day he sailed to America 'to look around', and the vast Western plains caught his imagination. He rode with Red Indians, saw the last of the great bison herds and started cattle ranching in Wyoming. His friends, Lord Lonsdale and Lord Dunraven, enthralled by visits to his 'log castle' built on Powder River within sight of the Big Horn Mountains, returned to England to badger their trustees for funds to invest in Moreton's cattle ranches.

The gentlemen enjoyed themselves playing at being cowboys, but capital vanished when blizzards and droughts and the problems of over-grazing hit Moreton's 'Outfit 76'. One night in 1880, when on his way to Washington, where he intended to explain to the Senate the pending cattle disasters, Moreton was invited to Mr Leonard Jerome's big brownstone house in Madison Square, New York. There he met the golden-haired Clara who was about to accept the Earl of Essex in marriage. She had spent rather too many years flirting under the eagle eye of an ambitious mama determined that Clara should make as good a match as the raven-haired Jennie. Clara had allowed herself to be wooed by Lord Essex and Mrs Jerome was preening her feathers. She was very keen on English earls, placing them well above French dukes.

Clara appeared acquiescent, but she had grown so accustomed to Mama's hunt for ever bigger and better game that she found it hard to visualize actually landing a quarry.

When Moreton strode into her father's drawing-room, Clara took one look at the tall, lean Englishman, and banished all thought of peers of any realm from her mind. Clara's diary for December 1880 survives: 'Friday. Unspeakable happiness. Moreton came at 11 and stayed with us all day till 5. Came back to dine. Mama and Leonie go off to the Opera giving us our first evening to ourselves.' This was totally unlike Mrs Jerome who *never* allowed her daughters to sit alone in the drawing-room with any man, so Mr Jerome, or some other person must have been present – perhaps at the back of the room.

They were married at Grace Church in the spring. Presents poured in from the New York society of which Clara's father was the most attractive and cultivated member. All seemed set fair – very fair in fact – for this interesting young couple as they departed by train for a prolonged honeymoon on Moreton's ranch. Clara's trousseau filled several large trunks, her riding habits had been tailored in London, her gowns came from Paris. Naturally, Marie, her French lady's maid, came too. She would have to dress and undress her young mistress who had never in her life actually laced up her own boots.

As the train rolled westward Marie's face fell, and it grew longer still when at Cheyenne one hundred cowboys of 'Outfit 76' rode up with shouts and cheers to welcome the Boss and his bride. A ninety-mile ride in the Deadwood coach, sitting beside a male cook known as 'Black Hank', reduced Marie to nervous prostration. Staid butlers and genteel footmen had formed her circle during country house visits of the past. '*C'était bien différent chez Lady Randolph . . .* ' After a wing had been added to the log house, which the ranch hands called Frewen Castle, a minstrel's gallery was built in the hall from which cowboys could sing.

Clara loved it. To her mother, who had departed to Europe and was doing the cure at Marienbad, she wrote ecstatically of riding away for two or three days with Moreton and sleeping under stars 'diamond-sharp in the crystal air'. Then she began writing for baby clothes and 'a pale blue dressing gown from Paris'. 'Now darling Mama, do think of me and love me. I love you so dearly and hate to think of how cross I was to you sometimes last winter but you'll see how I'll make it up to you hereafter.' A note enclosed for her sister Leonie rambles on,

This is our *real* honeymoon. Moreton is the greatest darling *sur terre*! But there, I won't gush any more, *c'est si bête*. You'd love it out here if you were married; for a girl it is too much out of the world, but the air is perfectly delicious and the scenery so beautiful with the snowcapped Big Horn Mountains in the near distance and troops of antelope come by our house going down to the river to drink.

Feeling very fit Clara continued riding 'a very nice lady mule which doesn't tire me.' Despite this quiet mount, she one day threatened a miscarriage. Moreton had to drive her over rough tracks to meet the Deadwood coach and make fast for Cheyenne, where a baby daughter was still-born. Clara boarded the train for New York in a state of collapse.

Mr and Mrs Jerome, who had just returned from Europe, were furious with Moreton, so he hurried off to Washington where open invitations had been extended to him by various important politicians. His letters to Mr Jerome, far from containing regrets and apologies for the dangers he had allowed Clara to endure, sought to explain the disintegrating effects of Free Trade. With Moreton it would always be big talk, big ideas and incredibly big financial mess-ups.

Clara never returned to the Big Horn Mountains. Her next child was born safely in London, at 18 Aldford Street, off Park Lane – a house that kind Papa had purchased for her. This little boy was named Hugh for his godfather, the famous sporting Lord Lonsdale, who had galloped the Shires and the prairies with Moreton. Hugh Lonsdale always said he could judge any man's character by the way he sat a horse!

A year afterwards, on 9 September 1885, came a daughter, who was given the French version of her mother's name – Claire. Soon after this happy event, both aunts, Jennie Churchill and Leonie Leslie were gazing into the frilled bassinet saying wistfully, 'How lovely to have a little girl!' Jennie's two sons were aged ten and five. Leonie was awaiting a first baby (who turned out to be a son). Jennie did not have time to pay daily visits, for Lord Randolph Churchill, lately become Secretary of State for India, had just stepped into the crescendo of his political career, but the baby's grandmother, Mrs Leonard Jerome, came every day and usually brought Leonie with her. Leonie's leather-bound diary records on 12 September, 'Drove in the carriage with Mama to see Clara's pretty little girl', and again on the 15th, 'Drove with Mama to see Clara'. Soon after making this entry, on 24 September, Leonie's own son was born. They named him John after his

father and Randolph after his Churchill godfather, but at the age of eighteen John Randolph would cast away these names, preferring as poet and Irish Nationalist, to be known as Shane Leslie. And Claire would choose to shed the 'i' from her name and henceforth became known as Clare.

Grandma Jerome little dreamed, while visiting her daughters, what consternation these two babies born in the same month, would eventually cause. She thought – quite naturally – that her three girls had married well. Jennie's match was proving far more brilliant than the Jerome parents had expected. Admittedly Lord Randolph Churchill, about to become Chancellor of the Exchequer, did show occasional eccentricity, but it looked as if he must soon become the youngest as well as the most attractive Prime Minister in Europe. Clara's husband had an extraordinary imaginative mind and must surely become a millionaire – his schemes could not *all* fail! And Leonie – little dark Leonie, least pretty, but wittiest and most beguiling of the three, had married the *only son* of an Irish baronet – a dear fellow who stood up manfully to his sarcastic mother Lady Constance Leslie when she made rude remarks about Americans.

The Frewens were still based at 18 Aldford Street when, in 1887, a third baby was born and named Oswald. As a small child Clare played with her brothers and later with the two Leslie boys – John Randolph born a fortnight later than herself and Norman a year after. She never met any other girls or even heard about them; her circle was entirely masculine.

During early years the Frewen children lived chiefly in London. They hated the streets and the dull park. The world of joy opened up on visits to Brickwall, the Elizabethan house which belonged to that uncle in Sussex. Here they saw fields of buttercups and Clare would remember her little brother asking in awe, 'May one tread on them?'

Then came blissful visits to Banstead Manor, a house at Newmarket rented by Lord Randolph Churchill where he could keep an eye on his race horses, and allow his own boys to enjoy untrammelled holidays.

Clare was ten years younger than Winston and five years younger than Jack Churchill. They were the first 'big boys' she came across and she regarded them with apprehension.

During the autumn of 1890 Mr Leonard Jerome sailed over from America. He stayed at 18 Aldford Street and every evening the Frewen children tiptoed in to see him. A magnificent-looking old man, he

had grown suddenly frail. He sat in a big red velvet chair and Clare would always remember being dolled up before her turn came to 'amuse Grandpapa'. Mrs Jerome gave the blond curls a final twist and re-tied her blue shoulder ribbons before the little girl entered. Grandpapa Jerome was kind and understanding and told exciting stories in a curious husky voice. Mama said he had bronchitis and must not talk much, it made him short of breath.

In January Jennie moved Mr Jerome to her own house at 2 Connaught Place and the little Frewens walked across the park to see him every day, while Winston, who was old enough to have been charmed by this rugged old grandfather kept writing for his news from Harrow. It was Count Kinsky, who lunched with Jennie almost daily, who wrote back to Winston reassuringly: 'Your Grandpa is much better again. Quite as well if not better than he was 2 months ago the Dr says.' Then Mrs Jerome rented a house at Brighton for the air and the invalid travelled down by train and horse ambulance. Count Kinsky found a lodging house nearby where the three daughters could stay, and here they installed Mrs Everest (the Churchill nanny) with Jack Churchill and the three Frewen children with their nurse Susan. Jennie, Clara and Leonie took turns travelling down from London. Winston and the young Leslie boys said good-bye to their grandfather without knowing they would never see him again.

Clare heard that Grandpapa had died and was suddenly returned to London where she found the big red velvet chair looked terribly empty. Spring came and Grandma wandered around mournfully in her crackling black bombazine dress. Lord Randolph Churchill was away in Africa and Aunt Jennie on a round of country house visits. This meant that Winston, who was suffering dental troubles, had to be looked after by his aunts Clara and Leonie during frequent visits to London. Clare, taken to drive around with her mother and aunt, gazed shyly at the swollen face of her big cousin envying him the drama of an 'abscess'. How she hoped they would have to keep on putting Winston up, seeing him on to trains, and otherwise making up for the absence of his beautiful busy mama. The little girl revelled in these visits of her schoolboy cousin. She hardly dared to speak to Winston – she just watched him and listened to her nurse talking to Mrs Everest. Thus she learnt that 'Clare was a dull child, Oswald lovable, Winston headstrong'.

Mrs Frewen proved a dutiful aunt and when Jennie declared that

she could not break off her house parties to attend Speech Day at Harrow, Aunt Clara travelled down in her stead: 'Better than nothing for Winston'.

Then came the annual Eton–Harrow cricket match during which the schoolboys were loosed on their families in London. Clare never forgot it. Winston, determined not to miss a minute of freedom, took an early train so as to join his mother at 18 Aldford Street where she was 'economizing' after Randolph's political downfall. He arrived at eleven in the morning to find his mama and Aunt Clara breakfasting (a social meal in the dining-room – not trays in bed!) with Count Kinsky and the Frewen children. The afternoon was spent watching cricket from a coach decorated in Harrow blue. Clare wore corn-flowers to show which side she was on, but was bewildered by hearing that her own brothers and the Leslies were going to Eton, the rival school.

Next morning, after another Aldford Street breakfast, Kinsky promised to drive Winston to the Crystal Palace that evening. A Gala Tournament was to be produced for the Emperor and Empress of Germany. Later the Frewen children listened agog to tales of fireworks and wild beasts and royal personages. As Jennie wished to go off for the weekend Count Kinsky promised to make up for her absence by driving Winston down in his own phaeton. The sixteen-year-old boy would give graphic descriptions of their return (after a champagne dinner) with the Count taking the reins and passing everything on the road.

During the summer of 1891, Jennie asked both her sisters to bring their offspring to stay at Banstead. The Frewens stayed in relays accompanied by their own nurse, Susan, while the Leslie boys were looked after by Mrs Everest.*

Winston and Jack had built a retreat out in the garden, a sort of playhouse of logs. It had a ditch around it which they filled with water and a drawbridge which really did pull up. Winston and Jack were sufficiently magnanimous to allow the younger boy cousins to share the delights of this hideout, called 'the Den', but Clare was allowed only to creep through the nettles and thistles to clean the place. When battle started and 'the Den' was attacked, nurse Susan would hurriedly drag her away while Clare struggled to get back into the

*In 1970, before he died, my father boasted that he was the last person on earth who could say he had been given his bath by Mrs Everest.

fray. Her admiration for Winston increased, although 'he had a disconcerting way of looking at me critically and saying nothing'.

Grandma Jerome stayed through August and so did the useful Count Kinsky. Not only did he improve the boys' horsemanship but he taught them to shoot. He also encouraged the unenthusiastic Winston to study French with a special tutor. Jennie had searched in vain for an 'ugly' French governess. 'Mama, why do boys of that age need *ugly* governesses?' asked Clare. Just before the holidays ended Winston invited the 'grown-ups' to tea in 'the Den', and Clare was allowed to serve biscuits. Jennie wrote to her husband, 'Mama, Clara and Leonie are here and one of Clara's children. It is a bit overpowering – but I don't mind . . .'

In October the boys were back at school and the Frewens returned reluctantly to Aldford Street. In one of the many letters penned by Mrs Everest to Winston that winter, his old nurse begs him to try to 'disappoint some of your relations who prophesy a future of profligacy for you . . . Grandma Jerome is in bed with acute bronchitis. I went to see her last night, had tea with Susan and the children. Do you know those 3 little things repeat German verses beautifully! It is funny to hear them.'

Clare was getting on for seven years of age when she spent her last summer at Banstead Manor. Although Jack Churchill allowed her to play around 'the Den', Winston had passed out of the childish imaginative world. He had no time for her now that he was 'swotting' to get into the Army, and the little girl felt lonely and unwanted.

2
Enter King Milan of Serbia

ALTHOUGH she had been born an American and brought up close to her own parents, Mrs Moreton Frewen emulated the English upper classes by reducing contact with her own nursery to the minimum. She was an affectionate woman, devoted to her difficult spouse and somewhat over-impressed by the grandeur of her sisters' position in London Society. As a result of ceaseless worldly activity – in which there was no time for small children except for that half-hour when they were brought to the drawing-room in clean clothes – Hugh, Clare and Oswald found their little world dominated by Susan, their nurse, whom they called Nene. Unknown to the children, Mrs Frewen intended to get rid of her as soon as they were ready for a real governess. Susan taught them their letters and to recite French and German verses, which they learnt by ear without comprehension, but when lessons became serious she would be dispensed with. Susan held very strong religious principles and perhaps it was her disapproval of Mrs Frewen's admirer, King Milan of Serbia, which hastened her departure.

Clare was always delighted when orders came that she was to be dressed in her best lace dress with the blue sash and taken downstairs to curtsey. She found the huge, dark King, who called her 'darling' and asked her if he might be her 'savage', immensely appealing. In fact, it was only when *Monsieur le roi* was present that the little girl felt a kind of bond with her mother. Mrs Frewen, all soft-coloured

rustling silk, sitting in a flower-filled room, would then become a real person. She only seemed able to communicate with her daughter when this Balkan Majesty was holding Clare on his knee.

One Christmas when the three Frewen children had been stricken with measles, King Milan insisted on climbing all the way to the nursery with his presents. They could hear his voice booming up the stairs as he approached from the drawing-room floor. For the boys he brought lead soldiers, cannon and a fort. For Clare there was a baby doll in long clothes and a miniature tea set. He fascinated them all with stories told in a deep melodious voice and dramatically laid mimosa sprays around the cots. Nene watched suspiciously and when he left made impolite remarks. He was a very wicked man, she said, because he had separated from his Queen. 'But Mama likes him aw-fully,' protested Clare. 'It does not matter who your mother entertains downstairs,' replied Nene, 'a King who has left his wife has no right in a *nursery*!'

This argument seemed difficult to comprehend. In later years the children realized that for ten years or more King Milan had been to their mother what Count Kinsky was to Aunt Jennie – a beau, or, in the parlance of the time a cavalier attendant – the term 'lover' might be used but it had a more innocent meaning then – a lover could be simply he who loved a lady – his hopes might be imagined but the doings were not implicit. Lover-in-chief of Mrs Moreton Frewen was Milan of Serbia, who occasionally abandoned his throne but never lost his fortune. Moreton was a difficult husband and the unswerving devotion of a Balkan King must have been just the right medicine for his neglected, financially harassed wife. When Milan first set eyes on her, wearing a gardenia, he suffered *le coup de foudre*. He ordered a daily gardenia to be delivered at her door, and then, to reduce comment, told the flowershop to deliver thirty or thirty-one on the last day of each month. Clara could not help being flattered, and the servants of every house in Aldford Street watched surreptitiously at each month's end to check if the large, sweet-smelling box would arrive. Little Clare learnt to make unfavourable comparisons between the fragrance of her mother's drawing-room and the smell of her own gas-lit nursery.

Milan Obrenovich popped on and off his throne with bewildering frequency. He had first left his own country in 1886 after an un-successful campaign against the Prince of Bulgaria who took over the

[15]

Serbian throne only to be abducted by Russian agents and forced at pistol point to abdicate. Back to Belgrade came Milan and set himself to liberalizing the constitution. Off he went again at Russia's insistence. Then he quarrelled with his Russian Queen who retired to Wiesbaden with their only son Alexander. During ten years of exceedingly inflammable Balkan machinations Milan roamed Europe and kept reappearing in Paris and London, a forceful ladykiller with a certain Slav charm. Queen Victoria refused to receive him because she disapproved of matrimonial separation, so Milan sought an introduction to the moderately influential Prince of Wales. It was by chance that he met Mrs Moreton Frewen at a ball and poured out his woes to her while noting the gardenia she pinned to her gown. He took her to the opera, exchanged their opera glasses, and called at tea time next day with a note asking if he might correct the error and the affair was on. Clara invited him to dinner at Aldford Street and promised to introduce her sister, Lady Randolph Churchill, to whom the Prince of Wales was very devoted. Jennie sat next to Milan, but she didn't like his table manners, and was hesitant about introducing him to the Prince. Queen Victoria heard of these goings on and sent verbal messages through the Prince of Wales. Milan's conspiracies were making the Tsar uncomfortable. Would Clara kindly persuade him to leave the country.

So although Milan obtained no political sympathy, he fell violently and lastingly in love with Mrs Frewen. She was gentle by disposition and prone to believe any hard-luck story. Also, she had a touch of her mother's snobbism and liked having a Majesty in tow.

'But *what* a King! What a place to be King of,' snapped Jennie, 'they're always *killing* each other.'

Moreton was consistently unfaithful to his wife and conceited about his amatory prowess. 'Every woman I have ever enjoyed has been completely paralysed by the vigour of my performance,' he wrote, quite seriously, in his journal. In fact, he was too self-confident to be a jealous man and he rather liked Milan, although he disapproved of lavish royal dinner parties during a winter of industrial depression, when ragged groups stood hungry at London street corners. On occasion he thought it amusing to request an invitation for King Milan at the country house shooting parties where he, Moreton, was such a brilliant performer with a gun. Thus Milan introduced a note of novelty into the English county scenery. He travelled with his foster

brother as bodyguard – 'a glorious fellow with fifty inches of chest measurement', and neither Milan nor bodyguard had any hesitation in referring to what in central Europe is so naturally spoken of – the 'bond of lactation', created by sharing milk from the same woman. Human lactation was not a permitted subject in English drawing-rooms, but nothing could mute King Milan's resonant voice recounting the occasions on which his 'milk brother' had saved his life. The stories were astonishing. At their tranquil tables, hostesses would pause, open-mouthed, silver teapot in hand, as the King described that Belgrade state banquet where a trusted *aide de camp* had been seen dropping poison into the King's wine. 'As this traitor lifted the glass my milk brother touched my shoulder, whispered the danger and named the villain ... I pulled myself together ...' Milan gesticulated dramatically and his roar drowned other gentlemen's calculations of pheasants slaughtered. 'I stood up.' Now there would be complete silence. Not a teaspoon tinkled. ' "Gentlemen," I cried, "a toast to Serbia! I honour X by sending him my own glass." And the villain drank it down and died on the hearth rug!'

'Well, well, what an escape ... ' the ladies might murmur. But when children had overheard this 'spiffing story', it would be relayed back in the nursery, and although no one there knew what an *aide de camp* or *milk brother* was, nannies did not think the tale sounded *nice*. Nor were English gamekeepers impressed when Milan boasted to them, 'Lay down my gun because of the rain! No fear – *I* draw my energy from goatherd stock!'

In 1889, having bullied the Metropolitan of Serbia into giving him a divorce from Queen Nathalie, Milan returned to Belgrade with his son Alexander. He appeared to be able to dominate the country when present. But suddenly, without giving any reason, he abdicated in favour of the seventeen-year-old Prince, and arrived back in London to dance attendance on Clara. He tried to impress her with a tale of a gypsy fortune-teller who had long ago prophesied that unless he could snatch a certain golden-haired woman from the west the Obrenovich dynasty would end.

At least he was different. Milan possessed volubility and animal magnetism. Clara, wearied by her husband's ceaseless schemes, felt the attraction. It was only Jennie who couldn't get over the way he handled his fork! 'But he spent his boyhood hiding in the mountains with goatherds after his father got assassinated.'

'Nonsense,' riposted Jennie, 'he was brought up in the Palace Hotels of Europe.'

Leonie, the tactful one, would intervene. 'Do leave poor Clara's King alone. *I* know he went to a French *lycée*.'

But whenever Jennie was giving a dinner for the Prince of Wales she consistently avoided inviting Milan. He dropped strong hints. Once as Mrs Frewen departed for Lady Randolph's house a box of violets arrived with a note. 'Perhaps these flowers, coming it is true from an ungummed chap (*un dégommé*) might be useful on this occasion . . . ' This note and many others, all written in French, have survived. '*Ma chère et charmante amie*' they begin, and most of them end '*Je vous baise les mains*', or '*Vive amitié*', or simply '*Votre dévoué Milan*'. The envelopes and paper, embossed with gold crowns and initials in various designs of red and gold, blue and gold, silver and mauve, were too gorgeous to throw away. These pretty sentimental notes found their way into the children's scrap albums but the *real letters* Clara kept in a locked box which travelled with her. These private letters of which only fragments remain are signed *Oiseau*, the nickname which Milan took after his divorce to show he was 'free as a bird'. Sometimes he just drew a little bird. The bird motif also crept into his gifts. There was an exquisite gold music box from which at the touch of a button a little feathered bird would emerge to trill a song and beat tiny wings. King Milan also gave her a magnificent edition of the *Arabian Nights* newly translated into French (unexpurgated, but no matter, for the Frewen housemaids could hardly read English, much less French). His Majesty had the vellum binding embossed with violets – the symbol of fidelity (not very appropriate as Milan still kept his mistress, Madame Kristich, who had borne him two sons, which, as head of the Serbian Orthodox Church, he had legitimized). In the first volume of this fine set he wrote, '*A la plus gracieuse, noble, charmante et aimable des Occidentales Mrs Moreton Frewen – respectueux et amical hommage d'un reconnaissant Oriental – Milan. Londres – 5 Février 1891.*'

These volumes were not left lying around, but in the notes which Clara gave to her children were discreet flowery compliments and references to the kind of presents which it was perfectly proper for a gentleman to send a lady – a roll of silk for the little daughter, or some exceedingly expensive, specially-designed, jewelled knick-knack.

One day King Milan lifted Clare high in the air, kissed her and

asked what present she would like sent from Paris. '*Une poupée!*' she replied, speaking French as fluently as her mother.

'What kind of *poupée*? With blond curls like you?'

A few days later the King's personal attendant arrived carrying a large doll with a trousseau trimmed with real lace.

'Too good to play with,' said Mama, and Clare never saw it again.

When old Leonard Jerome lay dying, hampers as well as gardenias had arrived at Aldford Street. One card survives: '*Quelques bouteilles de vieux cognac que j'ai procuré de Paris pour votre cher malade.*'

Milan was terrified that his son might be endangered by the intrigues of Queen Nathalie. In 1891, when a bloody revolution seemed imminent, the Queen was expelled from Serbia and Milan settled in Paris saying he would leave the young King 'to his own devices'. Mrs Frewen occasionally rented a small apartment in Paris 'to economize' and there little Clare saw *Monsieur le roi* for the last time. She was nearly seven years old and as a gift he had brought her a ruby heart encircled with diamonds. Now he talked to her as if she were grown up and suddenly she gathered up courage to ask the question which had worried her ever since Nene's mutterings. 'Why don't you love Queen Nathalie?'

Her mother's face fell in horror but Milan laughed and drew the child to him. 'I will tell you what it was like – when she was my fiancée I wove romantic dreams around my Russian princess and to delight her I planted a whole field with lilies of the valley – *une prairie –*' he stretched out his huge arms '*un champ de muguets!* but when my bride arrived and I led her to the enchanted scented meadow she looked at it coldly and said, "But I don't care for lilies of the valley – ". And now does my little Clare understand?' But it was still not possible to explain to Nene.

In 1893 Milan returned to Serbia to help his son. As politics grew ever more complicated and brigands rampaged through the country, Milan decided that he ought to remain. He sent a frantic message to Mrs Frewen to meet him once more in Paris, but Clara refused. Milan then issued a royal decree annulling his divorce and brought Queen Nathalie back to Belgrade where he thought he could control her – 'my detestable spouse' he called her in letters to Clara which were anything but discreet.

Soon he was back in Paris and pleading with Mrs Frewen for an understanding. 'Monseigneur, I still love my husband', was the reply

she gave (or at least that is the reply she told her children she gave!). Milan said he would love her *malgré tout*. Clara laughingly riposted, 'And despite Madame Kristich and Queen Nathalie I will love you *quand-même*.'

One day Moreton picked up a signet ring with the Frewen crest which he had given his wife. He noticed that the motto beneath the crest had been erased and re-engraved *Quand-même*. He puzzled about this curious happening for quite a time and never guessed the explanation.

3

Nursery miseries

ALTHOUGH Clare had spent her own American childhood clinging to her mother's skirts and Moreton could boast about a superbly free boyhood in Sussex, the dismal conventions of English Victorian education were relentlessly imposed on their children.

After the nine-year-old Hugh had been sent to boarding school, when Clare was eight and Oswald six years old, Nene received her notice. In her stead an Alsatian governess, who could teach two languages simultaneously, arrived. When the gift of words had come to Clare, she would describe the new Mademoiselle – 'a red face and very long greasy hair that descended to her ankles, and which in the process of braiding she coiled several times around her neck. She might conveniently have hanged herself in this fashion, but unfortunately she did not.' For nearly five years she brought a nightmare quality into the schoolroom. To teach verbs she pinched the children's arms blue and beat them on the bare bottom with a wooden spoon – often in front of a housemaid called in to watch, who would remark inertly, 'Fancy now! And you being such a naughty little girl, who'd ha' thought it?'

About the same time, Papa, who had written a book called *The Financial Crisis*, suffered one of his own. Brilliantly as he might lobby Senators in Washington concerning world economic betterment, Mr Moreton Frewen never seemed able to pay his household bills. His rejoicings over a Gold Crusher which he believed was going to bring him a fortune became pathetic. In 1892 he wrote to his wife, 'The first fourteen days of July will be the most exciting of our lives.' Clara had economized (when they were owing thousands of pounds!) by

giving up smoking. Now her husband wrote to her, 'Begin again. When once I had got accustomed to seeing you smoke it no longer was the least annoying to me.'

But the mills in Utah could not obtain sufficient water to make the Crusher work. Papa vanished into Western America with $12000 and returned to Salt Lake City without a cent. On 28 August he informed his wife, 'Darling, it is no use. At some point I have got to stop and this is the point reached at last.' To Jennie he wrote,

Clara is so sweet and good and brave. She has fled to Dinard to escape creditors. I told her to start smoking again . . . you and Leonie all look so elegant puffing away when you get nervous. I never could take to it myself. Brookie [Lord Warwick] is backing me. The diamonds are pawned and the children go to Brickwall.

The Jerome sisters had not been brought up to consider money. Whatever fortune Leonard Jerome was in the process of losing he had never allowed his wife to worry or suffer embarrassment. They had been reared as daughters of a millionaire who took a few jolts but always protected *them*. They became dazed when Jennie had to live on her own settled £6000 a year (the commitments of an English duke made her father-in-law poor on £40000 per annum) and Clara found the expenses of home and education depended on what her father had considered a dress allowance. Leonie, because she had married the only son of an Irish baronet with £20000 a year was left so little that she could not even afford a carriage of her own. Old Mr Jerome had never guessed that Lord Randolph Churchill would fall by the wayside, that all Moreton's schemes would be wrecked and that the rich Leslies might enjoy taking their American daughter-in-law down a peg.

During her eighth year Clare overheard talk of 'affairs reaching a low ebb'. Not only could Mama and the aunts afford fewer Worth gowns – they suffered the humiliation of not being able to afford *tall* footmen! And then suddenly there were no footmen at all and for the Frewens no town house. Clare and Oswald, under the dark shadow of Mademoiselle, were dispatched to the family home, Brickwall. Mama only appeared at intervals. Country house visits and dartings to Paris where King Milan exchanged his woes for hers, kept her busy.

To 'economize', Leonie lived just outside Mayfair in a large house, 53 Seymour Street* which Moreton often visited. When not travelling he spent hours writing letters on her notepaper. He must have used

*Now demolished.

boxes of it. Men were still fascinated by him – Senator Jones of Nevada, Lord Grey, Lord Desborough, Lord Dunraven, treated him as a prophet – this popularity could hardly have continued had 'Mortal Ruin', as he was now known in the City, not been the best of company.

The Leslies noticed that the Gold Crusher had ceased to be a topic of conversation, but before they had time to wonder Moreton produced another invention – *Electrozones*, 'a purifying liquid made by passing electric currents through sea water'. After Western cattle and Universal Currency Reforms, Moreton had found something to 'cure every plague'. Faithful friends were asked to admire *Electrozones* during a 'scientific display at the Newcastle Sanitary Congress'. Brains reeled; Lord Desborough wrote to Jack Leslie, 'We thought his idea was to save the squirearchy by squeezing gold out of rubble, now it is disinfecting the whole world.'

Despite an interesting scientific test, the magic liquid did not prove easily marketable. Mrs Murray Guthrie, sister of Jack Leslie wrote,

It was a good disinfectant but had a terrible smell. Murray and Lord Desborough and Lord Grey invested heavily. To 'create a demand' they ordered bottles from every chemist in London for their lady friends, tied up in tissue paper and ribbon. I poured mine down the sink. Other ladies, who thought they were receiving *eau de toilette*, were furious.

Mr Frewen claimed that *Electrozones* if used as a mouth wash would make dentistry unnecessary. Those prone to itch, boils, rinderpest or skin odour could try it instead of bath salts. It could also be used to advantage on sewage farms 'to kill the harmful bacilli while allowing the effluvia to fatten the Thames trout'. Rotten meat might be safely devoured if sprinkled with *Electrozones* as a sauce, but when Moreton produced a bottle at country house parties suggesting its use 'when the fish was slightly off', hostesses looked displeased. Clara retreated with old Mrs Jerome to Dinard, famous for its air. In certain circumstances air is a particularly pleasant commodity – it is free!

On 16 February 1893, Moreton, full of hope, wrote to his wife:

Randolph has spoken this evening on Home Rule extremely well tho' very very nervous – almost inaudible but when he found his voice it was admirable. After dinner I went to Mrs Adair [famous American hostess]. She had Princess Mary and the Tecks* to dinner. Prince George is very coy I am told! That is the difficulty. Jennie and Leonie were there.

*The future Queen Mary and her parents the Duke and Duchess of Teck.

I have lively letters from Cane Springs this morning. It really looks as if that camp will make us rich by the year's end. I have sent Winny a typewriter today from Lily!

(Moreton had persuaded the rich American Lily, Duchess of Marlborough, to buy the eighteen-year-old Winston the obvious aid for aspiring journalists.)

Oblivious of the existence of his own three children, Moreton wrote from Lord Lonsdale's home, Barleythorpe, of the joys of once more galloping over the shires. 'I am woefully short of money but I think things are lifting – Hugh has had bad luck with his horses this week having killed one and staked another . . .'

Back in London he was always at the House of Commons or dining with duchesses. Millie Sutherland amused him. 'She had been down to Windsor to dine and sleep and the old Queen would pump her about the family row! Kept them waiting till nine-fifteen for dinner and kept them all standing afterwards for fifty minutes. Rather doubtful entertainment.'

And then, one midnight, he wrote to his wife from 53 Seymour Street,

Leonie has gone with 'Baby' Hatzfeldt [American wife of the German Ambassador] to a masked ball at Covent Garden, only whisper it not to any soul. Leo has great fun at these things and no one spots her. Last time she talked for half an hour to George Chetwynd who thought she was Lillie Langtry. Keep this dark. Your mother would have a fit.

Later on, he rejoiced:

The cable has just come. The best yet. Good times are near. Leonie is so thoughtful and affectionate because she knows I am worried and that you are . . . she has so much heart, is so good to me now I am in trouble.

The devil is I may again lose this chance by frittering away my stocks before they are ripe. But it's no use croaking; one can but do one's best. Leo says she will come out to Chicago in the autumn with you if I go West . . .

Winston wrote to me this morning on *the* typewriter!

Winston *was* pleased by the gift of the typewriter, but not so pleased with Moreton's suggestion that he should form a 'crisper' style. What he actually wrote was: 'Dear Uncle Moreton, I am very grateful for your letter and for the encouraging criticisms therein. The only great prose writer I have read so far, is Gibbon – who certainly cannot be accused of crispness . . .'

Meanwhile Clare and Oswald suffered under Mademoiselle at

Brickwall in Sussex. The beautiful black-and-white Elizabethan manor had a dark panelled drawing-room in which hung Vandykes and Lelys, and a row of Knellers. There was also a Holbein of Lady Guildeford which Uncle Edward was about to sell for a few hundred pounds.*

Behind the house (which lay hidden from an ancient main road by a high 'brick wall') stretched walled gardens, rambling stables and a park with old twisted oak trees. Everything around Brickwall was beautiful and here Papa and his brothers had known untrammelled happiness. But *they* had not been harassed by a Mademoiselle!

The children's bedrooms, in the oldest wing, were reached by a creaking oak staircase which the servants said was 'haunted'. New terrors seized Clare and Oswald. When they went to bed up the creaking stairs lesser ancestors watched from panelled walls (ancestors, that is, painted by lesser artists than the drawing-room lot) and not only were the children aware of the eyes of their forebears, but they had to walk past the 'Egyptian mummy' brought back by a great-uncle.

All that winter Moreton strove to impose his views concerning Silver Currency on the parliaments of the world. In the spring of 1893 he wrote to his wife: 'I want to see your old mother after Thursday's Silver debate and then come on to you, but I must get things on foot in the City so that, if troubles come, I can leave things brewing and go abroad.' By now Mr Moreton Frewen had cauldrons bubbling and brewing in every corner of the world while he repeated the refrain 'I ought to be able to borrow enough to keep us going till harvest.'

A few days later he wrote: 'I left immediately after dinner for the House [of Commons]. The old villain Gladstone who knows as much about Currency as I do about match-making made a most attractive little speech...' But for Moreton the Silver debate proved a disappointment. 'The Irish and the Labour men all voted with the Government and of course that amiable being Randolph did! I fear it may be years before it comes and Brickwall may be gone and heaps more of the old families will be down before they find out what is hurting them.'

On the occasions when Mama visited Brickwall it was to discuss the purchase of a beautiful derelict house on the Frewen estate. She wanted to turn it into her own family home. Built as a great hall attached to an older chapel in 1350, Brede Place had lain on Frewen

*Eventually purchased by William Vanderbilt who presented it to the Frick Museum.

land for several hundred years but was only used to lodge an occasional gamekeeper. Uncle Edward did not desire a second house five miles from Brickwall and he gladly let Clara have it with a couple of hundred acres of park carved from his own vast acreage.

During the year 1895 the children learnt of two family deaths. In February Lord Randolph Churchill, whose cold, vacant stare had frightened them at Banstead, died, leaving Aunt Jennie to build up a new life as a widow. Moreton wrote from Washington (where he appeared to be initiating his own legislation in Congress), 'Dear sweet little Jennie, my mind runs on her very much . . . oh to have got rid of that hair shirt for ever!' And in April, Grandma Jerome died.

In the following summer, Countess Hatzfeldt invited Clara's family to stay in her husband's castle on the Rhine. Clare and Oswald spoke German and they could have enjoyed the visit, but Mademoiselle kept them away from the grown-up house parties. During good weather Clara decreed that they should study out of doors. Every morning Mademoiselle led them out into the woods for lessons which invariably started off with beatings. One morning Clare ran into her mother's room where Mrs Frewen, all lace and frills and ribbons, lay in bed with a breakfast tray. 'She beats me every morning and I can't bear it!' Clare's story tumbled out incoherently and her mother found it hard to believe. Stormy scenes ensued. Mademoiselle was questioned but evaded dismissal.

Delectable Mama had become the belle of the constantly changing house parties. All summer long a nearby regiment used to come over to dance and to organize riding parties. When the regiment departed, a handsome Captain rode over to say good-bye. He lifted Oswald to his saddle and carried him to the gate. 'Tell your mother,' he said, 'that as we left, the band played "The Girl I Left Behind Me".'

'Why do you think he said that?' the little boy asked his sister, 'Mama isn't a *girl*!'

4

Clare as a débutante

THROUGHOUT these years, the near bankrupt 'Mr Frewen of England' was in constant demand in Washington for consultations on the Silver question with the Senate. When he returned, optimistic letters from his friend Lord Grey would be read aloud at the breakfast table. On 17 July 1896 Grey wrote, 'I told Rhodes all about *Electrozones* and he has consequently, with the object of doing you a good turn, written to ask you to send out fifty dozen bottles at his own cost. I congratulate you . . . Rhodes has a very warm feeling towards you.'*

Rhodes of Rhodesia possessed tremendous prestige in the nineties, and the nursery had reason to be proud of his compliments sent to Papa. It was a pity that he had neither warmth nor time, for the cringing little figures at Brickwall, but Mama appeared more often to talk of the home she was creating. During intervals of threatened bankruptcy she spent £5000 on the magical old house known as Brede Place. The children walked over to see the moss-covered roof being patched and medieval windows reglazed. There had been no 'improvements' since the sixteenth century when a brick 'Mews' where the gentlemen could perch their hawks had been built around the front door. They crept up and down the old oak staircases and selected huge panelled bedrooms for themselves.

Then, in August, a telegram announced that Uncle Richard Frewen had been swept off his yacht and drowned. The Irish estates inherited from his mother now passed to Moreton. So instead of moving into Brede Place, Clare and her brothers travelled to Innishannon,

*Rhodes's warm feelings did not help Moreton later on, when *Electrozones*, under another name and other management, became a famous mouth wash.

a sporting property on the river Bandon in County Cork. Immediately adjusting themselves to new possibilities Clare and Oswald found it easier to escape from their governess in this exciting new wilderness, where the local people willingly helped them lay false trails.

Mademoiselle's hatred of Ireland increased when she realized the impossibility of keeping Clare and Oswald away from the big boys, Hugh and the Leslies, who arrived for holidays from Eton. Out they would troop together to shoot or fish on their own, worshipping the gamekeeper as well as old poachers who had in the past taught Moreton to tie fishing flies.

Now the only shadow was the knowledge that soon Oswald must go to boarding school. When he reached the age of eleven Mademoiselle escorted him to England and Clare found herself suddenly alone in the nursery. She missed her brother desperately. Then Mama appeared, all silken flutter: 'I want to break it gently – Mademoiselle is not coming back.' Clare burst into tears, to the surprise of her mother, who did not recognize tears of relief.

Moreton was full of optimism at this time. At Innishannon he built hatcheries for Canadian rainbow trout with which to stock up the over-fished rivers of Ireland, and the Frewens returned to their former splendid mode of life in London. After the purchase of a large house at 25 Chesham Place, a great deal of entertaining began – useful to Moreton and intoxicating to his wife.

As the education of a girl was deemed unimportant, Clare spent most of her time at Innishannon, and revelled in the holidays when the boys re-appeared. Moreton was good with boys. He taught them to climb trees and peer into herons' nests. He was so much more entertaining as a naturalist than a bi-metallist, and he even showed some interest in his daughter when she revealed how well she could ride. He had himself been a famous horseman and he *could* teach. The only person whose equitation he found hard to improve had been his mistress Lillie Langtry in the distant past. Every time he lifted her into the saddle and the horse stepped forward she shrieked. Even so, he had eventually trained her to the point that she could appear in Rotten Row on his well-mannered chestnut *Redskin* – and then the Prince of Wales took over.

When school drew brothers and cousins away, Clare would try to settle down seriously to her books. The governess of the moment would be her only companion indoors, and outdoors, the grooms and

poachers. Every now and again Mama appeared and, remembering her own intensive schooling in Paris, would loudly complain that *this* was no education – but she did nothing to improve matters.

Clare disliked visits to London and marvelled at the feverish energy with which Mama plunged into social activity. Moreton had long been bored by Society. He had known too much of it when as a handsome young sportsman he was invited to every ball for his 'presence', and to every big shoot because it pleased the keepers to watch a gentleman with a perfect eye bringing down the birds. London meant to him now only a place in which to find backing for the latest scheme, but his American wife delighted in tagging along with her sisters in the Prince of Wales's set. At one stage Jennie did indeed try to interest His Royal Highness in that little working model of the Gold Crusher machine which so badly scratched the Frewen dining-table. The Prince peered, murmured politely and did not invest. In the end a full-sized Gold Crusher only succeeded in crushing enough gold for the wedding ring of one of the investors. It was a huge machine needing tons of water and no water seemed to exist near gold mines.

When Winston, now an officer in India, sought to write military articles for the *Daily Telegraph*, it was Moreton whom he inveigled into asking the editor to double his payment. And when young Churchill wanted the proofs of his first book, *The Malakand Field Force*, to be hurriedly corrected, it was Moreton he chose for this chore. With the best of intentions Moreton re-wrote Winston's prose *more clearly*, and the book went to press in a state which the author later called 'nice and plain and simple so that an idiot in an almshouse could make no mistake.' To Leonie Winston wrote: 'Moreton let me down most sadly by the careless way in which he revised the proofs, & his terribly illiterate punctuation. I have said nothing reproachful to him . . . Nor need you.'

Clare saw little of her cousin during these years, but when she was suddenly uprooted from Ireland and placed in a convent in Paris, Winston wrote her encouraging letters:

My dear Clare, do not be low spirited. It is something after all to be fed and clothed and sheltered: more than most people in the world obtain without constant and unwearying toil. Cultivate a philosophical disposition, grow pretty and wise and good . . .

What *had* happened to Winston? *Good* was the last thing she wanted to be, *pretty* she knew herself, and *wise* . . . at fourteen she felt herself

as wise as most of her elders. Shane, being her own age and unhappy at Eton wrote with equal pomp but more drama:

Darling Clare, you see I, true to my contract, am writing to you just as I shall for the next fifty weeks or so until you come back. Not a Sunday will I miss. If I am ill, however bad, I will dictate and have it sent to you. So you may know that only death can be the cause of a non-arrival.

Clare, who had never met any girls at all, and was a Protestant to boot, could hardly enjoy the company of French girls who knew nothing of fishing or riding and who referred to her as *l'Hérétique*. She spoke fluent French, the language was no barrier, but the lessons bored her. As the Boer War gained momentum – that war which was to offer Winston the chance to make his name and fight his way into parliament, Clare's schoolmates took to cries of *'Vivent les Boers . . . à bas les Anglais'* whenever Clare entered a room.

During the summer holidays at Innishannon, Mama announced that the Bishop of Cork would shortly be visiting the district and would confirm Clare.

'No!' gasped *l'Hérétique*, 'I am going to be a Catholic.'

Mama turned pale but kept her temper. 'It is better to be a Catholic than nothing at all, but it will make it very difficult for you to get married in England.' That was the crunch. Clare would be expected to marry well and the English aristocracy was almost entirely Protestant. Instead of returning to the convent Clare found herself packed off to a Protestant family in Darmstadt who were supposed to counteract the convent influence and 'finish' her education by visits to the Opera. One of Mama's friends paid a visit and reported seeing Clare playing ping-pong with a bunch of young German officers. Mama listened anxiously. Her daughter was now sixteen, German officers might give her ideas. Supposing she fell in love? Moreton growled, 'Send your German maid over to bring her home.'

So Clare returned to Innishannon and no more attempts at education were made. She could speak German and French, she had heard some music, had visited several museums, and was now left entirely to her own devices in Ireland. She discovered the library and for a whole year, alone in Innishannon, she indulged in hours of unguided reading. She made no selections. She took to literature shelf by shelf.

Meanwhile Shane, intending to be 'a great scholar', worked feverishly at Eton. He wrote to her:

... you said you would excuse me from writing to you during trials. Please don't, I take a pleasure in writing to you, and it doesn't interfere at all ... It is curious to observe the boys you do your trials with. (They mix up the whole school so you may work in a room with boys you have never seen before.) There is the boy, with a book, learning up to the last moment ... there is the college genius who has no need to look up trials ... there is the dunce, anxious-looking, dreading the exam ... there is the fellow who does not care a rap what happens so long as he just scrapes through ... there are hundreds of different kinds and I amuse myself observing them. Eton is just a little world and it prepares you for the world outside.

But for girls it was different. They needed no preparation for the outside world. They just stepped into it.

After Winston escaped from the Boers he came to lecture at Eton College. His four cousins who were there – Hugh aged sixteen, Shane fifteen, Norman fourteen and Oswald thirteen, each wrote an account in their diaries of what he told them: 'Don't make your mind a munition magazine for the use of others. Make it a rifle range to fire the munitions of other people.'

When Brede Place could be considered habitable, Moreton let it to Stephen Crane, author of *The Red Badge of Courage*, and his curious mistress Cora. Delicate, tubercular, Crane scribbled away beside smoky wood fires, and at intervals the local intelligentsia – H. G. Wells and Joseph Conrad – were splendidly entertained, along with various astonished members of the county aristocracy. The great Henry James who had settled four miles away in the old town of Rye, was kind to Crane, but too careful of himself to suffer the medieval discomforts of Brede Place, even for an evening. Mrs Frewen had started renovations with the roof and the garden, not with the plumbing, and Moreton considered the sixteenth-century privies perched on the steep slope outside to be an interesting historical feature. 'We love Brede with a wildness which I think is a little pathetic,' wrote Stephen Crane to Clara. 'We have been in the old house nearly a month and every day it seems more beautiful to us.'

The village had long feared its ghosts, and after talking of 'raw gold sunshine' Crane went on to describe the heavy storms in which 'the whole house sung to us like a harp and all the spooks have been wailing to us ... we have not yet found maids who will sleep in the house'. But a drunken cook, a decrepit butler and a serving man remained there at Moreton's bidding supervised by his own faithful valet Mack. 'We like Mack very much,' wrote Crane, 'but he sometimes com-

plains of inconveniences, and sometimes longs for five or six footmen which, of course, we do not need.'

Mack was not interested in literary geniuses. He liked *gentlemen*, and the Cranes' idea of entertainment was enough to drive most servants to drink. The alcoholic cook remained for a year but gallant Mack, who had seen 'goings on' enough in his day, found it hard to tolerate the Cranes' idea of celebrating Christmas week in 1899.

A play, entitled *The Ghost*, put together by Stephen with contributions by Henry James, H. G. Wells, Joseph Conrad and Rider Haggard, was acted in the village schoolhouse to terrified yokels. Then Cora hired a troop of servants 'for the week' and organized a three-day bacchanalia. The whole house was festooned with ropes of holly and ivy. Sixty guests were put up in cots hired from the local hospital, while Mr and Mrs H. G. Wells deemed themselves lucky to find a warm four-poster in which to sleep. From iron brackets made by the local blacksmith, candle grease dripped on the dancers. Fifty flaming plum puddings made their appearance each midnight. The cook rose to the occasion pouring brandy into herself and the puddings indiscriminately. But on the third night – that of the Big Ball – a heavy fall of snow kept many guests from arriving. And Stephen began to cough. In the early hours Cora woke H. G. Wells to tell him that her lover was having a lung haemorrhage. Wells found a bicycle and set off across the dawn-lit snow to find a doctor. The sixty guests in residence departed breakfastless and a week later Cora transported Stephen Crane to Switzerland. Three months later he was dead.

Moreton, who was always generous to people outside the family, wrote telling Cora to 'skip the rent', and added, 'I send you £20 which I hope may suffice.'

After this interlude, Clara Frewen herself continued the restoration of Brede Place.

Every now and again Clara took her daughter to see the aunts in London. Jennie would give them tea in her drawing-room which was so different to others, being crammed not with Victorian knick-knacks, but with antique Italian furniture. One day, forgetting to pour out the tea from the silver teapot, she sat describing Winston's first speech in the House of Commons, while tears of emotion filled her eyes. 'And there I sat in the same Gallery where I had so often heard his father speak – in the great days you know,' and she kept squeezing Clare's hand. On the rare occasions when Winston now met his cousin, she

perceived that he had no time for admiring schoolgirls. He would give her a hug and she saw his eyes focussing elsewhere – on some person from whom he could ask useful advice or glean information. He had, however, developed an endearing habit of slipping her an occasional pound note 'tip' – as if seeing a child off to school. Once she dared to ask him, 'Have you forgotten "the Den"?' He burst into laughter. 'How could I? And you were the only girl allowed in our battles. Consider yourself unique.'

King Milan died in 1901. He had been mortified by the marriage of his son, King Alexander, to a commoner. Milan had written from Vienna: 'After devoting myself body and soul to my son, he has played me the trick of marrying a perfectly impossible woman who is fourteen years his elder, to the great scandal of the country and of Europe.' When King Alexander and his Queen Draga were horribly assassinated in Belgrade – dragged from the bedroom cupboard in which they were hiding and cut into small pieces, the more intimate parts being thrown over the balcony to jeering crowds below – Mrs Frewen felt thankful that her *Oiseau* was not alive. Clare watched her mother when the news arrived. Shuddering, Mrs Frewen, had slipped out into her rose garden; snip, snip; how peaceful England seemed; snip, snip. The fourtune-teller's prediction had come true. The Obrenovich dynasty had ended. She still kept the box of love-letters locked away.

After her seventeenth birthday Clare had nothing to do except to read and ride. It excited her to go out hunting on a frosty morning and although always a little afraid of the big banks and ditches, she was a girl of spirit, and local gentlemen observed that she was ready to put a good horse at any obstacle. She loved the long rides home in the wintry dusk, and the blazing log fire which awaited, and the peace of living undisturbed in a house with only the soft-voiced Irish servants to talk to. Sometimes she wondered if it would not be pleasant to marry one of the local sporting gentlemen and spend the rest of her life here – riding through sunlit mists all day – reading by the fire at night.

But *that* was not the intention of her parents. Moreton was once again in a tight financial corner, and when he looked around for final assets, that tall, golden-haired daughter caught his attention. Clare must be married off to the eldest son of one of his own rich friends; with a son-in-law to wring funds out of trustees and such-like he would

recoup his losses and consolidate that elusive fortune which had so often nearly been within his grasp.

The large house in Chesham Place had to be sold, but a smaller one, 39a Great Cumberland Place, replaced it, and Clara's mauve silk curtains were re-hung in a new drawing-room, and Moreton's famous buffalo head gazed glassily down the new front hall. The scene was set. Jennie Churchill lived at No 37a Great Cumberland Place and Leonie at No 10 a few doors away. The Jerome sisters could trip in and out of each other's houses with their whispers and plans.

In the spring, when hunting ended and the Irish countryside was breaking into flower, Clare was ordered to London and prepared for her first ball. Moreton's old friend, Mrs Adair, the American hostess, was giving a fancy dress ball for her niece Nelly Post, who had also been reared in Ireland. Mrs Adair arranged an Irish Quadrille in which Nelly and Clare, dressed in flowing green with crowns of shamrock, should dance. There had to be rehearsals, and at the last of these a young man arrived late, to be introduced to Clare as her final partner – he had been too busy to attend previous rehearsals. Looking at Wilfred Sheridan, Clare decided immediately that this was the only man she would ever care for.

Mr Sheridan led her on to the floor and dazedly she counted out the steps of the quadrille. He learnt quickly and then sat out with her asking questions. She tried to seem intelligent and talked about Ibsen's plays, which she had just discovered on the library shelf.

'And what do you think of my ancestor's plays?' Wilfred asked lightly. She looked blank.

'Richard Brinsley Sheridan – he was my forebear,' explained Wilfred.

But Clare had never heard of Sheridan, or indeed, of any eighteenth-century writers or politicians. She tried to cover her confusion. 'I thought Sheridan made furniture.'

'That was Sheraton!' Wilfred laughed, but not unkindly. He found her ignorance appealing.

On the night of Mrs Adair's ball, 11 May 1903, the Irish Quadrille proved a high-light. The two fresh-faced girls in green gauze gowns made their début to applause. Wilfred took trouble with his partner all through the evening. He was courteous and easy to talk to – yet there was a little sadness in his glances, for Wilfred Sheridan had made inquiries and they were unsatisfactory. Not for him, alas, with an old

family home and no money, was the daughter of 'Mortal Ruin'.

All through that summer season of 1903 Clare suffered the pangs of first love. Fond as she was of her aunts, Clare writhed when she over-heard them discussing her 'chances'. Of course they wanted her to make a big marriage. Jennie and Leonie had no daughters and it was so natural that they should enjoy introducing this one gorgeous niece into Society. And they were so much better at the game than poor Mama with her *obvious* ambitions.

Clare put on a sulky face when Aunt Jennie tried to over-haul her. 'Now that your hair is *up* dear child, get it waved each day . . . and you *must* pull in your waist.' Aunt Leonie was gentler but even she could give a terrific scolding on hearing that a girl had done something likely to 'stop nice men from proposing marriage'. Clare did just such a thing when a Russian friend asked her to look after his Borzoi. Alone, she walked the dog in Hyde Park, and, worse still, wore a floating chiffon scarf which, said Aunt Leonie, *drew attention*. 'But I thought you told me to always look nice,' Clare pleaded tearfully. '*Nice*, but *not* conspicuous, and *never never* go out alone – what couldn't have happened to you!'

'Well what?' argued Clare. 'With all Mama's friends out for their constitutionals *and* that dog, what *could* have happened?'

'Don't be foolish, my child – your reputation is precious. It is unwise to walk alone, it is madness to be *seen* walking alone.'

From then on Clare had to take exercise with a maid trailing at her heels.

Wilfred showed no sympathy when told of the incident. 'You shouldn't mind scoldings. Young girls have to be looked after – you don't *want* to be thought fast do you?' Clare had a secret hankering to be considered *a little fast*, but she could see how grievously this possibility affected those she loved, so she accepted restraint with resignation.

The enchanting Wilfred living on a small allowance was trying to earn money in the City of London so that he could run his family home later. With his magnificent looks and charm it would be easy for him to wed an heiress – everyone was eager to help him to do this, including several young heiresses. The one thing he could not think of was a penniless wife. Wilfred resolved not to woo Clare, but there could be no harm in improving her mind. He lent her not only the works of his ancestor Richard Brinsley Sheridan and his grandfather John

Motley's *The Rise of the Dutch Republic*, but also the novels of Jane Austen, Thomas Hardy and George Eliot. Whatever he ordered, Clare obediently consumed.

And how she hated the dances which he did not attend. In Wilfred's company she felt herself utterly natural, sparkling and gay. In the presence of eligible young men she froze. Years later Clare would be able to analyse her feelings.

The fact was that not only did I care for Wilfred, but I was paralysed by the general attitude of society towards elder sons. I could not bring myself, however charming they might be (and who shall say that elder sons cannot be charming?) to talk to them without self-consciousness . . . I could not get rid of the sensation that they knew that I was poor and that I knew they were marriageably desirable. I could not bear that they should think, or that anyone looking on should think, that I made the slightest effort to be unduly amiable.

How different it was when the forbidden Mr Sheridan stepped across the floor to ask her to dance. Then her face lit up and her feet flew to the music.

Only once did Wilfred make her acutely miserable, and then it was her own fault. The aunts had been particularly busy that night introducing the right young men and Clare's temper was frayed. Returning to the ballroom she heard that Wilfred was to partner Viola Tree (the daughter of the great Sir Beerbohm) in a cotillion. 'But he's mine . . . you can't have him!' The words tumbled from her lips. Viola shrugged her shoulders. Wilfred was shocked at Clare's lack of restraint. He gave all his cotillion favours to Viola and the aunts took Clare home in tears.

'It's an infatuation dear – you must learn to hide things and to behave decorously. *Never* let a man see you care – you've so much to learn. Don't think we haven't been all through it, but remember Englishmen don't *like* these outbursts, and you were very rude,' scolded Jennie, but Leonie said nothing. She just patted Clare's hand.

Towards the end of the Season, the pick of the eldest sons fell in love with Clare. He came to see her at Brede and Mama preened herself in incoherent euphoria. Clare liked him but didn't want him. It was agony. Moreton put an end to it by taking for granted the proposal and acceptance. He was off to the City borrowing money on his future son-in-law's assets before the question had been popped. Demented trustees held counsel. They did not want to spend the rest of their days entangled with 'Mortal Ruin'. The swain was sent for, lectured, implored. Wistfully he sent a telegram to Mrs Frewen:

'Terribly sorry. Cannot come down on Sunday.' Brede Place never saw him again. Many years later, as a very old man, he would tell the author how sorry he had been when his hand was forced. Clare relaxed despite her father's black looks. But Moreton raged. He thought *she* had let *him* down!

5
Beginnings of a career

IN August, when the London Season ended, Clare returned to Inni-shannon. With her went a trunk of books lent by Wilfred. In September she celebrated her eighteenth birthday alone and decided to become an author to atone for being a social failure. Her first novel *L'Ingénue* took long hours of work. She had never studied English under a qualified teacher. Now her own lack of grammatical knowledge confused her. The ability to speak French and German did not help an inexperienced girl to construct phrases, and the philosophy which Clare wished to impart was pathetically juvenile.

Mama grew snappy. 'You go about it in the wrong way.'

'Go about what – ?' She was considering shorter sentences.

'Making your own life pleasant . . . In *my* day we were *taught* how to treat gentlemen . . .' Mama would beckon coyly and then assuming a shocked face put up her hands and push away. Clare couldn't help smiling but she refused to emulate. 'I don't *want* to lead them on – and if I did I mightn't want to put up my hands.' It was Mama's turn to look shocked.

Oswald arrived back from the Navy for Christmas. His diary records shooting and riding with Clare on terrifying horses that scattered the locals as they thundered up hill. He notes, 'A couple of decent hymns and a ripping sermon' on Christmas day and lovely leather presents from Aunt Jennie.

In January, Aunt Leonie suggested that Clare try Dublin for the 'Winter Season'. This meant a new spate of balls and Vice-regal parties. It would be a delight, said Leonie, to leave the icy Leslie home in County Monaghan and chaperone her niece.

[38]

Aunt Leonie knew everyone and was adored by all. She had met her own husband in Dublin when Jennie and Randolph were part of the Vice-regal set-up. Phoenix Park glowed romantically for her. 'Give me the pleasure of taking you around,' pleaded the tactful aunt. Clare realized that she was being given 'a second chance' and Leonie made it seem so alluring. She packed the white ball gowns which had been necessary for the London Season and could now be produced in Dublin.

Clare did not enjoy the pomp of Dublin Castle. A letter to Oswald describes a ball there. 'I never saw so many tumbles in any ballroom (or so many dresses reduced to shreds) and all because the men have to wear uniforms and consequently spurs. Princess Pat and others came crashing down . . .'

The only man who interested Miss Frewen was the elderly Sir Frank Swettenham, recently Governor of the Malay States, who was a successful, somewhat exotic, author and '. . . a waste of time, my dear – a sheer waste of time.' But Clare found Aunt Leonie more tolerant and more understanding than Jennie. Although the most popular woman in Society, when alone with a 'difficult girl' who seemed averse to playing the usual worldly game, Leonie imparted her own secret philosophy. Clare began to trust her and to love her, and to try to copy her wit which was more delicately humorous than Jennie's.

When Leonie took her niece to stay with their Royal Highnesses the Duke and Duchess of Connaught at the splendid eighteenth-century Royal Hospital, Clare noticed the warmth of the welcome which the royal duke, who was Inspector-General of Forces in Ireland, extended to her aunt, but she never guessed that he had for years been passionately in love with Leonie. *Ma Tante*, as Clare usually called her, had handled the affair so discreetly that it seemed possible for H.R.H. to visit her at Castle Leslie and to pay almost daily calls during the London Season without arousing adverse comment. And the bookish German princess who was his duchess also appeared to worship Leonie. Clare couldn't help being impressed by the grandeur and by the extraordinary position held by her aunt in the Connaught household. And she was charmed by the two young Princesses of Connaught. So far she had known few women – Mama she regarded as a dear goose, Aunt Jennie half-charmed, half-provoked her, Aunt Leonie inspired. Now she was genuinely surprised to find congenial companions in Princess Margaret and Princess 'Patsy'. They were both tall and lovely.

Like Clare they were expected to marry 'suitably'. It was, however, even more difficult to find heirs to thrones than heirs to fortunes. When the first shyness wore off the three girls recognized each other as human beings in somewhat the same circumstances. The husband-hunt kept them agonizingly self-conscious.

During the following London Season, when Clare was again being dangled around the London ballrooms, she found her friendship with the 'Connaught girls' grew even closer. The unmentionable predicament of being a marriageable princess, under the eyes of the gossips, seemed quite as embarrassing as being the daughter of 'Mortal Ruin'. Clare tagged along with the 'royals' and scarcely saw Wilfred. In fact, she had meekly written to her mother in April 1903, 'Give my tenderest love to Aunt Jennie and Aunt Leonie who have both been so sweet to me – et dis que la saison prochaine si je suis à Londres je ne flirterai pas avec un penniless detrimental quoique W.S. est si gentil et quoique je l'aimerai toujours.'

In that very conventional society where married women could carry on illicit love affairs for years, it is entertaining to note that these three girls – Clare and the lovely princesses – *shocked* the King's fast set by refusing to wear uncomfortable, high-boned collars by day. Instead, they invented a kind of frilly blouse which left their young necks bare and this tiny rebellion – half artistic, half for comfort, caused eyebrows to lift. 'They won't get husbands . . .' It may have been symptomatic of Edwardian hypocrisy that little whalebone collars should spike the jaw all day prior to very free revelation of the bosom every night.

When in the following winter, the Connaughts went to Egypt, Princess Margaret wrote long letters to Clare describing the Nile by moonlight, the Pyramids at dawn, and eventually the Prince who asked her to marry him. It seemed too good to be true. Prince Gustaf Adolph of Sweden had proposed at a ball given by the Khedive and he had kissed her on the balcony. 'Tell my friends,' she wrote to Clare, 'I want them all to know that this is no "*mariage arrangé*", *we are in love!*' These romantic effusions reached Clare in Cannes where she was in no position to tell anyone anything, for Mama had thoughtlessly run out of money on the way back from Malta where she had taken Clare to see midshipman Oswald. The Mediterranean Fleet gave dances on board which should keep the girl's mind off Wilfred – but Mrs Frewen had to watch her very carefully for naval officers were *never* rich!

Only the daughter of an American millionaire could have made the discovery that she simply *had no money left*, with the insouciance of Mama. She had not lost her purse; she simply 'found it empty'. Furiously her daughter looked around Cannes station. There wasn't a friend in sight. Clare *had* to produce the two precious five-pound notes given her for Christmas by Winston and Jack Churchill, change them into francs and hire a cab to the Grand Hotel whence cables could be sent to Moreton. But *he* had unexpectedly sailed for America and did not reply. Mama wept daily when the post produced no fat envelope.

In desperation Clare made friends with another girl of her own age. This was Leila, the daughter of General Arthur Paget. Leila spread the news that old Frewen was not answering cables and Clare found fifty pounds thrust into her hand by General Paget. Mama cried still more when she heard, but then a wonderful idea struck her – they would go to Monte Carlo and double it in the Casino and pay it right back. So mother and daughter took a train and Clare won twenty-five pounds. The Pagets refused to be repaid until 'old Moreton' could be traced. And Clare, who had been taught that no monetary gift should ever be accepted from a gentleman discovered that the rule appeared flexible!

By May 1905 they were back in London and Clare was once more going around with Princess 'Patsy' and her radiant elder sister. She did not tell them of what had happened in Cannes. Sweet as they were, 'royals' could not have understood the pitfalls and embarrassments surrounding a daughter of 'Mortal Ruin'.

Margaret would become Crown Princess of Sweden, but 'Patsy' was firmly refusing to marry King Alfonso of Spain. She confided her feelings to Clare. 'Imagine having to become a Roman Catholic and watch bull-fights.' Clare backed her up. King Edward was disappointed at 'Patsy's' disregard for an alliance useful to England. He was determined to have an English queen in Madrid, even if the poor girl did turn away her head when horses were disembowelled. Eventually he got his way with another English princess.

In June Princess Margaret married her handsome Gustaf at Windsor Castle. Guests in full evening dress travelled from London by special train at 8 a.m. Aunt Leonie, had to chaperone not only her niece but a covey of fluttering, tulle-clad girls. Aunt Jennie had given Clare a dress for the occasion, taking her to Monsieur Worth, who remembered

making Mama's dress years before for a function at the Tuileries. As Clare stood for her fittings, Monsieur Worth, a quaint little Englishman who had started his business in Paris, reminisced sentimentally about the court of the Empress Eugénie: 'I can see your mother as she was in 1868 – how lovely – all in white – and how lovely her daughter is now . . .'

Clare dissolved into sentimental tears during the ceremony at Windsor and when on departing Princess Margaret whispered, 'May it soon be for you too – ' they poured down her cheeks. She had, of course, told the Princess about Wilfred. But there seemed to be no hope.

Once again she trailed through the London Season, feeling the eyes of the Dowagers on her, feeling the comments of parents with eligible sons like cold hail on a thin skin. 'I'm getting too old to go on dragging through the market place,' she expostulated to Aunt Jennie. 'Only nineteen, dear child – the age I was when I married Randolph – and I was not eager to marry I promise you – your mother and Leonie were twenty-five when they married – though they enjoyed collecting proposals . . .'

'But you had a rich father,' blurted Clare. 'You weren't made to look as if you were trying to catch a rich husband.'

Jennie threw her arms around her – she wept easily. 'My poor darling – if only I could give you something. How has it happened that we don't seem to have any money? . . .'

It was indeed bewildering for the Jerome sisters who had been brought up as daughters of a millionaire, to find themselves reduced in middle age to tiny incomes. Jennie had blown all she could of her own settlement. Impulsive, extravagant and impractical she had wept with emotion when, on taking his seat in the House of Commons, Winston had sent her a cheque for £300. It was a 'thank you' for the 'wit and energy' she had given him – but it all went on ball gowns and when he relieved her of the obligation to pay him his allowance of £500 a year, she did not demur.

Leonie had (almost by chance, because it was a love match) married well, so old Leonard Jerome had left his remaining shred of fortune to the impecunious Clara, half demented by her husband's near-miss money-making. Even the glorious diamond rivière bought for old Mrs Jerome when she went to the court of the Emperor Napoleon III had eventually vanished into the maw of Moreton's schemes. And now

both Jennie and Leonie who had gladly forgone their share of the diamonds had only affection and advice to give their niece.

Winston always encouraged Clare. He did not laugh when she revealed her longing to write a book – any book – as long as it gave her a little financial independence. He always embraced and cheered her. On the occasions when they met in Society he was amused by her truculence and determination to make good in some way of her own. But Winston regarded males as the people who mattered; the ones who made the world go round. This did not mean that he was incapable of deep love for women, but what could women actually *do* except please and inspire the male sex? He couldn't help admiring Clare's spirit and being sorry for her – fretting with personal ambition while that old bi-metallist father touted the country for Free Trade. He used to chaff her about the Borzoi incident, and Jennie would scold. 'Don't laugh about it, Winston. *It isn't funny.* A great *many* people noticed and spoke to me about it – even without a Borzoi Clare would attract attention if she walked alone.'

Of her cousins, the one who would always remain closest to Clare was Leonie's elder son – that John Randolph who was now at Cambridge University, an Irish Nationalist with his name changed to Shane. He was a curious mixture, dark, handsome, poet and athlete, brilliant, moody, uncomfortable to have around, scornful of Society, impractical but burning to help the poor and right the world's wrongs, rude to his conventional relations, charming to elderly scholars, disdainful of 'girls', and very maddening as the heir of a large estate and future title.

During his years at Cambridge, Clare often visited him, but she waxed indignant at the way in which he entertained her. After ordering her to admire his stroke when rowing on the river, Shane would take her to hear the singing in King's College Chapel – one of the most beautiful buildings in the world – and then to a workingmen's tea house for a bun. He had become a Roman Catholic, which dumbfounded his father, a landowner with estates in Protestant Ulster, but Leonie understood and Clare felt once again that urge towards the Catholic Church which had assailed her even in the convent she hated.

While Shane studied Gaelic and Latin, wore shamrocks and green scarves and worked with passion for John Redmond's Irish Nationalists, Clare paid occasional visits to Castle Leslie in County Monaghan – for Innishannon was now closed except during the salmon fishing season,

[43]

and Mrs Frewen lived almost entirely at Brede Place. Clare loved the mysterious old house in Sussex and when her father reappeared from his travels he drew a mixture of interesting people to his table. He and Lord Warwick (grown tired of the delectable Daisy's efforts to help the poor) had spent a year in Kenya, referring to the virgin forests there as 'unknown territory just waiting for rich settlers'. Moreton was a stimulating talker and the Sussex intelligentsia enjoyed driving over to Brede where, in the fourteenth-century Great Hall, he held forth on his adventures. So it was that Clare met Henry James, Rudyard Kipling and George Moore, who dealt kindly with her literary aspirations. In the eyes of these novelists an attractive girl who was pursued by rich peers but only wanted to *be a writer*, had great interest. They could not know of the said peers' worried trustees.

Henry James lived four miles away, at Rye, and Clare frequently bicycled over to lunch with him in Lamb House at the end of its steep cobbled street. The great novelist took immense pains not to quench her ambitions. Sometimes when she travelled down from London by train, he would meet her at Rye station and take her to his house for a meal and literary advice – both kinds of sustenance delightfully and openly delivered. Once, when he was not at home when she called, he wrote to her afterwards:

My dear Clare; Your note has followed me. I am touched and horrified at your having had to resort to the musty *Mermaid Inn* for slaking thirst and repose of body. I should have been delighted to put you up indefinitely, had I only been where I had so much best have been. I didn't mean to do it – to be away – and will almost never do it again. And this is a very tiny absence. I return tonight for indefinite fidelity, or rather (for that is vilely put) for the most definite possible . . . Make me another early sign, follow it up close.

While rejoicing in Henry James's patronage, Clare saw that her own prose would never resemble his. Happily for her peace of mind she did not try to copy. No one could emulate Henry James and she should have been sufficiently thankful of the honour of being talked to as an equal. With a pathetic childlike innocence Henry James would tell her that he simply could not understand why his books lost money for his publishers.

Rudyard Kipling, who lived fifteen miles away, was fascinated by Moreton and his adventures. But Clare disliked return visits because Mrs Kipling always interrupted her husband's stories. 'Clever men,' Clare wrote cheekily, 'should not have wives, only cooks!'

H. G. Wells frequented Lamb House, but Henry James did not consider him a suitable acquaintance for a young girl and firmly refused any introduction although Clare begged for one. He took her instead to Sir George and Lady Maud Warrender, who lived near Rye. Aunt Jennie did not look too pleased to find her niece frequently visiting the Warrenders' manor house. Hugh Warrender, the tall, good-looking brother of Sir George had been in love with Jennie for years, and swore he would never marry anyone else. Jennie liked to keep her swains tagging along indefinitely. When her young second husband vanished to shoot in Scotland, Jennie would visit dear Maudie, and dear Hugh always came to stay at the same time. It was most aggravating to notice Clare watching quizzically.

While Mrs Frewen laid down a garden of variegated roses, Clare devised a 'friendship' garden. She asked friends to send their favourite plant so that it became a floral autograph album. Princess Margaret donated her name flower, and Princess 'Patsy' some shamrock (which withered on Sussex soil), and the Duke of Connaught a miniature jungle of bamboo; Rudyard Kipling sent rosemary and lavender, and George Moore wrote, 'The flower that came into my mind at once on reading your letter was a fuchsia, so why should I seek further? When I was a child in Ireland I liked fuchsias better than almost any other flower.' Lord Howard de Waldon, charming, handsome, enormously rich, who looked so like Shane that they were sometimes mistaken for each other, sent her forget-me-nots. Clare sighed a little for here was an eligible young man whom she *did* like but he explained frankly both to her and Shane that his trustees were plaguing him not to get entangled with Moreton. So it was just 'forget-me-not' on both sides.

Wilfred's gift dominated the others – he sent Antoine Rivoir's rose trees and these flowers were kept singularly active. Whenever Clare contemplated matrimony to some other man she would retreat to her garden and find the thorns of Wilfred's rose trees caught her garments as if beseeching her to say 'No!' But none of this cultivation – literary or floral would get a girl anywhere, thought Mama.

In the following winter Clare and Nelly Post were dispatched to Stockholm to stay with Princess Margaret, recently become a mother. Mrs Frewen now genuinely believed her daughter might be happier married to a foreigner. She had already begun to press Clare to accept Baron Van Heekeren, an older man of a certain charm and large fortune. He owned a famous castle in Holland. Moreton, however,

approved of Sweden – there were a number of millionaires there, and Mama naturally approved of royal visits.

The girls enjoyed a fairy-tale winter. They inhabited a corner of the quadrangular palace where old King Oscar, who had been the lynch pin in the separation of Norway from Sweden, lay dying. Their days were spent driving through the snow-covered city to the sound of sleigh bells which lent romance to the most ordinary official functions. Occasionally Princess Margaret took them off on an expedition into the countryside. It was all fascinating, but Clare's heart remained that of an ice maiden.

When she returned to England she made a new friend. This was Violet Asquith, the 'brainy' daughter of the Prime Minister. Violet was in love with Winston, who, since Pamela Plowden's marriage to Lord Lytton in 1902, had remained almost aggressively heart free. Clare approved of the politically-minded erudite Violet, only three years younger than herself but so much better educated. She seemed the perfect spouse for a dynamic politician. In fact, Clare thought how satisfactory it would be if *her* friend Violet married Winston and she could move in and prove that three *can* be company. She was still very naïve.

In the meantime Violet travelled around to country house parties with Clare and the girls spoke of their literary ambitions. Violet was asked to write an anonymous article on country house entertaining for the *National Review*. Fearing to write from a position of privilege, Violet handed the offer on to Clare who set to work with enthusiasm and a certain insolence. Clare had *not* been happy in the big country houses where she often felt herself appraised coolly. She jotted down her impressions in vivid style, and several hostesses recognized themselves. Rumour soon had it that the eminent Maurice Baring must be the author of this well-written article so obviously based on inside information. Then the truth emerged. A saucy girl had dared to observe and record the doings of her elders! She would never be asked again. But Clare was incapable of contrition – she had earned her first ten pounds!

Constable's publishing firm noticed the article and suggested that she write a book. She didn't know how to go about it but she was certain she could improve on *L'Ingénue*. Returning to Brede Place she sat diligently scribbling and gazing out at the sunlit lawns, or listening to the ghostly flutterings of owls in the eaves. She was ashamed of this

novel, yet she craved for a genuine criticism. Among the men of letters whom she had encountered during excursions into the ballrooms of London, was the great George Moore. He took enormous trouble over Clare's efforts but it was the 'quality of his praise' that killed. On 29 June 1907, he wrote to her:

. . . It was with difficulty that I restrained myself this afternoon from writing to you that I had read a third of your book and liked it so much that I had to tell you before reading any further. The phrases that rose up in my mind were: 'What a dear little book she has written and what a charming girl she must be to have thought so well, so truly and so prettily. . . There are just a few points to correct and if she were staying in the same house with me it would be a pleasure to revise her book with her, a few touches here and there, deftly done – for it would be a thousand pities to do anything that would change the petal-like flutter of her pages, scented with all the perfume of her young mind. A real young girl's book.'

Clare cringed. She had intended to astound the world with her sophisticated philosophy and it had turned into a 'petal-like flutter'. She kicked the manuscript around the room before setting it on fire.

Aunts Jennie and Leonie were not entirely frivolous. They took their niece to the weekly receptions of Millie, Duchess of Sutherland, who mixed intellectuals with her ordinary guests at her huge London residence, Stafford House. Millie, a half-sister of the famous Daisy Warwick, would stand shimmering with diamonds at the top of a wide staircase, introducing writers and artists to an aristocracy longing to meet this Bohemian world, but too shy to know how to go about it. Clare never sulked at Stafford House. She did not feel embarrassed here and her eyes sparkled when she met men who could not *possibly* regard themselves as likely husbands. Among these was Robert Hitchens, author of *The Garden of Allah*, and through him she first became aware of the charm of the desert which later was to affect her so much. He sent her many letters during his winters abroad. Once he wrote concerning the boredom of beauty in heroines. '. . . some beauties have very ugly spirits. But of course we are much governed by beauty. I, being a man, am as susceptible to it as most men. Perhaps you realized that the other day. But I also saw the kindness looking out of your eye . . . ' He sent her carnation roots for her friendship garden adding, 'You don't know how sensitive I am. I ought to send you a specimen of the sensitive plant . . .'

Aunt Jennie was now living in a fine old moated manor house named Salisbury Hall, seventeen miles north of London. Leonie took

Clare to spend an occasional Sunday there and she would row around the moat with Winston and Jack, reminiscing about the old days at Banstead. She was thankful for their company – with them it didn't matter being a penniless girl. They could not possibly consider her as a bride.

Then suddenly, in the summer of 1908, Jack married the dreamy Lady Gwendoline Bertie and Winston became engaged to beautiful Clementine Hozier, with her red hair and huge blue eyes. Clare felt she had lost her Churchill cousins; and poor Violet Asquith fled sadly to the country where she mourned for Winston.

Winston's wedding took place at the fashionable church of St Margaret's beside the Houses of Parliament. Clare was among the five bridesmaids. The others were Clemmie's sister Nellie, Madeleine Whyte, Horatia Seymour and Venetia Stanley (Clemmie's cousin whom old Prime Minister Asquith would love with tragic intensity). London was empty in mid-September, but devoted relations and friends filled the church. Clementine wore a dress of white satin and carried a white prayer book, the gift of her godfather Jack Leslie; the bridesmaids were in apple green tulle and bewreathed. Leonie and Clara sat beside Jennie – a spectacular trio in their fifties. As the couple came out of the church a shrill Cockney voice cried, 'You're a lucky girl, Clemmie', and Jennie pinched Leonie's arm, 'I think so too.'

The bridesmaids and their mothers went on to the reception at Lady St Helier's house in Portland Place. They stood in the open window watching the costers whom Winston had aided to keep their barrows, dancing in pearl-button suits in the open street.

It was a sunlit joyous afternoon but Clare felt a surge of the old embarrassed resentment when, after the couple had departed for Blenheim, Jennie half tearful turned to her and said, 'My two are fled – Shane says he's never going to marry. It must be your turn next, darling Clare.'

6

A brief independence
in Capri

MORETON Frewen continued to balance on various tightropes stretched between vast fortune and bankruptcy. When bailiffs had to be announced the old butler used a special scornful voice which gave warning of the visitors' status. Sometimes these characters remained sitting in the hall all day. Clare learned to discern bailiffs from other men by their manners; bailiffs did not stand up when she entered and kept their hats on indoors! On one occasion, she and Oswald, returning from a walk, were surprised when the front door was opened by a smart young fellow whom they took to be a new footman out of uniform. Hurrying upstairs they scolded their mother. 'How can you engage another servant when we are so hard up!'

'Hush,' whispered Mrs Frewen. 'He is a bailiff. I've given him ten bob and he has cleaned all the mirrors and promised to answer the doorbell.'

Yet despite their financial straits, the amusing Moreton and charming, if absent-minded Clara, were still invited to all the grander London parties. English people do not drop friends in parlous circumstances. Moreton had only missed becoming a millionaire by selling too soon his interests in land around the Great Lakes, in Broken Hill Mine, *Electrozones* and the Denver City scheme. Now he embarked on a last dream. He believed it possible to develop Prince Rupert on the Pacific coast as a rival to Vancouver. His plan for the port sounded simple. While the trade of Alberta was to flow out, the fish of the Pacific was to flow in.

[49]

Observing that Mr Frewen knew everyone of importance in Washington and London, a tough railway tycoon named Charles Hays offered him an option on 600 acres of vital seafront. Nothing was written down. Moreton always preferred the elasticity of a gentleman's agreement. When, after making use of Moreton for two years, Hays perceived the astronomical rise in land value, he backed out of his promise. Moreton was outraged – already he had had maps made of plots with which to entice buyers. Lord d'Abernon, also closely entwined in the scheme, wrote sympathetically. 'The facts are clear. Hays entered into definite arrangements when he thought sales might be difficult, and is now trying to get out of them when he finds Prince Rupert a success.'

Oswald returned on leave from the Navy only occasionally. It was Clare, the girl, the one who had to live at home until she married, who suffered most painfully from her parents' condition because *she* was expected to do something about it. Papa made it plain that a rich son-in-law would make all the difference to *his* life.

Mr Frewen was in America when creditors suddenly descended on his unhappy wife at Brede Place. Her letter dated 8 April 1908 survives:

My darling – I am having a terrible time – bailiffs came to Brede for a judgement against *you* not against me – and although I assured them there was a bill of sale they went to the extent of coming to say that if I did not pay the wretched £18 before 2 o'clock they would post bills up on the front door . . . I had to go into Hastings, find the most respectable pawnbroker and pawn my diamond ring for £30. Then Clare is very ill with measles, poor Oswald having taken two splendid Seconds had come home and as Susan* is nursing Clare, he, poor boy, is all alone – I came to London to pack up my silver and see if I can pawn it . . . I am going to be up all night to pack and take away little valuables given to *me*, like Milan's presents – I shall see all my little treasures go one by one – Jennie says she will buy in a few small things for me if she can, but you know how hard up *they* are . . . [Jennie had married George Cornwallis-West and they were both trying to *earn*! He in the City which he did not understand; she by writing her memoirs and a play which would make no money and cost her a husband.] Well the bright spot is Hugh's splendid appointment [he had obtained an official position in Nigeria] . . . and Winston will be in the Cabinet – how exciting – perhaps Colonial Secretary. Goodbye. No time. Not a moment more. Your distracted but loving old wife.

It seems unbelievable that the huge fortune of Leonard Jerome could so completely evaporate, and that poor Clara could be landed in such

*Their beloved nurse had returned to them.

a situation. But the sale did not prove too cruel, for Jennie and Leonie and other devoted friends used their pin money to buy back most of her treasures.

Clare would always remember that summer at Brede. It was so beautiful and so sad. The original fourteenth-century house had scarcely crumbled, nor had the wings in pale Elizabethan brick. The porch entry kept its mews where visitors might hang either hawks or hats, and on the grassy slopes around Clara arranged little lead tickets on the trees planted by famous people – she had King Edward's tree, and Kipling's tree, and Lord Milner's tree and Queen Marie of Roumania's tree, one planted by the possibly famous Winston, and in a certain corner two trees standing side by side – one carried the identification card 'H.R.H. the Duke of Connaught' – the other carried none. Leonie had brought her duke down and they planted their trees together, but being a *true* Edwardian she did not think it would be good to encourage curiosity among the gardeners! Amidst this sylvan setting Clare recovered morosely from measles while watching her distracted mother, who, whenever a cheque arrived by post would order the trap and drive off to retrieve belongings from the Hastings pawnbroker.

On his return, Moreton did not appear abashed. He merely said that he was sick of financial scandals and scoundrels and now thought he would stand for parliament. Aunt Leonie travelled from London with the hamper of *objets d'art* retrieved from the sale. She brought her nine-year-old son Lionel, who, like all boys, found Moreton spellbinding. Inspired by Mr Frewen's sporting tales Lionel drifted out alone to catch minnows in a nearby stream. As he climbed through the woods he came upon a pool containing large and beautifully coloured fish of a type he had never seen before. After some hours of patient work with hook, worm and net, he managed to land several that were a good twelve inches long, and brought them home in triumph. His aunt gave cries of dismay. 'But they are rainbow trout from the hatchery!' However, Moreton had almost forgotten that scheme and had lost interest. 'As he caught them let's have trout for dinner!' Leonie reckoned that each rainbow trout had cost several hundred pounds.

Oswald's diary reveals the extraordinary situation in which the Frewens lived. They *always* stayed at Claridges or the Ritz because the Jerome women had been taught that hotels were a method of economizing. You left your house and in some mysterious way that saved

money. It was, for some reason, economical to go *where you were known*. On 29 November 1908 Oswald wrote: 'Lunch at Claridges with Ma and Chicken [Clare]. At 3.15 Pa called and took us to the American Consulate at Bishops Gate where we signed away patrimony recklessly to the extent of £4000 respectively. Clare swore the Affidavit as though it were the wittiest joke imaginable.'

But the joke rankled. When Oswald had departed for a year at sea, Clare wrote Hugh a miserable ten-page letter saying that she had telephoned Wilfred but he was away, and that she never wanted to see her father again . . .

My friends always dress me . . . I am young, I am liked, and I have the world on my side. There is not a soul among the people I live among who will not sympathise with me. They are all tired of his schemes . . . I wish you luck. You are going away. It is a good thing. It is so easy to be brave at a distance. With love, Clare.

When Princess Margaret (now, of course, Crown Princess of Sweden) returned to visit her parents at Bagshot Park, the Duke and Duchess invited Clare to the weekend party. As always in country houses the guests would assemble in the drawing-room to an 8 o'clock gong, not to be given a drink, but so that each gentleman could be instructed as to which lady he was to escort. One night Clare found herself on the arm of Lord Dudley. As they walked into the dining-room he whispered that he was doing all in his power to prevent his own family trustees from closing in on her father – but trustees were the devil! 'Do tell your mother that *I* don't want her to lose her home – assure her of my devotion.'

Clare sat down at her place, and as she gazed down at the long table, at the laughing guests glinting in diamonds, tears started to fill her eyes. What was she doing here in this carefree throng? Princess Margaret who remained sensitive through her own happiness watched Clare's face and later that night she begged her to come again to Sweden. They would go out sketching in the woods together. It would be an escape.

So Clare travelled back to Stockholm. She and the Princess converted a palace ballroom into a studio, and there they worked in oils at sketches started out of doors. It was a spectacular golden autumn and Clare did find one man to enthral her. He was quite the wrong choice, of course – the famed lover of the neurotic Queen of Sweden! Princess Margaret had taken Clare to stay with the middle-aged Queen, who spent much

time on a romantic island in the south. Her Majesty inhabited an Italian-styled villa which had marble columns and Roman oil jars strewn outside. The only other guest was Doctor Axel Munthe, since become famous as the author of *The Story of San Michele*, but then only well known for powers out of the ordinary as a psychiatric doctor. He had out-Charcoted Charcot, and as rumours spread that the Queen of Sweden could not live without this mysterious presence, Munthe was a character who intrigued the whole of Europe, or at least the section of it which was 'in the know' about queens' lovers. Everyone wanted to meet the elusive, irresistible doctor. Clare had heard of Munthe all her life and now, each morning, suddenly, she found herself alone with him – alone because he never could induce Her Majesty or Her Royal Highness to leave their feather beds and walk with him before dawn. The doctor was already going blind, and he suffered desperately from insomnia. He felt attracted by the exuberant girl and she by the man whom Henry James would describe in a letter to her father as 'poor, strange, interesting, stricken Munthe'.

He offered her a retreat in a Saracen watchtower on Anacapri. 'You will be completely isolated but perhaps you will find you can write.' Clare grew excited. Returning to Brede Place she relayed Dr Munthe's dazzling suggestions to her father, who was again in New York. Moreton replied angrily on 2 November 1909:

I have read your long letter over again, the first one from home and it satisfies me less and less ... It is *self* from beginning to end! ... you have missed great opportunities. I have never pointed them out to you for the reason – a bad reason – that I am extremely proud and to suggest to my child that she might have helped me immensely, and can, is frankly disagreeable to me. You are a beautiful woman with a mental equipment which, rightly employed, might have helped infinitely. God forbid that you should angle for men whether old or young ... but if you would look around and make useful and not merely Bohemian or ornamental friends, I might, and thus you and your mother and Oswald might have been much further along the road! ... Don't be content to butterfly in the sun. Get down to the plot and plan of life; it is not enough – not nearly worthy of you – to stick seeds in a garden patch. You have got those qualities which might yet leave a deep impression on contemporary life.

Clare absorbed this missive with indignation. In the spring she persuaded her mother to take her off to Capri where Dr Munthe promised an ancient watchtower for the daughter and a comfortable house for Mama. There was no question of a girl travelling unchaperoned nor had Clare the money for such a journey, but Mrs Frewen

c

acquiesced happily. Munthe met them at Anacapri and a procession of boys and women carried their luggage on their heads up the winding mountain path. Passing Munthe's own villa, they reached the edge of a cliff. Here lay a tiny house set amidst flowering olive groves for Mama and beyond it the Saracen watchtower where Clare could live entirely on her own, climbing a ladder up to the bedroom! She would be ostensibly chaperoned, yet joyfully free!

Intrigued by royal amours and longing to see what *was* going on between the Swedish Queen and her host, Mama accepted the situation calmly. The Queen was living in seclusion in another of the doctor's houses on Anacapri and after Munthe had enjoyed his dawn walk with Clare ('all quite proper' a letter assured Leonie), he would devote the rest of the day to Her Majesty who, wearing a trim tailored suit topped by a straw boater, walked among the happy peasants.

For two months Clare let herself enjoy a blissful stupor – she did not write another novel, but she sketched and read and became aware of the heart of the island as Munthe said she must. She adored him and obeyed him. Then, just when the flowers were at their most wonderful, came the news that King Edward VII had died. Mama showed all the symptoms of hysteria demanded by such an event and started to pack. 'We must get back to London for the funeral.'

'But *why*? Who wants to see the funeral?'

'My dear – it is historic – and he was always so good to me.'

Clare rushed to Dr Munthe. 'I can't bear to leave it all.'

'I am not a doctor for nothing, dear child. I shall prescribe a little sickness – but at the very last minute. Your mother must enjoy the funeral, but I think it will be too dangerous for you to travel with a temperature.'

The ruse worked. 'You can safely leave your daughter in the hands of an old doctor,' he said.

'Unchaperoned?'

'She lives in her own establishment . . .'

So Mrs Frewen, already wearing a black veil, departed for Capri port preceded by the line of laughing boys and girls with suitcases on their heads, and flowers in their hands. She reached London in time for the pageantry.

Clare remained alone in her tower for a fortnight and then Munthe took her to Naples and on to Rome, where they discovered that no train sleepers could be procured for ten days. It might be highly

irregular, but the doctor decided there was nothing for it but to install Clare in a hotel and show her the city, deserted as it was in the heat ol mid-June. Munthe's eyes kept him in black spectacles all through the blazing day, but each evening he drove Clare out to see ruins and churches by moonlight or starlight. This freedom to go around with Munthe and enjoy his rare intelligence, spoiled Clare's taste for ordinary sight-seeing and, indeed, for ordinary life in England. Before she departed Munthe perceived her inner state and spoke to her severely. At times he could sound rather like Papa. 'Clare, you must marry. You cannot go on like this. *The time has come for you to marry.*' When he put her on the train she felt he was probably right. She did not want to marry but she would – she must. And of the gentlemen available that Dutch baron was the pleasantest to contemplate.

On reaching Brede Place she found a letter waiting from him which contained a fresh proposal. He seemed devoted and he was rich enough to please her parents, although old enough and wise enough not to get entangled in Moreton's schemes. Walking in her friendship garden she thought of Wilfred. The thorns of his rose trees did catch her skirt but she decided that dream must die. When Mama was informed that she was accepting the Baron Heekeren, Mrs Frewen heaved a sigh of relief. Henceforth Clare would be châtelaine of a noble castle rising out of a moat – a delightful place for in-laws to visit! But Mama had only twenty-four hours in which to preen.

Moreton no longer owned a town house, so when Mrs and Miss Frewen went to London they stayed with Aunt Jennie. Mama could hardly wait to break the news to her sisters before announcing the engagement officially. But on this occasion she and Clare arrived by a late train and there was no time to speak to Jennie before going up to dress for a dinner party.

Dear Aunt Jennie – how quickly she sensed things. *Could* it have been chance that on this particular night she should have chosen Wilfred Sheridan as a spare man?

7
Wilfred

WILFRED Sheridan had not seen Clare for two years. He had always been attracted by her animal spirits; now he watched her and thought her wonderfully matured, even more amusing to talk to, utterly different to other girls. And Clare picked strange words to mark the effect this man had over her. She found him 'more beautiful than ever'. They sat next each other at dinner and before coffee arrived Wilfred had made up his mind. He was going to marry the impossible one. He led her to a sofa in Aunt Jennie's drawing-room. Clare recorded the conversation that followed:

'Tomorrow Mama and I go to Holland.'

'What for?'

'That no longer concerns you.'

'To marry – ?'

'You always spoke highly of marriage . . .'

'But you would be happier in a cottage with *me* than in a castle with *him*.'

'I have always thought so.'

'Marry *me*.'

Clare bowed her head.

They announced it. Aunt Jennie flung her arms around her. An incurable romantic she had always desired this. Mama's face fell. 'Your father won't be pleased.'

This statement put it mildly. When Moreton returned to England he was sore displeased. But what could he *say*? Wilfred was a great gentleman, he came of the crispest upper crust of the English country aristocracy, he had great literary talent in his family, he was often

referred to as the best-looking man of his time – scholarly, athletic, a man whom other men admired and respected and who attracted every woman he met.

Wilfred's parents did not hide their bitter disappointment. How could the handsome Sheridan heir choose to marry an absolutely penniless girl? It meant he would have to go on earning in the City so that *his* sons could go to the right schools. Later he would inherit Frampton Court and live quietly in Dorsetshire. He would have books and horses and an estate of 6000 acres to run but no town house, no travel, no worldly luxuries. Clare and Wilfred had waited so long while elders explained the impossibility of such a match: now they wondered why they had wasted time.

'Surely your sister's marriage should satisfy them?' complained Clare. Wilfred's elder sister Sophie was the wife of a very rich man, a well-known all-round sportsman, Willie Hall-Walker (later Lord Wavertree), who bred race horses according to their horoscopes, one of which had won the 1909 Derby.* Sophie, petulant and childless, had been 'carrying on' with King Edward during summer weeks at Marienbad. She thought it smart to be the King's lady at spa time. Clare was not supposed to know about such things, but the excitement engendered at that time by the peccadilloes of royalty could hardly be missed even by girls who scarcely knew the facts of life. Sophie's set would never be Wilfred's set. His friends were 'high brow'. Winston was among them. He appreciated Wilfred's literary conversation.

The engagement of Wilfred Sheridan and Clare Frewen caused immense interest in London Society. It had been a gloomy summer with entertaining held in abeyance because of King Edward's death, and this romance had much appeal. Clare and Wilfred were such a *wonderful looking couple*, everyone would want them at balls.

Clare kept three of the letters of congratulation which poured in – from Henry James, Rudyard Kipling and Dr Axel Munthe.

Reform Club,
Pall Mall.
July 14 1910.

My dear delightful Clare!

I am a poor creature for jubilations in these days being still a most halting correspondent – even with the music of your beautiful voice in my ears. But the charming, the admirable news you gave me thrusts the pen into my poor hand . . . I give you

*Minoru, which he had sold to King Edward VII.

together what I venture to call a fond benediction, and verily shade my eyes a little before the dazzle of your combined personal lustre . . .

Your affectionate, your truly tender old friend,
Henry James

July 5th 1910.

Dear 'Child',

Your cold and unimpassioned statement of the 23rd inst. to hand . . . We do most highly approve of the new entente cordiale. It's all rot to say it's happened before, etc. because it hasn't: and there is no earthly reason why the thing shouldn't endure even as you wish it to . . . But I should chuck poetry and literature if I were you. They don't make for married happiness on the she-side. If you two dotards can totter so far please crawl here on Sunday . . .

Ever yours permanently (no change),
Rudyard Kipling

Dear Artemis,

. . . Yes I am very glad and happy to hear that you are safe with a nice clean and honourable man at your side, who will steer you through life. I told you I was jealous of the men who made love to you but not of the man who would be a good husband to you; on the contrary, I was longing for him to turn up. All you told me about him was right and well, and with a Greek profile par dessus le marché it sounds better still.

. . . But Artemis is gone – you remember no mortal man ever could call her his, and Artemis you are no more . . .

Axel Munthe

The magnificence of the wedding presents which began to arrive at Jennie's house astonished the family. Clare realized how much Wilfred was liked. To help the bride and her mother, Lady Naylor Leyland loaned them her enormous house overlooking Hyde Park (now the French Embassy), where rows of gifts could be laid out on view in the spacious drawing-room. The date chosen for the wedding was 15 October 1910 and the time was to be 2 o'clock at St Margaret's, Westminster. Mr Asquith, the Prime Minister, promised to attend on condition that Clare and her father came at midday to the Oratory where his niece-in-law was marrying Lord Lovat. Clare enjoyed the rush and was preparing to go to 10 Downing Street to see Laura Lister drive to the church, when her own wedding dress arrived from Worth. (If Monsieur Worth himself had not departed this world, the events which follow would not have happened.) A representative from the firm rang the Leyland doorbell and stepped into the marble hall while

a girl carrying the bandbox placed it firmly on the floor. The butler and two braided footmen were then asked to inform Mrs Frewen that the dress could not be left unless paid for *in cash*, a cheque would not suffice. The Naylor Leyland household had never heard of such 'a carry on'. Poker-faced, the footmen conveyed this rude message to a housemaid who whispered it to Mrs Frewen's personal maid. Poor Mama, purple with indignation, but forced to realize that her husband's straits were known to the dressmaking fraternity, had to hurry out to her bank where a dazed manager provided the required sum. Meanwhile Clare was chatting to the Prime Minister and praising the other bride of the day at Brompton Oratory. She had only just time to get back and inquire with thumping heart if her own gown would be available. It was, and she donned it with Princess Margaret's lace veil which the Princess had lent, saying: 'It has brought me happiness – may it do the same for you.'

Oswald, who had been suffering from jealousy of Wilfred, tore off to the church to join the ushers and then seat himself beside the Royal Pew where 'Ma and the Swedens were in possession, just in front of Charlie B. [Lord Charles Beresford], who was separated from his spouse (how neat of him!) by Mrs Patrick Campbell . . . Mrs Pat kept making the most startling remarks all through the service.'

It was a very grand wedding with the royals and Prime Minister Asquith and four Cabinet ministers and, of course, Winston.

Clare in her shimmering satin and royal lace, walked up the aisle on Moreton's arm, trying to appear calm. When the Canon, in his address, proclaimed the importance of a man and wife having 'common interests and common friends' Wilfred whispered to his bride, 'That's all right – I have lots of common friends,' and trembling with laughter she knew afresh how much she loved him.

But although in later years she may have exaggerated her disillusion, there was much to displease Clare in the conventional network of her early married life. Wilfred, who was an exceedingly attractive male, had enjoyed the favours of many ladies in Edwardian society. As *une jeune fille*, Clare was not supposed to know this, but she did, and her artistic inclinations aroused in her the desire to make an effect on her wedding night. She and her contemporaries had all surreptitiously read Elinor Glyn's novels (hiding them under the pillow and extinguishing the light at the approach of maternal footsteps). When, therefore, they had crossed the Channel and the moment loomed in which for the

first time a husband would enter her room, Clare staged the scene with care. No tiger skin lay handy as for Elinor Glyn's heroines, but there *was* a bear skin in front of the fire – less dramatic and very prickly, but the effect could be the same. In her lace-trimmed, beribboned white nightgown Clare stretched herself out before the hearth, and lay back eyes closed. According to her own account, Wilfred entered the nuptial chamber in grim English fashion, climbed into bed and stared with surprise at the sacrificial figure on the floor. 'Come on,' he said, 'jump into bed. You're not supposed to be a mistress. *You're* supposed to be a wife.' Clare never entirely recovered from his lack of appreciation of the tableau.

Later on there were marital quarrels but these she could laugh at afterwards. Her wedding night she *never* got over.

It was Wilfred who enjoyed the clash of temperament – she was so emotional and vulnerable, while he remained intellectual and cool. Winston, and other men of note relished Wilfred's company, but Clare did not appreciate his tendency to read poetry aloud. He found fulfilment in the written word while she was groping towards artistic creation. Despite their differences – or perhaps because of them – she and Wilfred remained in love. Mutual friends noted with amusement that he had 'tamed' her!

Until he inherited Frampton Court Wilfred thought it his duty to earn a livelihood, so that in the future he could run his family home. Because Clare liked the country, he leased a Tudor house that lay half-an-hour south of London on the estate of his friend Lord Myddleton – a small house that could easily be run by five servants, a normal quota for the not-very-well-off! As Wilfred was determined to *make* money, he left for the City every morning by train and returned tired in the evening. Clare resented the fact that he was forced into this routine. She thought finance devitalizing and unworthy and that he ought not to submit to dull necessity. Why not live like the Italian peasants? – grow their own food, decorate their own pottery? But Wilfred was conventional. He did what he believed right and when Clare expostulated at 'waste of life' he would pick up Browning and read aloud, stilling her protests with poetic phrases, while the cook prepared a normal English dinner and the parlourmaid put on frilled cap and apron to serve it.

Clare talked a great deal about Munthe and Anacapri and the Saracen Tower. Wilfred listened amused but seemed untempted to

throw up his job. The set-up was unusual. On the first time he paid a visit, Oswald found Clare walking to the village in a cretonne sun bonnet, a Swedish smock, and wearing a necklace of amber beads 'each as big as a plum'. Then came 'orgies of poetry after dinner!'

On one occasion Jack Leslie brought his sister Olive to dine with the young couple on a Sunday night when Clare had sent the servants out, and had herself prepared what she described as Italian peasant stew. Unfortunately she did not realize that hard beans have to be soaked, and the *potage* resembled glass beads in green water. After the first crunch Wilfred asked if there was anything else. Clare turned pink, as always when she was on the defensive, which usually enhanced her exquisite colouring. Holding her own bowl up against the light she maintained: 'You might at least say it *looks* lovely.'

'It does, but we are hungry.'

Despite domestic arguments the Sheridans remained very happy and for people of their class extraordinarily self-contained. Although invited to all important entertainments, they refrained from joining in the London social life which lay open to them. They had known enough of that during the long years of waiting for each other. Occasionally they stayed in town with Aunt Leonie or Aunt Jennie for some particularly interesting dinner party, or they would dine quietly with Winston and Clemmie. These were relaxed evenings with family jokes about their own 'cat and dog relationship'. Winston thought the simile extremely apt for married couples and not at all disagreeable. 'She is my golden puss cat and I like barking at her and seeing her climb up a tree and spit,' he said of Clemmie. And Wilfred laughed: 'I'm the one who gets treed.'

'Oh, my poor black puss,' exclaimed Clare, 'fancy marrying a nasty cross – '.

'Don't say it!' cut in Winston. 'I can't see Wilfred treed.'

After this Clemmie always referred to Wilfred as 'black puss' and to Clare as 'pink puss', not dreaming how sadly the joke would turn.

In July 1912, Jennie organized a Medieval Tournament at Earls Court stadium and many members of her family were corralled into action. The Duke of Marlborough, Jack Churchill, George Cornwallis-West (her husband), took part along with Count Charles Kinsky, and Lord Alexander Thynne, one of the most amusing flirts in London, who caused uproarious merriment among the 'Waiting Ladies', who were led in on horseback by their henchmen. The names of these ladies listed

in Jennie's magnificent parchment programme might have been picked for future renown. After Muriel Wilson, the heiress who had been ineffectually dangled before Winston, and Countess Zia Torby, daughter of the Grand Duke Michael of Russia, came Lady Diana Manners (Cooper), Miss Vita Sackville-West, Miss Violet Keppel, and the only married member of the throng, Mistress Clare Sheridan.

Within two years Clare had borne two daughters. The elder, Margaret, had her father's good looks, dark flashing eyes and black hair. Wilfred adored and spoiled her. He never had the chance to care for the second baby for little auburn-haired Elizabeth developed a form of tuberculosis which lasted throughout a year of pathetic baby torment. During this heart-breaking period Clare and Wilfred did not wish to see many people. Leonie came to them bringing her atmosphere of philosophic calm which emanated so strangely from the sharpest-tongued, liveliest of women. Jennie was travelling around in a restless state after divorcing her second husband, and indignantly reverting to her former name of Lady Randolph Churchill. She attended the wedding in Rome of her nephew Hugh Frewen to the Duke of Mignano's daughter Maria (Mémy), and tried to bring a smile to Clare's face by describing Hugh's expression of outrage as the priest's discourse on his disapproval of 'mixed marriages', was translated to him.

Then Shane came to stay, bringing Marjorie, his new American bride. At first Clare did not like her. Her jealousy had been aroused by Oswald's description: 'She has the loveliest hair I have ever seen and an unusually good complexion.' Clare had always regarded Shane as her own possession and although ready to share him with the Catholic Church, this leap into matrimony displeased her. She did not mind Hugh marrying; it was different with Shane. He belonged to *her*. Marjorie Ide, who had been a spoilt belle in American diplomatic circles, was trying to assess her husband's extraordinary relations. She approached Clare with open arms, recoiled at her coldness, and then gradually the two women came together over the tragic little figure lying alone in her pram. Clare hated and feared the strict special nurse who would not allow her baby any human contact – not even the comfort of a mother's arms. Marjorie feared nothing. She said what she thought of the cold-eyed, hard-lipped nurse and Clare loved her for it. But it was too late. Little Elizabeth died of tubercular meningitis.

Clare's parents could do nothing to assuage their daughter's grief.

She did not want them near her. Indeed, Moreton had little sympathy in his nature. The Irish Nationalist Party had elected him as their Member of Parliament for West Cork and Winston had welcomed his uncle-by-marriage into the House of Commons. Unable to straighten out world finances, Moreton Frewen was now bent on bringing about Home Rule for Ireland, and through Jennie's old beau Bourke Cockran he succeeded in raising thousands of dollars from American millionaires for his Nationalist party.

In the spring of 1914, Wilfred sought to distract his wife by a visit to Italy. He hoped this would help to heal the wound inflicted by her loss of the baby. When they reached Capri, Clare nervously wondered what Wilfred and Munthe would make of each other. The strange old doctor (he was always old but never became older) looked at Wilfred and liked him instantly. Utterly frank and never jealous of youth, he offered to lend his own villa, San Michele, and there they found solace. Clare recorded: 'I wanted to show him Munthe's beautiful things, but above all I wanted him to see the wild mountain top where I spent my happiest days before sorrow came, and where, as a lover of flowers, Wilfred would find delight.' Clare found the flowers and arranged them in patterns to paint. Wilfred knew their Latin names.

In his diary Wilfred wrote: 'I rather like Munthe, only one must not be civil to him or expect civility. Manners are not in his line – he is kind, and more than kind to all the poor people at Capri most of whom adore him and all fear him.'

Four years had passed since Clare had lived on this island. Then she had little anticipated that she would marry her loved one. Now she could not guess that her married life was nearly over. It was March 1914.

8

Blossoming of a sculptor

ALL through the following summer the possibility of war tormented the intelligent and intoxicated the feather-brained. Never had the London Season been gayer nor the sky bluer. Clare, aching for her child had no wish to attend parties or balls. She found a new distraction. In the effort to design a memorial for her baby's grave, she herself started to model. Mrs G. F. Watts, the widow of the artist, ran a pottery studio at Compton, a few miles away. Clare visited the workshop and watched the craftsmen at work. Noticing her rapt expression, the foreman suggested she take away a few pounds of clay to see if she could create something. A craftsman offered to call and advise her. From that day on Clare knew she wanted to do nothing except model. For Elizabeth's grave she shaped the figure of a kneeling child with wings. The little face that looked at her out of the clay became the face of Elizabeth. After finishing the figure she considered a memorial relief for the family church in Dorset. To work at this she entered the Guildford technical school. When Clare pressed her hands into clay she forgot time and sorrow. Nothing existed but the joy of creative effort.

Oswald's diary describes the bas relief's removal from the workshop. A press photographer had arrived on the scene and 'Clare in her inimitable way impressed him into carrying the plaque (one hundredweight) into the car.' The photographer was then made to sit with Clare and Oswald on the mudguards while the driver wended a precarious way in and out of the traffic with Clare's purple cloak flowing in the breeze.

In August war broke out and Clare saw her brother off at Southampton for a long spell at sea. He wrote in his diary: 'She arrived in gay colours leaving me her beautiful ring as a mascot . . . thank God she has Wilfred.'

During the first months of war Clare, burning with emotions impossible to share, felt that she was walking in a trance. The people she loved and trusted seemed to be overwhelmed by passions incomprehensible to her nature. She could not accustom herself to the knowledge that men with whom she had waltzed at so many balls – the jaunty English officers, the German diplomats and Austrian charmers, were going to kill each other. She did not share England's delirium or sense of heroism, but for Wilfred's sake she tried to say the things he would like to hear. She took Margaret down to the Portsmouth road where the child could stand on a wall waving to the soldiers passing by. It was like being caught up in a play, conscientiously acting a part and yet knowing it to be horribly true.

In September her mother came to stay, overwrought at having two sons in danger and murmuring anti-German slogans of thirty years before. How well *she* remembered fleeing from Paris in 1870 with Jennie and Leonie and Grandma Jerome who sprained her ankle and had no bonnets. Clare found her mother's sense of history comically fascinating. Mama *would* choose this moment to insist on visiting the Empress Eugénie – a forgotten old lady living in retirement at Farnborough. Now the three American girls whom her Imperial Majesty had known in Paris during the sixties were the mothers of grown English men facing yet another war against the relentless power of Germany. Bismarck had driven the Empress from France – she could not wait for revenge.

Eugénie received Mr Leonard Jerome's daughter, grand-daughter and great-grand-daughter with open arms. Huge casualty lists had resharpened memories of her own son killed in the British Army long ago. After tea she led them into her private room to look at a portrait of the Prince Imperial. She drew its veil aside: 'You remember?' she asked Mrs Frewen, who had danced with him at Compiègne.

Within weeks Hugh had managed to get himself into the Royal Naval Division. All Clare's men friends were clamouring to join this service devised by Winston, which had a splendid if unorthodox reputation and seemed as complicated to enter as a London Club. When Hugh attained officer status, he parked his Italian wife with

Roger, their new baby, in freezing Brede Place for the winter, a situation which she did not appreciate. Later on, his letters from Gallipoli would, like Jack Churchill's, paint horrific pictures, but at the beginning he deemed himself wildly lucky to be 'in the show'. At the siege of Antwerp this Naval Reserve had to be thrown into action untrained because no other troops were available.

Jennie's former husband, George Cornwallis-West, who had once been a Guards lieutenant suddenly found himself a Lieutenant-Colonel and he led a band of raw boys in to attack shouting 'Don't mind it. Don't be cowards', a battle cry which made him unpopular with all ranks. When the Royal Naval Division returned from Antwerp, Hugh intended to enjoy a few days' leave at Brede Place, but he met short shrift from his Italian wife. He penned an account to Clare as possible material for a short story!

When Roger was but a few days old his mother said to me, 'I want you to engage a foster-mother. In Italy those in my position never nurture their own children. I want to enjoy life, not to be tied to a cradle.' I told her that during my intensive training I had no time to devote to such matters, but on the following Sunday I called on her Doctor and asked for addresses. 'I doubt,' he replied 'if you can find a suitable subject in the whole of London. In England few women look for such work and she would have had to have had a child within three weeks of your wife's confinement. However, I will see . . .' Eventually a Lying-in-Hospital produced a single name and address. This woman had written from the country, the hospital knew nothing about her. She lived in Berkshire, a village two miles from the nearest railway station.

I entrained from Paddington to find on my arrival a single taxi-cab, and proceeded to the village enquiring for Ivy Cottage . . . I rang the bell and was confronted by just the sort of female I had expected – a cross-eyed housemaid who had had 'an accident'. 'Are you Mrs de Maurice?' I asked.

'Oh no, do you want Bobbie? She's upstairs.' Then, raising her voice, 'Bobbie, Bobbie, a Naval officer to see you!'

I blinked twice when Bobbie came tripping downstairs, and then, with the feeling one might have when soliciting a winged angel, asked with bated breath if it was indeed true that she was asking to become a wet-nurse. The expression seemed so indecent when addressed to one so lovely.

'Oh yes,' she answered as if this were quite an everyday proposition.

'Then might I speak to you in private?'

For answer she threw open the parlour door, and waved me to enter. As she dropped behind I was convulsed to hear her whisper to her companion, 'Isn't he a lamb?' which I took as a compliment to my uniform.

She sat demurely while I offered the wage – or should I call it salary, offered by the hospital.

'Just wait a jiffy,' she said, 'while I pack and give a last drink to my baby.'

Presently she reappeared with the effect of a butterfly emerging from the chrysalis.

She was wearing a coat of silver fox that would have been cheap at a hundred guineas... By the time the train reached Paddington we were marvellously well acquainted. This surprising Cockney girl had been working at the *Folies Bergère* in Paris. Quite why a baby had arrived on the scene seemed best left undiscussed. But she was certainly a trier and eager to put her present situation to financial advantage.

On reaching London I had to arrange for her to be vetted by a doctor at the hospital and found myself sent to a chemist, still in my uniform, to purchase a breast pump. The man who served me never batted an eyelid – they are wonderfully trained.

It had been a long day so I took her to an hotel for the night (I did not dare claim my usual couch in the home of either Aunt Jennie or Aunt Leonie). Next afternoon, having enjoyed the sights of London we took the train to Sydenham where Mémy was staying temporarily. We arrived shortly before midnight in pouring rain and tramped the two miles from the station while I carried Bobbie's suitcase, for there were no taxi-cabs at that hour. We arrived like drowned rats. The house was empty. I opened the front door with a latch key, lit a fire, for our clothes were wringing wet, and found some ham and a loaf of bread.

It was nearly two in the morning when Mémy came home from the bright lights and her first words at the front door were: 'Did you get the wet nurse?'

'I did.'

'Where is she?'

'You will find her in the dining room.'

She went out, looked at the silver fox coat, and nearly hit the ceiling.

'Are you sure she is all right?'

'Tops,' said I.

'The real trouble occurred next day when Mémy tried to buy the fox coat from Bobbie, but Bobbie refused to sell.

This was Hugh's account. Within weeks he had sailed for Gallipoli and his wife went off on her own. Bobbie of the *Folies Bergère* took baby Roger back to Brede where she remained for six months, conscientiously seeing that he got enough to eat. The dénouement occurred when Oswald appeared on leave before going off as navigating officer in a mine-layer, an extremely dangerous assignment. His old parents feared that he could not return alive and longed for him to 'leave behind a little life'. Oswald complained that he met *no* girls in the Navy, so they actually suggested that he marry Bobbie and 'get her in foal'. (This is an interesting side-light on the changes that a few months of murderous war could have on conventional parents. Bobbie would be a beautiful mare to breed from while there was still time!)

Apparently Bobbie's reply was: 'Oh, Oswald, I couldn't – I am in love with Hugh!'

Later, when Mémy came back and dismissed her, Bobbie flared up:

'I have stayed for six months for baby Roger's sake; I wouldn't have stayed six days if I hadn't been in love with your husband!'

When Hugh returned from Gallipoli he could find that his wife had returned to Mignano with her mama the Duchess. They thought poorly of an English *eldest* son who had proved heir to the draughtiest house in England where only the nurse sported silver fox furs.

Bobbie did not return to the *Folies Bergère*. She married an officer to whom Hugh had introduced her and when he was killed she retired to his large country estates in widow's weeds, still talking broad Cockney.

Norman Leslie, a captain in the Rifle Brigade, had met death early on from a German sniper, and Shane, more talented at poetry than mechanics, was unconfidently driving an ambulance around the mud roads of the Western Front. Eventually he would set forth for the Dardanelles in charge of pack mules who proved even less controllable than the ambulance. Soon he would be hospitalized in Malta, injured by mule kicks and suffering a form of shell shock.

Wilfred moped. He was an Englishman cast in the noble mould. He wanted to get into immediate action, but as an untrained 35-year-old, it would not be easy to reach the front line.

Throughout the autumn of 1914, Clare found him uncommunicative; drifting in a world of male decisions beyond her ken. She argued gently. He had never been a soldier. Surely he could serve England without learning to shoot? Indeed, her heart leapt at the prospect of dramatic circumstances dragging her husband from dull routine in the City of London – but not to bayonet charges! She visualized him on intelligent diplomatic missions which would *stop* the war!

On the evening that Wilfred told her he had joined an officers' training unit she felt her heart twist, such was the elation shining in his eyes. Quietly he explained that their little house would be closed and their belongings put into storage while he underwent his training. Clare heard her voice softly reminding him: 'Do you remember what you said when we moved here – "the lease is eighteen years, it will last until Margaret comes out"?' Wilfred glanced at the small, scampering figure of his daughter. Would he ever see her in her white ball gown? Would he lead her on to the floor for her first waltz?

Clare found the atmosphere of wartime London dazing. It was all so different to that affair in South Africa where Winston had enjoyed himself courting danger and getting captured and escaping. This was

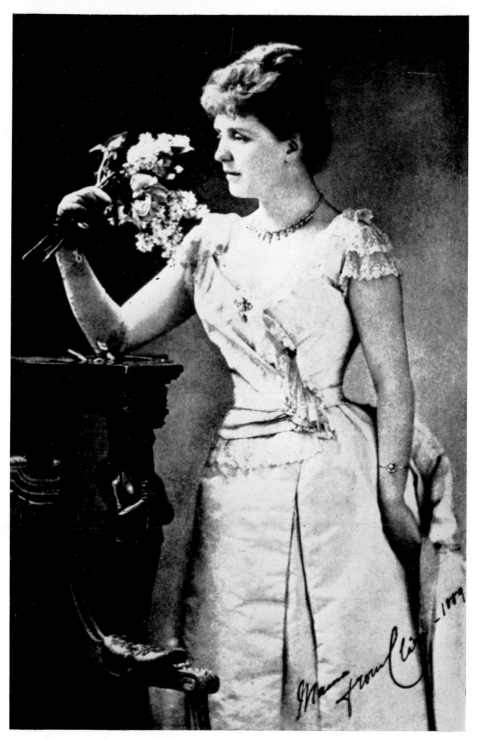

'Mama', 1889.

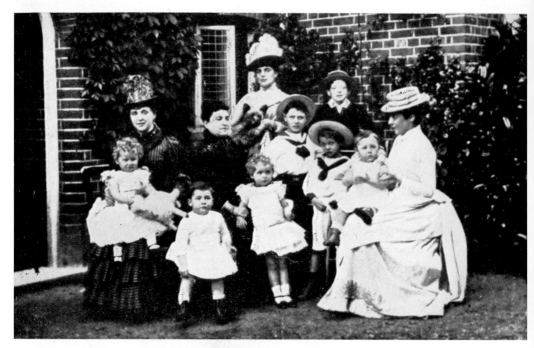

Above: The Jerome family. Back row: Jennie and Winston Churchill. Middle row: Clara Frewen (with Oswald on her lap), Grandma Jerome, Jack Churchill. Front row: Shane, Clare, Hugh, Leonie Leslie with baby Norman.

Below: The Frewen children – Hugh, Clare and Oswald.

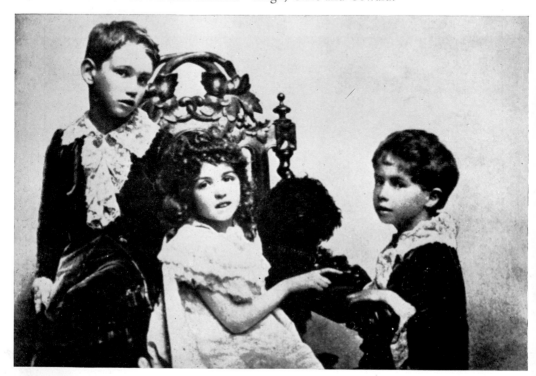

Clare by Emil Fuchs (1908).

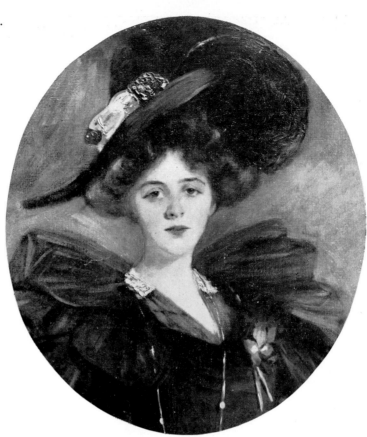

Wilfred (1915).

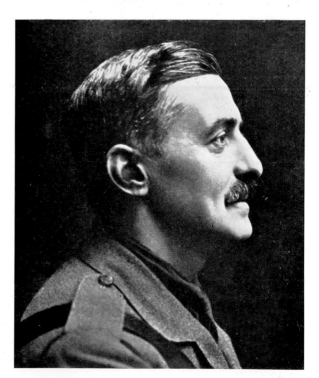

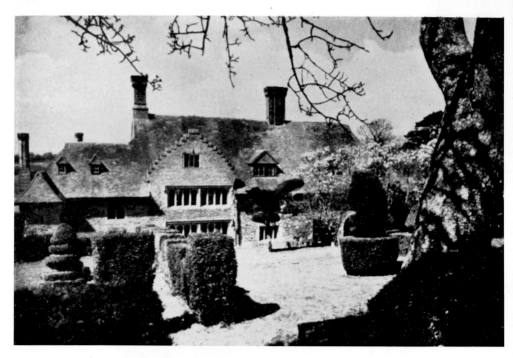

Above: Brede Place.

Below: Frampton Court.

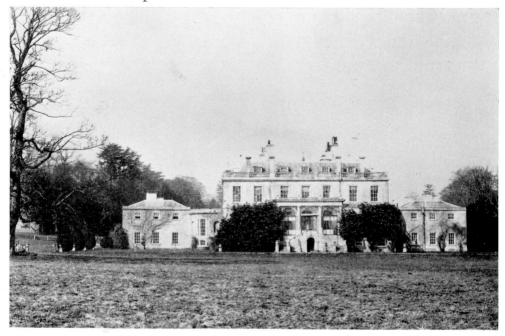

such a gloomy, frightening war. Huge casualty lists filled the newspaper columns, in small print. All the men she knew expected to be killed within the year, yet they appeared jubilant, as if life had been dull before. Now England wanted them, and it excited them to be *wanted*. They believed their country worth dying for and that this would be the war to end wars. Besides – it couldn't last long!

While Winston retained his position as First Lord of the Admiralty he had no time to see the Sheridans. These were the most desperate months of his life, during which he battled to win the war by swift attack on the Dardanelles. Aunt Jennie walked across Hyde Park daily to visit him at the Admiralty. She believed she could impart something of her own vitality to sustain him. After this morning walk to deliver her 'injection of good spirits', Jennie would return to her house at 10 Westbourne Street, near Lancaster Gate, to give what she called 'a little casual lunch party'. This meant that a mere three courses would be served by Amazonian parlourmaids in striped waistcoats instead of by footmen – an innovation that astonished Society for a week.

The Jerome sisters, perhaps because of the mixture of Red Indian and Puritan blood that ran in their veins, liked 'austerity'. They considered it *bad taste* not to go a little hungry in wartime – a logic which many paunchy old Edwardians could not follow. Jennie and Leonie liked sugar in their tea; as soon as this commodity was rationed they gave it up entirely for the duration. 'It makes one feel a little noble,' they said.

Piano playing at concerts and dabbling in canteen work would never assuage Jennie's tempestuous spirit. Her 'little luncheons' were always stimulating and often unexpected. One day Clare turned up early with Anne Haight, an American cousin, to find the Prince of Wales and Prince George sitting on the steps waiting for the parlourmaids to return with the day's rations. Jennie had invited the princes to lunch, promising to give them records of the latest dance tunes from America – and had forgotten to get back in time. She called her luncheons 'casual' – and they certainly were.

Clare found herself carried away by the excitement of political conversation, while at the same time her whole being recoiled from war talk. The word pacifist was hardly in current use, but she felt outraged that the men she knew were having their bodies blown to smithereens. She could not understand the logic that had driven England to declare war. Certainly Germany had not expected it – with

[69]

what surprise and anguish had the German Ambassador left London! Lord Castlerosse, wounded early on and captured for a few hours, told her that a German officer scolded him as he lay bleeding on the ground, 'Why have you gone to war with us your cousins? Don't you *know* that the Duke of Connaught is Honorary Colonel of my regiment?' Clare recounted this story to Aunt Leonie who relayed it to the Duke. Leonie's son had been killed, wearing a sword engraved for him by H.R.H. Had this German officer found it in the mud he might have been yet more mystified.

In the prevalent atmosphere of hysterical nationalism Clare knew it wiser to keep her opinions unspoken, but she found it very difficult. Certain aspects of her reasoning were, however, understood even by the martial-minded Winston – he shared her indignation that any man in a civilian suit could be handed a white feather while Lord Fisher and Lord Kitchener issued contradictory plans. 'How is it the nation does not rend these gaga old buffoons limb from limb?' demanded the pacifist at one of Jennie's luncheons. 'Why don't they let Winston do things properly – make a *real* plan!' Embarrassing silence would follow such an outburst. Everyone was so near to everybody else.

Clare hesitated to produce Hugh's letters from Gallipoli although the reading aloud of missives from the fighting lines had become common practice. Hugh, like Jack Churchill, was writing eye-witness accounts. Winston had grieved deeply when he got Hugh's letter describing the death of his commanding officer, Kenneth Dundas, who was killed beside him. Winston had stayed with Dundas in Africa; he was a very close friend. To Clare, Hugh described not only death but actual conditions:

The worst horrors are to be found where dead and living must share the same trenches. In one place I noticed a brawny Scottish rifleman with his bayonet in the stomach of a Turk while the latter had transfixed him with his bayonet through the throat. Every night I cram my cap into my mouth and against my nostrils to try to get some sleep.

'And what is your husband doing?' people would ask Clare.

'Well, actually, he *has* managed to join up. It wasn't easy at his age . . .' There was no elation in her voice, no pride. Yet when for the first time she saw Wilfred in his uniform he appeared 'more beautiful than ever' and with a pang she wondered at the radiance of his smile; he seemed more content than ever before. The sense of comradeship and of heroic duty held men together in bonds inexpressibly joyous. Clare was sensitive to mood and there could be no mistaking the look

of fulfilment. How dull stockbroking must be if trench warfare seemed pleasanter.

Once she let fly at Jennie, who was hot-tempered enough over wars and politics, but on this occasion her aunt listened quietly. 'We Jeromes never think like the rest,' she said. 'You might be right in theory to decry it all if Germany really was taken by surprise – but they weren't my dear – they have been planning this for ages – the only thing that surprised them was us standing up. You don't know what King Edward told me about the Kaiser – he *couldn't* control the German generals even if he wanted to. The world has got to be ruled by the British Empire *or* the German Empire – it can't just drift on its own.'

'I'm an anarchist,' asserted Clare. 'I think it can.'

'All right, my dear. Be just that – it's a fine new word – but see that Wilfred knows you love him.' She did not add, 'While there is still time.'

During March and April, while Wilfred finished his training, Clare passed the time by modelling heads of her friends' children. Few of these small early works have survived because they were only cast in plaster or terracotta, but one, in wax, the tiny head of Lady Crewe's new baby, remains unchipped and evocative.

Clare had known Peggy Crewe for many years. She had been born Lady Margaret Primrose, the younger daughter of Lord Rosebery (Prime Minister 1895–96 and great friend of Lord Randolph Churchill). Peggy's brother, Lord Dalmeny, had been the most eligible of all the eligible young men who had aroused eager hope in the breasts of Mr and Mrs Moreton Frewen. Peggy had married Lord Crewe, the eminent statesman many years older than herself, and lived in Crewe House, Curzon Street (the most beautiful Georgian mansion still existing in Mayfair). As Clare passed the portals she recalled that it was here that Winston had first met Clemmie. He'd once spoken to her of it as 'the temple of my fate'.*

In this bleak March of 1915, she paid Peggy a visit after the birth of her second child. She walked up the grand staircase past those elegant rooms where amidst the music and laughter Winston had first cast his

*Although unmentioned in recent books and films, Winston's nostalgic feelings for this house are shown in the following unpublished letter: '24 Aug. 1908. Board of Trade, Whitehall Gardens, S.W. My dear Crewe: The fact that it was at your house I first met Clementine makes your letter appropriate as it is kind. I am most grateful to you for it. We shall certainly hope to come to Crewe on our way to Manchester: Yours v sincerely, Winston Churchill.

eye on the tall girl with the red-gold hair. They were silent rooms now – half the men who had come here to dance and to flirt already lay dead.

Lady Crewe was, according to the habit of the time, recovering on a couch, prolonging maybe the days of quiet retreat. Clare sat beside her sipping tea, and when a nanny brought in the new baby she exclaimed: 'But it* has perfect little features – how strange that I never noticed this with my own daughters – may I do her head?'

Peggy Crewe assented with delight. Next day Clare returned by taxi and a footman carried a block of clay up to the *chambre de naissance* where she spent happy afternoons modelling the tiny face with its neatly chiselled miniature features. Hard concentration on an object so small gave Clare respite from the fear that hung over her as over every woman in England. Years later she would talk about her sudden perception of the perfection of a baby's features.

She was herself glad to be again pregnant and when it became tiring to model she retreated to Brede Place with Margaret and her parents. Wilfred, now in a training camp near Sheerness could chuff over on his motor bicycle for breakfast and stay over Sunday. In the evening the villagers would assemble to cheer him riding away in a cloud of dust. Margaret would always remember her father thus.

In May Winston lost the Admiralty, although he remained in the Cabinet and could implore and admonish. Wilfred, now a Lieutenant in the Rifle Brigade, joined his regiment in France and throughout the next three months he and Clare wrote each other a daily letter. They were closer than ever before. Clare knew a certain tranquillity during these strange terrible months of 1915, in which she awaited the advent of her third child.

A letter to a friend survives, dated 26 May 1915: 'Black Puss went to France yesterday – I feel as if it were the end of the world. I can hardly hold my head up. Didn't know one could live through such hell . . . I wish it were time for this babe to be born, I want to be master of myself.'

It was thought suitable to go to Frampton Court so that the 'son and heir' could be born in the family home.

In August Wilfred joined her there for two weeks. He wished that his leave could be postponed, for the baby was not due till mid-September, but preparations were being made for a big attack. Officers

*'It' is now Mary, Duchess of Roxburghe, owner of the head.

were requested to get their leave over and be ready. The carnage known as the Battle of Loos was about to begin.

On Wilfred's last day Clare walked with him through the old garden. He had been a soldier for almost a year. He looked so well and so proud. They said good-bye at the gate. 'I don't want you to come to the station,' he insisted. 'A station is not a place for good-byes.'

So they parted amidst the green trees. She stood there watching him walk away – so light of step, sunburned and handsome. Once he turned to wave. Then he was gone.

9

Death of a hero

THE golden envelope, the little dagger which was to cut Clare's life in two, arrived at Frampton Court during the last week of September 1915. The trembling maid who received it at the door did not take it to her – in wartime one did not hand telegrams to women with a new baby in their arms. As was right and proper she carried it to the master and mistress of the great home, old Mr and Mrs Sheridan. Together they opened it and read the formal message which thousands received each week in England. 'The War Office regrets that Captain Wilfred Sheridan is reported missing . . .' The Sheridans' eldest son had been killed in the Boer War, and Wilfred, the handsome, adored Wilfred, had become heir to Frampton, to its land and pictures and its precious library. The manuscripts of Richard Brinsley Sheridan lay here and paintings of his wife Elizabeth Linley by Joshua Reynolds hung on the walls. Who was heir now? The week-old baby chirping in his cot? What was he heir to – the house, its 6000 acres, the ancestral portraits, enough money to send him to the right school?

For a fortnight Mrs Sheridan ironed all traces of grief from her face whenever she entered Clare's room. Her daughter-in-law had suffered a difficult confinement and the doctor feared the news might disastrously affect her health. Every day for a week after the birth Clare wrote to Wilfred describing their baby son and one pencilled note had arrived back, pathetic in gladness – but it was written on the eve of a battle. Wilfred's troop was under orders to attack – 'The men are singing their way down the street, and I must follow.' Thus ended his last letter.

For a time Mrs Sheridan skirted evasively around Clare's questions. There had been a battle . . . posts were disorganized. The older woman

sat by her bedside day after day, white-faced, calm and controlled. On 29 September Clare wrote to her brother Oswald that the only news she had of 'Black Puss' came from his wounded servant David, who wrote,

We made an attack on Saturday morning at 4.30. I was in the German trench with Mr Wilfred and another officer. We were going around the trench when a German met us, shot the officer, wounded me and Mr Wilfred shot him down before going on to the 2nd line leading his Bombers fine. He did not seem to care in the least, he simply went on at the head of them into the Trenches. He was alive and well when I was carried back.

Clare added innocently, 'Isn't it *glorious*, can't you see him – with his blood up, everything forgotten – that's how he plays games – heart and soul in it and the world well lost! God bless him. I'll let you know the moment I hear he is safe.'

After Winston made special inquiries at the War Office he had to tell the Sheridans there was little hope. Although his death might never be confirmed Captain Sheridan had been seen to fall leading his thirty bombers in the first attack. The territory they captured had been lost and not regained.

Then a packet of Clare's letters was returned to her with 'Killed in action' scrawled in red pencil on the envelopes, and Mrs Sheridan could no longer dissimulate. Baby Dick and the three-year-old Margaret would never know their father. 'But I'm *Daddy's own little girl* – he said so,' Margaret kept saying in puzzled misery.

Clare accepted the news quietly and let strength seep back into her body. When she had recovered from the trauma of childbirth she opened the letter Wilfred had left for her in his writing desk.

You will only read this if I am dead, and remember that as you read it I shall be by your side . . . Remember that all over England are broken hearts and ruined lives, remember that one splendid woman, such as you are, refusing to weep, and hugging her soul with pride at a soldier's death, will consciously or unconsciously stiffen up and bring comfort to these . . .

God keep you and help you and bring my little Margaret up happily.

I can leave you nothing, darling, except the memory of years, and you know what our life together has been. Surely if perfection is attained we have attained it.

This letter she placed in a drawer with her own missives which had been returned. Perhaps the children would some day wish to read them. When she got up she walked alone through the woods where they

had talked together during Wilfred's last leave. He had so hoped the baby might be born early while he was yet there. For a time sadness engulfed her, then Clare began to wonder what the fighting was about. Almost every man she had known had been killed in the last year – starting with her cousin Norman Leslie of the Rifle Brigade, shot while leading an attack. Admittedly England had often seemed dull, but it was secure and reasonable – statesmen were placed in office to keep it so. What were parliamentary discussions for if they ended up in craters filled with dead bodies and countless desolate hearths was the result?

All through her youth Clare had met and listened to the statesmen of England – because if you were a young lady in Society those were the gentlemen you met at dinner parties and you were expected to listen and to amuse. Now in the emotional whirlpool evoked by reading each morning's newspaper where the lists of dead filled column after column, Clare realized that her entire background had crumbled. The patterns of ordinary behaviour in which she had been brought up and secretly resented, had, after a twelve-month blood bath, ceased to exist.

The old Sheridans accepted their losses. English sons must die for their country. Clare rounded on them and hurt their feelings. 'But if every Englishman is killed there won't *be* an England . . .'

Her sadness turned into anger. What had been inflicted on her and on thousands of others was not noble, but intolerable and stupid. She could not meet the neighbours – when they offered condolences she flared up; several times she whirled on well-meaning visitors. 'They've taken my husband – they'll never take my son.'

Frampton Court lay in the heart of fine open hunting country and there were always fit horses in the stables. Mr Sheridan hoped that in a few months their daughter-in-law might alleviate sorrow by riding to hounds. But this customary English anaesthetic was not to Clare's taste. She could not bear to linger on in the old family home. She wanted to strike out, to heal her wounds on her own, to be independent.

'But there's no money dear; how will you live?' they asked. The rents of their 6000 acres were ploughed back into the land. Handsome Wilfred Sheridan had been pressed to marry an heiress capable of supporting Frampton Court. And the lively Clare Frewen had been expected to marry a rich man to support herself and her father. It was

just unfortunate for the parental schemes that Clare and Wilfred had ever set eyes on each other.

As she wandered through the grounds, covered now by autumn leaves, Clare found the place intensely melancholy. The old Queen Anne house had been ruined by Richard Brinsley, Sheridan's grandson, who had turned the back into a front with a pillared portico but no steps. Clare was offended by the lack of architectural harmony. And despite a large number of servants Frampton was extremely uncomfortable. Now for the first time she noticed that Mrs Sheridan never spoke to her husband except to reprimand him icily. But the old man did not seem to care as long as he had plenty of good hunting and shooting.

Clare faced the facts. It would be unbearable to live on indefinitely with in-laws who could afford horses and grooms but found it impossible to give her an allowance. She could hardly return to her own ageing parents, for in their beautiful fourteenth-century home not only was there no electric light nor heating, except for wood fires, but they had a penniless Italian daughter-in-law and two small grandsons on their hands. Both Frewen brothers were away fighting. A terrible despair filled her at having no trained skill. Clare raged at her useless upbringing and wondered where to turn.

A moving letter arrived from Henry James:

The thought of coming into your presence and into Mrs Sheridan's with such empty and helpless hands is in itself paralysing; and yet even so I say that, the sense of my whole soul is full, even to its being racked and torn, of Wilfred's belovedest image and the splendour and devotion in which he is all radiantly enwrapped and enshrined, makes me ask myself if I don't really bring you something of a sort, in thus giving you the assurance of how absolutely I adored him! Yet who can give you anything that approaches your incomparable sense that he was yours, and you his, to the last possessed and possessing radiance of him.

Henry James had always encouraged her to *express* herself. But Clare could not suddenly overcome tribulation by becoming an author.

It was to Winston that she must turn for encouragement. A tempestuous affection had always existed between them. Winston had liked Wilfred and grieved at his death; he could not fail to give her comfort and advice, although he himself had just lost the Admiralty and was undergoing the torture of watching the disasters of the Dardanelles. Clare knew well how bitter his mood must be, but surely he could produce an idea for her.

She decided to go to see him, and to while away the train journey

she read through a packet of family letters written over the last four months which her own mother had sent on to her. There was one from Aunt Jennie dated 4 July:

I went yesterday to the Farm to see the family. I motored Winston down. I'm afraid he is very sad at having nothing to do. When you have had your hand at the helm for four years it seems stagnation to take a back seat, and for why? No fault can be found with his work at the Admiralty and they give him the sack whereas a gigantic mistake is made at the War Office and the man responsible for it is screened and given the Garter [Kitchener]. It makes my blood boil! However, the truth will out and we shall see a mighty fall. What do you hear from Wilfred? And how is he?

All right *then*. Yes, in the ominous hot days of four months ago Wilfred had been all right. And Dick unborn.

Clare arrived in London draped in the black widow's weeds considered essential at that period, and with her new baby and her lovely little daughter and a nanny in tow. Winston had not only lost the Admiralty, he was even out of the new War Council, and to alleviate his agonies of frustration he had insisted on going back into the Army as a Brigadier.

Clemmie received Clare with understanding. She had written to Winston courting danger in the trenches: 'My darling, I don't know how one bears such things. I feel I could not weather such a blow. She has a beautiful little son, eight weeks old, but her poor "black puss" sleeps in Flanders. You must come back to me my dear one – (you are now my orange pug again) . . .'

Clare stayed a few nights with Aunt Jennie and when Winston returned on leave he promised he would see her. Wilfred had been killed in the first hours of the two-day Battle of Loos – an offensive which failed after 5000 British lives were lost, against 9000 Germans. The patch of land on which Wilfred had been seen to fall was not recaptured until the war's end. Clare would never know more than what his batman David told her of that pre-dawn raid; Mr Wilfred had gone on 'leading his Bombers fine'.

Winston was heard to mutter that with one half of the military effort directed against the village of Loos, *he* could have captured Constantinople and reorganized the whole Eastern world. 'So, he died for nothing,' sobbed Clare. Neither Winston, Jennie or Clemmie could contradict her. They had all liked Wilfred. But Winston understood her predicament, which was difficult when widows of volunteer officers did not qualify for pensions.

[78]

'Officers are *supposed* to be rich . . .' wailed Clare. 'I've always belonged to a class that was *supposed* to be rich. Why aren't we?'

Winston was comforting. He put his own feelings aside for a moment to advise her. 'Officers are supposed to be gentlemen of means. It's most unfair. But there *are* Boards and Committees that can be applied to . . .'

'Help me. You know about such things.'

'Dearest Clare – I only know such things exist – we'll find out.' He still had the valiant Eddie Marsh as secretary and he would know *how* an officer's widow (attractive) and two children (lively) could keep the wolf from the door. 'We'll say what is *almost* the truth – that you've nothing to eat – but not a word about staying with Mama or no one will be sorry for you!'

So it was that Clare returned to Jennie's house with a ray of hope. 'Darling girl. You'll never get over Wilfred. Don't try. Keep him as the love of your life – but find other things.'

'You mean other loves, Aunt Jennie?'

'Things not loves – things to do – keep yourself busy.'

'How am I supposed to do that at Frampton Court – no, Aunt Jennie, please don't tell me to drown my sorrow by riding those terrifying horses . . .'

'Don't worry my dear. Winston will find out who can help . . .'

The War Office granted her a widow's pension of £250 a year, and this enabled Clare to consider herself free to the end of her days.

Jennie sought to console Clare by a change of ideas; she took her to the concerts which continued determinedly in war-stricken London and slipped little presents into her muff. It pained her to see Clare floundering like a wounded animal. Then '*Ma Tante*' persuaded her that in Ireland lay peace – 'We'll go to Glaslough for the winter.' Responding to the sensitive, affectionate Leonie, Clare agreed to bring her children to Castle Leslie for six months. She would find solace in this family home lying so quietly beside the silvery lake and ancient forest.

10

Watershed

LEONIE, having lost her son Norman in Flanders, could understand Clare's jagged nerves. Margaret and Dick brought laughter to the big, sad house. Huddling at night in front of wood fires in their high-ceilinged bedrooms, Clare would ask Leonie where she thought Norman had gone, and if she felt him returning to his own unused room where sporting cups and trophies decked the walls and a bunch of flowers always lay on the bed. Leonie told her of the evening before the telegram arrived. Jimmie Vogan, the old keeper who had taught Norman to shoot as a boy, had dropped in to ask 'When did Captain Norman get back?' He had seen him walking by the lake. Next morning the yellow envelope arrived with the automatic War Office regrets.

David, Wilfred's soldier servant who had been wounded before Wilfred disappeared for ever, arrived for a visit. For hours he rowed Margaret around the lake, and described all he could of her father's last day – the preparations, the knowledge of an attack, the brave figure running in front of his men, the disappearance in a shell burst – all anyone would ever know. To Clare he could but say, 'He was so glad to get your letters and to hear the little chap had arrived.' David offered all that a simple soldier could of comfort, then, healed of his wounds, he returned to the front.

At first Clare had thought she never wanted to hear any war news, but soon, like Leonie, she began to hanker for the daily post and the newspapers. Winston wrote letters from the trenches, which Clemmie showed to her mother-in-law who in turn copied them for Leonie. Jennie had been utterly miserable at Winston's insistence that if he

could not affect war policies he must go and fight, but he found mental relief in hardship and danger. Jennie was never afraid for Winston's life – she merely suffered from a sense of outrage that the government did not use him to *win the war*. It was Clemmie who knew the ordinary wife's fear of death, but she comprehended the alleviation of his mental torture when he wrote: '... aided by wet and cold & every minor discomfort, I have found happiness & content such as I have not known for many months.'*

Meanwhile Jennie strove to help in the only way she knew. She invited to dinner those who might be useful in getting Winston *back into power* – Curzon, Bonar Law, Balfour, Garvin, editor of the *Observer*.

Leonie tried to twist an occasional line of philosophy out of herself into brief letters to her frustrated nephew. 'Always constructive,' Winston called them later. '... extraordinary woman my aunt Leonie, never said anything useless, always it was worth saying – very very unusual.'

In March Winston returned from the front to speak in the House of Commons. Leonie's letter bag became almost too heavy for the village postman on his bicycle. It was obvious that Winston was set on toppling the government and himself leading England to victory. 'By God I would make them skip if I had the power even for a week ...'

'How can we ever forgive your nephew,' wrote Margot Asquith. 'Such madness. Such disloyalty!'

Leonie and Clare writhed at the insults which flooded their daily correspondence. They did not possess the dispassionate judgement of Winston's wife. All they could do was scribble angry notes back. 'Don't you want us to win the war?' Leonie riposted to the Prime Minister's wife. 'How can you listen to that mean old Balfour – oh, I know he's unusual, we all know *that*, and musical, but no red corpuscles – no go.'

In Castle Leslie there settled a gloom broken only by the scratching of Leonie's pen and her occasional 'What do you think of this? – haven't I put it nicely? Do read it before the post goes.'

The winter of 1915–16, spent by the silvery Irish lake, was the watershed of Clare's life.

On 22 January 1916, Clare wrote to her father concerning Margaret:

Life of Winston Churchill, Vol. III, p. 580 (Heinemann, 1974).

. . . I've told her about Dadi. You wanted her to know and it seemed to make it easier for me to talk to her. Of course she didn't understand but she said this, 'Mumi, did Dadi die up in the sky?' I explained that he had so to speak to throw off his coat, which is really all the body is, before he could rise . . . she says she quite understands . . . She said, 'What *would* you do without me and Dick? I know – you'd just go off and find Dadi – .' I said, 'Yes, that is exactly what I would have done,' – and then after thinking a space she added, 'Well after all Dadi's got God.'

When spring came and the snowdrops and then the daffodils started to show their sharp green noses, Margaret ran around the terraces shouting, 'Look what Daddy is pushing up for us out of the earth,' and Clare felt a touch of the old sunshine. She had undergone a metamorphosis, and knew she could accept the shattering of her world and start afresh.

In May Clare wrote her name in the Castle Leslie visitors' book recording the six months spent there with her children. Aunt Leonie, herself growing restless in the dreamy mists of Monaghan, saw them off from the little station. 'Good-bye, Clare dear, I'll be returning to those old canteens – can't stand much more here receiving letters from Margot Asquith saying how odious Winston is!'

Within weeks, Leonie was back at Victoria Station. She wrote:

I can't just try to help the war by depriving myself of butter and sugar. At first I was disappointed when my application to act as interpreter at the War Office was turned down – I spoke French like English, but I did not know military terms, and for translation work only men were wanted. Oddly, I found I *liked* washing dirty cups and chatting to soldiers off to the front. George Cornwallis-West came by one day. I saw that good-looking face in an officer's cap and had just enough spark in me to snap his head off.

'The day I left Jennie was the worst in my life,' he said.

'The luckiest in hers,' I replied.

But Jennie could not stand canteens. 'I'll pound the piano – I won't wash cups.'

Deeply as her aunts felt for Clare, they were both worldly wise and naturally they looked around for a replacement for Wilfred. Even in Ireland Leonie had driven Clare by jaunting car to the neighbouring estate, Caledon, owned by the bachelor 5th Earl of Caledon, who was exactly Clare's age. 'Caledon has such a fine Nash façade, and it would be so nice to have you as a neighbour.' But Clare flared up as she had when pushed on the marriage market as a girl. 'Thanks, *Ma Tante*,

but I don't want to marry a Nash façade. I really prefer that handsome brother Alex.'*

'Well he is too young for you – and anyhow you'd be a rotten wife for a *real* soldier . . .'

Leonie still spoke of marriage in the Edwardian fashion where matches were arranged by the older women. It was *they* who decided on suitability and gave advice.

'Clare, my dear, you *have* had proposals in the past from very important *partis*, quite apart from the ones with families nervous of your father. Things are different now, but it still *means* something to be an earl and have a lovely home – doesn't it?'

Clare dodged the issue. She wondered if it meant anything at all. Earls headed the uncomfortable cast of gentlemen who got killed off when England went to war. Those who remained alive seemed to be either weaklings or simpletons. She liked the taste of freedom and she was aware of the impression she made – heads did turn when the picturesque, fair-haired widow swept by in deep black with rosy children and a nanny in tow. Nannies and servants were not yet scarce even for people who considered themselves penniless. Clare would never in her life cook a meal, and Leonie, in the depths of 'economizing' never considered running Castle Leslie with less than ten servants. Lack of fires and hot water, freezing rooms and two courses for dinner, were the hardships which Edwardians regarded as the ultimate – they just did not *know* that staff could be reduced, and would have considered it unkind to put servants out of work. Now the able-bodied men servants had to enlist but women lugged the heavy coal scuttles up to top floors, while ancient odd-job men crept around basements. Fearful of being drawn back to Frampton, Clare settled at her parents' London base – Ormond House, near Regent's Park.

During 30 and 31 May, Oswald, serving as navigation officer on H.M.S. *Comus*, in the North Sea, witnessed the Battle of Jutland from the deck and wrote in his casual fashion, 'I took no photos of the action. *Invincible* [a big warship blown up while he watched through binoculars] was possible but explosions don't come out well when surrounded by masses of smoke.'

Three days after this battle, in which the British Navy twice crossed the tracks of the German Fleet, Oswald was back at Scapa Flow going out to watch baby Redshanks scampering on the dunes. In his diary,

*Later Field-Marshal Earl Alexander of Tunis.

the blowings up of battleships evoke just the same cool descriptive phrases as the observation of wild birds through binoculars. One sometimes wonders whether he is referring to birds or ships.

Throughout this summer Clare stayed with friends who had big country houses and were ready to accept her along with two children, nanny and pram. From 5 to 21 September they stayed with Lord and Lady Crewe. Clare's terracotta head of the Crewe six-year-old son proved one of her happiest early efforts. It still partners the little wax head of their daughter Mary. The blue leather guest book of Crewe Hall shows Clare's distinctive flowing signature on several occasions. After a long working visit, she wrote in the book 'with Margaret and Richard Brinsley'. Later on, when the Prime Minister and members of the Cabinet are in the party, the children's names do not appear. They had been installed with their grandparents. Moreton's groans because he, once the best shot in England, could not go out to 'pot at Germans' would be among their earliest memories. So would Grandma lamenting with Great-Aunt Jennie over the miseries of Winston who had, after his winter in the trenches, returned to parliamentary duties and was demanding a public Dardanelles Commission. 'He'll go mad if they don't give him something to do,' insisted Grandma. 'He honestly believes he could use power better than any other Englishman.'

Clare saw Winston once only during this terrible period. He was with his friend Lord Birkenhead, the Attorney-General, whose magnificent intellect and pointed wit could bring a smile to his face in the depths of gloom. Winston was too immersed in the tragedy of the war to notice how Birkenhead's eyes lit up whenever Clare appeared. She did not immediately notice it herself for she was preoccupied with the idea of earning her living as an artist, and with this end in view she was about to move from her parents' house to a small studio in St John's Wood, and, towards the end of 1916, she was being relentlessly pursued by a very young man. Known as 'Simon', the 6th Earl of Wilton had fallen in love at first sight and immediately started to beg Clare to marry him. He was not yet twenty-one, enormously rich and perfectly idiotic. His trustees approved of an older woman who might make something of not very promising material. His mother distrusted the romance, but then she had great distaste for Simon anyway; she said he drank and told lies, and she wished her younger son George was the heir. Clare felt rather sorry for Simon and thought him most engaging when he rolled up at her parents' house in a large

car (carrying a sort of gas bag for fuel) and begged her to sally forth on shopping sprees – she might order anything she liked, for *anyone*. Oswald, whose ship was up in the dreary reaches of Scapa Flow, was surprised and charmed to receive enormous, expensive Fortnum and Mason food hampers from 'Clare and Simon'. These made him very popular in the mess where rations were grisly.

Moreton now perked up and Clara encouraged her daughter. Any conquest was better than nothing these days. Nearly all the men of Clare's generation had been killed and how was it possible to live without a gentleman paying attention? 'Why, you dear thing – it doesn't look as silly as you think – you've kept your beauty and he looks so sickly. There might be only five years between you.' Jennie approved in a humorous way. 'Well, all *my* suitors seem to be twenty years younger than me – what is eleven!'

Oswald's diary meticulously noted the progress of this engagement:

16 December 1916. Fed the entire Mess. The fiancé is evidently of generous and lovable disposition. That Puss [Clare] should marry him, an Earl with £90000 a year aged 20½ cannot fail to look bad, and indeed the material benefits accruing thereto are so great for the entire Frewen family indirectly that I have the utmost circumspection in admitting a desire for it even to myself – *I don't* like the idea of her marrying again when the first union was perfect – but she is not the sort to go coldbloodedly after money & a coronet is certainly nothing to her. He is *very* much in love with her (his heart is weak and he requires humouring), she is obviously fond of him, old Wilfred expressly told her that if he *were* killed he hoped she would marry again.

Some excellent plum puddings from London's most expensive shop cheered H.M.S. *Comus* over Christmas, so that soon Oswald, and indeed, his entire ship, approved of the engagement despite the fact that sub-lieutenants in Naval Intelligence 'too delicate for active service' were not usually popular with the men who went to sea.

In February 1917, Oswald came to London on leave. When Aunt Jennie demanded that he lunch with her, he strove to get out of it for he did not want to be interrogated. Instead, he went to tea with Priscilla, Countess Annesley, a famous Edwardian beauty much adored by other ladies' husbands while suffering an odious one herself. Oswald described her as

nothing but a mirror which has been reflecting back Clare's sillinesses to her and thus intensifying them . . . The trouble is that Puss, a war widow, was, I thought, going to live the rest of her life for her children, with modelling for a distraction (thought I)

D [85]

and for a livelihood (thought she). I would have supported her as best I could if all went ill . . . Suddenly, last October, she met Simon who fell in love with her. She accepted a gold wrist watch from him, which shocked *me* (Lady Annesley describes me as a prude, or a 'prig' is it?); she motored with him, together they decorated her 'studio' (in reality it is a maisonette) in St John's Wood. After that I was positively relieved when she said she was engaged to him. He is 20, she is 31. She is, moreover, his first love. He is a Ward in Chancery and his mother disapproves. All her friends were against it, argued it out, said what a dear he was (which he is) & that he is *so* unlike Wilfred that they don't clash, that Wilfred wanted it. Anyway I finally came round to it. Besides it was her affair & I was loyal to her. They have been engaged now a couple of months, he has been before the Judges for permission & got it for April, had a row with his mother, announced it in the papers; now because Puss has tonsillitis which appears to have the same effect as jaundice, she says she isn't going to marry him at all! No reason; just a whim. Thinks she won't be happy – after weighing it all up & saying 'Yes', now to do a volte-face, shatter his faith in her whole sex, make him miserable, make herself & all of us who were loyal to her the laughing stock of the whole world, & set aside (for what it is worth) a comfortable & assured future for Wilfred's children. I think she is acting a 'sick man's dream' but she appears balefully lucid, with the whole of her vitality converted into an expression of selfishness. . . . I decline to follow her gymnastics any further. She has brought me round to approve of it all; with time & trouble I have reconciled myself to it. I have met him & he is a ripper; and I am just *not* going to turn again. I would consider any girl who treated any man so, rather a beast if she were young & he were old. I would consider any woman who treated a boy so as a cad. So I labour to induce her to behave rationally & honourably & I am therefore in bad odour. My leave is entirely wrecked, not on an accident but on an ill humour. I think however ill *I* was, I wd make some sort of generosity to *my* brother if he were near me for a week only of rare leave in a real war.

Two days later Aunt Jennie and Simon came to lunch at the Frewen house. Jennie was quietly vetting him. 'You're no judge', she told Clara, 'that boy drinks – he'll drop dead soon. If that is what Clare wants she'd better marry him. Couldn't take it on myself.' Clara listened tremulously to her sister and then hurried off to drive out in Simon's Rolls-Royce.

Sub-lieutenant Lord Wilton could not do enough to please. Next day the Rolls took Oswald through heavy snow to Brede Place where he 'kissed the children for Wilfred'. Then Oswald came back to find Aunt Jennie at the tea table 'denouncing the fierce ingratitude of children loved' because Winston and Jack had no time to see her. 'What do you get from children hated?' asked Oswald. 'No worse,' she answered, 'they are then grateful for the smallest tenderness.'

'What are we going to do about *Clare*?' Aunt Jennie turned her extraordinary eyes on Oswald. 'Let her boil. Let her bubble and boil

and if she has any sense she'll marry him – and if she hasn't, well, she'll still be our Clare.'

On 8 February Puss was 'still in bed & black tempered', and Simon took Oswald to see the large studio he judged suitable for her modelling. By the end of the month she had recovered sufficiently to move to the King Hotel, Brighton, where Simon booked her a room and Oswald travelled down to walk beside her bath chair on the esplanade: '. . . pleased to see me but no more, I felt. Not intimate. We looked at shop windows & she bought some trinkets (in wartime!) & was altogether as incomprehensible as though I had been her lover, not her brother.'

Aunt Jennie also went down to Brighton to hold Clare's hand during this unsatisfactory episode. She saw clearly that her niece was not in love, but half enthralled by the idea of freedom from her parents and in-laws. To Leonie she wrote:

I wish they could get married soon. He is very obstinate & headstrong but very devoted, but I think she tries him highly. He has been nursing her day and night; fills her hot water bottle and sticks it in the bed; gives her medicine and poultices etc. There is neither romance nor vanity on her part. Personally I could not bear it, but Clare never likes to do anything like anyone else. I hear that on coming of age his fortune will be between 90 and 100 thousand a year!

The prospect of such riches had a curious effect on Clare. It made her extremely cross. She scolded Simon for being rich even while he lavished gifts on her family. Oswald made inquiries at the Admiralty and grew more cautious about young Wilton when he realized the boy was trying to dramatize himself as a spy when merely employed as a junior in the intelligence department, and he wondered *why* old Lady Wilton, whom he had met, had said that she wished Simon's brother George was the heir. 'But,' wrote Oswald, 'if he is genuine the marriage will go through and *I* think she will make something good of him (I am quite certain that otherwise no one will). If so so. If not, we are all solid with Puss and will look after her and the babies. The main thing is that *we* are united again, and Puss in her right mind.'

Four days later the engagement was off. Five days later Simon was threatening suicide. Ten days later he had married another woman and Clare was in love with another man.

11

Revival

LORD ALEXANDER THYNNE, brother of the 5th Marquis of Bath, and Tory member of parliament, had served throughout the war in the Royal Wilts Yeomanry, a regiment consistently taking heavy casualties. Twelve years older than Clare, and exceedingly attractive, he made a pleasant contrast to the over-amorous and juvenile Lord Wilton. Despite his fame as a flirt, Alex Thynne possessed a serious side and Clare found a faint reminder of Wilfred in his intellectual approaches. Although she swore she would never fall in love again, 'at any rate not as I did as a callow girl', it became evident that she could still care.

During his occasional leaves, Alex sought out lady friends assiduously and their recorded descriptions of his approach vary widely. Several dubbed him 'a pouncer', but to the exotic Lady Cynthia Asquith (daughter-in-law of the Prime Minister) who was being painted by Augustus John and McEvoy, he seemed artistic, sensitive and amorously reticent. To Clare he was 'entrancing – alive – able to give a sense of purpose'.

She had moved into 3 St John's Wood Studios where she could be independent. It was a huge beamed studio with a tiny rabbit-hutch bedroom inserted into the top of it. The place delighted her. The front door had to be reached by walking down a narrow alley which un-expectedly opened into a little lawn with a fig tree. Aunt Jennie professed horror: 'Just the sort of alley one gets murdered in.'

'Really?' riposted Clare. 'How exciting!'

Her father remained scornful of her efforts to earn, and at first she found it heavy going. For shops she made garlands of painted plaster

fruit and owl sundials. It was easier to sell interior decoration than portraits. 'Cadging for fivers,' Moreton called Clare's efforts to make money, but she had set her heart on a career, and she worked away for the shops while each morning taking lessons from the eminent sculptor John Tweed. It gave her a sense of achievement to be paid for *anything* created by her own hands – even painted plaster fruit for other people's houses.

Clare slept in the little top room which had a balcony and worked in the studio all the afternoon, occasionally flinging herself down on a divan to rest. Each evening she walked to Ormond House for tea with the children. Then, when dark fell, friends would call for her and take her out to dinner. Sometimes she was too tired to hold her head up, but not when Alex appeared. She fought against the old feeling of dependence on a man, but found him delightful company. They were happy to be alone, or to go to an art gallery or concert together.

Clare recalled the first time she had heard the great Suggia play in a London drawing-room; her supreme artistry and the unearthly expression of her face held all audiences rapt. But one wit broke the spell: 'She seems to be practising adultery with her cello.' Even the musical Aunt Leonie said, 'The remark is so apt it destroys one's concentration – I wish it hadn't been made!'

Noticing how much of his precious leave Lord Alex Thynne spent at Clare's studio, Lady Cromer, his sister, introduced *a treasure* – Mrs Johnson, a stalwart Cockney cook weighing twelve stone. 'She had a heart of gold,' said Clare, and 'a wonderful mind.' Clare responded to this jolly, motherly person and confided all her problems to her. Every morning Mrs Johnson, who had a husband and a son fighting at the front, would arrive to give Clare breakfast in bed. And at noon when Clare laid down her scalpel or returned limp from her lessons in John Tweed's studio, there would be a 'tasty morsel' laid out beside the studio divan. And with Mrs Johnson and her nine-year-old daughter Hilda joining in the spirit of bohemian life, it became possible to give dinner parties. When all work had finished and candles could be lit, Mrs Johnson would 'do something marvellous with the rations'. *The treasure* disliked housework, however, so a 'tweeny', as untrained maids were then called, worked under her command. This girl, Amy, a cousin of Clare's 'snooty nannie' who resided at Ormond House, astounded Mrs Johnson because she had never heard of the important people who came to tap on the front door. Winston, now Minister of

Munitions, would call. 'And how is my gallant Coz?' He liked her statuettes of land girls, soldiers, and sailors, and above all of a blind soldier who came to pose from St Dunstâns. Tears streamed down Clare's face as she worked at this head but she let them flow for he could not see her weep.

When a few commissions for portraits arrived, Clare worked feverishly, studying in the mornings while earning in the afternoons. Many people desired small heads of their children in terracotta or plaster and she used Margaret and Dick as models for objects such as book-ends, which private buyers could carry away although they might hesitate to commission a bust in marble.

November 1917 brought the Battle of Passchendaele with a million killed and wounded. Clare heard that 'someone high up' was trying to get Alex out of the trenches – he had been in the front line so long and was due for a staff job, 'but don't let him know strings are being pulled' whispered her informant. As if she would – nothing made a man cling more obstinately to hellish danger than the whiff of some well-meaning plan to get him out of it.

In the following April Alex was wounded slightly in the left arm which gave him a month in London. During this time he and Clare grew extremely close and Mrs Johnson thoroughly approved. She always spoke frankly to Clare and she told her 'That's the one for you, dear. I never knew Mr Wilfred but I feel he is like him. Lord Alex is my choice and don't you get up to no tricks – marry the gentleman.' Clare longed for his wound to go septic, but too soon it healed and he rejoined his regiment.

In May 1918, Aunt Jennie came to tea. She seemed more exhilarated than usual, eyes flashing, full of optimism. At first she did not talk about herself. She wanted to know about 'that brave Alex'. Did Clare really love him? Did she notice the age gap? – twelve years was very little. Was he her lover? Yes, he must be. Did she mind not being the only one? Clare only half-listened. She was giving her attention to a clay head under its wet cloth. She tried to remember what John Tweed had told her that morning about a way of denting the corner of the eye by twisting the scalpel. Suddenly she realized that the endless gossip of pre-war days meant nothing – only her art interested her. She was developing her talent late but it *was* there. What could any husband mean but an interruption to the discoveries an artist makes. Lovers might stimulate but the married state resembled fetters.

'Yes, yes, I love him,' she admitted fractiously. And then Aunt Jennie dropped her own bombshell. 'I took him to Castle Leslie,' she said, 'and Leonie liked him – Seymour was there too – we got on like a house on fire. He's good company, my dear, and he really loves me. I've agreed. We're going to get married.'

Clare regretted her inattention. 'Who to exactly?'

'My dear child – you must know – Porchie, of course, Montagu Porch. He's twenty-three years younger but it doesn't matter – do you think?'

It was the first time that Clare had ever seen her brilliant aunt hesitate – embarrassed – longing for assurance. 'I don't think *anything* matters as long as you are sure you want to do it – *are* you sure?'

Jennie could not speak at first. 'I only wish it was you, Clare darling, who had found happiness.' Clare promised her that she knew fulfilment and peace in the activities now filling her every hour. They were very affectionate on this afternoon. It was the first time they actually stood back and saw each other as women of different epochs. Jennie belonged to a vanished social system. It would have disappeared inevitably in the next decades, but the massacres of the Western Front had smashed it in one blow. Clare belonged to the future. A few days later Clare happened to meet George Cornwallis-West and told him that Jennie (whom he had made so unhappy) was going to marry again. George, now miserable with Mrs Pat Campbell, wrote her a most loving letter, to which Jennie replied affectionately, 'Clare will have told you everything. George, we will always be friends.'

Aunt Jennie married Montagu Porch on 1 June at a London Registry Office – Winston and her two daughters-in-law were present. Clare did not attend. Jennie had asked her not to. 'It would make me feel shy!'

All through July and August Clare worked hard to develop her technique, and being in love helped her old exuberance to seep back. Peace seemed very near. Then she could think about marriage.

It was a September morning of 1918 when young Hilda Johnson went into the kitchen of their little working-class home where her mother always read the newspaper before going out to Clare's studio. With two of her own menfolk in the trenches she always wanted to see the casualty lists – and get the fear over – before starting for work.

Hilda would never forget the scene which suddenly ensued. 'My mother gave a sudden cry and dropped the newspaper on the floor. Her cheeks were scarlet, her eyes full of tears. "Lord Alex has been

killed," she cried, "poor Mrs Sheridan. I must go to her before some fool rings up to tell her." '

Hilda trotted along beside her mother to the studio, who let herself in and went straight up to Clare's bedroom where she always brought her breakfast on a tray. She went to Clare's bed, hugged her, and told her gently. Clare just lay back and stared at the ceiling. 'Then my mother made her a cup of tea and wisely disconnected the phone.'

Later in the day she told Clare that they ought to go to see Lady Cromer who would surely have received the news of her brother's death. They walked together to the nearby Cromer house and it was Mrs Johnson in her rich Cockney voice who seemed able to say the things which did not jar and were not trite condolence. Then she walked Clare back to the studio and said, 'Now, m'dear, you get to work. Lord Alex was a great gentleman – a real good sort. For his sake we must all pull ourselves together.' Clare picked up her scalpel and set to work – this way she would get accustomed to the idea that she must not expect him – that never again would Alex appear smiling at the door.

During the next few weeks Mrs Johnson guarded her from callers. Only Jennie and Leonie were welcome at No 3. Leonie approved of 'forgetting everything in work'. Jennie was sympathetic but full of her own troubles. She had been refused a passport to Nigeria and could not join her new husband. Even Winston's influence had no effect on authorities reluctant to allow her to sail over a sea full of enemy submarines.

In November, two months after Alex Thynne had been killed, the Armistice was signed. Clare rejoiced in her own way. Wearing a brilliantly coloured cloak with a scarf tied around her head she set forth for central London. Everyone went out on the streets on Armistice Day, but most went in family parties. Clare wished to fling herself alone into the fray. That night Lady Maud Warrender was horrified to see her dancing 'Here we go round the Mulberry Bush' in Trafalgar Square with a group of workmen. She reported the matter to Moreton who was taking his wife to his club where they could view proceedings from the balcony. 'Your daughter is out of her mind. You must stop her.'

Moreton fought his way to Trafalgar Square. 'Stop this at once, nd join us!'

'You go to hell,' said his daughter.

12

Career woman
1919–1920

A NEW age had been born. The old pattern vanished when the aristocracy of England lost a generation of men. When entertaining on a grand scale recommenced and awnings once more stretched up to the imposing front doors and the sound of music came from lighted windows, the gentlemen arriving in their meticulous white ties and long-tailed coats all appeared to be aged under eighteen or over sixty. For Clare and others, single women in their thirties, there appeared to be no male equivalents. The result was that what able-bodied men existed became extremely spoilt.

The great Edwardian ladies who had survived the conflict bravely tried to resurrect the past but war had changed habits. A new code of immorality arose with pre-dinner cocktails and the first nightclubs. Clare found herself joyously free to behave in whatever way she chose. She did not drink – 'No one with Jerome blood should touch spirits,' said Aunt Jennie, 'we're born intoxicated!' Nor did Clare smoke, although her mother and aunts did – so the long elegant cigarette holders of the period which for some reason were considered a 'proper gift' from gentlemen, like chocolates and flowers, were wasted on her. But she loved to dance. And soon she had collected a number of what were called 'beaux' who knew the latest steps. She found more pleasure in dining with a man in one of the new restaurants and then dancing for an hour than she had in former days when attending the great balls of London Society. American men excelled on the dance floor so she

cultivated several who worked in the Embassy. 'I wish they could talk as well as they dance,' remarked Aunt Jennie. She insisted on Clare bringing 'one of those dear colonels' to teach her the Boston Trot.

Clare, now proud of being able to earn several hundred pounds a year, 'of my own, my very own', was giving dinner parties by candle-light. The large dark studio became transformed with bright materials hung on the walls. Meals were served on a low table surrounded by divans. Mrs Johnson revelled in the smartly dressed figures who would arrive – slightly bewildered after losing the way and unable to believe anyone *could* live down this narrow alley. Having removed coats and wraps they would lower themselves gingerly on to the divans and gaze around at the wooden pedestals each bearing a mysterious clay shape wreathed in wet cloths. Lord Birkenhead, with or without Winston, was a frequent guest. In these romantic surroundings some of the best dinner conversation of London took place for everyone whom Clare invited was interesting in some way. Mrs Johnson would be drawn from the tiny kitchen where she concocted her 'miracles' to be intro-duced by Clare: 'My mascot. Since she came I've given up book-ends for real commissions.'

But however hard she worked Clare could not make ends meet. The production of plaster decorations remained a necessity. Even after selling Wilfred's library, most of his collection of English prints and Staffordshire china and all the wedding presents, she had to accept anything to 'keep the pot boiling'. Clare imagined that to the outer world she appeared triumphantly successful, but one afternoon an American, Colonel Dentz, knocked at her door with an introduction and found her covered with paint and glue intent on finishing off a batch of wall decorations for the shops.

He insisted on looking at her real sculpture, but said very little. A few days later when he took her out to dinner, Colonel Dentz spoke plainly. 'Your talent is valuable capital. If you waste time on plaster fruit you are just fooling – letting your capital go to waste. I guess when your husband went off to France he counted on those left to see you through. Stop wasting your time on nonsense. Please let me give you £1000.' He placed big notes in her hand.

Clare was stunned. She remembered all the admonitions of her girl-hood – a woman should never accept anything from a man except flowers that wither or food that can be eaten. She consulted Mrs Johnson, that fount of commonsense. 'Keep it. That will feed us all for

three years. It's like a *big* box of chocolates, and a very handsome gesture. You're quite safe, my dear. The colonel has a wife in the States. He's just very generous and dotes on you.' So Clare ceased making trivial decorations for shops and concentrated on learning to model portraits.

Hilda Johnson records:

Among Clare's first sitters were H. G. Wells, Arnold Bennett, Gladys Cooper, Lady Diana Manners, Lady Lavery and Asquith the former Prime Minister. On his first visit the great Asquith was left standing on the door mat because Amy, the 'tweeny' had never heard of him and when he gave his name, expecting a fanfare of trumpets, all he got from Amy was 'Just wait and I'll see'. My mother and Clare went into whoops.

Mrs Johnson approved of Asquith however – a lower-middle-class Prime Minister being nearly as good as a 'real gentleman born'a ccord-ing to her special form of snobbism. And yet she admired Clare for 'lack of class consciousness'. Mrs Johnson's differentiations were extremely subtle. According to her 'real ladies' like Lady Cromer and Mrs Sheridan were devoid of class consciousness, but all the rest of the world was very conscious indeed and should be.

Clare had been longing to study under Epstein, but he took no pupils and she felt too shy to request a special favour. She contrived the matter in a different way. When Colonel Dentz suggested she choose a Christmas present, she asked for her own portrait by Epstein. While the great sculptor was at work she could watch, study and learn.

Those days are unforgettable. Epstein at work was a being transformed. Not only his method was interesting and valuable to watch, but the man himself, his movement, his stooping and bending, his leaping back posed and then rushing forward, his trick of pressing clay from one hand to the other over the top of his head while he scruti-nised his work from all angles, was the equivalent of a dance . . .

He wore a butcher-blue tunic and his black curly hair stood on end; he was beautiful when he worked. Then I learnt the thing which has counted supremely for me ever since. . . . He did not model with his fingers, he built up planes slowly by means of small pieces of clay applied with a flat, pliant wooden tool. He told me that he could not understand how other sculptors could work with their fingers which with him merely left shiny fingerprints on the surfaces. This was what I had always suffered from, the shiny smooth result of my finger touch. It had exasperated and perplexed me. It is his method of building up that gives Epstein's surfaces their vibrating and pulsating quality of flesh . . . Without his ever suspecting it, I acquired from merely watching him, knowledge that revolutionised my work.

Meanwhile, Clare finished a bust of Princess Patricia of Connaught who had become engaged to a naval officer, Sir Alexander Ramsay.

A royal bust in marble evoked public interest and brought commissions.

In January 1919 Oswald arrived in London to work in the Admiralty and found he did not altogether approve of his sister's new way of life. 'She can't indefinitely regard herself as a struggling artist bound to leave her children on a permanent visit to their grandparents!' Sometimes he remained to sleep in the studio and one night, after much argument, Clare ordered him to bed at ten o'clock, 'while I stay up writing to someone who *does* love me.'

Oswald was furious when she told him that, although welcome for meals when interesting people came, he was not to embarrass her by opening his big mouth to 'discuss Art'. He scribbled petulantly in his diary: 'It amounts to this, that anyone who even suggests a criticism of the Girl or her mode of life is persona non grata, & she is young & good looking enough to be able to always command sufficient adulation to keep her time filled.'

Now and again Aunt Jennie turned up at the studio with a car loaded with what she called 'loot'. This meant things which other people didn't want and had given her and which finally she did not want either. So she dumped picture frames and massive, sometimes valuable, furniture on Clare, who revelled in being treated as a junk shop. At this particular time she was working feverishly for her first exhibition. This was to take place in February at the Grosvenor Gallery under the auspices of the National Portrait Society. Clare's small statues would arouse great interest. No one had seen anything quite like them. Apart from Princess Patsy and the blind soldier from St Dunstans, there would be Lady Lavery as a golden madonna, Diana Manners in bronze, Gladys Cooper in coloured plaster and Oswald, in the naval outfit worn at sea, which critics praised for dramatic quality.

On 27 February, when Princess Patsy was married, her sister Margaret, the Crown Princess of Sweden, sent a motor for Clare's children so that they could watch from a Clarence House balcony. Dick, who was now four years old waved merrily to the crowds who, thinking he was some royal child, cheered lustily. 'Clare and Jennie all dressed up' were, according to Oswald, 'with the Nobs in sight of the altar.'

Clare appeared to be established as a successful Society sculptor. Commissions from those 'Nobs' referred to by Mrs Johnson and Oswald must now come her way. She was so talented, so tragic, so lovely.

On April Fool's Day, Oswald decided to play a trick, and as sometimes happens, it worked beyond his dreams.

Rang up Puss (the most gullible person I know) and said I was the Fire Life Assurance desirous of settling Out of Court for the value of her five works of art destroyed in last night's fire at the Grosvenor Gallery. Puss abed, her servant did not seem to think she would come to the phone, so I was bilked, but did my best by giving a bogus number on the Holborn exchange for her to ring when she *did* get up.

That evening on leaving the Admiralty, Oswald called innocently at the studio wondering what the result of his hoax would be. Clare met him full of the 'rotten joke' someone had played which had resulted in a horrific day for her friends.

She had started by scolding her servant for ringing off on the most important call she'd ever received. She tried to ring the Holborn number and got an aggrieved merchant. Then Aunt Jennie rang up and obtained a version of Clare's woes. Jennie advised her to ring McEvoy, the painter, who also had work on view. She did so and then thought of ringing the Gallery door porter, who had received calls in consternation. 'It's all right, nothing has happened here. And I notice it is the first of April ma'am.' Clare, realising it was all a joke, re-rang Jennie and learnt that Jennie had already rung Lady Lavery who had sent her husband post haste to the Gallery to save what he could. Clare then decided the perpetrator of the joke must be her American Colonel, and determined to pay him back, rang his office leaving a message to say the Duchess of Westminster expected him to lunch with her at 1.30. Then she rang another American in the building who assured her the luckless man had gone off to communicate with the Duchess on a private phone ... It all sounds too good to be true but Puss seething with indignation told it to me ... I laughed so all the way home that I feared the Police would apprehend me.

Throughout 1919 Clare's success continued. She herself noted: 'Life seemed to be evolving along a well-directed plan.' Oswald's diary describes a series of 'Bohemian supper parties' in the studio. These were attended by the enchanting actress sisters Zena and Phyllis Dare, Cabinet ministers, artists and writers. Lobster and champagne now graced the table.

In May Clare purchased a Buick car and learned to drive. Oswald describes outings where she 'threads her way bravely through traffic'. Oswald was more cautious and only took the wheel when Clare's chauffeur was there to guide his feet and hands. Occasionally brother and sister went out together for 'traffic practice' and by the end of what was still called the London Season Clare was 'making great strides in the art but avoids streets where one has to change gear.' Oswald appeared to be a dud at the wheel. After spending six pounds on

lessons he 'misjudged turning left and buckled off-fore mud guard on a gate post', after which Clare, displeased at seeing her car dented, took over all driving herself. They proceeded to Carlton House Terrace when Lady Lonsdale invited them to watch the Victory March from her house. Oswald sat beside her. 'One is used to the policeman putting up his hand to stop vehicles that pedestrians may pass, but never to one putting up his hand to stop the pedestrians so that *our* car may pass. Puss drove quite well in the circumstances and hurt nobody.' All went bravely until on the return journey they met a Rolls face to face which seemed more than the Buick could take – 'the off-hind tyre went off with a bang.'

As well as receiving the honour of doing a bust of Mr Asquith for the Oxford Union where it would be placed between Gladstone and Lord Salisbury, Clare received orders for other portraits.

During the winter of 1919–20, Captain Freddy Guest, a cousin of Winston (through the Marlborough side), asked Clare if she would accept commissions to do busts of *all* his famous friends. If she could inveigle them into sitting he would have the whole lot cast in bronze, including one of himself, for his private collection. She wanted to start with Lord Beaverbrook's rugged features but he bluntly refused. Lord Reading agreed but then went off to India. However, Winston and Lord Birkenhead were ready to sit for her – Birkenhead only too ready in fact. Winston was staying in Freddy Guest's luxurious house at Roehampton for a few months, and 'F.E.' came down there most weekends, so Clare thought it would be easy to arrange her models.

On Saturdays Birkenhead's large car would call for her at St John's Wood Studios and take her down to Roehampton. The house was great fun and Clare had three devoted men to model. Winston spent every available minute painting, so Freddy Guest had converted a north room into a studio for him. Clare set up three pedestals in different parts of the house. Each carried a large lump of clay which gradually turned into likenesses of her host, of 'F.E.' and of Winston. Clare wrote:

Birkenhead, who had been painted by every artist in London was self-appointed critic. Sometimes McEvoy joined the party and would try to paint Winston while Winston painted me, and I modelled him. No one would keep still for the other, and it was small wonder that no one got very far. Of all the portraits I have ever done Winston's was the hardest, not because his face was difficult, but because it was for him a physical impossibility to remain still. He said that Sunday was his only day in

the week to paint, and so I waited, I watched, I snatched at times and moments, I did and undid and re-did, at times in despair. Freddy would come in, beseech him to 'give her a chance' and 'it's for *me*, Winston', and Winston would be contrite and promise and say he was sorry and that he knew it was hard on me, and he would sit compassionately for three minutes and then begin to fidget. Not only would he not keep still for me, but more usually he expected *me* to keep still for him! Once a secretary arrived from the War Office* with a locked despatch box. He stood there, but Winston went on painting, neither seeing nor hearing. For some time the secretary watched us both; I looked at him wondering what he thought, and saw that he was smiling.

Now and then Winston, remembering me, and that I was trying to portray him, would stop still and face me with all the intensity with which he had been painting. These were my momentary chances which he called sittings!

When the light faded he would leave his canvas and turn excitedly to the window where he had a sketch of the cedar tree outside waiting for the sunset background. During one of these passionate moments of trying to catch the dying colour he said to me, without turning round, 'Sometimes – I could *almost* give up everything for it.'

She felt at the time that, had he from the very beginning put his colossal energy into art, he would have been among the greatest, 'But power is more dear to the heart of man than all else – the destinies of the British Empire must pursue their way, and in the end it will not make much difference whether Winston for a little while did or did not add his shoulder to the wheel.'

At the time she wrote these words they seemed presumptuous, but both Clare and Winston would live to see the end of the British Empire.

These weekends at Freddy Guest's magnificent residence continued throughout the spring of 1920. Despite his restlessness Clare worked doggedly at her portrait of Winston. Although he took her artistic side seriously, although he was always ready to tease her out of stormy tears when she begged him to sit still on the revolving stand, he just couldn't. He would suddenly wander off to look out of the window completely forgetting that he was supposed to be posing. It was a little better when he began sketching her at work but not until the day that she coaxed him on to the stand and he started to knead a piece of clay himself did he really remain still.

'But you can do anything with it!' he cried.

Clare nodded. 'I thought you'd like the feel.'

Four hours later he was still absorbed in his little clay figure. Clare had worked without ceasing and the head was nearly finished. When

*Winston was now Secretary of State for War.

they were alerted by the dressing gong Clare dragged herself upstairs and lay on her bed in her smock exhausted and wondering how she could summon the energy to bathe and change into an evening dress. She came down late and Winston looked at her quizzically. 'The fulfilled artist!' he said. 'You'll never get me for four hours again.'

'I won't need to – it hardly needs touching,' said Clare. Champagne glasses were lifted 'To Clare!'

After dinner Freddy Guest would invite his guests to dance or listen to Winston. 'Choose – you can't do both!'

Clare did not care for conventional evening attire. Her working clothes would be replaced by brilliant flowing silk gowns and fantastic necklaces. She was extremely attractive in a provocative way and it amused her to note how numerous and how strong were the bolts on all the bedroom doors. 'You *are* a considerate host,' she remarked to Freddy, who laughed, 'Well, I've known other compliments.'

Her affair with Birkenhead ('F.E.') was supposed to be secret, but two such spectacular figures could hardly walk in the garden twice without creating an 'impression'. Old Mrs Frewen, left with the children in London or at Brede, wrote anxiously to Leonie about it:

The poor darling does not realise how people enjoy saying unkind things. It is getting to be quite a scandal but Jennie just laughs – she says Clare needs that sort of man to perk her up. I begged her to ask Winston to speak to F.E. about it but she says he does not care. He adores Clare, thinks she can do no wrong after all she has suffered and he is *devoted* to Lord B. – you know how he always stands by his friends. So whatever scandal these two create together is in Winston's view *no* scandal – they are 'splendid', and whatever they feel like doing is 'perfect'. So there it is – c'est lui qui tient la chandelle.

Clare was seldom on speaking terms with her father but she found 'poor old Mumpkin's' warnings rather fascinating. 'I am thirty-five this year and what haven't I been through – this is a happy interlude – Winston, F.E. and myself – we *get on together*.'

Clare continued to work in London, taking time off occasionally for tea with Princess Patsy (now Lady Patricia Ramsay) where they practised the new dances together, or to lunch with Jennie where she met her new uncle Porch, and received lectures concerning the importance of secrecy in love affairs. Then Leonie met Clare in the street and whispered her favourite axiom, 'Cache ton jeu'. London was full of rumours.

In March Oswald dined at Leonie's house with his mother, father

and sister. He was in a sour mood (two girls they had recently advised him to marry had turned him down).

Aunt Leonie amusing about poor Porch in his new and unaccustomed rôle of *Homme du monde* – Aunt Leonie's and Aunt Jennie's rotten *monde* – the aunts are shallow, worldly, self-centred (*terribly* self-centred), self-satisfied and cynical. They function only on the intellectual plane, and they have neither of them even much intellect – Aunt J. *none*. They live unhappily in a rotten world of their own, blind and deaf to the beauties of the Great world.

They had been scolding him for doing nothing and Clare for doing too much. None of the Frewens could tolerate criticism even when it was constructive. Oswald was secretly intrigued by the 'rotten world' in which the aunts shone wittily and where he, after his long naval training remained tongue-tied except on the subject of the Battle of Jutland.

During the rest of the spring he lodged at the studio and helped Clare who was having the place redecorated, which meant much heaving of the heavy furniture which Jennie had given her. Clare grumbled. 'Oh, the torture of *belongings* – of *things* – what does one do with all this. I wish Aunt Jane* had *not* given it to me.'

Occasionally, around tea time, Oswald noted in his diary, 'The Lord Chancellor called at 5 so I withdrew.' Birkenhead was furiously pursuing Clare not only at Freddy Guest's weekends, but during the week in St John's Wood. She enjoyed his sardonic humour and half-enjoyed his egoistic, energetic, amorous pleadings. Jennie bumped into him twice in the alley and began to drop warnings, a habit which Clare could not abide. 'You will be careful dear? After all he has a wife and children.'

'Honestly I know *that* – I'm doing a head of his daughter Eleanor. She is fascinating.'

'I *never* took on married men – it always seemed complicated enough without . . .'

Clare tossed her short curly hair. 'You think in such old-fashioned *terms*. I don't regard this as a love affair. I'm just enjoying a man's company. . . .'

'Be careful, dear.'

'Why? – *you* never were!'

The argument was interrupted by the arrival of a large block of marble which Clare had to direct to be sent off with her plaster head

*Jennie was sometimes called Jane.

of Asquith to the firm who would copy it. In the following week
Oswald accompanied her to watch the cutting. They left when a
marble flake hit Clare in the eye and her language did not edify the
workmen. But her brother admired her for 'putting in yeoman work
and looking so handsome'.

Mrs Johnson could not abide Lord Birkenhead. Her daughter
Hilda's reminiscences of the affair do not pretend to be impartial. Mrs
Johnson admired and spoke much of Lady Cromer whose behaviour
was that of a 'real lady'. She would cross the street to introduce her son
to Mrs Johnson and was full of consideration for others. Not so Lord
Birkenhead. Mrs Johnson found him a come-down. Hilda writes to
the author:

My mother always said Lord Alex was the love of Clare's life, after Captain Sheridan.
She used to talk to Clare for hours and saved her from many indiscretions but Lord
B—she could not turn her away from. It was partly him being Mr Winston's good
friend. They had awful rows, him and Clare and once he told her (when she was going
out with American officers) that someone at his luncheon table had said she was
promiscuous. Well you can imagine what Clare said to that. '*Your* guests *said what* at
your table?' Well then, he would get round her again and Birkenhead and she would
discuss what a child of theirs would be like – the old story about her beautiful body
and his brains. But my mother said there were enough reproductions of *him*. Later on
when Lord Birkenhead was holding forth as President of the Divorce Court, my
mother was so incensed she wrote him a letter asking him his *right* to moralise. This
was long after his affair with Clare, of course.

Maddening as it must have been for Mrs Johnson to have to witness
her beloved lady falling slightly under the Lord Chancellor's spell,
she must have enjoyed being in on the scene and able to offer her
opinions. It was an anxious day for Mrs Johnson when her own hus-
band and son were demobilized and, being kept at home to look after
them, she had to find a neighbour's daughter to substitute as Clare's
cook. She found Louise, a young girl who she feared might not
appreciate the flavour of goings on in 3 St John's Wood Studios, and
perhaps be indiscreet. Amy the 'tweeny' was, said Mrs Johnson, 'too
stupid to catch on to anything'.

In May, the Crown Princess of Sweden died unexpectedly. Oswald
noted: 'Puss having taken Princess Margaret for granted as it were
now realises she has lost the only woman friend who counted at all
and is very unhappy.'

All through June, July and August, Clare remained working in
town. Occasionally she took a few days off to see the children at Brede

Place, and once she induced Oswald to drive them all over to see Rudyard Kipling, in the side-car attached to his new motor bike. Kipling loved children and once gave up a London banquet so that he could enjoy a long evening with Margaret and Dick.

Briefly, Margaret was packed off to a convent boarding school in Kensington, where she was utterly miserable, then retrieved to stay at Freddy Guest's house where the child felt dazed. Only Winston, who always loved children, spoke to her kindly.

That summer it was hot and humid in London and Clare grew very tired working for the autumn exhibition, which had been offered her by Agnew's in Bond Street. It was a great honour to be shown alone in such a gallery. She had the heads of a number of well-known people ready and she intended to add those of Shane Leslie and Princess Patsy. On 17 August she gave a luncheon for Winston, the artist McEvoy and Mr Agnew of the Gallery. Oswald attended and wrote:

Winston was . . . interesting about the Bolsheviks, France having just recognised Wrangel, a South Russian anti-Bolshevik leader. He said nobody hated Bolshevism more than he, but Bolsheviks were like crocodiles. He would *like* to shoot everyone he saw, but there *were* two ways of dealing with them – you could hunt them or let them alone, and it was sometimes too expensive to go on hunting them for ever. This from our fire-eating Minister for War was interesting.

Clare sat innocent and starry-eyed while Bolshevism was discussed. She had, by chance, just seen a newspaper photograph of the first Soviet Trade Delegation to visit Britain and the features of one in the group had caught her interest. When Princess Patsy and her brother-in-law the bereaved Crown Prince visited her one day with Shane, she remarked lightly: 'What fun to add a Bolshevik to my Agnew exhibition!' Shane knew that Winston intended her to join him on Lord Birkenhead's yacht – it would be a good rest before her important show, and Clare had leapt at the idea, saying she was so tired the sea air was just what she needed.

When Mr Kamenev, head of the Trade Delegation (who was married to Trotsky's sister) heard that a cousin of Winston Churchill would like to sculpt a member of his mission he sent a message inviting Clare to visit the Soviet Office in Dover Street. Clare was intrigued until she saw Kamenev himself – an ordinary-looking little man with a neatly trimmed beard and pince-nez. 'He might have been a French bank manager,' she muttered to Shane.

Kamenev spoke French and seemed extremely amiable. The Soviet

Government he said, 'loved artists and he would gladly come to her studio and sit. Clare did not want *him*. She wanted that rugged Slav face she had seen portrayed in the background. His name was Krassin. But there was no way of getting one without the other, so she made arrangements to do them both.

Although she did not clearly explain to Mrs Johnson who these afternoon callers were, that good lady scented mischief. These were no *gentlemen*, and from the day that Kamenev called and, finding Clare out, left a bunch of red roses at the feet of her war memorial *Victory*, Mrs Johnson was full of suspicion.

So, actually, was the Foreign Office. One of Clare's former 'beaux', a man who had often taken her out dancing, was delegated to watch her and report. Thus it went on all through the last half of a very hot August – Lord Birkenhead meeting her on Sunday, Shane and Princess Patsy, who were to be 'draws' at the exhibition posing on weekdays, and the Bolshies scuttling in ('nervously,' said Oswald) for sittings.

On 27 August Clare wrote in her dairy:

Dined with Aunt Jennie. She asked me what work I was engaged on but I took good care not to mention either Russians or Russia. In the course of conversation, she told me that I was being criticised as having too much freedom. I chuckled over this, as I visualised to myself the great band of people who grudge one that freedom, because they have not got it, and because they knew that freedom counts above rubies.

I said to Aunt Jennie, 'And how is that grave condition of things to be rectified? I am a widow and earn my living, how is it to be otherwise ordered?'

She had no suggestion, it would have been out of place for her to suggest re-marriage which, in fact, is the only way of ending it, of ending everything, liberty, work, and my happiness which is dependent on my work.

On the following day, still without telling her aunts what she was up to, Clare took Kamenev to stay with a friend in the Isle of Wight. Kamenev enjoyed himself greatly. He lay on the lawn watching the sun set and poetically held forth on the joys of the Russian Revolution.

During the following week Clare obtained a visa for Sweden. On 2 September she went to Brede Place for a few days with her children. Moreton was away in Ireland fishing and her mother swallowed the story she told of an impending yachting trip in the Mediterranean. Mail need not be forwarded.

It was only to Shane that Clare blurted out the truth – she did not intend doing Birkenhead's bust or taking a holiday on his yacht. Kamenev had invited her to return to Moscow with him to see for herself how artists were appreciated in the New Workers' Paradise.

13

To the Kremlin

On 5 September 1920, Oswald wrote in his diary:

Puss is trying to go to Moscow (rien que ça) with Kamenev to sculpt Lenin and Trotsky . . . I'd rather she didn't go but she has got 'Bolshevism' badly – she always reflects the views of the last man she's met – and I think it may cure her to go and see it. She is her own mistress and if I thwarted her by telling Winston she'd never confide in me again . . . I went to the Bolshevik Legation in Bond Street with her and waited while she saw Kamenev. Several typical Bolshies there – degenerate lot.

On 7 September he added: 'Puss getting ready for her October Exhibition and going for the weekend either to Lord Birkenhead *or* to Moscow!'

As Cabinet ministers, Winston and Birkenhead had already been receiving reports of Clare's midweek outings with Kamenev. She had taken 'her Bolshie' to the Tate Gallery and to Hampton Court where, after dark, they had hired a boat and Clare rowed along the Thames bank while Kamenev sang the Volga Boatmen's Song. Winston was amused, Birkenhead unamused. What neither of them could know about was the invitation she had received and accepted.

Only to Shane and Oswald did she confide her intention. It was all quite proper, she insisted. Kamenev's wife would, he had assured Clare, welcome her with open arms in the Kremlin. Doing busts of Lenin and Trotsky *must* bring her world fame. She thought this Russian visit much more important than attending to her forthcoming exhibition – or improving her health on Lord Birkenhead's yacht. She had procured a visa to Stockholm and Kamenev assured her he could then 'fix things' for further travel.

Shane was in the studio when Kamenev rang: 'The delegation is

leaving tomorrow morning. They want to know if I am coming,' exclaimed Clare.

'Ought I to let you go off on this mad venture?' groaned Shane.

'I *am* going. Such a chance will never fall my way again. Only promise not to tell Winston, at least not for a week.'

Next morning she put the 'tweeny' in charge of 3 St John's Wood Studios. 'If anyone asks just say I am away on a visit.'

Reluctantly Shane drove her to St Pancras Station. She rejoiced that the aunts were out of London. She would reach Stockholm before anyone realized she had gone – or so she thought.

Shane helped her on to the train. 'What you and Oswald have got to do is to see that all my sculpture gets to Agnew's in time for the exhibition. Be sure they include Kamenev and Krassin – and here is a list of important people to invite to the *Private View*.' She pressed a list of two hundred names into his hand.

At this moment Kamenev and several of his staff appeared, carrying a big box of chocolates tied with red ribbon which they presented to Clare. 'Look here, my girl,' Shane muttered, 'you'd better give me your jewellery.'

Clare was wearing her usual brooches and rings and bracelets. She pulled more out of her handbag and handed the lot to Shane who placed it in his pocket and watched the train roll out with very mixed feelings. Then he took a taxi to the bank and asked for a safe deposit.

As the train rattled north to Newcastle, Kamenev grew talkative. He described the failure of his mission and the row he had had with Lloyd George on the previous day. They conversed, as always, in French, but Clare had had the foresight to buy a Russian dictionary – that and her scalpels were her sole preparations for the adventure which lay ahead.

Two days later, when they reached Stockholm, Clare had grown slightly less enthusiastic about life with 'comrades'. It was so uncomfortable. They had to wait in a dull hotel until a ship left for Riga, and Kamenev got busy procuring some kind of Estonian visa for her. Without considering her own emotional and political inconsistencies Clare telephone the royal palace where she had stayed as a girl and asked to speak to the Crown Prince. He had visited her at the studio only a month previously (Princess Patsy and Jennie had been present and provoked him into criticizing her war memorial as 'gloomy'). He

came to the phone: 'Clare, *you*! Come to lunch and tell me what you are up to.'

Kamenev listened with astonishment while Clare asked the Crown Prince if he would send Amy, the late Princess's personal maid, to help her shopping. Amy drove around with her translating into Swedish and collecting the parcels. At noon Clare left her and hailed a taxi. 'To the Palace.' The driver looked vague. 'Palace Kronprinzen,' said Clare.

He drove her to the Kronprinzen Hotel. Unable to make herself understood Clare went in and asked the hall porter to explain. This he did to the amusement of guests and staff. Eventually she reached the Palace.

'The Prince looked very lonely in those big rooms,' she wrote, 'they were extraordinarily vibrant and reminiscent of *her*.'

During lunch he listened with interest while the lady-in-waiting and two A.D.C.s looked bewildered.

Gustaf was a sad widower and Clare had been his wife's best friend. He did not seem shocked at her wish to go to Russia, he only feared for her safety. 'And do you really think *you* ar going to get Lenin and Trotsky to sit for you? Or see anything of Russia?'

'Prince Gustaf was overwhelming in his desire for my material comforts,' wrote Clare in her diary. 'He telephoned for biscuits, and two large tins arrived, also cigarettes . . . Finally, he escorted me to the taxi that awaited me in the courtyard, and wished me good luck and Godspeed.'

The Crown Prince never dreamt that the press had got wind of Clare's visit to the Palace and that later the newspapers would print embarrassing insinuations that Gustaf condoned the Russian revolution.

Kamenev had arranged her visa for Estonia and they boarded the steamer for Reval that night. Later on, Clare admitted,

I wrote an apology to F.E. explaining why I had not turned up at Charlton to do his bust. It was one of the things I felt badly about for I had left England the very day I was due at Birkenhead's. I could not at the time explain . . . It is funny that none of these people, not even Kamenev, have heard of F.E. either as Smith, Lord Birkenhead or Lord Chancellor. Chancellors of the Exchequer were understood but no other Chancellor.

Tea and caviare was the fare during this journey. Clare enjoyed a luxurious sleeper on the train from Reval to Moscow, and during the second night Kamenev tapped on her door. 'An old friend Zinoviev

has just joined the train. He says that Lenin agrees to sit for you. The telegram asking him arrived in the middle of a Soviet Conference. Lenin said, "What can I do but consent when she is coming so far for the purpose?" '

Elated by this news, Clare began to study her Russian dictionary trying to memorize the words for clay and revolving platform. It did not occur to her to wonder why the Soviet leaders were permitting a cousin of their most virulent and outspoken enemy, Winston Churchill, to enter the very heart of Russia. They may have thought she was a spy worth watching, or they may have considered it good propaganda to flaunt her presence before the hostile outside world. Certainly they could not have cared about being modelled.

After two days and nights of leisurely progress, the train drew up in Moscow and Clare jauntily prepared herself to meet Madame Kamenev, the woman who was supposed to prove a veritable soulmate. It was slightly dispiriting to view Kamenev with a hang-dog expression pacing the platform beside a dumpy woman who seemed to be scolding him unmercifully. Could such a virago be the sister of the great Trotsky? Eventually Kamenev induced his wife to climb on the train and be introduced to Clare. He had badly miscalculated the effect the first sight of this tawny English lioness might produce. Madame Kamenev glowered, stared disapprovingly at the crusts and cheese remaining from breakfast and snapped in French, 'We do not live *chic* like this in Moscow. It is bad for the people to see. They will think Leo Borisovitch has turned into a bourgeois.' Leo Borisovitch, as Kamenev was called henceforth, quailed and stared uncomfortably at Clare throughout the next outburst, which although in Russian, was only too comprehensible to her. Madame did not like foreign blondes and she was damned if she was going to play hostess in the Kremlin.

Kamenev pleaded. 'But where else is she to go?' Eventually, the unhappy trio walked to a large car and drove off through the dismal deserted streets of Moscow. Clare found the exotic gates of the golden-domed Kremlin exciting, but the romance of coming to Russia as an artist began to wear thin. When the car stopped, a Red Army soldier carried the luggage up a long staircase to their 'quarters'.

If Clare had expected to be lodged in Tsarist splendour she was quickly disillusioned. The Kamenevs inhabited a few sparsely furnished rooms. The 'sitting-room' resembled a dentist's waiting-room with one large table covered with propaganda albums. Deflated and tired,

Clare asked for her bedroom. Maybe she could have a bath after the long journey? Leo Borisovitch ordered the peasant woman who acted as servant to prepare hot water, while explaining that it would take three hours to heat. Trotsky's sister, whom Clare now mentally referred to as the bitchovich, remarked that it was not customary to waste money heating bath water when people were starving. Kamenev bit his lip and stared at the floor until he could in decency hurry away to 'overwhelming accumulation of work'. His wife swept out with him and Clare found herself left for the day with no one to talk to except Anna, the rosy-cheeked peasant servant who spoke a little German.

The only food available was the same for every meal – black bread, salt herrings, casha and chicory coffee. How long could this incarceration last?

The Kamenevs' teenage son took her for a walk in the Kremlin precincts, but he explained that if she passed out of the great gate guarded by its square towers from which the Imperial Eagles still looked down, she would never be able to get in again. The idea of starving in the Moscow streets had little appeal so Clare tried to enjoy views from the fortress. 'It was a gorgeous September day with a little touch of chill in the air. The leaves of the trees in the garden below were bright yellow and fluttered slowly down as a warning of winter. Red soldiers marched or drilled or sat in groups.' The coppery blue and green domes of Moscow glistened in the setting sun, and then, as the air grew cold, she returned to the 'apartment'. Anna had no idea when the Kamenevs would return. They seldom reappeared before midnight when conferences and committees ended.

'But I want a bed,' wailed the foreign guest. Anna roared with laughter and pointed to the sofa. Eventually her hosts came in and supper was served. This consisted of tea without sugar, more casha and raw herrings. 'Tomorrow we will open the cases I brought from England and have sugar and sardines,' Kamenev coaxed.

His mate looked at him coldly. 'We have got used to doing without such things, but did you bring me a *hat*?'

'I've brought you a mackintosh.'

'But I asked for a *hat*,' Madame querulously cried. 'There is no such thing as a *hat* in Russia; there *are* mackintoshes.'

The little man twitched. Clare could not help feeling sorry for his wife. She was ugly and ill-mannered and could not conceal her jealousy, but this longing for a *hat* instead of a raincoat was at least

human. '*I* never wear a hat myself except for the fur ones I make, or a turban,' soothed Clare.

'*I want a hat*,' whined the sister of Leon Trotsky, the second most powerful man in Russia. '*A hat from London.*'

Clare wondered how long she could endure it. She felt grateful when eventually the son, Alexander, was moved from the passageway which they called his bedroom, and she found herself installed there with a screen around her bed. Host and hostess would have to pass her whenever they entered or left their own room, but at least she could undress and bury her head under the blankets. It seemed curious that in such a vast place as the Kremlin they could not find her a room of her own.

One moment of sympathetic contact occurred between the two women when Madame Kamenev admired the bright silk dressing-gown which Clare wore for trips to the none too salubrious toilet. She touched the material wistfully: '*Vous avez de si jolies choses – ici nous n'avons rien – rien – rien!*'

During the next four days Clare found herself virtually a prisoner. The Kamenevs disappeared early each morning leaving her alone with Anna who chatted cheerfully but seemed unable to produce hot water either for coffee or to wash with. Chilly walks around the fortress soon palled. She wondered if she would ever sculpt the Bolshevik leaders – or ever see her children again. Clare grew hungrier and colder and even more sorry for herself. To Shane she wrote long letters which she could but hope would go by courier. Then, on the fourth day, Anna announced an Englishman. Clare rushed forth to meet Mr John Reed,* a prominent American Communist who had come to the Kremlin to protest about permits promised but not delivered. Clare poured out her woes. 'Fend for yourself,' he answered curtly. 'No one will bother about you unless you do.'

On the fifth morning she tackled Leo Borisovitch. 'What have you led me into? Why don't you put me up in a hotel and get Lenin to sit for me as promised? Your wife hates me. I must get out.'

'But you wanted to come!'

She stared at him in amazement. 'But not to *this*...'

'I will make arrangements from my office,' he said abruptly. 'There *are* no hotels. Tomorrow we will send you to the "guest-house of the People's Commissariat for Foreign Affairs".'

*Author of *Ten Days that Shook the World*.

She bedded down in the passageway praying that it might be for the last time. Outside the window Moscow's domes gleamed in the moonlight and beyond the silent hungry city stretched Russia's vastness – her plains, her towns, all facing famine, all breathless with terror of the Secret Police. And the great forests rustling under the night sky might have been weeping at man's cruelty to man. Meanwhile in the Kremlin Trotsky's sister sulked because she hadn't got a hat.

Meanwhile in England the impact of Clare's departure had begun to make itself felt. On 19 September her mother, still not knowing what Clare was up to, wrote to Jennie: 'Where *is* Clare? I'm told the rumour in London is that she has gone off with – Kamenev!!! Ha! Ha! Honestly, I was told this seriously. People don't know what to talk about do they?'

This was the last ha! ha! in a Frewen letter for a long time. Within the next few days the cat began to slip out of the bag. While attempting to make Sussex neighbours believe that Clare had merely departed in a hurry to sculpt the Crown Prince of Sweden, Clara wrote piteously to her sister Leonie:

Moreton, Oswald and I thought best to keep Clare's doings to ourselves but Jennie writes me that rumours are going about London – we think we must tell *you* and *Jennie* what is happening – no one else. She *has* gone to Sweden to execute some orders but now writes that she *may* go on to Russia – perhaps to Moscow, but no one has to worry about her at all. We three poor things here at Brede are anxious and miserable for if she does go into Russia Heaven only knows how she will ever get back. She writes me that she is just off to see the Crown Prince Gustaf which seems comforting to me. Oswald and I are trying to quiet down Moreton who is frantic.

On 16 September Shane wrote to Oswald.

I am very uneasy about the girl. She reached Stockholm with Kamenev and this morning's papers report his arrival with his 'wife'! His real wife, Trotsky's sister, is in Moscow! However, she can take care of herself and I had such a long serious talk with her the night before she went that I am certain she will not make a liaison, even platonic, with any of these red harbingers of New Russia. She will act as an artist only, but Heaven knows when she will be able to get back . . .

We must keep the matter a dead secret as long as possible. Francis Meynell is here and he tells me that there are Govt spies in the Bolshevik H.Q. so that Winston may learn of her escapade at any moment. The old birds will have fits but I can reassure them . . . Anyway keep the matter a dead secret and send me at my Talbot

Square house any letters for the girl, as I have a way of sending her letters by hand. Yours distractedly, Shane.

Then a letter from Stockholm addressed to Oswald in Clare's unmistakable hand reached Brede Place during his absence. Moreton opened it and when Oswald got back, 'Found Pa – I can only call it raving, and Ma inexpressibly shocked.' Oswald said they should not open letters not addressed to them and tried in vain to offer consolation by reminding them that Prime Minister Lloyd George had shaken Kamenev by the hand. They would have none of it and forbade Oswald to issue invitations to the *Private Viewing* at Agnew's Art Gallery, and wrote furiously to Shane. He replied on 24 September:

. . . It was impossible to dissuade her and as she was armed with a passport from a high friend in the Foreign Office and accompanied by the Secret Service I imagined Winston would have her turned back at Stockholm. I asked Lord Buckmaster. He said she was perfectly in the law and within her rights in going to Russia and that I could have done nothing. Aunt Jennie says I should have called a policeman but I could only have invoked a White Slave Regulation and I preferred at least to chaperone her departure in a way that made it obviously not an elopement. Besides in respect of the higher law she assured me that there was no amorous intrigue and she is less likely to be made up to in Moscow than in some of the stately homes of England. She goes as an artist. I dissuaded her from wearing jewelry and I hold all her jewels and Wilfred's in my bank in trust for her children.

When newspapers started to print the reports from Stockholm, Leonie wrote tactful letters all round. To Olive Guthrie, her Leslie sister-in-law, she wrote:

I expect you have heard of Clare's mad escapade of going off to Russia to do Lenin's bust? I hoped it would not be known and have sat here biting my nails and marking time, but Jennie writes there are rumours. I had a few lines from Clare on her way, radiant at the prospect, begging me to explain to her parents. Clara writes me so quietly. Making every allowance for Clare's love of adventure – I do admire her for it. I know you will be a good friend to us all and make light of it. When we meet we can both damn her to our heart's content.

And to Clare's mother she wrote:

She has done nothing dishonourable. She is misguided but it is not for *Family* to turn against her. Darling, if I *may* advise you – say *nothing* – or just as little as you can. Put on a brave face and act just as if everything was all right and very likely things *will* turn out all right. Clare is a dear, impulsive, illogical artist. They are different beings from the ordinary run of people, and must be judged differently. Besides *why* judge? We are none of us faultless. I beg of you not to worry unduly. These things seem so much more terrible at the moment . . . Her love of adventure and artistic

aspirations lead her into rather dangerous experiments but I'm sure she will come out of it all right – particularly, if we all keep calm and minimise the whole escapade. I had a few letters from Stockholm and wrote to Jennie as Clare sent her her love – she also asked me to comfort the 'old birds'.

The 'old birds', however, would not be comforted. Oswald described the situation:

Ma and Pa have taken Puss's journey desperately to heart. One would think there was one woman only in the world and that all eyes were rivetted on her. Of course you and I agree that it is unfortunate that she has gone. We also, knowing her, realise that once she meant to go no one could stop her. She left without a visa as it was. Ma talks of 'shutting her up in a room'. I gather Shane is the miscreant who omitted to do this! In vain I talk of *Habeas Corpus* – what does Ma care for the Magna Carta or the police? As it is her friends already know, Lady Lavery alone is as good as a gramophone on a housetop.

My government invited Kamenev here, my Prime Minister shook hands with him. So did I. He is the most green-grocerist little bourgeois I ever did it with.

If Clare had imagined that the novelty of exhibiting Bolshevik heads could charm Bond Street she made a mistake. Agnew had presumed that Clare would personally attend the exhibition and that various royal personages and interesting social figures would flock to place commissions. Oswald had to bear the brunt of the Gallery's displeasure. He wrote:

I find a general air of passive resistance shown by the partners to what is Colin Agnew's 'private arrangement' for Puss, of which they obviously disapprove. I find Press Day will be 11 October and Puss has gaily arranged for her statuary to arrive on the 12th . . . And lastly the Manager simply declines to admit Kamenev and Krassin – in bronze or flesh!

Oswald attended a pre-show luncheon given by Jennie and Porch:

Talk all about Clare – What Lady Essex said – What Lady Lavery said (the latter weaves in 'romance' – the act of an un-friend). What Winston said – Aunt Jennie relayed this, 'How enterprising!' It's a nine-day scandal to Jennie's friends and the rest of the world won't even know or care that she has gone.

Oswald's surmise proved incorrect. The rest of the world would find out and care very much indeed. And Jennie's version of what Winston said was inexact, she merely produced it as a smoke screen to silence gossip (she hoped).

Winston was understandably angry with Clare. As Minister for War he had led the faction desiring continued military intervention in Russia. He believed that the cruel Communist power should be broken by force and a moderate government helped to power. How

could it *not* make him look ridiculous when a member of his family flitted off to do portraits of Lenin and Trotsky?

He sent for Shane and gave him a dressing down which was far more accurately described in Oswald's diary than at Jennie's luncheon table.

Yesterday lunched with Mumpkin. It is madness to sympathise with her because it only fans the flames. She is quite capable of working herself into hysteria without outside assistance . . . Her account of Winston and Shane and their 'awful row' was so grotesque that I simply couldn't look her in the face, and even in this I was not suffered to suffer in my own way, for I found her saying 'and Winston just looked at him like this – *LOOK AT ME DARLING* – *like this*.' What Winston had said to Shane and how Shane's head had hung lower and lower and how finally he had got up and said he couldn't remain any longer, and how Winston had refused to shake hands with him, all had been embellished in the telling, but to have a sort of Movie addition with Ma 'featuring' Winston was too much.

Oswald trotted off to Jennie privately and asked her what had really happened. She told him that Winston *had* sent for Shane and told him that he ought to be ashamed of himself for allowing Clare to sneak off on a crazy adventure which could hardly fail to result in most undesirable publicity for him, Winston, who had, as Minister of War, pressed so hard for anti-Bolshevik military intervention. Why had Shane not told him in time? He had known perfectly well that, while pretending to prepare for the weekend with Winston and Birkenhead, she was secretly plotting to go to Russia. Here Jennie began to shake with laughter. She said, 'Shane's excuse to Winston was that he had promised her not to tell on her for a week. And Birkenhead is fulminating. I suppose he thought that the honour of doing his head would so excite her that he could do what he wished with her. It serves Winston right for holding the candle. I supposed it amused him to hear F.E. teasing Clare, it's so easy to make her turn pink and argumentative.'

Shane and Oswald conferred in Clare's studio. 'We had a most merry time looking on the humorous side of Puss's escapade.' But old Moreton was not feeling merry. He wrote to Shane:

. . . Now a word about your indiscreet oath to give her a week's start. Is an oath of that kind binding? . . . And after a scene with Winston you divulge at dinner to the three worst women gossips in town that she had not started for Stockholm to sculpt the Crown Prince but with Kamenev to see Lenin in Moscow . . . Depend upon it that is why Winston is so angry with you. Had *you* said to him privately, 'I am released from my oath,' *you*, by a cipher message through the F.O. could have stopped her in Stockholm – then we had saved a daughter and a scandal!

Unfortunately, Shane could not resist turning it into a funny story so that Jennie wrote to Leonie: 'Can't you tell Shane to keep his mouth shut. He goes around holding dinner tables with his own special account – making a joke of everyone except himself in the telling. I can't get hold of him. He's *your* son. Restrain him.'

Oswald also began to see the comic side of this expansion of his sister's career, and wrote it up each day in his diary. He had to open Clare's mail and found it somewhat embarrassing to find a letter from Princess Pat asking for snaps. How could he answer, 'Here are the snaps, I opened your letter in Clare's absence as she is on a visit to Trotsky's sister'?

Just before the Private View at Agnew's, a charming letter to Clare arrived from H.R.H. the Duke of Connaught saying how nice it would be to see her and for her to drop a line to Clarence House to say if 3 p.m. would suit. Oswald took up his pen and began: 'May it please your Royal Highness, my sister Clare has not yet returned from abroad . . .'

On 12 October Leonie and Jennie took up battle stations for the Private View. Whatever the rumours, London Society would *not* be permitted to see the family in confusion. In their newest hats, with the coolest of smiles, they dodged questions and parried the thrust direct. The loyal old Duke of Connaught arrived on foot, 'amiable to all and apologising for wearing a bowler'. The gossips, bursting with curiosity, tried in vain to penetrate the aunts' veneer. Lady Wavertree (Wilfred's sister) stood beside Oswald beaming and smiling, occasionally hissing at him (for she disliked Clare), 'Of course I fight her battles for her.' Never was there such a Private View – no one looked at the sculpture – although the bronze of Birkenhead's lovely daughter, entitled 'Lady Eleanor Smith as a Baccante', aroused comment. In the evening the throngs had to depart still choking with the questions they dared not ask.

The story had got afloat that Shane had been seen pocketing the Imperial Crown Jewels when he saw Clare off at St Pancras – she having just conjured them out of the Soviet Trade Delegation. And Mrs Johnson in her own little home fulminated before her daughter, crying out, 'These are no gentlemen – had I only been with her she would never have gone – now she is finished . . . finished!'

14

Duet with Trotsky

MEANWHILE Clare was growing increasingly chilly and restless in the Moscow guest-house. This was a requisitioned mansion on the Sofiskaya Embankment which lay behind elegant wrought-iron gates guarded by a sentry wrapped in furs.* From her bedroom, lined with green damask, she could watch the sun setting romantically behind the Kremlin, but the atmosphere was that of a boarding school. The inmates consisted of commissars on the move and a handful of foreigners on official missions. For breakfast they had chicory coffee and black bread; for lunch and dinner, cabbage soup and boiled rice with occasionally a few lumps of 'irredescent [sic] meat', but tea from the samovar was available at all hours.

Clare had a huge marble bathroom all to herself and there was hot water promised once a week. In the evenings she and various other foreigners were driven to the opera or ballet. She watched the faces of the working-class people who wore shawls and cloth caps, gaping in the red and gold Imperial setting. The productions were superb and the audience ceased munching apples and listened in wrapt silence when the curtain went up. Clare tried to discover how this proletarian audience was chosen out of millions but no one could tell her. To Shane she wrote of the appalling aroma of 'the great unwashed but it is only fair to observe there is no soap in the country'.

After several days of inactivity. Clare took to long walks through the dismal Moscow streets. Once she was taken to see an art school. A young student told her in French, 'We are expected to work here from 9 a.m. until 6 p.m. without food,' and another woman whispered,

*It is now the British Embassy.

'Madame, we are waiting for deliverance. When will this nightmare end?'

Clare's heart had started to sink, when Kamenev phoned to say he had arranged for a studio for her in the Kremlin, and she would be given a pass enabling her to go in and out at will. On arrival at the fortress she found a large, white-washed room placed at her disposal. It had no furniture except a gilt Louis XVI sofa carried in for her by soldiers. They also brought sackfuls of dry clay to her door and this she started to break up with a crowbar. She did not pound for very long. Accustomed as the Russians were to the sight of women doing hard labour, this spectacular lady smashing up earth in the corridor was too much. A carpenter was delegated to pound, water and stir the lumps into the necessary consistency.

Zinoviev* was Clare's first sitter. Then came Dzerzhinsky, Head of the Tcheka (the Red Terror). This man, feared and hated above any other in Russia, looked a pale, sickly little fellow. He coughed incessantly, but could converse softly in German. While Clare calculated the planes of his face, he explained that eleven years in prison had ruined his health. His meek manners and platitudes covered the intensity of a fanatic. That astute judge of men, Lenin, had selected him for the most inhuman job of a heartless régime. Through his Secret Police he was really chief executioner and chief torturer of millions. Clare did not realize this at the time; she was viewing all the Bolshevik leaders through rosy spectacles, but in Dzerzhinsky's presence she felt 'strange vibrations'.

When, shortly after Dzerzhinsky's departure, Zinoviev arrived for more sittings, she found his presence almost unendurable. He exhaled a vulgarity and coarseness, whereas Dzerzhinsky seemed to be an ascetic encircled by waves of evil. At the time Clare wisely kept these impressions to herself.

H. G. Wells arrived in the guest-house for a couple of days and, after meeting Lenin, he mocked her for hoping to sculpt the Leader. H.G., who was greedy, deplored the guest-house menu, and although a serious Socialist, which Clare was not, he complained that the streets with shuttered shops and tired, sick-looking people shuffling along depressed him.

'At least there are no false values here,' Clare riposted. She told him about Wilfred and the long years she had waited to marry. 'Wilfred

*President of the Third International.

said that in the early days he kept a little typist as mistress. She cared more for him than the great ladies who sought him for his good looks. Think of it – Wilfred could afford to live with the typist but not with me whom he loved. And I, who loved him, had to break my heart while hundreds of pounds were spent on clothes and non-essentials which might have been spent on teaching me to earn.'

H.G., who had endured a tough, proletarian upbringing, could not understand her resentment. 'You married him in the end – '

'Too late,' sighed Clare. 'We should have had ten years together not five.'

'Well, let's hope there's more than cabbage soup for dinner tonight,' muttered Wells unsympathetically. She was glad when he cleared out.

Her walks from the guest-house grew gloomier with the increasing cold. To Shane she wrote, 'If one were not so conscious of the titanic substratum efforts one could mistake the apparent calm for dullness.' Starvation does make people dull.

H. G. Wells had just departed with a final sneer, 'You'll find Lenin has no time for your sort', when the guest-house commandant received orders that Madame Sheridan was to proceed each day to the Kremlin and execute a bust of the Russian Leader. She could not sleep from excitement.

Next morning she was driven to a Kremlin side-door guarded by sentries, then taken upstairs, along passages, past more guarded doors, and through several rooms of scribbling staff. Lenin's private secretary, a hunchback girl, pointed to a white baize door swinging to and fro without any latch. Clare pushed it open and found herself standing in front of a huge desk littered with papers.

The man working at it did not look up for a moment. Then he ceased writing, rose to his feet and walked over to shake hands. Clare became aware of the extraordinary proportions of his head. The huge brow made it appear too big for his body and the small deep-set eyes seemed to focus not on but beyond her. Lenin's smile was pleasant enough. He spoke in English: 'I have no interest in art, but you can work here as long as you don't disturb me. Eleven till four are my hours.' His relaxed manner put her at ease. He might have been the host in an English country house – politely explaining to a local amateur that he had to attend to the running of his estate while she sketched him.

Three soldiers struggled into the room carrying her stand and the

[118]

clay. The room was peaceful. Lenin settled down to his papers. Clare recorded:

. . . Even as I walked around him in circles measuring him with calipers from ear to nose, I did not seem to arouse in him any consciousness of my presence. He was immediately and completely detached, concentrated and absorbed. I worked until a quarter to four, which is the longest I have ever done at a stretch. During that time he never ate nor drank nor smoked, nor did I stop for a rest or food . . . He had but one interview, but the telephone was of great assistance to me. When the low buzz, accompanied by the lighting of a small electric bulb, signified a telephone call, his face lost the dullness of repose and became animated and interesting. He gesticulated to the telephone as though it understood.

I remarked on the comparative stillness of the room, and he laughed. 'Wait till there is a political discussion,' he said.

At intervals secretaries entered with letters. Clare's efforts to start a conversation met with no encouragement, so she concentrated on her modelling until she was so tired that she had to retreat to the window seat for rest. He knew she was Winston Churchill's cousin. Why had he admitted her? Did he find the situation piquant? He had nothing to say to her. When she plucked up courage to ask if he had any news from England, he handed her some copies of the *Daily Herald*, the Socialist newspaper.

By four o'clock Clare felt faint with weariness and hunger and she was glad to get back to the guest-house. Dinner was not served until nine, but tea could always be had from the samovar. That night when she sat down wearily, an American who was awaiting some mining concession talked to her. 'Make Lenin tell you things and write down what he says. History will thank you.' She explained that he liked silence.

Each day Lenin greeted her in the same distant polite fashion. Then he retreated into his own world – the world he was forging for the future. The hours passed in silence. Clare might have been an artisan engaged to paint the walls or mend the floor. She began to feel the same extraordinary terrifying waves of hatred blowing as when in Dzerzhinsky's presence. Suddenly Lenin looked up and saw her, as if for the first time. He walked over to the bust and smiled, while interrogating her.

'What does your husband think about your coming to Russia?'
'He was killed in the war.'
'Which war?'
'In France.'

'Ah yes – of course.' Lenin nodded. 'I was forgetting you English have only had one war. We have had the Imperialist War, the Capitalist War, the Civil War and now our wars of self-defence. How futile and heroic was England in 1914 – why did she enter?'

Clare had often wondered that herself. 'I don't know,' she replied.

'Are you based in London? How many hours do you work?'

'An average of seven.'

Then came a pause.

'Your cousin, Monsieur Churchill, he must be pleased with you!'

'Is he hated in Russia?'

'He is our greatest enemy. All the force of your Court and your Army lie behind him.'

'He is Minister for War, but the Court has very little power in England.'

Lenin knew of King George V's bitter hatred of the Bolsheviks who had murdered his cousin the Tsar and his family at Ekaterinburg.

'It is a pose to say the King does not count. He counts very much. He is the head of the Army, and he is the bourgeois figurehead. Churchill is backed by him.'

Then, as a concession, Lenin agreed to spend fifteen minutes on the revolving stand. Clare saw that once she got him talking about Churchill and the King, he forgot the time. Half an hour passed with only the telephone interrupting. Then, 'I'm sorry,' he would say, and return to his perch.

When the portrait was finished Lenin asked his girl secretary's opinion. 'Karasho – it is good,' she said. Clare shook hands and said good-bye. She noticed that although Lenin smiled he was not looking at her. 'I like a fast worker,' was all he said, and turned back to his desk.

Soldiers arrived to carry the bust and heavy stand away to her studio, 'Room 31'. She followed after the panting men through rooms of astonished secretaries, out into corridors, past sentries and through to the main building. Two or three times the soldiers had to pause and deposit Lenin's head on the floor. They were dripping with sweat when they arrived. Clare offered them several handfuls of the paper notes which Kamenev had doled out to her. They smiled, refused and pointed to their Communist badges, then offered her, touchingly, their own precious rationed cigarettes.

Clare maddened most women but to men, especially strong men who could carry out tasks useful to her, she had immense appeal and

her sense of drama delighted them. When Kamenev asked her to write a list of things she needed before he went off on a tour, she solemnly listed:

> Caviare
> A fur coat
> Trotsky
> A young soldier of the Red Army.

The last two were, of course, to be put on the revolving stand and sculpted! Kamenev had said he could induce Trotsky to sit when he returned from the Crimea, but the War Minister had bluntly refused.

Clare imagined that the Soviet government would purchase these busts after they had been cast in bronze in England. She had signed no contract, made no monetary arrangement. Money bored her. Here, where it could buy nothing, she found it agreeable to dispense with all thoughts of that vulgar commodity. It would be nice if they gave her the £1000 vaguely mentioned but it was recognition not lucre that she desired. She liked being housed and fed and transported free. That was an artist's due. But black bread and cabbage soup were getting monotonous, and the weekly hot bath water had proved a myth.

Shane, who was sending and receiving letters through the 'Soviet Office' in London, smiled at her plaints.

On 11 October she wrote:

Not one word of news, either by letter or telegram since I left a month ago. Yesterday Kamenev sent a wire to you for me – asking for news of the children. . . . This week I did Lenin, spent eight hours in his office. It *was* interesting! I told him about you – he thinks we are funny sort of cousins for Winston to have! I have done Dzerzhinsky, the President of the Extraordinary Commission, and Zinoviev, President of the Petrograd Soviet, and I'm waiting for Trotsky to get back from the front. . . . Am also going to do a typical soldier of the Red Army, and a peasant . . . H. G. Wells has just been but everyone agreed that in his lightning trip he can have learnt nothing, and has absorbed none of the atmosphere. The courage, and the calm grim determination written on the face of the people in the street is beyond everything inspiring.

More inspiring, maybe, to those able to leave Russia, than to those caught in her tentacles of misery!

Soon she was grumbling to Shane that no cobblers existed to mend her shoes and she had to wear her travelling rug around her shoulders like a peasant shawl because her coat did not keep out the biting autumn winds. Kamenev sent her a large sheep-skin hat but that only kept her head warm. Curiously, this outfit, the fur hat and thin coat,

seemed to embarrass the commissars. Kamenev told her that although artists were not 'paid' in the Soviet Union, she was to receive a 'useful reward'. Gleefully she wrote to Shane: 'My own cloth coat lets me freeze. Snow is lying on the ground! Tomorrow I am to be given a fur coat from the Government Store: it is a great excitement.'

But on 14 October, Borodin, one of the Communist 'diplomats' lodging at the guest-house prior to posting, found Clare in tears, and shivering with cold. Borodin asked what the trouble was. She had heard that a courier had arrived from London and she could not go out to see if there were letters for her because she had not been given the promised fur coat. Borodin wrapped his own furs around her, descended into the garden shed and carried up a load of wood and himself lit a fire.

Next day two Commissars were delegated to take Clare by car to a requisitioned fur store. The seals of the storage room were broken and she was told to enter and make her choice. She longed for one of the glamorous Russian shubas – velvet cloaks lined with sable or mink – but even Clare had to realize that an Artist of the People could hardly walk the streets of starving Moscow, or bun-fed London for that matter, wearing such a garment. Seeing her hesitate, the Commissars suggested that she choose several furs – Siberian ponyskin for everyday, a mink coat, a black sable cloak, and a wide ermine stole. Having made her selection, Clare inquired, 'Whom do I thank?' A tiny wizened old man in charge of the store rattled off his speech in German. 'You can thank me but it is not necessary. You have shared in the government distribution of bourgeois property to the people.' Had she been given furs confiscated from private people? Clare felt a guilty twinge, but no, these furs came from a store. 'A share in the government distribution' seemed quite justifiable.

While awaiting Trotsky's return she asked her Commissar guard, Comrade Alexandre, to produce a typical Russian soldier to be modelled. 'Not feeling brave enough to go and review a platoon and make my own selection I described exactly what I wanted.' But, to her annoyance, instead of the splendid Slav she expected, an ashen-faced little rat of a man with a waxed moustache appeared. She stood him on a stand and tried to work out quite a different face – a product of her imagination. Then Litvinov* arrived in the guest-house and said he had induced Trotsky to sit for her. As with Lenin, Clare would

*As Head of Foreign Affairs, he would become well known in the West.

be permitted to model while he worked at his desk. Once again she could not sleep for excitement. Next morning a car fetched her to the War Ministry. Trotsky's secretaries were all soldiers and armed sentries stood at every door. She walked past a line of fixed bayonets to be shown into a large ballroom with white columns. Trotsky stood up to receive her. He was formal and unsmiling.

'Anything can be moved as you wish,' he said in French. Clare explained that she would prefer to drag her own stand around trying various lights. She found the place that suited her best and started work. Soon she had forgotten everything. As the light moved, she moved her stand. An hour or so had passed when she realized that Trotsky's foxy little eyes were watching her with interest.

'Even in clay I have to travel – and I am so tired!' he laughed. She saw that he was very different from the impersonal Lenin. 'Aren't you cold? A fire would be nice?' A peasant woman answered the bell. He watched her intently just as he had watched Clare. 'I often ring for a fire just because I like this woman to come into the room. She walks softly and has such a musical voice.'

Then he started to write and Clare had to kneel down at the other end of the desk to catch his features on a level. She had been so accustomed to the indifference of Lenin and indeed all the other Soviet personalities, that it never struck her as peculiar to rest her chin on the table. Trotsky suddenly looked up and found her staring at him. His gaze met hers and remained fixed. 'I hope my ways of looking do not disturb you,' she apologized. His eyes sparkled. 'I do not mind. I have my revenge in looking back at you. And it is *I* who am the winner!'

Such compliments made her uncomfortable. Comrades were easier to sculpt when they did not converse. Rising, she asked permission to measure his face with calipers. 'So you wish to carve me with steel?' He became flirtatious. It was most distracting.

After four hours she had not made much headway, chiefly owing to the bad light. Trotsky walked over to her. 'You look tired,' he said. 'Stop working now. We will have tea and tomorrow you must come in the evening and see if it is easier to work by electric light.'

Clare thought this might be a good idea. She was thrilled by his strange pointed face, piercing gaze and magnetic personality – she wanted to catch something of the fire which made him so popular with the Red Army.

From then on the War Ministry car arrived to fetch her each evening

at 6.30. One night during an early snowstorm it punctured. The car carried a hood but no method existed of closing the sides and when Clare reached Trotsky's room she was half frozen. 'I can't work for a bit,' she said, 'my fingers won't move. I had to sit for half an hour in that open car while they changed the wheel.'

Trotsky kissed her frozen hands and led her to the fire. 'To make up, I promise to stand by the side of your clay for five minutes every half hour.' He was charming and considerate. The five minutes grew ever longer. Occasionally the telephone rang. He would not move for a moment, then, 'Have I your permission?' he would say, and walk off to issue orders in Russian. Then he would return contritely to the modelling stand. '*Je veux travailler cela avec vous*,' he said. 'I never mean to allow any other sculptor to do me . . . ' And his bright little eyes watched her joyously. 'Even when your teeth are clenched and you are fighting with your work *vous êtes encore femme*.'

So it went on. Every night for a week Clare worked from seven till midnight. Trotsky spent less and less time at his desk, more and more beside his bust watching Clare as if trying to memorize her face. In her diary she wrote:

I could walk around Lenin and look at him from all sides, he remained absorbed in his reading, and apparently oblivious of my presence. Whenever I go near Trotsky he looks up from his work, sharply, with piercing eyes, and I forget which part of his face I am intent on.'

They disturbed each other. When he sat at his desk reading and she tiptoed around behind him he would suddenly turn down his papers, get up, put his arms around her and stand beside the clay critically watching every stroke and making her feel nervous.

I undid, and did it over again. The room was hot, and the clay got dry . . . Never had I known anyone so difficult. He is subtle and irregular . . . When I asked him what he thought, he stood in silence with a suppressed smile before he let himself go. 'It looks like a French bourgeois who admires the woman who is doing him, it has no connection with Communism!'
'Don't you like it?'
'I like *you*,' he parried.

When she was too tired to go on modelling, she would find herself led to the fire and her feet placed on a low chair. Then Trotsky would sit beside her and talk and talk. He told her about his own early life and of how he hated the British for arresting him on a neutral ship when

he left America for Russia at the beginning of the war. 'But in that Canadian prison camp I did propaganda – and *you* if *you* – can't see through the suffering of this great birth that Russia is undergoing – if you vilify us back in England I will follow and cut your throat . . .'

'I want to see more of Russia,' said Clare. 'What have I seen but Moscow? I want to go to the front.' Trotsky thought a moment. 'You can come with me. I return there next week. Wrangel is falling back. The war is nearly over.' One night they talked until after the midnight curfew. Trotsky himself offered to accompany her in case of trouble. They left the War Ministry long after midnight with an armed guard. On the bridge over the Neva a group of soldiers stopped the car. They demanded its permit and slowly handed it from one to the other. 'I don't think they can read – why don't you say who you are?' whispered Clare.

'*Taisez-vous*,' snapped Trotsky, and afterwards she realized that he had been afraid. The armed sentry at the guest-house gates let them pass without recognizing more than an official car. 'May I see your room?' asked Trotsky. She couldn't resist taking him upstairs. How shocked everyone would be if they knew – not only her own friends in England, but all Russia. The wood fire was not quite out and sha-dows flickered on the damask-covered walls of the big room that had been decorated for a merchant prince long-fled, or dead. 'A woman like you,' said Trotsky, 'could be a whole world to a man.'

During the long undisturbed evenings in the dusty ballroom Clare began to feel Trotsky's passion was helping his portrayal. He was a difficult subject. Trotsky resembled no other man; he looked like a caricature of himself. His expressions changed continually. His eyes lit up and flashed. He seemed highly strung and always on edge. During their last evening the electric light failed. They sat talking for a time by candlelight and then Clare walked over to her clay and stood back looking at it. 'It's finished,' she said, 'what do you think of it – it *is* finished; isn't it?'

'Yes,' he said, 'the head is finished – but is everything finished?'

'I will tell them in England how nice you are.'

He was very close now. 'Tell them' he whispered, 'that when Trotsky kisses he does not bite.'

She realized that he was mad about her, and, strangely for Clare, she was afraid. She did not find him unattractive. He was so quick-witted and sensitive. But she felt the danger of the situation. It was all

the more dangerous because she really liked Trotsky and really wanted to go to southern Russia with him.

'I'll ring up Litvinov about you,' he exclaimed suddenly. 'If you were an enemy agent I would have to shoot you myself – and then shoot myself – wouldn't I?' Perhaps he wanted to be certain of her from the security point of view, but surely the Bolsheviks could not be suscpicious of a woman so completely lacking in guile.

'Well?' she asked, after he had spoken to Kamenev on the phone. 'Do I see the Crimea?'

Trotsky put his arms around her. '*C'est à vous de décider*,' he said. 'Do come with me. Do come with me!' He kissed her passionately before leading her to the door. There, he stood a long time just staring. 'Whatever happens, I will keep the memory – of a woman with a golden halo of hair and hands covered with clay. But tell me – do we leave together tomorrow?'

Clare half-nodded. Then she turned and walked away passing the sentries with fixed bayonets, and followed by the curious gaze of the military staff. She wanted to go, but she did not dare.

15
Moscow and Mayfair

AFTER Trotsky departed a feeling of flatness smote Clare. He had wanted her to do a bust of Chicherin, Commissar for Foreign Affairs,★ but when she reached the Foreign Office, formerly the luxurious Hotel Metropole, the smell of drains was so horrible that she had to hold her nose while mounting the stairs two at a time. Chicherin, a strange little man suffering various neuroses, seldom left his rooms at the Foreign Office – he slept there, never took exercise, never opened the windows, and presumably seldom approached the stinking staircase which housed the sewer. He slept in the daytime and kept his unhappy secretary working all through the night. After one frightened glance at Clare he cried, 'It is impossible – impossible.' Later, a messenger reached the guest-house asking if she would like to start work at four the next morning, Chicherin's 'quietest time'. She sent back word that unfortunately it was *her* quietest time too, and regretfully she was leaving Moscow.

But this was easier said than done. Kamenev had taken her passport and gone off on one of his tours. Litvinov seemed reluctant to help and quizzed her about English friends whom he called spies. Clare began to grow uncomfortable. Her work was finished. Winter was falling.

She put in time visiting museums and exploring interesting corners of the Kremlin. Litvinov remarked caustically, 'You walk in there as if you owned it.' As a diversion she attended the funeral of John Reed, the American Communist who had, soon after meeting Clare, died of

★He was one of the few Bolsheviks who had been a Foreign Office official in Tsarist days.

typhus. He was given the full Bolshevik hero treatment with red banners and masses of wreaths, made, to Clare's disgust, of *tin* flowers. Clare thought it all dismal.

There were speeches in English, French, German and Russian. It took a very long time and wet snow was falling. Although the poor widow fainted, her friends did not take her away . . . The faces of the crowd betrayed neither sympathy nor interest . . . Russia seems numb. I wonder if it has always been so and whether the people have lived through years of such horror that they have become insensible to pain.

The guest-house grew more like a polite prison. She longed to see her children – and, it was long past time for a shampoo! When Kamenev returned from his travels – a month's beard hiding his prim little face – he informed her that within a week she would be permitted to depart by a special train taking the Director of Railways and a large consignment of gold to Germany to purchase locomotives. The plaster casts which had been made of her work would accompany her packed in special cases. There seemed to be no foundry in Russia. When the busts had been cast in bronze at her London foundry – or, in the case of Lenin, copied in marble – then Krassin, who was still attached to the Trade Delegation, would pay for this work and return the busts to Russia. She could, of course, have copies made for herself if she wished.

Clare, at this juncture, was disdainful of money gain. Artists ought not to be bothered with finance, she said; they only needed to be housed and honoured and fed (but not entirely on cabbage soup). She did not, however, quibble when Litvinov wrote out a cheque for £1000 for which she had to sign a receipt to the All Russian Central Executive Committee of Soviets. Then Kamenev handed her back the £100 in notes she had been given by an English friend of Shane's before leaving London. There was an odd glint in his eye when he did so, then looking out of the window he remarked coldly, 'The only thing we cannot stand is espionage.' Once again a little frisson of fear at what lay outside the charmed Kremlin circle touched her spine.

On 6 November she finally departed. She distributed most of her belongings to the maids in the guest-house; her soap, hot water-bottle, shoes, galoshes and one hat made splendid gifts. They kissed her hands and wept. On reaching the station Clare learnt that the plaster busts in their coffin-shaped crates were still in the Kremlin. A lorry had waited three hours to get in but the sentries had refused entry. Litvinov pushed her on the train and promised he would see the crates caught the boat from Reval. This 'special train' which was carrying millions in

gold kept breaking down, but Clare had a luxurious sleeper and, with two suitcases of sable and mink beside her, she left Russia quite contented.*

In Reval the British Consul lent her his bathroom 'for an hour and a half', and the crates reached the ship as Litvinov had promised. After three days of storms the ship reached Stockholm. Clare, and the Minister for Railways, were searched – not for arms as she expected, but for *lice*. Then Clare found herself taken to the Hotel Anglais where a new experience awaited her – one for which she was ill prepared.

The place was absolutely packed with reporters, and they were all waiting for *her*! They even entered her room without knocking. To Shane she wrote: 'I am so ignorant of the papers they represent that I say all the wrong things. One Conservative paper says that I declared Trotsky to be "a perfect gentleman". Never would I use so mediocre a description for Trotsky. I might call him a genius, a superman or a devil . . . ' Whether the 'perfect gentleman' assessment reached the Kremlin remains unknown but it appeared in headlines in London. Gentlemen who considered themselves gentlemen took fearful umbrage. What Clare meant, of course, was that Trotsky had good manners. She stopped short of deeper explanation.

Having babbled indiscreetly to flocks of reporters who cabled their stories to every country in Europe, she rang up the Palace. As the Crown Prince was in Rome she went to tea with his children in their nursery. 'Princess Ingrid looked sad, big-eyed and rather pale. The baby, Johnny, is adorable . . . one feels the maternal spirit arms round him.' It was a great surprise to Clare when the Comptroller of the Queen's Household, an old friend made in the days of girlhood visits, bade her farewell coldly, saying that he could not share her views about her recent hosts.

On 23 November her ship reached Newcastle, and she was besieged afresh by reporters. Cameras flashed and interviewers rushed their stories off by telephone. *The Times* representative handed her a letter from Shane, and begged her *not* to divulge interesting material to any other papers. Clare was glad to creep into her sleeper and pull down the blinds. She had thought that the feat of reaching Moscow and sculpting

*Most of Clare's Russian friends, luckily for themselves, died before Stalin came to power. Kamenev was executed in 1936 after a horrific trial during which he made incredible confessions, probably due to drugs or torture. Trotsky was assassinated by one of Stalin's agents in Mexico City in 1940.

the Bolshevik leaders would bring her great fame. She never dreamed it would also bring disparagement. Winston had, in his youth, seized *every* opportunity to make *himself* famous – he had told her so himself – how he deliberately rode a grey horse in dangerous open positions to catch the general's eye – how he used the full dramatics of his escape from the Boers to get into parliament. She thought that now he would be pleased with her. It was perhaps unfortunate that *her* bid for fame had materialized through those Bolsheviks he had sought to exterminate, but one had to snatch every chance, and it was more difficult for a woman.

Shane had sent a letter of sound advice, and this she re-read in her sleeper:

I am negotiating privately with *The Times* to take your story, which, with a little literary camouflage should be the best story out. We are sick of Mrs Asquith. I am afraid it would be difficult to give your busts of the Red Leaders a good exhibition unless you loaned or sold them to Mme Tussauds. You say you wish the common people and not Society to see them. Well, Mme Tussauds is the only place where you could exhibit them profitably and safely today . . . Do stick to Art and Literature and leave Politics . . . and say nothing about poor Winston. Lloyd George chaffs him terribly in the Cabinet about you, and he has threatened to put you into quarantine when you return. So tread delicately and print nothing that has not passed over my typewriter. – Shane. P.S. If you take my advice I may recover caste with the family! There are only three people who will never forgive you, 1) your father, 2) The Lord Chancellor [Lord Birkenhead], 3) Eddie Marsh [Winston's Secretary].

No sooner had Clare reached her studio than Shane appeared and insisted that her diaries should be given to *The Times* alone, for prestige reasons. The *New York Times* would syndicate them.

Oswald's diary takes up the story from early morning on 20 November: 'The telephone rang incessantly with pressmen, and Puss gave her best interview. *The Times* gave her £500 for the first instalment. We still tried to sell exclusive photo rights, also got her to sign about £400 of most pressing bills.'

How tiresome it was to return to the world of bills and overdrafts. Life without money grew pleasanter in retrospect. Clare forgot her hunger, the cold, the abysmal dullness. Her articles occupied a full column of the editorial page of *The Times* for a week. She enjoyed seeing the placards – 'With Lenin and Trotsky. Diary of an Englishwoman'. How innocently she revelled in her new-found fame – 'All the city clerks read it in the omnibuses and the Tube on their way to work. I boarded both during the "rush" hours to watch them doing it!'

In this blaze of euphoria and the bliss of meeting her children once again, Clare did not fully comprehend the indignation that she had aroused among the very people who had previously been ready to give her commissions. Winston did not wish to speak to her – which was natural, for she had greatly embarrassed him. And the Royal Family could not condone a visit to the murderers of their relatives. London Society now dubbed her 'a traitor to her class'. Oswald's diary recorded succinctly: 'The Lord Chancellor is wroth and most of her former friends shocked to the core. Puss amazed!'

The aunts, who opened their arms cautiously, when they got her alone behind closed doors dealt out severe scoldings, but Jennie was inclined to burst into laughter while telling her off, and finally admitted: 'You're so like me really – I would have loved to do it in your place.'

Two days after her arrival Oswald escorted her to lunch at Jennie's house in Westbourne Street. Leonie was the other guest.

The aunts relieved each other alternately at blackguarding the Bolshies and soothing Puss. Puss is really very good. She has come under the influence of what are obviously very magnetic men, whatever else they may be, and very prominent too – she's *so* easily attracted to the latest causes and always so drawn to the prominent, but she doesn't preach Bolshevism, she will just tell you what happened, without ramming of tenets down your throat, unless you interject (as the aunts did) 'That vile creature' or 'the horrible assassins' etc. *Then* she gets pink and restive and says, 'Oh, all right, I won't argue. *I* don't talk politics. I won't talk any more . . .' Then the appropriate aunt pacifies her and starts her off again, and then interjects more abuse, or worse still sarcasm and the *other* aunt has to do all the pacifying!! It was highly electrical and the vastnesses of Russia must have had a very beneficial effect on Puss' nerves or there would have been an explosion.

If a family meal with those who loved Clare dearly could be like this, it was unwise to launch the returned traveller into the thunderstorm of Society. And yet a lot of people were dying to meet her and express their horror. One of Leonie's deliciously astringent letters gives a description of Jennie 'grooming Clare for the paddock'.

'Now darling *we* understand and *we* love you but do imagine what other people feel. One just doesn't *think* of Bolsheviks as lovers –'

'But they weren't. I didn't,' from Clare.

'Of course not. How could you! How could *one*. How could anybody. Oh those terrible little beards and dripping with blood . . .'

'The beards . . .?'

'No, their hands, their souls, those massacres. And your foolish, foolish words about

that terrible one – the worst of all – with the pince nez. Unbelievable how any man could machine-gun millions with a pince nez . . .'

Clare bridled. 'Do you mean Trotsky?'

'Yes, my dear. Of course I *knew* there was nothing in it but why tell reporters he was gentlemanly?'

'I said he had good manners.'

'No man with a pince nez who kills millions could have *good* manners. Rivers of blood and shooting down the Tsar *is* bad manners. . . .'

And so it went on until Clare accepted the invitation to a ball given by Lady Islington. Anne Islington, one of the most original hostesses of pre-war days, was a close friend of Leonie's. She entertained brilliantly and prided herself on drawing unusual people to her house. In the last months Clare had made herself very unusual indeed.

Shane accompanied his spectacular cousin and very lovely she looked in a golden ball gown and that black sable cloak. (Sometimes Clare had no sense of the ridiculous.) Anne Islington watched her mischievously. As Clare entered the door, Lady Lonsdale, who had often had her to stay in the past, remarked tartly, 'Ah! The Bolshevik!' and turned her back. Clare had not expected this and she felt crushed. She looked beseechingly at Shane who promptly introduced her to the Grand Duke Dmitri: 'I think that Mrs Sheridan's adventures might interest you.'

The Grand Duke's manners were even better than Trotsky's. He asked her to waltz and then led her to a sofa where they sat out several dances. He was genuinely interested in her description of his unhappy country. Eyes were focussed on them. Anne Islington's ball was even more 'interesting' than usual! But Clare could not face any more parties. If London Society scorned her, she would scorn it. She accepted Jennie's scoldings because '. . . to the world she adopted a loyal defence of me, her attitude being that she could abuse me if she wished, but nobody else should'. For the rest, she would have nothing more to do with Society – except to sell off the sables when she was tired of wearing them.

Shane's wife Marjorie came to the rescue in due course. She knew a lady of high estate but questionable virtue whose eyes had brightened at the description of Clare's furs. This person was invited to Aunt Jennie's house and there a transaction was carried out with myself, the author aged six, listening in on these extraordinary grown-ups. 'But they probably belonged to one of my murdered friends,' said

Clare with Dick and
Margaret.

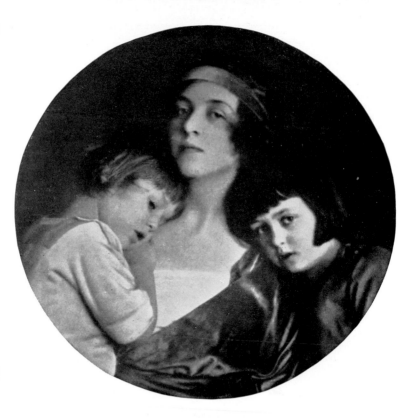

Proud Mamas:
Princess Margaret of
Sweden with Prince
Bertil; Clare with
Margaret.

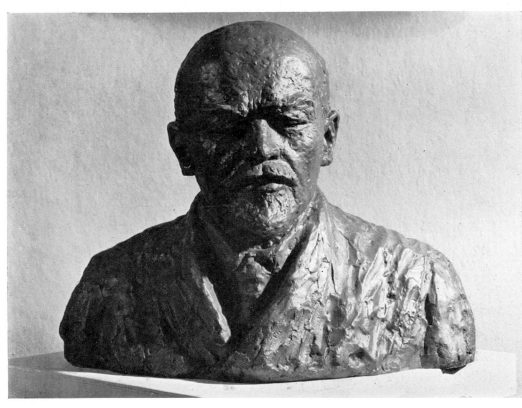

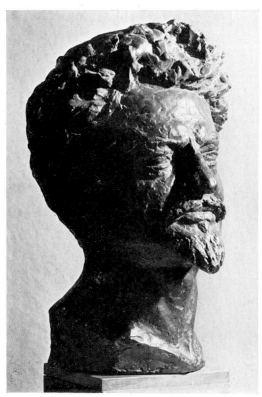

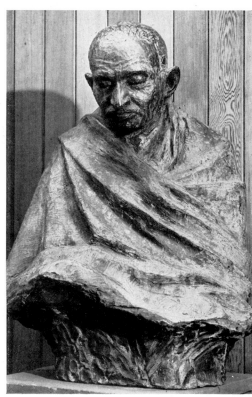

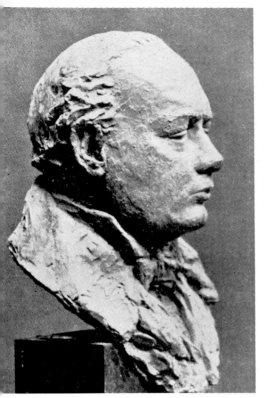

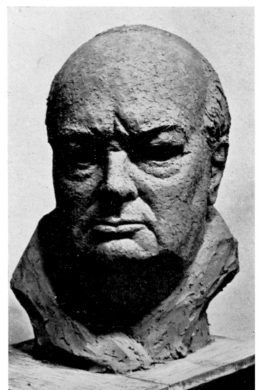

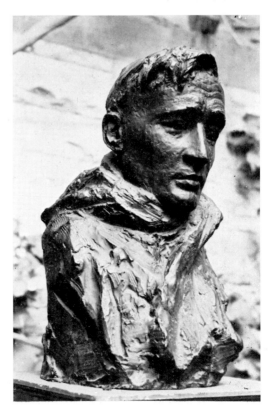

Bronzes by Clare Sheridan.

Top left: Lenin. *Below far left:* Trotsky. *Left:* Gandhi. *Above:* Winston Churchill (1920 and 1942). *Right:* Shane Leslie.

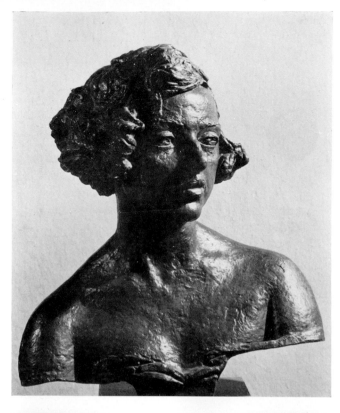

Clare by Epstein.

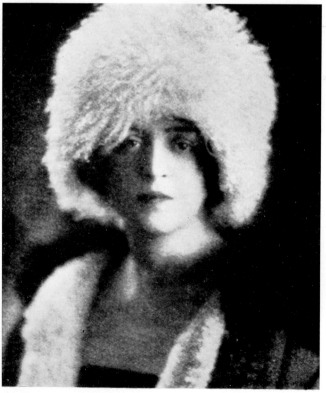

Clare in her Bolshevik
fur hat.

Leonie when the buyer had gone. 'Impossible,' Clare insisted. 'They came from a warehouse and in Russia artists are given sables instead of money.'

Meanwhile, Clare continued to entertain Krassin, whose Slav features had originally led her to the Soviet Delegation, and various Labour leaders in her studio. She did a head of George Lansbury, but no other commissions came her way, and when the fur sale money ran out, and she had arranged for Krassin to fetch the bronze heads of Lenin and Trotsky from the foundry for transport back to Russia, she felt it time to leave sticky old London and 'go somewhere I'm wanted'.

The obvious place was America, her mother's country, where the Russian articles published by the *New York Times* had made a stir. Wilfred's sister, Lady Wavertree, wished to keep Margaret during Clare's absence. The child had to be operated on for appendicitis a week before Clare sailed, and then at the last moment the American Embassy refused her a visa. Clare threw hysterics. She didn't want to leave because of Margaret, but she had agreed to a lecture tour in the States. Was it possible that because of her trip to Russia she should find America banned? Aunt Jennie immediately intervened, but the United States Consul remained politely adamant. Jennie then went to the Ambassador who sent minions scurrying. It was finally discovered that the British Foreign Office had a 'dossier' on Clare, and this it had shown to the American Consulate.

'A dossier about me? What does it say?' screamed Clare. 'Oh dear Aunt Jennie – help me! The *Aquitania* sails the day after tomorrow and my lecture dates are fixed . . .'

At this stage the Lady Randolph Churchill did not hesitate to indulge in name-dropping and Clare's 'dossier' was opened for her inspection. Apparently the detectives ordered to watch 3 St John's Wood Studios had reported long visits by Mr George Lansbury, a Socialist closely connected with the *Daily Herald*, reputedly subsidized by Moscow. Jennie telephoned Clare that she was having a personal interview to explain that Mr Lansbury was merely sitting for his bust, and not plotting revolutions. 'I did it beautifully,' she explained. 'The Foreign Office is satisfied and the American Consul himself will receive you.' Clare dressed herself with particular care, drove to the Consulate, and emerged with her visa. The Consul had admitted, 'You are not exactly my idea of a Bolshevik!'

That night, her last night in London, Clare dined at Jennie's house. It was a family party – Leonie, Shane and Marjorie came to wish her well in this new enterprise. Shane who had learned at Eton and Cambridge how to hold an audience in debate, told her that it hardly mattered what she said so long as she spoke clearly. Jennie passed on the advice Henry James had given *her* when, years before, she had contemplated a lecture tour in America – '. . . It doesn't matter what you say – they only want to *look* at you!' Clare became fussed. 'I don't really want to talk at all but the most enormous fees have been offered me – ' At midnight the Leslies drove her home. There were still preparations to make for the early start.

Next morning Clare reached Paddington Station in icy darkness. Her train left at 8 a.m. and to her amazement she saw Aunt Jennie waiting on the platform. She had got up in the raw cold of a January dawn to see Clare off. Her niece was deeply touched – it must have been hard for an older woman to make the effort. And she looked so beautiful that morning, and wistful. 'She put her arm through mine as we walked down the long platform and said, "Remember, if you are not happy come straight back. You have a powerful family who love you and we are all here to open our arms to you."'

Clare could not guess that she would never see Aunt Jennie again. Oswald travelled to the ship and promised that he would watch over Margaret in the Wavertrees' various establishments. In Oswald's diary that night he wrote: 'She has that utterly indefinable and unknowable "something" which makes everyone she comes in contact with *give* to her.' As the *Aquitania* slid out he watched his sister, a tall waving figure on the deck, wearing her Siberian ponyskin coat and a Cossack hat, five-year-old Dick clutched by one arm, and Louise, who came as nurse and maid, by the other.

Before England faded into the winter mist Clare settled herself to read Aunt Leonie's farewell letter:

You are wise dear thing to go off for a few months, but remember we all love you and want you back soon. Anne I[slington] secretly relished the incidents you caused at her ball but, of course, she won't say so and it is best to let people forget. I thought the Grand Duke was splendid. His heart must ache to hear about his country. Take my advice darling Clare on one line only try to be a little more *discreet*. It is quite permissible to *think* a man is wonderful in any way you like – but one does not *talk* about it. Don't let the Wavertrees hang on to Margaret too long – and remember that to Jennie and me you are very dear – our only niece – that is why we get so wrought up over you. One doesn't trouble except with people one really loves. And remember

also that you are the nearest thing to a sister that Winston ever had – and apart from the embarrassment you can cause him when your unusual doings are associated with his name – he can be deeply wounded. *So don't do that again.*

From Winston himself came a long letter which Clare regarded as 'a kind of peace treaty'.

<div style="text-align: right">

War Office,
Whitehall, s.w.1.
27.1.21.

</div>

Private
My dear Clare,

I do not feel that you have just cause to reproach me. You did not seek my advice about your going and I was not aware that you needed any on your return. Anyhow it was almost impossible for me to bring myself to meet you fresh from the society of those whom I regard as fiendish criminals. Having nothing to say to you that was pleasant, I thought it better to remain silent until a better time came.

But that does not at all mean that I have ceased to regard you with affection or to wish you most earnestly success and happiness in a right way.

While you were flushed with your adventure I did not feel you needed me: and frankly I thought I could not trust myself to see you. But no one has felt more sympathy or admiration for your gifts and exertion than I have, and I should be very sorry if you did not feel that I would do my best to help you in any way possible or that you did not count on my friendship and kinship. But note at the same time please that you have those other friends and have to train your words to suit their interests.

I hope your work in America will be successful and that you will come back in a few months with a healthy gap between you and an episode which may then have faded and to which we need neither of us ever refer.

<div style="text-align: right">

Your affectionate cousin,
Winston

</div>

16

Mexican interlude

CLARE landed at New York in what she aptly described as a state of 'spiritual unfitness'. She had steeled herself to deliver lectures in packed halls, but she could not abide driving around with the publisher of her forthcoming book, *Mayfair to Moscow*. The publicity manager showered her with advice on 'how to attract a maximum of attention' and scolded her for fleeing from reporters after his firm had spent so much money on advertising.

Ordered to place herself at the disposal of the press, Clare sulked throughout hours of questions in an over-heated hotel. The telephone never ceased ringing and she found it was her duty to go out to dinner every night with a chosen escort while a reporter interviewed her in the taxi. Usually she was expected to wear evening dress, but one night when she put on crimson velvet and ermine (she had sold only the sables), she was fetched by a gentleman in a tweed suit who took her to a basement club. 'Everyone else wore day clothes and we ate our supper in our laps. I was in what America calls "Radical Company".'

When she could escape from the 'manager', Clare was entertained by New York high society – the Cornelius Vanderbilts, the Whitneys and various Jerome cousins. After lunching with Travers Jerome, the famous attorney, she wrote: 'He talks well and says things so like Winston – I realise the strength of the Jerome blood.' Sometimes a few sarcastic questions about her jaunt to Moscow were put by the 'capitalists' who, somewhat naturally, formed a majority at Vanderbilt dinner tables, but on the whole, she found herself petted and pampered. She was 'news'.

Tact had never been Clare's greatest asset, and she did not get on

with many Americans. At a women's luncheon, without intending offence, she said, 'Any man can be chivalrous towards the woman he is in love with, but the American man is chivalrous towards the woman he *isn't in love with*!' Matriarchs in feathered hats regarded her coldly.

The obstreperous young Dickie thought poorly of America's hotels, but liked digging the snow off doorsteps. Clare heard an elderly lady say to him, 'Your Daddy *will* be proud of you.'

'My Daddy got killed in the war.'

'How terrible . . .'

'Yes – and we don't seem to have got much out of it.' He was, of course, only echoing his elders, but the words fell poignantly from baby lips.

Although Winston would not speak to Clare when she was in England, he had written his old wartime friend Bernard M. Baruch to keep an eye on 'this wild cousin of mine – she's brave but has no judgement and might get into trouble'.

Barney Baruch, a great character in the American political and financial scene, had first met Winston in 1917, when he went to Europe as Chairman of the War Industries Board. He produced a million six-inch shells just as England's needs were most desperate and was the hero at Winston's Ministry of Munitions. Later, in 1919, Baruch, as Economic Adviser to the American Peace Commission, travelled through Europe with Winston, when their friendship increased. No more charming older man could have been found to guide Clare along her tangled ways, but maybe Winston thought his cousin would make a hilarious contrast to this eminent financier, adviser of boards and presidents.

When Mr Baruch was asked by the Pulitzers to dine with Clare at the Ritz, he observed her with wry amusement. Baruch was sufficiently famous to be able to regard it as comic that Clare had never heard of him. She started off the dinner having misheard his name as 'Brooke', and when the general conversation led her to understand that she was talking to someone famous, she plucked up courage to ask if he came of the same family as Rupert Brooke! Mr Baruch looked at her with raised eyebrows. 'I'll spell it out for you,' he said and wrote BARUCH on the menu. Clare hid her embarrassment by explaining she had given a lecture that afternoon and felt dizzy. In her diary that night she wrote: '. . . by a faint glimmer of memory Wall Street came to my

mind, and I seemed to have heard in London that he was a friend of Winston. He was interesting and unprejudiced.'

Mr Baruch let her rattle on about Russia and how stupid the English were. He found her very good value and never mentioned the fact that Winston had asked him to keep an eye on her. Herbert Swope, editor of the *New York World*, and his wife were also at this dinner. They took Clare on to a cabaret revue called 'The Midnight Frolic', a type of entertainment unknown to her. When dropped home at dawn Clare wondered if these kind people might not tell her how to break her lecture contract.

A week later Mr Baruch rang Clare to ask if he could in any way help, and admitted, 'Winston asked me to look after you.' She had just returned exhausted from Pittsburgh. After a cold reception from the steel magnates and the wrong kind of railway sleeper into the bargain ('just a curtain in the corridor, not at all like that heavenly Russian compartment') she needed consolation, and cried out happily, 'I knew Winston would never abandon me. If you really are his friend you'll get me out of this tangle . . . ! I'm signed up for months to keep lecturing about Lenin and Trotsky. Everyone asks the same questions. I'm dead tired. I want to stop.'

The relationship which then developed between Clare and Barney Baruch was vividly narrated to me in 1936 when, aged twenty-one years, I spent a week with the magnificent old man on his plantation in South Carolina (Clare had arranged an introduction as Winston had done for her years before). Mr Baruch enjoyed talking of 'your colourful cousin Clare . . . what a woman – how fascinating and how maddening.' But, he said, 'I couldn't really take to her – she was *too* wild.' Baruch was then around sixty-five, very tall and still very handsome. Most famous of Jews he was not Jewish looking. 'People tell me I look more like a Pope than a Prophet,' he would purr.

Sitting out after dinner while the cicadas fluted, Mr Baruch would reminisce with relish about the extraordinary woman he had found entrusted to his care. 'You can imagine what I expected when Winston asked me to look after a cousin who was lecturing on Russia and had got herself into hot water because of Bolshie propensities. I visualized some grim Communist schoolmarm, and it was not with particular relish that I went to meet this lady whom Winston called a "poor girl". No one could have expected the swan in many coloured cloaks who swept into the Ritz and when I rang her up after she had been to

Pittsburgh the voice that answered the phone vibrated like that of some diva at the height of a tragic scene. She needed *help*! I sent my car around to fetch her. Well, you know Clare – she swept into our drawing-room dressed in cascades of some shiny material with a little boy clinging to her hand – that was Dick – a cherub but awfully naughty and bored stiff with New York, and usually left in the charge of a maid. "Are you a reporter?" he asked me, and threw himself into the sofa cushions and stood on his head. Clare, a large, golden, tearful goddess began to pour out her woes and beg *me* to subdue her manager and end her contract. "They don't want me anyway," she wailed. "And I am a sculptor – I want to start sculpting again – how can I escape this hell of lecturing?" '

There would be occasional long pauses while Barney Baruch shook with laughter at his recollections. 'I was bowled over. Next day, of course, I saw her manager and settled things. Clare was released. But that was only the beginning of it. She then informed me that she had brought most of her sculpture over in packing cases. These were lying at the docks. It would be nice if I telephoned the Customs men and assured them there were no bombs in those crates labelled Lenin and Trotsky. Colin Agnew, who had, she said, been displeased by her jaunt to Moscow had now forgiven her and was prepared to lend her his own apartment in Fifty Sixth Street. A family friend Mr Archer Huntingdon would arrange an exhibition in his gallery. Would I please ensure that it was all a success! The launching of artists was new to me, but I had Clare to several dinner parties and invited friends whom I thought would be riveted, and these were many. Among them Herbert Swope, editor of the *New York World*, always accepted, and soon I heard him offering Clare the post of newspaper correspondent in the Balkans, or anything else she desired, while she was saying "When do I leave?" This was before her exhibition even. Every man she met seemed ready to give her a job and run around at her beck and call. I did not have an affair with her – although everyone of course thought I did. You could not take her to a restaurant or to dine in a friend's house without giving that impression. She was wonderful looking, and exciting to have around, but so damn fatiguing. I'm sorry now, maybe, but I was happily married. I did not want upsets.

'And she didn't get on with women. She wouldn't try. Something had got into her – energy – sex-drive – she ran around New York like

a fire engine out of control, scandalizing high society by saying she couldn't think why women had to depend on men – it was a woman's privilege to bear a child to the lover of her choice and the State should support her financially. It was ignominious to have to marry a man and pin him down for money before you dared breed. I can remember one dinner party when the ladies sat silent with horror and their husbands, who were mostly wealthy bankers and men of that type, did not dare raise their eyes from their plates. Finally, one of them turned to me and said, "Well, Barney, you are supposed to be the greatest economic expert America has produced – what do *you* think about reorganizing the system?" For once I found myself unable to voice any opinion. Sometimes I had to wonder if Winston was deliberately playing a joke when he gave me this exotic creature to "look after". She was impossible!'

In her diary Clare wrote: 'In England one hesitates to accept to dine out unless one is very sure who is going to be there. Here one can go at random, it may be strange, it may be incomprehensible, but never is it dull!'

Commissions started to roll in. On 23 March she wrote:

I spent the afternoon at Knoedlers, who have generously taken on show my exhibition, for two weeks before the Numismatic Society. My things look well in their big room, and it is comic to see my bronze Soviet leaders daring to show their faces in Fifth Avenue! No one lookes at Winston or Asquith, they go straight to the Russians, as though fascinated with horror!

In May she visited Washington for a few days. Alice Longworth took a great liking to her and fetched her for meals and took her around the Senate where Clare expressed amazement, for they were holding forth about Ireland, and she had just learned that the gamekeeper at Innishannon, a friend since childhood, had been shot dead – either because he was a Scot or because he tried to stop poaching. Then, just as Mr Baruch had persuaded several very rich and very important people to have their busts done, Clare heard of Mexico – a country full of music and possessing a revolutionary president with an interesting face! Maybe she could do *his* bust! In any case, the sun always shone there and Herbert Swope agreed to pay her for articles.

In May Clare cabled her parents that she wished Margaret to be educated in America. Miss Spence, the headmistress of a famous girls' school had offered to educate her free. A furious controversy on this topic began and Clare set sail on a steamer for Vera Cruz sizzling with

temper. Dick and Louise accompanied her. A seven-page letter to Moreton Frewen shows the tempo of family communication. Written on heavy vellum embossed with her initials 'C.S.' this missive begins:

S.S. Monterey 14 June 1921.
en route for Vera Cruz.

Dear Pa

Half an hour before I left New York the mail brought me *one* letter. It was from Sophie [Lady Wavertree] enclosing a copy of yours to Willie [Lord Wavertree].

1st. She did not know what it meant. Not having heard from me that I wanted Margaret.

2nd. I am not in a position to have Margaret yet – but I am working towards that end.

3. When I have achieved that position, do you think that all Sophie's protests, or any of your 'support' of those protests would alter my determination?

4. Do you imagine anyone can keep my child from me when I claim her?

5. Why do you hope 'soon to hear that Dicky is at Harrow'? Dicky is not yet 6 – at earliest he could not go to Harrow for another 6 years.

6. If he had to go to Harrow *soon* who would pay – you? or *me*?

In conclusion I think that you are the most *disloyal* Father and friend that anyone *ever* had. It is due to *you* not Winston that I had to leave England. I learnt on my return from Russia that you had written to your friends Lady Lonsdale, Lady Algy [Gordon Lennox, sister of Daisy Warwick], Lady Maud Warrender – and goodness knows who else – terrible things about me, asking why you had fathered such a creature. You made public opinion impossible for me – I could get no work. I had to leave.

You are only a fair-weather friend. When I am 'up' you like me, when I am 'down' you damn me.

No one knows better than you do that my position with my in-laws is not one that is helped by *your* criticism of me.

At least say of me that since my widowhood I have not asked you for money? I have been and am battling through. I mean to *win*. It takes time, but I shall succeed. Success can only be crowned by the re-uniting of my children *with me*. Curiously enough I love Margaret, and but for the fact that Wilfred's two children are as unprovided for as stray illegitimates she would not be living with people whom neither she nor I have any affection for.

Your letter to Willie W. was unjustifiable. If Margaret had been *your* Frewen heir whom I was proposing to bring up *in Russia*, you could not have said more.

Meanwhile I realise the futility of sending Dick with Louise, as I had planned, to *you* after Mexico, to autumn and Xmas with you . . . he would be forcibly detained. I will keep him with me and *send* for M. when I have a home for her. If she isn't sent I'll fetch her. Both my mother and Wilfred's mother belong to America. They have plenty of ties. If I find in the U.S.A. *work*, opportunity and more kindness than in England I shall bring my children up there – or if I took it into my head to bring them up in Communist schools in Russia, or in the Sahara Desert I shall do so.

You have no right to object and advise. You have never done anything for me, except urge me to marry a drunken and profligate young man eleven years younger

than myself. This would not have helped Margaret. Mama may be fair game for you – what she had you may consider yours, but Hugh is ruined by you and Oswald out of the Navy without a job – I do not respect your judgement, and I beg of you to leave me and my affairs alone. The mere fact that you imagine I can live for any length of time without Margaret, or give her up for ever, shows that you have not only no sense of moral duty – but no understanding of parental affection.

I never deluded myself that you had any for me. I have for you exactly what it is natural I should feel towards you. Your afft. daughter, Clare.

Moreton Frewen preserved this letter among his papers in order to show posterity what he had to put up with. The Wavertrees had wished to adopt Margaret permanently, now they suffered cables ordering them to increase her ballet and art training prior to her forthcoming New York education, and their indignation waxed strong.

The Mexican trip was a failure. There was plenty of sunshine and a great deal of sightseeing, but Dick and Louise remained unmoved by Aztec monuments and Obregon, the President, refused to be sculpted, although Clare argued with him.

'Lenin thought me tiresome to want to do him, but he consented because I had come such a long way.'

'If you were less famous, Madame, and my sitting to you therefore less conspicuous, I might consent.'

'Would you favour an obscure artist?'

'Madame, I have not yet allowed myself to be portrayed by a Mexican artist, what would they say if I gave the first favour to a foreigner?'

So she had to content herself with the writing of articles for Herbert Swope.

Then came a terrible blow. Her mother cabled that Jennie was dead. Clare replied in the Frewen tradition of lengthy cables. 'I shall never get over losing her – I never realised till now how much she did for me – how much she meant – Oh beloved Jennie.' And in her diary, she wrote:

I have left England to 'make good' and of all the people I love, and who love me, and whose eyes have followed me across the sea, Aunt Jennie's were the keenest. I would have liked to do my best work for her appreciation. Her praise, her approval, her advice was something that counted. The loss of her and the contemplation of years to face without ever seeing her again is difficult to grasp. I cannot imagine returning to an England that does not contain her. My second mother – my loyalest friend. She had the rarest qualities and the largest heart.

To Winston she wrote from Mexico City : 'Oh how bleak it will be

without her. She was "worldly wise" yet neither wise nor worldly. She loved passionately and generously as her heart dictated, and always she gave out more than she received.'

Winston wrote back: 'My dear Clare: Your words were so true. She was a giver, and she understood *you*. We all miss her terribly. Yrs affectionately, Winston.'

Now in the suffocating heat of Mexico, Clare took her diary again and wrote:

... I used to admire and love Aunt J. in a rather awe-struck way and when I was 17 I believed that she could do no wrong. Her judgement seemed to me infallible ... I seemed after marriage to catch up with her, and in my widowhood we had a perfect understanding. There was nothing that we would not tell one another, and I bowed to her superior experience and judgement. When I returned from Russia she was my loyalest friend and championed me. My last evening before sailing for New York was a re-union *de famille* at her house for dinner. She took me aside and made me promise that if I didn't like being in America I was to return at once, 'You have a loving, loyal, powerful family.' She was brilliant and beautiful; never banal, never conventional.

Jennie was close to Clare because she could comprehend the hunger for experience, life and beauty that had always tormented her niece.

There being no such thing as airmail, Oswald's letter concerning the accident arrived some time afterwards. Jennie had been visiting her old friend Lady Horner at Mells. Hurrying down the slippery old oak staircase for dinner she had fallen and sustained a compound fracture of the ankle. Next day the local doctor wished her to go into hospital, but no, she insisted on driving back to London in an ambulance. Doctor Andrews went with her and she chatted bravely through her pain. 'I'll send you my book of reminiscences,' she promised as the stretcher-bearers carried her into 10 Westbourne Street, 'you *must* read my book.' She had day and night nurses but sister Clara sat up with her for two nights when the pain was worst.

Oswald's account was graphic. 'Aunt Jane has had her left leg amputated above the knee; wherefore the Churchills announce the loss of a *foot* – so Churchillian!' He described meeting Leonie in the hall – 'incoherent as she did not know where she ought to be – with Marjorie miscarrying in the Talbot Square house or with Jennie'.

On 22 June he wrote to say that Sophie Wavertree and Aunt Leonie had received Clare's letters introducing Mr B. M. Baruch. Oswald added rudely, 'I'm not in on this act. I suppose you think that because they are both titled they will appeal to him?'

[143]

While Clare was indignantly writing to explain that the charming Mr Baruch was far too intelligent to be impressed by titles, Oswald let her know that Marjorie Leslie had not miscarried and had, in fact, some to see Jennie on her way into hospital for a Caesarian operation, timed for 8.30 on the morning of 29 June. Jennie, who had received her breakfast tray, said to the nurse, 'I wonder what the baby will be,' then whispered, 'I think my hot water bottle has broken' – closed her eyes and died quietly of haemorrhage at the precise moment that Marjorie's son was lifted into the air.

These events, said Oswald, had brought Leonie and Shane to the verge of nervous prostration.

Leonie's second grandson *would* be born in the minute that Jennie died – such quick and bloody arrivals and exits. Was there ever such a family? Winston and Jack stricken. Poor Uncle Porch had just been cabled 'no need to worry'. I went, of course, to the funeral at Blenheim – special train – Ma as *eldest sister* in the rôle of Chief Mourner – Leonie looking distraught – Shane 'carrying on' – you know his form – one would think *he* had had the Caesarian operation – one doesn't know whether to laugh or cry – but it's mostly cry.

Clare was the one who had to weep alone. No one in Mexico City had heard of Lady Randolph Churchill. Having hired mules and taken Dickie and Louise sightseeing, she attempted a few political interviews. But she kept thinking of Jennie's getting up so early to see her off at the station on that icy January morning and of her words of encouragement – it was just as if she had known it was a last meeting.

As the heat of August increased Dick got dysentery. Clare awaited his partial recovery and then took him away out of the city towards what she imagined would be healthier air in the south. Swope would publish colourful articles about those new oil-fields in the wilderness and she thought that the 'camps' would be camps in the British sense – clean, tented outdoor places with plenty of he-men fit to amuse little boys. But the two-day train journey did not provide a satisfactory convalescence for Dick, and then every car she hired got bogged on roads of deep mud. After a few weeks in a thatched hut outside the village of Micos, Clare celebrated her thirty-sixth birthday philosophically. Dick managed to climb a palm tree to pick her a bunch of gigantic mauve convolvulus flowers. Then she developed a high fever and Dick got inflamed eyes. By 15 September she had returned to the Texan border and was longing for the healthy air of America. At the end of a horrible car journey, with Dick shivering in her arms,

the United States immigration authorities refused to pass them. The official doctor declared Dick was suffering from trachoma, a contagious eye disease. With a pet parrot on her shoulder and a weepy child holding her hand, Clare had to watch the train move off without them. It was so tantalizing to see the American flag flying from the buildings across the river – they so needed a good hotel and a good doctor. She had to retreat to Monterey. In her own words: 'From there telegrams were despatched invoking aid. One to Herbert Swope, the other to Barney Baruch.' In Swope's words: 'Clare's articles were fine but her personal cables grew as long as her articles and when we learned that she was "angry with God" because of Dickie's tummy trouble I had to cable back, "Terribly sorry. Leave God out of it. Boil drinking water. B.M.B. getting you home." '

It was Barney Baruch who set the official wheels in motion. He had just returned from his trip to England where Aunt Leonie and Sophie Wavertree had indeed entertained him while begging the great man to exert his influence over Clare. He had seen Winston who was terse. 'Dissuade my cousin from her wilder schemes.'

On reaching Washington, the august Mr Baruch was confronted by Clare's howl from the Mexican border. Secretaries got busy. Cables were dispatched and within a few days Clare was being shown every kindness by what she called in her diary 'local American magnates attached to the Smelting and Refinery Works'. They had been briefed by Mr Baruch to look after a lady in distress and they obeyed with alacrity. A new doctor proved sympathetic and Clare's diary grew more cheerful. 'Of course Dick has not got trachoma – the doctor here recognised it as the most ordinary Mexican eye disease prevalent among children.'

To while away the time, and thinking that a bullfight might be something like a circus, Clare took a slightly recovered Dick to one. She was sickened by the cruelty. The bulls, too young to fight and with horns sawn off, refused to face the horses so the *banderillas* were charged with fuses which detonated and burnt letting smoke emanate from the black, bleeding wound. One animal jumped the paling in terror and was hauled back to be tortured with explosives and clumsy sword-play. Happily, Dick was too young to comprehend the pain. He just stared mesmerized at small boys wallowing in the puddle of bulls' blood.

Next day the Manager of the American Smelting Works visited her

and said that 'full instructions had arrived from Washington'. Medical and financial aid was to be arranged. 'I don't need money.' Clare tossed her head. 'Just get us back into America.' The Manager smiled. 'I have orders you are to be got over the border *somehow, anyhow* – in a special train with the blinds drawn down if necessary. Don't worry. There will be a different Doctor on duty at the Post.'

After a re-examination of Dickie's pink eyes the party was bowed courteously into Texas. From San Antonio Clare cabled Barney Baruch. 'Thank you for revelation of American chivalry.' He replied, 'Chivalry always there but take Herbert's advice stop boil drinking water stop.'

17

The Charlie Chaplin idyll

FOR a week Clare revelled in the luxury of that San Antonio hotel.

I ring the bell of my bedroom and ask the room service to send me a jug (no, a pitcher I have to call it), a *pitcher* of lemonade. I don't always want lemonade but I love to see it when it comes. The glass jug is a real object of beauty – cherries, ice and green-leaved herbs. It is a riot of colour, a delight to the eye. I might be drinking in a dream the sap of iridescent precious stones. . . . I am making use of these quiet days to try to tame Dick. At present he is a savage. He keeps hitching up his trousers as one un-accustomed to wearing clothes and exclaiming 'Jesus!' He learnt it from the Texas boys in camp.

Clare's articles on Russia, Mexico and even America, had been syndicated in papers throughout the States, and she was again perse-cuted by reporters. She had no idea that it could be unwise to give interviews in the same frivolous tone suitable to private house conver-sations. Asked if all European women had lovers she laughingly retorted, 'Of course they do – as many as they can get.' These opinions were blown up into unfortunate headlines. It was no good saying later that it wasn't quite what she meant. And of course she *was* Winston's cousin.

A spate of cables arrived. One of these came from Metro-Goldwyn-Mayer asking her to come to Los Angeles all expenses paid. A car would be placed at her disposal. She would be shown Movieland.

Sam Goldwyn, whom she had briefly met in New York, had ordered his Studio President, Mr Lehr, to locate her, show her Hollywood, and

keep her entertained until Charlie Chaplin returned from his triumphal trip to Europe. Charlie had made millions but he was lonely. He had read Clare's book *Mayfair to Moscow* and told Sam Goldwyn that she was the one person he longed to meet.

The Goldwyn cable was tantalizing, so Clare embarked on the two-day train journey to Los Angeles. There she was amused by vast film sets and charmed by V.I.P. treatment. After she had been shown the sights of Hollywood, Metro-Goldwyn-Mayer offered to transport her to friends in San Francisco. The company sent a car to take her to the train. When the hotel porters shouted down the line of parked cars 'Goldwyn studio car' the crowd of dinner arrivals simply stood still and stared. Clare emerged, parrot on shoulder, Dick and Louise following, and stepped into the Goldwyn car with the self-consciousness of a recognized film star. Dick and Louise simpered, the parrot squawked.

In the smart suburb of Burlingame Clare found social activities exhausting.

. . . they all *know* each other very well and *they* see one another every day – sometimes three times and sometimes *four*. Their houses are close together. There are no big properties as in England to rouse one's sense of inequality. They *motor* to each other's houses and to the country club although they are only a stone's throw in distance, and every time they meet they are pleased to see each other. I wonder they have anything left to say, yet they talk all the time!

Clare was bewildered by that American social innovation – the Country Club. It was so different to country house parties in England, where a few guests, picked to interest each other would stroll or ride within the walls of their hosts' demesne. The English upper classes obtained their fortunes from land, rents and coal. How did these chatterboxes get their incomes? It was most puzzling to Clare, and Louise too thought it all most odd. 'Perhaps the warm climate oils them up till they can't stop talking.'

However, Clare realized that Metro-Goldwyn-Mayer were keeping her in California for their own reasons. She was to be produced for Charlie Chaplin, who had said he was enthralled by a story of upbringing so opposite to his own.

At this time Clare hankered to start sculpting again so she lingered on while M.G.M. dangled the bait of modelling Charlie. On the night of Chaplin's return from Europe the Lehrs invited Clare to meet him for dinner at their house. Charlie was, they said, extremely shy but there

would only be the four of them and he was desperately anxious to know her. So Clare and Charlie arrived and faced each other.

She saw a small, dark, extremely good-looking man with a whimsical smile. He saw a tall blonde arrayed in Mexican shawls. There was no moment of shyness. Clare found Charlie intriguing and he was almost hypnotized by this woman who had been brought up in a world into which he had never entered. After suffering a boyhood of terrible poverty, he hated the English class system. Clare's flight from all that he had once envied amazed him. Here was a woman reared in the world he resented, to whom the great houses of England had been open, and she had chosen to fling it all aside and go to Russia as an artist. Charlie always maintained that he was not a Communist, but he hated the slums he had been reared in, and governments which allowed physical degradation.

However their compatibility was soon felt and Clare was well away. They sat side by side like two children relating their dreams and believing them. He tucked himself away on a sofa out of the lamp light while she grumbled that America forced her to write instead of asking her to sculpt. 'American males fear the *vanity* of having their heads portrayed for posterity!' Charlie looked at her half shyly, half humorously. 'But *I'm* vain!' he cried.

'Thank goodness!' she said, and so it was fixed. 'I will stay on until I have caught you in clay – then you can choose bronze or marble for posterity.'

That was their first meeting and Clare wrote pages in her diary:

It has been a wonderful evening – I seem to have been talking heart to heart with one who understands, who is full of deep thought and deep feeling. He is full of ideals and has a passion for all that is beautiful. A real artist . . . And then in spite of his emotional, enthusiastic temperament, with a soundness of judgement that surprised me, he said: 'Don't get lost on the path of propaganda. Live your life as an artist.'

You can see the sadness of the eyes – which the humour of his smile cannot dispel – this man has suffered . . . He is not Bolshevik nor Communist nor Revolutionary, as I heard rumoured. He is an individualist with the artist's intolerance of stupidity, insincerity, and narrow prejudice.

Three evenings later Clare was writing:

I have been with Charlie from midday to midnight. He has just left me. First we went to his studio, and Dick came along with us to see *The Kid* . . . Dick reacted to it in the most stirring way. When the Kid was to be snatched from Charlie and put in an orphan asylum, Dick clung round my neck crying and sobbing, 'I can't bear it'.

F [149]

Charlie kept tiptoeing over to the harmonium to play his own melodies during the scenes of pathos. However, the effect on *this* audience exceeded expectancy. When the lights went on Clare and Dick were tear-soaked. Charlie produced handkerchiefs and reassured Dickie. 'It's only a play – it will all come right in the end.' But to Clare he remarked quizzically, 'However, *you* are supposed to cry – you're grown-up . . . it's the little boy who worries me!' He gave Jackie Coogan's cap that had been used in *The Kid* to Dickie and the three of them drove to Charlie's hilltop mansion for lunch.

In the hot evenings they went for long walks, Dick scrambling wildly up steep slopes while Charlie and Clare explored the winding hill paths. Charlie was serious. He kept trying to work out the ultimate aim of human effort. 'There must be no dreams of immortality, no desire for admiration . . . there is in the end but oneself to please . . . Be brave enough to know that within yourself is your whole world . . .'

Clare admitted to ambition. She wanted her children to be proud of her, but, Charlie continued, 'You should just want them to love you in a primitive animal way because you are you.' He added sadly, 'I loved my mother almost more when she went out of her mind. She had been so poor and so hungry – I believe it was starving herself for us that affected her brain. She so wanted me to be a successful actor. If only she could have realized what I would become –'

Then he would tease Clare a little about her desire to create enduring works of art. 'My celluloid may not last as your bronzes – but in a thousand years people will only look at them and say "Who did you say did that? Clare Sheridan? Oh really! Where is the motor with our picnic?" Nothing makes people forget their tummies.'

During the next week Clare worked happily in Charlie's large rented house. She felt that she was catching his curious lively spirit in the clay.

Now and then we stopped for a cup of tea, for a tune on the piano, for a breath of air on the sunbathed balcony, and Charlie with his wild hair standing on end, and his orange dressing gown dazzling against the white walls of his Moorish house, would either philosophise or amuse us with impersonations. Dick romped around adoring his host. 'Charlie you're the funniest man there is . . .'

One night, while dining together, at the Ambassador Hotel in that gay restaurant full of jazz music, Clare and Charlie began talking again about their childhood. Clare had always felt sorry for herself. She thought that the tyrannies of horrible Mademoiselle and the shame of

being led out into Society to hook a rich man were humiliating, but her tale of woe could not compare with Charlie's. Perhaps he had never been able to speak so openly to anyone before. Perhaps Clare's passionate approach to life and her naïve desire that humanity should know joy and fulfilment, loosened something that had been locked away. Around them moved the dancers' bodies throbbing to the saxophones and in the shadows sat Chaplin recalling his youth. He described the tiny slum room in which his fragile mother strove to bring up her two little boys; he told of her fear and the hunger when her singing voice broke from malnutrition and overwork, of the drunken actor father who left her for another woman, of the workhouse, the floggings, the terrible insecurity. He spoke with simplicity and detachment, but Clare could hardly bear to listen. Yet despite the workhouse, Charlie had always known the warmth of a mother's love – and Clare had not. Certainly her mother loved her – but there was no atmosphere of closeness. 'I think it is easier for poor mothers to make their children feel they care,' she told him. And he looked at her curiously. 'I am very rich now and very lonely. I have made one disastrous marriage and it's finished,' he said. 'Stay with me a little – give me something.'

So she stayed on and when a French friend came to see the bust of Charlie and exclaimed, 'But it is Pan . . . One can never deceive a woman!' she felt a certain truth through the laughter. She was happier than ever before over a portrait and Charlie himself seemed to like it. He said, while staring half-puzzled, 'I find this damn fellow interesting – I wish it was not me so that I could judge coldly.'

When the head was finished, he suggested they go camping before he had to recommence working. It was not easy for Charlie Chaplin to move in California without being recognized, but one fine morning they drove along the coast looking for some hidden nook for their tents. Clare brought Dick, and Charlie, when Clare confessed that she could not cook *at all*, brought a chauffeur and a chef. The cortège found a secluded wilderness only with difficulty.

'You should do like the Mexican motors and go across country,' piped Dickie, as they tried one road after another. Towards evening they discovered a sandy track that looked promising. It led towards the sea, and at its end within sound of the breakers, lay a wood of eucalyptus trees. The setting seemed perfect. Clare rhapsodized. 'Late into the night I sat with him over the camp-fire. A half moon rose

and the little veils of sea swept like gossamer over the dunes and the naked eucalyptus stems cast black shadows; mingling with the night bird cries, the rhythmical sound of the sea beat on the shore . . .'

A week passed. They danced barefoot on the sand, slid on the dunes, splashed in the Pacific, discovered a hidden lake. Dick rioted along beside them. The 'staff' attended to the five tents and the meals. Then the idyll ended in disaster. Clare was amazed at what occurred but Charlie Chaplin had expected it. A number of children from a nearby farm house, to which the eucalyptus grove belonged, had taken to visiting Charlie – rather too large a crowd for comfort. He loved children, but what he did not love and Clare in her innocence never suspected, were snooping reporters who questioned the children. On the last day two pressmen arrived on the scene complete with cameras. Charlie and Clare were 'caught'. Within hours the eucalyptus wood had become big news. Charlie Chaplin emerging from his tent! Clare Sheridan emerging from hers! Dickie looking furious. The chef and chauffeur looking guilty. The tents being hastily taken down. It all turned into very good copy. And Clare's careless remarks to journalists in the past concerning 'lovers' made what Metro-Goldwyn-Mayer's office could not conceivably have regarded as the right sort of publicity. Although they tried to parry questions it was not long before the headlines began – *Charlie Chaplin going to marry British Aristocrat.*

'Oh, well – let them call me anything except Winston's cousin,' groaned Clare. 'I adore your company – I adore being alone with you – but are we ever going to be able to be alone together again?' Charlie found himself mobbed by reporters. To one question concerning age he answered truthfully: 'Mrs Sheridan is four years older than I am.' This the press gallantly translated into: 'She is old enough to be my mother.' It was all a hideous anti-climax to what Clare would always describe as 'not exactly a love affair but a meeting of kindred spirits – we were like two fireflies intoxicated with the same magical feeling for beauty – dancing together by the waves, recognising each other's souls . . .' The meeting of souls, however, has less interest for the gutter press than hasty flight from tents in a eucalyptus grove. This little excursion – esoteric in Clare's view – reached almost every newspaper in the world.

It was mid-November and Clare had been expected back in New York for over a month. Baruch now cabled her that commissions were waiting, and when Charlie returned from the wilds and put on a trim

everyday suit, she felt him to be less congenial. 'Do we really know each other?' she asked. 'How different it seemed by the seashore.'

It was time to go. Charlie came to see them off, and was allowed past the barrier on to the departure platform, a privilege that made him conspicuous. They did not kiss good-bye for fear that reporters would be watching. As it was, the train conductor took Dick aside to ask, 'Might you be Jackie Coogan's brother?'

'You mean *me* the brother of the Kid? Oh no! And it wasn't true – only a story. Mr Chaplin told me so.'

18
Good-bye to New York

As the four-day train journey progressed, Dickie inquired querulously: 'Don't these trains ever break down like Mexican trains? I like getting out to explore while they mend the engine.'

Mr Baruch was waiting in New York. He seemed unaffable. 'How could you do such a thing?' he demanded of Clare when he got her alone.

'What do you mean?' she asked innocently. It had not entered her mind that stories of her romance might follow across the continent.

'You know what I mean. It's so embarrassing for Winston, linking his name with Trotsky and *then* with Charlie Chaplin.'

'But I never mention his name,' Clare retaliated. 'All I do is sculpt interesting men and those two happen to have extraordinary faces and . . .'

'Well, look at this.' Barney Baruch put a heap of newspaper cuttings in front of her. Several of them carried an unauthorized announcement of her approaching marriage to Charlie.

Clare burst into tears. 'All I want is to settle down as an artist in America and get Margaret sent out from England. Those cruel Wavertrees are hanging on to her. Now they'll say I'm not fit to bring up a daughter.'

'People are bound to criticize if you get talked about in this way. Wouldn't it be better to issue a statement to the press? Say you are going to get married or else say you have broken it off.'

'But there is no question of marriage and I *refuse* to break off a link with the most beautiful soul. He is unique. He is the most alive, fascinating person I have ever met.'

'Don't talk to *me* about souls – you've done that to the press and a choice story they've made of it,' snapped Baruch. 'The word "mistress" so delightful in Europe is less so over here where women like other women to sign on the dotted line . . .'

'I'm *no* man's mistress and never shall be – I'm my own mistress – and I *work* for a living,' roared Clare.

Baruch had to give it up.

'You're impossible,' he said. 'I'm sorry for Winston having you in his family. And I wish you weren't such damned good company. I like going out with you but everyone stares. You dress so startlingly – it is better to dress *quietly*. How are your finances?'

'I seem to be down to nothing. But I earned $3000 in a week in Philadelphia before going to Mexico. It's quite easy.'

Mr Baruch ordered her to put down the advance on a studio flat in West 59th Street where she could start working at serious orders. Clare would only agree if Louise were permitted to return to England to fetch Margaret (now nine years old). As she could not both sculpt and look after a child, Dick would also have to travel across the Atlantic with this astonishing little nurse, now attired in Caucasian embroidered coats and Cossack hats like her employer.

The story continues through Oswald's diary. He was at this moment furious with Clare and sympathetic to Lady Wavertree.

She turned Margaret over to Sophie begging her not to thwart her when she grew up and to let here arn her own living on the stage if she so desired . . . And now she is ordering Margaret to be handed to Louise who is on her way back to England with the unfortunate Dick in tow.

A torrent of angry cables then arrived from New York. On 23 November 1921, Oswald wrote to his sister:

Darling Puss: Well, that *was* a surprise to greet me Monday morning! *What* cancellations of plans for the next fortnight I had to make! Was it a sudden inspiration on your part, or were you applying the old Austrian diplomatic principle of the 'fait accompli'?

What if Margaret when 16, or even earlier, begins to accuse *you* of having taken her away from a 'good home' and a complete, carefully thought-out education to share your ups and downs, to go to a New York school one month, a San Franciscan the next, a Muscovite the third? . . . When you asked Sophie to look after her you were a little bored with her. Perhaps by now she has become companionable enough to be a playmate to you, but assuredly if you see her for a good long holiday and then return her to Sophie for a bit, in a little while more she will have got through the important part of her education at no expense, and at *no trouble* to you, and *then,*

with the full glamour of Motherhood on you you can take her to yourself as friend, confidante and partner.

But ten days later he meekly obeyed Clare's command to meet Louise and Dick on the S.S. *Celtic* at Liverpool. Lord Wavertree indignantly accompanied him.

In the 2nd Class we found Dick minus his four front teeth and dressed like Jackie Coogan. Full of Americanisms and, owing to his lost teeth, talking as though he were drunk. Rather babyish, prone to excitement and a brown-orange colour due to sun and bilious spell, but otherwise very sweet.

Oswald and Lord Wavertree shepherded the arrivals to Euston Station by 6.30 and Louise was dispatched to meet her dear old Cockney parents at the studio. They hardly recognized their girl. Oswald took Dickie to dinner at the Charing Cross Hotel where, 'with the Jackie Coogan cap still over his eyes, he proceeded to eat whitebait with both hands.'

After a few days' rest at Brede Place, Dickie was brought to Sussex Lodge in Regent's Park, the luxurious mansion of the Wavertrees, to play with their adopted daughter and Margaret who was recovering from bronchitis.

By now various members of the family were imploring Clare to come to her senses and allow both her children to remain in Wavertree hands. Even Aunt Leonie wrote sternly:

Just think of my feelings when your mother fell and broke her leg exactly as Jennie did four months ago and I cable you the news and Louise answers you have *no* address – gone to camp with Charlie Chaplin – really my dear do think of us and not only of yourself – and can you expect Winston to be pleased at the latest press announcements?

Unfortunately, Moreton also heard of the eucalyptus grove, and what the newspapers were calling 'a marriage that could pulverise two continents'. Papa Frewen was never tactful in telegraphic correspondence and he now accused Clare of 'outrageous selfishness'. On 7 December Oswald received two cables from New York sent within minutes of each other. 'Full responsibility mine. Whatever Margaret's condition she must sail with Louise tenth, this final.' Then another: 'Louise bring back black bedspread, yellow brocade, several English editions my book and pension forms, agitate about Russian miniatures and Paris head. Bring both children and Russian coat.'

Oswald pasted these in his diary adding, 'The question remains

whether the author is a fit person to have charge of herself, let alone of young children.' He prepared the children for their journey however, and the Wavertrees sadly let them depart with Louise. Once again Oswald travelled with them to Liverpool, and placed a letter for his sister in Louise's hand before the S.S. *Celtic* sailed.

Dec. 8: My dear – I haven't any heart to write anything to you . . . I have been loyal to you – we were companions in adversity together once, you had much good in you, and intelligence, and you are my sister. Your Russian exploit I laughed at, your Communist ravings I ignored, your mode of life I – in a measure – condoned. I knew and know, that as you sow, so you must reap . . . You are of age, you started better endowed than most . . . In what you do for yourself I stand by you to others, although I would be wanting in *my* duty to you and *the Race* if I did not point out glaring errors that are far removed from the sphere of 'opinion'. Indeed, I have been wanting in my duty in this respect . . . But if I have been loyal to you in what you have chosen to do with yourself, I have no intention whatever of condoning your actions when they tragically and violently jeopardise the physical well-being and yet more the spiritual chances of a young child. Margaret is no more yours than the money in my No. 2 Account is mine; *she is yours in trust* . . . If you bring up M at the age of 9 to consider that a 'pure life' consists in living in camp with two different men within two months [Louise had blabbed about picnics with a good-looking youngster before Chaplin arrived] *this*, added to a complete absence of any education whatever, religious or secular, *this* is sinning. I have long known that you had no heart, but I did cling to the pathetic delusion that you still possessed an intellect . . . I realise that any thought of what may be good for Margaret is totally wanting from either your heart or intellect; *you* think that you want to see her and kiss her, *I* am convinced that you merely want her because you are jealous that another woman should lavish on her the semblance of true maternal love, because you want to be photographed with her for the Press, and because you think she would look wonderful on the films and would add to your own (imagined) celebrity.

This was hardly a letter to instil peace and goodwill at the festive season.

When the children arrived in snow-covered New York, Clare fell on them affectionately, but Christmas was not a success. Two Atlantic crossings in a month had upset Dick, and Margaret did not appreciate being yanked out of her curriculum. They had heard Oswald talk about their mother, and they thought the vast nurseries at Sussex Lodge might offer more scope for their talents. Clare had taken an apartment above her studio facing Central Park. It was rather beyond her means. She earned enough for rent but not enough for food, so all meals were taken with Aunt Alice, a Jerome cousin. Having sold the last of the sables and most of her jewels (but she retained the black

mink coat), Clare thought she could, through hard work, remain proudly solvent. Mr Baruch thought otherwise. As Christmas approached, Clare wrote: 'There was something very appealing about this man, his giant height, his kindly face, his soft deep voice and his sense of humour. They liked him, and so did I, and he liked us. All the toys the children had he gave to them.'

After Christmas Clare took pleasure in composing a suitable reply to Oswald's letter:

December 29: Your letter sent me by Louise is indelible. I cannot answer it. I don't know if you yourself realise what you wrote. Let us understand one another henceforth. As I do not ask for your advice or help and as *you cannot* help me, do not give me your advice unless I ask for it . . . As for Charlie Chaplin, when I tell *you* I'm going to marry him time enough for you to break it to the family, but I am supremely indifferent to your or the family's opinion of my actions. I don't require or ask your consent or approval or the family's to anything I do. Anymore than I should expect it or ask for it if I married Trotsky. All of you behave as if you very munificently gave me an allowance and were in a position to cast me off without a penny if I didn't do what you require . . .'

She felt much better after getting this off by post, but Aunt Leonie who received a copy, wrote to Oswald,

Let her blow off steam. All that matters is that her affairs should not be made public and make Winston look foolish – he loves her you know – we all do. It's the war that has broken her up – she *can't* be an ordinary widow and she *won't* be an ordinary wife. Only Wilfred could control her.

Oswald, who was living in the St John's Wood studio, paying its rent, attending to the chores, moving her busts to galleries or storage, and preparing the china, linen and plate for a let, ceased writing to Clare, but let fly in his diary:

The Studio and I having served her convenience are like the Lord Chancellor [Birkenhead], the Duke of Connaught and Sophie Wavertree – to be dispensed with. The Lord Chancellor remains wroth, the Duke hurt at Clare's rudeness, and Sophie sad at losing Margaret. What mood are the Studio and I to adopt? . . . She may find the Man in Possession 3000 miles away harder to evict than she supposes. She has herded too long with Communists who order their victims to dig their own graves first and then shoot them into them. Does she *really* suppose that I a Frewen, of *all* the crabbed and internecine-fighting blood, am going meekly to put *her* house in order, dispose of her busts, and hand it over in apple-pie order to a new tenant – perhaps *find* him for her? . . . No! if I leave I leave with 'a long arm and a stretched out hand' – I pay off Lottie, terminate my telephone contract, and walk out, taking my few things with me and sending *her* the keys to New York. I do it just as the rent and rates are due, stand by and applaud the deluge. *There* speaks the real Frewen.

Nevertheless, Oswald did let the flat for her, briefly moving out with a marble Princess Patsy and a bronze Sir Vincent Caillard, in a wheelbarrow! His last entry for January before departing to a temporary job in the Middle East reads:

I am wanted in Persia because of my affinity to Winston (poor Winston, *I* do not mind the affinity, but I expect he will!) . . . I cannot leave the parents longer than three months. On the other hand this kind of life is very near the intolerable. Pa regards me as a general factotum, valet, chauffeur and his Representative at Funerals. The Lord looks after the Sparrow but with £400 a year I am out of the Sparrow category. I am too rich to be poor, and with Brede too poor to be rich . . .'

During the next five months Clare worked hard in New York. Dickie grew very tired of Central Park and Margaret fretted at Miss Spence's smart school where the other girls laughed at her English accent. And they could not understand why she was dressed in jade green tunic and shorts decorated with yellow apples, when *they* all conformed to the school semi-uniform of navy-blue with a touch of red. 'Wouldn't it be nice if you had dresses like us?' remarked Margaret's 'best friend'.

'But why do you *want* to look like everyone else?' Clare replied to her daughter's pathetic complaints.

Margaret has since described the kind of mother Clare made:

For the first time, looking at her when she came up to say goodnight to us, I realised how beautiful she was. But the pitch of American life was too much for her. She thrived on high pressure, but it told on her nerves. There were terrible scenes with Louise when trays were flying across the room and coffee streamed down the studio walls. Louise, by now thoroughly out of hand, maddened Mama by her parrot cry of 'I'm as good as you are.' The Socialist experiment had run wild . . . But how beautiful she is as I remember her – hair that gleamed a cloud of gold, delicacy of colouring recalling Greuze, the height and bearing and almost the physical majesty of a Brünnhilde, with all the elegance of a great ship in full sail. She swished through life . . . Her air of helplessness before any difficulty was as deceptive as the childlike affability she assumed when about to say or do some scandalous thing, eyeing the world lambently in all innocence, spotless before the fury of her enemies . . . She dressed according to the mood of the moment, or her prevailing theme. In this she was chameleonesque. During the Russian phase she dressed more or less like a Cossack. To see her striding down Fifth Avenue in the days of sack waists and cloche hats was to experience a shock of recognition and delight. Mama in a tight-waisted, full-skirted coat of green velvet, edged with fur and lined with wine-coloured satin, wearing soft grey Russian boots, was a revelation.

She was lovely but embarrassing; as a mother impossible, as a person enchanting. With her superb disregard for consequences, taking risks and making others share them, she was always alive, never dim . . . During those New York days there was

often a terrible shortage of money. Few people can have realised how very little we had to live on. Although Mama went out to dinner wrapped in Russian sables or ermine, although she knew a great many rich people and was continually having orders for portrait busts, I overheard her once in floods of tears telling Louise she did not know where the next meal was coming from.*

Disdaining Barney Baruch's offers of financial assistance except in the form of children's toys and dinner parties, Clare discovered that her iron health would not stand up to the strain of New York social life at night followed by long days in the studio. When Doris Keane, the actress, criticized the head modelled of her small daughter, Clare dissolved into a kind of nervous breakdown. 'All the while nobody suspected I dined out every night stimulated by cocktails and laughed and danced and appeared to be having a good time.' She developed weeping fits and as the Italian painter whose studio adjoined hers would then seek to console her with champagne, pulse-taking, and more personal attentions, she felt the time had again come to 'up sticks'. Leonie, hearing of Clare's outburst wrote: 'No one ever tastes a cocktail in *my* house. I feel quite ashamed that it should be my country – America – which has invented the things. I hear people *go into dinner drunk*! It is unbelievable.'

The last straw occurred when, after interviewing Clare, a man asked for money as a 'press contact' – a term she had never heard. 'If you don't pay me to get the right stuff into the paper you will have to risk adverse publicity,' he threatened. She stared in amazement. 'But *I* usually get *paid* for being interviewed.'

No one, knowing of Clare's grand connections and seeing her float off to dinner with important people, could have guessed that she could hardly pay her rent – or that the earning of her own living had become an obsession. Herbert Swope was among several gentlemen who essayed to help her keep her head above water. He commissioned her to do his bust – 'We'll have it in marble for the office and bronze for the home.' Clare admired his strong features and believed she could do something really good, but modelling the editor of a big newspaper during the summer heat proved dementing. 'He woke up late, ate at any hour and worked all night. Once he kept me waiting till 2 a.m. and then only appeared to say he could not stay.' Mrs Swope who was with him on this occasion took pity on Clare and persuaded her husband to sit for an hour.

*Mary Motley, *Morning Glory*, Longmans, 1957.

It was then in that still silent night, when we were all so tired, that he asked me what was going to do with my summer.

'I want to go home . . .'

He thought for a moment and then asked if I'd like a roving commission to write about post-war Europe. I jumped at the offer.

Next day she finished the bust and told Louise to start packing. They were to sail back to England. Clare did not guess how exciting the next six months would prove. Journalism thrives in chaos, and European conditions were very much in her favour during that summer of 1922.

19

Roving commission

WHEN Clare's ship was due into Plymouth, Oswald, back from Persia, and ignoring the rude correspondence of a few months back, filled her studio with flowers from Brede. His diary describes the sister who arrived at Paddington Station.

She looked tall, handsome and matronly, rather like Gladys Cooper (she left pretty and jeune fille). For a moment I doubted who she was! She greeted me with affection and calmness – it is strange that she should have to go to America to learn calm! – and was altogether dans son assiette and unruffled by the luggage chaos. Dick and Margaret, clutching dolls and tin steamers, agreeably filled in the picture. Before we had left Paddington I made two new discoveries about Puss: – she has grown up and she radiates personality, not as a glow-worm radiates light, but as a furnace radiates heat: a dynamic personality. I feel she is very akin to Winston, that her orb has risen; it may wax and wane, it may even be eclipsed, but it won't set . . . We returned to the studio and she walked in. Immediately she began to criticise her own early work and damned practically everything except Winston and the Bolshie busts to destruction. I obtained a stay of execution for myself, for all the Women War Workers and several others things . . . eventually we bedded Louise down with cushions in the back room, I slept on the sofa and Puss in her bed, the two children upstairs.

Next day Mrs Johnson peeped in. Her son who had been three years in the trenches and awarded a Military Medal for bravery, had posed for the statuette of a soldier which matched Oswald the sailor. She hoped the men's war effort had not been forgotten and made some stringent remarks about 'hobnobbing with Charlie Chaplin'.

Clare found it difficult to take up the cudgels with Mrs Johnson. 'He wouldn't have been any good in the trenches. He is an artist.'

'A London lad like my lad,' was the tart rejoinder.

They travelled down to Brede Place and a fortnight later Oswald noted with amusement that his sister considered herself rich enough

to give a lunch party at Claridges. He described with surprise those who came to welcome her home. 'The whole bunch from the Crown Prince of Sweden whom she's treated disgracefully, down to the Lord Chancellor – that gilded cad! Puss raises her little finger and they flock.'

Next day she paid a visit to the family solicitor who told her 'that Dick was heir to Frampton which brings in £10000 a year all of which goes back on the land in wages and upkeep.'

'If there *is* all this money why can't I have some?' understandably queried Clare.

'When Dick inherits he could sell and re-invest,' teased Oswald, 'except that would make him a Capitalist!'

According to his diary she countered angrily, but she had already confided that *her* savings were to be invested by Barney Baruch. ' "*My* wretched savings could never constitute *me* a Capitalist."

' "Then won't you give me a definition of a Capitalist, dear?" I enquired sweetly.

' "A Capitalist is someone with a lot of money who *employs* people," she retorted.

' "But don't you employ Louise?" '

The argument ended in indignation on Clare's part and mocking laughter on Oswald's.

In the following week it looked as if a Civil War in Ireland might give plentiful employment to journalists. Clare hurried to London and lunched alone with Winston. He had now forgiven her Bolshevik escapade and expressed relief at this selection of a serious career. 'Do look at my credentials,' she boasted naïvely. 'I've got a Roving Commission – doesn't that sound good?'

'The title of my first book,' said Winston with a twinkle. 'So you can't use it for your next volume. But good luck to you, my dear. I think you have great courage.'

'For a woman,' parried Clare. She asked Winston if he would give her letters of introduction to Michael Collins and Arthur Griffith who had signed the recent Treaty. He thought for a moment and then said: 'Better not. You will fare better if you just go as correspondent for the *New York World*. The sight of you will produce copy. Leave your trinkets and go off bravely. Bless you. Don't confuse the Irish revolutionaries with Russian revolutionaries. The Irish all believe in God, uphold the family and love their country.'

[163]

Glad at having reinstated herself in Winston's favour, Clare sailed to Dublin, dumped her bags at the Hibernian Hotel and took a train to Cork to see the charred ruins of her old home at Innishannon – burnt no one quite knew why – presumably because Moreton Frewen was half English and spent his Sussex rents on doing up an Irish village!

Clare had the luck to board the same train to Cork as Michael Collins. Her father's friend Barry Egan, Lord Mayor of Cork, saw her and invited her into their carriage. Michael Collins was now at the height of his fame and popularity as Free State leader. He had been sent to London by de Valera to negotiate terms with the British, but ardent Republicans considered the truce he had agreed to was unacceptable. Many were already out for his blood. But during this journey in June 1922, the train stopped at every station for joyful demonstrations and contrymen flocked to the platform clamouring to shake his hand.

Clare sat with Collins and the Mayor. They discussed the problems of cattle grazing while Clare, thinking of the *New York World*, tried to turn the conversation into political channels. 'Without the United States we should have starved and when hunger prevails no cause can succeed,' said Collins. 'The only way to treat Ulster is the way the United States treated Vermont.'

On arriving at Cork, Collins vanished into a cheering crowd. Clare never saw him again. He was, as he half-expected to be, murdered by Republican extremists.

As her hired car drove through the village of Innishannon, where once she had known everyone by name, a few people stared unbelievingly, then smiled and waved. Her driver stopped before locked gates and she climbed the old garden wall as she had so often done in the past. And then she felt her limbs trembling at the sight of the blackened ruin of her old home. Sadly she roamed among the neglected roses. She did not stay long although the village people soon came running. 'Ah, Miss Clare! Fifteen years since we saw ye and your pretty face not changed at all. If the people knew ye were coming they'd be lighting tar barrels in welcome . . .'

There was nothing to write about here save her own nostalgia. She returned to Cork and took the first train back to Dublin, where the atmosphere was growing tense. Having interviewed Collins, Clare wondered if she might not reach his rival, the Republican Rory O'Connor, who with a band of kindred spirits was holding out in

the magnificent Georgian building known as The Four Courts against the newly formed Free State Army. Having cleared out of Southern Ireland, the British parliamentarians were busily making speeches telling the Free State how to handle rebels. The Free State indignantly replied that it did not require advice, and Clare was informed that the new Irish 'generals' had devised a technique of firing a sixty-pounder loaded with shrapnel which made a great amount of noise but did little damage. London newspaper correspondents, judging only by the noise, wrote with satisfaction of the 'stern measures' being taken against the rebels.

By luck Clare had caught Michael Collins. It would be a triumph if she wangled her way into the besieged Four Courts to interview Rory O'Connor. She made discreet inquiries and discovered where the Republican Headquarters were located. There she flourished her *New York World* credentials and someone looked up the telephone number of the Lord Chancellor of Ireland who had been ousted from the quarters now occupied by Rory. To Clare's amazement the line had not been cut. 'Who is there?' she asked.

'Rory O'Connor,' answered a deep voice. She explained her mission and he told her to arrive at the Four Courts within the hour. When she had reached the entrance and handed over her 'letter of introduction' from H.Q., Clare heard the gate being unlocked. She was brought into a courtyard where a number of boys wearing cartridge belts milled around.

Led up a stone stairway to a small room, she came face to face with O'Connor and sat down at a table opposite him. Rory had a pale, ascetic face with deep-set fanatical eyes. He talked slowly and almost sadly, while playing with his revolver. 'We had the British morally broken at the time of the truce,' he said. 'If only Michael Collins had stood firm Lloyd George would have been forced to deal with de Valera. Our cause, that so many have died for, was betrayed on the threshold of success. I would rather see us back in Westminster under protest than agreeing to be a kind of British colony – *no compromise!*'

'Don't stay here,' urged Clare, who was moved by his fervour. 'You haven't a chance.'

'If they attack I will either go down in the ruins or up in the flames,' cried Rory dramatically.

Clare departed near to tears, feeling that she was perhaps too emotional for a journalistic career. The iron gate was unlocked. She

slipped out into the puzzled crowd and walked back to H.Q. to meet de Valera and discuss the difference between the Constitution he had drawn up and that agreed to by Collins.

'You would have done better to go to London yourself,' remarked Clare. But it hardly behoved a journalist to make such a comment. She returned to the Hibernian Hotel to write up her interviews in detail. Next morning artillery fire woke the city at 6 a.m. Clare pulled on a coat and ran downstairs eager for copy. On the hotel steps she stared around hoping for some incident suitable for her paper but a Free State officer looked so shocked at her bare legs that Clare retreated embarrassed.

Indoors, a becapped housemaid was rolling a carpet sweeper. Clare sat down and asked for a cup of tea.

'Who is doing the shooting?'

'Them Free State troops.'

'Are many casualties caused?'

'Not before noon,' answered the maid enigmatically.

Silence then fell over the city. 'Has the Four Courts fallen?' Clare asked the hall porter.

'No – both sides are getting breakfast about now.'

Clare returned to her room and pulled on stockings and a hat. Respectably attired she made her way to Dr Oliver Gogarty, the famous wit and surgeon. The guns started again so she inveigled him to drive her to the Four Courts. 'I've got to see what is going on – I'm a correspondent . . . Oh, poor Rory, I do hope he doesn't get killed.'

They dared not remain near the quays for Republican snipers were now taking pot shots at 'Free State generals' touring in their Ford cars, and Gogarty happened to own a Ford. They drove to his hospital where wounded men were arriving followed by shawled women lamenting.

For twenty-four hours the Four Courts withstood bombardment and Clare hurried around the almost deserted streets looking for 'copy'. When frightened she put her hands in her pockets and whistled.

Then Aunt Leonie, who had been ordered to rest in the country because of a heart tremor, arrived by train from Glaslough and suggested hiring a 'jaunting car' to drive around and see the sights. Clare looked aghast. 'But you're supposed to be having heart trouble!'

'It's only boredom that kills. I've been at Castle Leslie for two months. I *need* excitement,' Leonie replied. So off they went behind

an old horse who shied every time an explosion sounded. 'There's nothing to be done with us Jeromes, is there?' said Clare, 'but *I* happened to be frightened.'

They listened to the arguments of a crowd. The people seemed to be sympathizing with Rory and his Republicans. 'It isn't fair, it's the English put Collins up to this carry-on.'

When Leonie had appeased her curiosity they drove to the Shelbourne Hotel for a cup of tea. Two men in plain clothes were guarding the steps, each holding a revolver. 'Who and why?' Clare asked the hall porter.

'I don't know why they're there or which side they belong to . . .' said the porter.

She joined two press photographers who were impressed to hear that she was the only newspaper correspondent who had got into the Four Courts or thought of interviewing the 'rebel' Rory O'Connor. They said this 'scoop' should be cabled immediately to New York. Clare had not the remotest idea how to embark on such business but a kind gentleman – himself the representative of *Freeman's Journal* – took her to his office and ensconced her in an empty room with pen, ink and telegraph forms. To the accompaniment of cannon and machine-gun fire in the street outside Clare learnt the usage of such words as 'stop' and 'quote' and 'unquote'. It took her two hours to get her story into cable form and then off it went. She enjoyed finishing up with: 'No other journalist has entered Four Courts STOP.'

On 30 June the Four Courts surrendered and proceeded to burn. The fine Georgian dome survived but an explosion filled the air with charred documents – much of Ireland's recorded history vanishing in the smoke. Winston's remark when he heard was: 'Well a State without archives is better than archives without a State.'

That evening, as capitulation of the Four Courts seemed complete, Clare sailed for England. While the steamer moved out of Dublin Bay she stood on deck watching columns of smoke rising against the evening sky. She would never again see Rory O'Connor who was to be shot in reprisal six months later. Or Michael Collins murdered in ambush. The charm and fiery idealism of both men had touched her. She did not yet realize that because of them she had made her name as a top reporter in America.

20

European melting pot

IT was good to be going back to the childern at peaceful Brede.
Oswald now possessed a motor bike with a side-car. He received a
wire 'Meet me 5 train' and that night Clare sat up in the old panelled
drawing-room feverishly arguing Irish politics.

'Did you interview Tim Healy? asked her father, harking back to
the days when he had represented Cork as an Irish Nationalist. 'He'd
have given you some witty stuff.'

'Well, no – there was so much fighting going on and I had to stick
to the Free State–Republican battle.'

Oswald whispered, 'It's cruel to tell him that his Nationalist Party
and William O'Brien and John Redmond are forgotten.'

'Whatever you do I forbid you to write stories true or not about my
niece Ruby,' snorted Papa. Ruby Frewen, married to Sir Edward
Carson, leader of those extreme Protestants of Ulster ready to stir up
mutiny in the British Army rather than accept Dublin rule, shared her
husband's views and had, according to legend, boxed the ears of a man
who offered her shamrock on St Patrick's Day. Regarded as a fiend
by the Irish (Free State *and* Republican), and a dangerous rebel by many
English M.P.s, Carson demanded that the North of Ireland should
not be ruled from Dublin but by a separate government based in
Belfast. Lord Birkenhead had made himself Carson's right-hand man
while with difficulty remaining Winston's friend, for Winston was
against this separating of six counties from the rest of Ireland. It
seemed to him unnatural and he was in constant correspondence with
his Aunt Leonie living in County Monaghan in the thick of the
'troubles'.

On St Patrick's Day she wrote to him:

My dearest Winston: I was indeed touched by your affectionate letter – full of sympathy – there is no doubt you are a Great Darling ... How I've admired yr courage and *patience* – we need to practise both here at present. This transition state is very difficult to cope with. It will be easier after the Elections – Meantime Jack and all those we can influence try to keep the peace – *being* the Border there is friction ... The Union Jacks are being silently stored away – the Sinn Fein flag floats on the former Orange Hall. The country will vote Pro-Treaty. Thank dear Clemmie – My love to you both.

Clare was with Oswald when a telegram arrived for her from New York. She had not realized the importance of a 'scoop' in the newspaper world. This congratulatory cable proclaimed a bonus of a thousand dollars to be added to her monthly salary. 'Where next?' asked Swope. 'Suggest Occupied Territory of the Rhine.'

Clare turned to Oswald. 'How good is your motor bike? You are to drive me to Berlin.'

A week later they departed, Oswald riding his motor bike, Clare with her luggage in the side-car. They crossed to Ostend and rode through Belgium to Aachen which was under Belgian occupation, on to Cologne under the British, to Bonn under the French and to Koblenz under the Americans. From each city Clare dispatched vivid articles to her paper. The German language dinned into her as a girl was proving useful.

Herbert Swope's directive to his editorial staff had been, 'Mrs Sheridan goes with no instructions other than to write the truth as she sees it; to write interesting articles and above all – accurate.'

She complied with these instructions. When Oswald had to return to England Clare travelled on alone to Berlin by train. There she found Chicherin who had avoided being modelled in Moscow, and Litvinov who admitted bitterly that 'the idealism had gone out of the Russian Revolution! It has turned *bourgeois!*'

To New York she sent factual accounts of ordinary Berlin life, of the perverted nightclubs and the feeling of madness created by the falling mark. In her search for copy she was helped by Vladimir Korestovetz, a Russian émigré and the permanent *New York World* correspondent in this part of the world. What a team they made! Korestovetz, enamoured of Clare, behaved as Russians do in this state. And Clare, intoxicated with the excitements of a journalistic career made full use of him as translator, history professor, and discoverer of

material for *her* to cable. Europe was at the time in a state of bewildering turmoil and Korestovetz, working on a book entitled *Europe in the Melting Pot*, made an exceedingly useful partner. Together they roamed the city by day and, after cables and articles had been compiled, Korestovetz showed her the night life.

In mid-August they left together for the Free State of Danzig, at this time administered by the League of Nations. Clare had thought the League of Nations to be a joke invented by President Wilson. Now she wrote: 'Upon enquiry I found that I was quite wrong, and then Korestovetz, who lives in Danzig (because a Russian must live some-where, and Danzig is as good as any other place, and is a centre of political intrigue and of international propaganda), said "Come and see."'

So Clare went and saw. She observed the scene certainly, and she wrote illuminating columns for her paper, the most heart-rending being those on the starving children rescued from Russia. She travelled and wrote by day and she danced by night. Korestovetz would be waiting to take her out to the little seashore town of Zoppot which consisted entirely of restaurants where Russian gypsies sang. Some of the gypsies turned out to be penniless aristocrats who had no other way of earning a living. The guests sang with them and wine flowed till dawn rose up from the sea. Korestovetz was always able to sing mightily, for there is no Russian devoid of ear and voice. Then back to their hotel they would go on a little train, leaving the last of the gypsy dancers still twisting on tables amidst empty champagne bottles. The editorial staff in New York could hardly have visualized their Danzig correspondents *at work*.

The partnership ended rather roughly. Korestovetz, who told me this story himself, had the jealous Slav temperament. And Clare really was a most unsuitable companion for a jealous man. She *would* look around at other men, and there were so many tragic, good-looking Russians in Zoppot. Hot words occurred one evening and Korestovetz told her that he was going to fight a duel. When Clare, feeling penitent, returned to Korestovetz's table, she sat herself down beside him listening to arrangements he was making with a man friend. They seemed to be discussing it in a matter-of-fact way and all was in order for 'revolvers on the morrow'. Then, as she started to intervene the man friend turned to her, 'So good of Vladimir to be my second.'

'What!' cried Clare. 'This isn't a duel about *me*?'

'Well no,' explained Vladimir. 'It's a different duel.'

She took the morning train out of Danzig in umbrage.

Back in Berlin, the British Ambassador, Lord d'Abernon, an old family friend, advised Clare to go to Geneva for copy. 'You will find all the statesmen of Europe there . . . and you will learn more about the true situations in each country than if you travelled for months.'

Forty-two different nationalities had sent representatives to Geneva. Clare described the city:

The hotels were crowded and prices were soaring. There was no social life, no frivolity, and there were few women. The hotel lounges resembled Parliamentary lobbies where men get together and talk in undertones . . . It was a strange atmosphere to reach after the depression of England, the chaos of Ireland, the madness of Paris, the decadence of Germany with its disintegrated Russians.

She attended countless assemblies and councils, but soon grew tired of having her hand kissed by impeccably dressed young secretaries in attendance on the delegates, and she often found it difficult to grasp the political arguments. In fact, the more people talked the less she understood. And she noted that interviews did not roll along in the unrestrained way which used to happen during a modelling session. After a week of attending political meetings, Clare met the aide-de-camp of King Hussein of Arabia who held forth on the war which had broken out between the Greeks and the Turks. Suddenly the peace councils of Geneva seemed tame. Clare hurriedly secured the first available sleeper on the Orient Express. The train took three days to reach Bucharest and another night on to Constanza on the Black Sea. She travelled in style. The wagons-lits attendant told her that he always went to a restaurant in Constantinople where the waitresses were Russian princesses. He said, 'It is very agreeable to be waited on by princesses, they do it so well, they are quiet and quick and amiable, and they accept no *pourboires*.'

By the time she reached Constantinople the Greek Army in Anatolia was in retreat, and journalists were finding it difficult to get news out because British, French, Italian and Turkish censors each deleted any remark critical of themselves. Clare found a hotel from which she could see minarets and hear the muezzins calling the faithful to prayer, and she obtained a special pass to see the Sultan driving forth to the Muhammadan Friday service. He sat expressionless in his carriage while eunuchs walked on each side and his scarlet-clad infantry followed.

The last Sultan was about to be displaced by Kemal Ataturk, adored leader of the new Turkey, who was at this moment in Smyrna. Clare decided she must reach Smyrna and interview Kemal – with luck she might sculpt him as well. She found a maker of clay pipes and bought a bucket of wet clay from him. This she added to her 'light luggage' and she procured a Turkish identification paper which she heard might be more useful than a British passport.

Owing to the fluctuating war situation travel was complicated, but she discovered a ship leaving for Beirut which intended to disembark a Red Crescent delegation at Smyrna en route, and she was able to board this. On arrival at the port, they saw that all hotels had been burnt down and smoke was still rising from the gutted houses along the waterfront. Clare hesitated before setting forth alone in a small boat for the devastated city, but she had made friends with a French newspaper correspondent who said that, before he sailed on to Beirut, he would introduce her to the Commander of an American destroyer anchored in the Bay. So they turned the launch towards this destroyer and drew alongside.

The Captain looked down with surprise at the boat bobbing alongside in which Clare, golden hair blowing, and a large pail of clay with two suitcases by her side, was gazing hopefully up. 'Is it possible to take a journalist on board? All hotels in Smyrna are burned down,' shouted Clare's escort.

'The town is full of irregular troops – no woman can possibly go ashore unguarded,' the Captain replied in horror. Then he took another look at Clare – 'She'll be safe with us. Let her come aboard. One of my officers will give up his cabin . . . But what is the bucket for?' he asked as her belongings were lifted on to the deck.

'In case I can sculpt Kemal Ataturk as well as interview him.'

The naval officers present burst into laughter but, like the Captain, they proved 'sports'. She wrote: 'I shall never forget those five days on board that destroyer. I was treated as a man with that absolute camaraderie and simplicity of hospitality that made one feel one was not in the way.' The Captain fell in with her plans. Next morning he sent her ashore by launch accompanied by a lieutenant who took her to the United States Consulate which had survived among the ruins. There he borrowed a car, and they drove to the house outside the town occupied by Kemal Ataturk.

Carrying pencils and notebook Clare climbed up the long steps to a

veranda where several people sat drinking coffee. Silence fell as the 'lady writer' was escorted indoors. It was an interesting moment when a fair-haired, blue-eyed man stepped forward and made a low bow. Clare registered a kind of magnetic attraction, but so simple was his uniform that, until he introduced himself as Mustapha Kemal, she did not realize that this was Turkey's new leader.

Kemal led her to a sofa and placed himself with his back to an open window. She felt the impact of his personality – a ruthless man, with scorn in him, but full of curiosity. She tried to harness her mind to questions which would interest American readers. Kemal Ataturk proved evasive over the plight of the Armenians who were being evacuated from the port. He insisted that they could not be assimilated into the Turkish nation. Yet he swore that the new Turkey would be tolerant of non-Muslims.

He was watching her like a cat. She thoroughly enjoyed seeing the feeling she could arouse in him, yet she remained thankful that a brisk American lieutenant was waiting for her in a car that carried the Stars and Stripes.

Then she told Kemal of the clay which she had with such difficulty found in Constantinople – of how she had lugged it out to the destroyer and of her desire to model his head. 'I could do something really good,' she begged. 'Lenin and Trotsky let me model them – Julius Caesar and Alexander the Great found time for sculptors . . .'

Kemal laughed and she thought she had him netted. But to Clare's dismay at this moment the door opened and in came a servant bearing saucers of sweet jam and glasses, followed by a round-faced young woman in western clothes who sat down and looked at Clare with furious disdain. The jam was swallowed from teaspoons in an uncomfortable silence. Kemal showed his guest how to wash it down with sips of cold water. Clare gladly copied him to avoid choking with exasperation. 'I will remain with the American Navy until you find the time to pose,' she said. But Kemal kept gazing anxiously towards the woman's scornful dark eyes which never left Clare's face.

'Madame,' he excused himself, 'I am not in my own quarters here. When we reach Constantinople I will sit for you.'

'But that may be a long time off.'

'No, not long.'

'You have clean-cut features and the expression of a sphinx. I would like to do you in your tall fur kalpak. *It would be good!* The American

Captain has promised to let the ship's carpenter make a stand. Do let me begin tomorrow.'

The Mohammedan religious ban on the creating of a likeness of living persons could not affect Kemal Ataturk the Reformer, but he shuffled uneasily – half pleased, half puzzled. 'I will sit for you in Constantinople,' he repeated.

'No, tomorrow,' begged Clare. But she had met an impasse. She did not know that the angry young woman sitting there was Kemal's bride-to-be – Latifé Hanum, leader of the Turkish feminine emancipation group. Well educated, charmless and very jealous, she had captured Kemal Ataturk, and her rage at seeing his obvious admiration for this 'lady writer' increased with each moment. Three years later Kemal would toss Latifé aside, but at this time she dominated him and was able to prevent Clare getting her man into clay. The saucers of jam were scraped clean, the glasses of water were emptied. Clare realized there was nothing for it but to rise and politely say good-bye.

'So, I must wait until Constantinople?'

'I'll be there.'

Latifé stepped forward. She held out a hand to Clare but could not bring herself to speak. Clare descended the long steep stairs nervously, hoping no large stone would descend on her head.

Back on the destroyer the officers sympathized with Clare's ill luck. She went ashore with them each day in the Captain's launch to struggle with the mob of hysterical refugees fleeing from Turkish rule. As their launch reached the pier, women would break through the cordon to kneel in front of the white-uniformed lieutenants, clutching them round the knees and begging for transport to Greece in an assortment of languages. On the first day they embarked 70000 people into eleven ships between sunrise and sunset but next day the crowds appeared as large as ever.

Clare was standing between an American officer and a Turkish guard, when she noticed a Greek just taken into custody staring intently into her eyes. He seemed to be fumbling at his neck. Suddenly she saw blood and realized that he was cutting his throat. She begged the guards to stop him but they watched with indifference. The wretch missed his jugular vein and fell on the ground where he tried to bash his brains out. Then he ran to the quay and threw himself into the water where he slowly drowned amidst rotting corpses. A line of soldiers was standing with fixed bayonets to prevent the crowd

rushing the gates, but no one moved to help him. Amidst the weeping and shouting Clare and the officers searched in vain for a boat hook.

That night, back in the clean, iron security of her destroyer cabin, Clare wrote a poignant description of the evacuation of Smyrna for her paper and described this incident.

I was amazed at the time it takes to drown. Every moment the red circle around him grew larger, and still he moved, like a wounded bird. The Turks, so prodigal with their bullets, never had the mercy to help him to his death. They just watched, and waited, and finally when he ceased to move, one of them waded out and removed his coat from him and searched his pockets.

After five days of struggling with dying, panicking refugees, lost children and desolate mothers, and of talking to the bitter Turkish soldiers who had themselves just crossed a country where their own people had been massacred by retreating Greeks, Clare's mind was reeling. She developed a new hate – not for Turks, nor Greeks, but for the statesmen of Versailles.

When a British cruiser steamed into harbour, the Captain, hearing that Winston's cousin was on board, invited Clare over to lunch. She did not guess it was to give her a scolding. 'To be a war correspondent is not a woman's job.'

She retorted, 'I am needed not only to write but to help, and we need English sailors here too. There aren't enough to carry the sick or give them water to drink or save the children from being trampled. Every time the pier gates close after the departure of a ship it looks as if people were lying asleep. But those are the corpses. What can one do with them? You can't carry them back through the refugees – so they just get pushed into the sea. All this because of politicians and statesmen – I am trying to let the world know.'

The Captain stared. Clare was the first of her kind.

On the night of her fifth day of working with the refugees, when Clare returned to the American destroyer, the Captain told her that a cruiser was leaving for Piraeus. She could have a passage on board if she left immediately. She took it and reached Greece at dawn on this warship. A launch conveyed her to the landing steps where she called a taxi and drove to a hotel. It seemed extraordinary to be back in the world of taxis and houses that were not gutted. After spending a few hours getting her newspaper reports in order (they were to win her fresh bonuses and commendations) she set forth to see the Acropolis. Then she began to fuss about her children. Margaret and Louise had

departed for New York where they were living in a hotel so that Miss Spence's education could be continued. Dick was still with his grandparents at Brede. Clare telegraphed home: 'Read my accounts Smyrna stop. Returning Constantinople stop. Bulgaria next.'

A peace conference was to be held in a village named Mudania on the Anatolian coast. Clare joined the throng of correspondents eager to get there. The British who intended to dominate this conference had forbidden the press to attend, with the result that reporters were scheming hard. Clare chose to join the American group, the members of which agreed to pool the cost of a tugboat and also to pool news. Carrying sausage rolls and portable typewriters they set out for the six-hour trip across the Sea of Marmora. To Clare, the sea shining like shot-silk under a full moon was stunningly beautiful. One by one the journalists fell asleep on deck, but on reaching Mamora at midnight, mosquitoes began to bite. Clare retreated to the sole cabin, but there fleas drove her back to the mosquitoes. It was a relief when the sun rose and the party could go ashore for hot coffee.

Clare proceeded to the Town Hall to interview the French delegate Franklin Bouillon, and immediately found *him* interviewing her. '*A woman – here – alone!* Where do you imagine you will sleep tonight?'

'Well, I hardly slept at all last night – anywhere one does not get bitten.'

'The French Navy had better look after you. We will go out to the flag ship with Admiral Dumesnil.'

So Clare found herself once again installed on a warship. It suited her perfectly, for Monsieur Bouillon, special envoy of the French government, who knew everything about the conference, occupied a cabin nearby, and he dictated her articles, which thus became spiced with real news. As the British censor might not have passed Bouillon's version, her dispatches were telegraphed by the warship to the French Embassy in Constantinople. Meanwhile the male correspondents were left itching amidst fleas and mosquitoes on shore. Clare did not dare let them know how well she was getting along. They *had* agreed to pool the news, but, how could she share her triumph now that she was reading every telegram exchanged between the French and Kemal Ataturk, and her cables were being framed word for word by Monsieur

Bouillon, and sent by naval-diplomatic channels? It was a scoop of scoops.

On 11 October, when peace was signed and the tension dropped, Clare knew she had from her perch with the French Navy done her paper extremely well. Swope again cabled congratulations.

The conference ended, she set forth by train across Thrace for Sofia. Stamboulisky, the shepherd premier of Bulgaria, had caught her imagination. She simply telegraphed him that she was arriving for an interview, and hoped for the best. Not a room could be had in any Sofia hotel, but Clare talked so glibly about her 'friend the Prime Minister' that a harassed manager finally installed her in the room of an absent guest.

Next morning she was in her bath when a girl's voice called through the door in English: 'Mrs Sheridan, I am the Prime Minister's secretary.' Wrapped in a towel Clare peeped out and confronted the enchanting Madejda Stancioff, the only woman interpreter ever to reach the platform of the League of Nations. They liked each other instantly. 'Isn't your father Minister in London? I've met him there,' remarked the dripping Clare in her best drawing-room manner. Madejda laughed. 'Yes, and we've been told to look out for you by You-know-whom.'

'You don't mean my cousin!'

'Yes, I do.'

'Oh, poor Winston!'

When Clare had dressed, Madejda carried her off to interview Stamboulisky. Madejda was herself so clever and fluent as an interpreter that Clare found it difficult to form any opinion of the peasant leader. She guessed at his shrewdness but could not assess his brilliance. All he really wanted was to use Clare as a megaphone to the outer world, calling for a port on the Aegean. 'Would you like an audience with our King Boris?' he finally asked. 'If so, Madejda will arrange it – if a King *can* be good – our King *is* good.'

Clare thought such a meeting might produce most interesting copy and Madejda made arrangements for the following morning. 'Come back to Bulgaria next summer and bring your children for a holiday; I will arrange it,' were Stamboulisky's last words.

King Boris wanted to talk about his railway system. Clare led him on to the subject of Bolshevism but he was single-minded and attributed all Russia's problems to the condition of her railways! America

had scarcely heard of Boris of Bulgaria, and a king always aroused interest even in a public not avid for news about Balkan agricultural reforms. Clare's articles in the *New York World* obtained great success. She would never return however to the 'village of roses' for in the following year Stamboulisky would be murdered and Madejda would marry the Scottish Sir Alexander Kay Muir and become one of Clare's life-long friends.

Having got what she could out of Bulgaria, Clare thought it might be rewarding to visit Roumania where King Ferdinand and Queen Marie had just enjoyed their spectacular coronation.

Marie, the first queen ever crowned there, had, to the delight of her subjects, improvised a tremendous show, for she possessed a surprising sense of theatre. She designed her own shimmering gold robe and a crown made in Byzantine style set with moonstones, amethysts, and turquoises.

Clare crossed the Danube by ferry and found herself held up by officials who disliked her visa from plague-ridden Constantinople. Only the assurances of her Bulgarian police escort, that she had shown no symptoms, got her to Bucharest. Once in Roumania she could look up acquaintances who would make her way easy and interesting. Princess Marthe Bibesco, an old friend of Aunt Leonie and Aunt Jennie,* was eager to help the 'amusing niece'. She invited Clare to stay at Posada, the Bibescos' mountain home, which lay near to Pelisor the royal summer residence above the resort of Sinaia in the Carpathian Mountains.

Marthe, celebrated as a woman of letters throughout Europe, possessed sparkling wit and a vivacity which might be called Parisian tinged with the oriental and she gave the sensitive, scholarly King Ferdinand the only happiness he knew during his repressed life. She liked the post of *maîtresse en titre* to the shy handsome king, and her heart was warm.

The Bibesco summer castle proved extremely interesting in 1922, for not only did Marthe make the most of her personal link with the King, but her sister-in-law, Princess Stirbey, briefed Clare in the history of the last few years. Clare was, of course, impressed by the dark good looks of the Prince Stirbey, the *éminence grise* of Roumania

*Marthe Bibesco had, in fact, encouraged Jennie to write her ill-fated play, *Borrowed Plumes*, and attended Jennie's first night party at the Ritz when Mrs Patrick Campbell flirted with Jennie's young second husband.

who had since 1907 been regarded as Queen Marie's lover, and wondered if *he* might not like to have his bust done. It would be, she was told, dangerous – but why she could not find out. Stirbey, much hated, but not by women, will remain a tantalizing character in Balkan history. He was not the only man to receive the favour of the Queen's affections, but he was the most interesting one. A visitor to Bucharest describes the Queen and Prince Stirbey at a court ball. They stood for half an hour talking, watching the dancers, without ever looking at one another. According to etiquette, even *glances* in public were forbidden.

The royal marriage had started badly when the seventeen-year-old Marie went to her wedding night ignorant of what might be expected of her. Taken by surprise she blamed Prince Ferdinand for the 'facts of life'. By the time she came to mind them less, he had become cowed by her displeasure. Ferdinand suffered from shyness, and too late he realized that the most voluptuous queen in Europe needed the wooing of a man who was *not shy*. Marthe Bibesco rescued his self respect and gilded his private hours.

Clare found herself back in the atmosphere of the Edwardian country house parties of her girlhood, with an oriental touch added. Marthe's guests included the British Minister and the Roumanian Foreign Minister, Jean Duca, leader of the Liberal party.* Both these gentlemen looked quizzical when told that Clare hoped to interview Queen Marie for the *New York World*. The spectacular Queen (most illustriously bred of princesses, for her grandparents were Queen Victoria, Prince Albert, and the Tsar and Tsarina of Russia) had just emerged from an unhappy war. Her first cousins sat on the thrones of England, Germany, Russia, Norway, Greece and Spain. She worked fearlessly in field hospitals and wrote desperate appeals for aid in American newspapers. Her renown in the Western hemisphere increased later when Queen Marie took to writing articles (all profoundly moral!) with such titles as *My Experiences with Men*, and *Making Marriage Durable*, and *Women and Beauty*.

Marthe, who was the Queen's closest woman friend, first arranged for Clare to visit Marie's son, the Crown Prince Carol, at that moment suitably married to a Greek princess. A few days later Marthe took her guest riding along forested mountain paths to Pelisor, one of the fairy-tale Gothic castles built for the new monarchs. 'When you meet

*Jean Duca was assassinated by the Nazi-financed Iron Guard in 1933.

Queen Marie,' warned Marthe, 'remember that she either bewitches or exasperates – there is no one else like her. Try to visualize her walking around the freezing hospitals of that terrible winter when Roumania went to war and Russia let us down. The soldiers adored her.'

'What did she want to drag Roumania into the war for anyway?' parried Clare, and at that moment they met King Ferdinand strolling in the garden which he had laid out with expert knowledge. Grooms led away the horses while he chatted amiably. Clare liked Ferdinand's distinguished appearance – the neat grey beard, the tall grey astrakhan Kalpak on his head, the restrained voice. The King's face lit up as he talked to Marthe, her scathing wit and her large dark expressive eyes drew away the veils behind which he hid.

Being German, he had recoiled against going to war against the country which had bred and trained him. Marie, being half English and half Russian, had struggled to bring Roumania in with the Allies. The Kaiser called her a 'trouble-making flirt' while the dazed, ill-equipped Roumanian peasantry died bravely for their dramatic Queen. 'You wish to talk to the Queen for an American paper? She awaits you,' and Ferdinand directed Clare to follow an aide into the castle.

The first person to appear was the ageing American dancer Loïe Fuller who had enthralled and shocked Edwardian drawing-rooms by skipping about to Chopin *in bare feet*. Clare had last seen her performing at 10 Downing Street. It was curious to meet that once seductive artist grown plump and garrulous, retired to a Balkan court. Loïe Fuller led Clare upstairs to a royal sitting-room with walls of gold decorated with lilies. Queen Marie was standing waiting. She always took pains to make an impression and she had dressed carefully for this meeting. It was, in fact, her intention to say *something to America* whose Red Cross had generously responded to her pleas for medicines and bandages for Roumanian soldiers. And Clare intended to win more laurels for first-class interviewing.

This was not to be. The electric shock waves of dislike between the two women rendered contact impossible. Clare took one look at the Queen, clad in embroidered Roumanian peasant costume with a blue turban and white veil, and the nervousness she had felt as a 'well-known Bolshevik' turned to irritation. And Marie, staring at Clare's Russian boots, forgot all she intended to say for the edification of the

American public. Waving her interviewer to a sofa, the Queen sat down beside her and, according to Clare, did not allow her to get a word in edgeways for an hour and a quarter. Her Majesty's indignation was understandable. Clare had 'stayed as a house guest in the Kremlin' with men who had mowed down the Romanovs in cold blood, and Marie *was* half Romanov. But the Queen knew all this in advance. She'd had time to prepare her mood. And it might conceivably have been of interest to her to hear Mrs Sheridan's impression of the murderers.

The two women, both famed for uncontrollable temper, sat viewing each other like queen hornets. But only Her Majesty spoke.

This was not Clare's idea of an interview. However, she had been brought up not to interrupt queens and she *was* in the other hornet's nest. Marie, at forty-seven, was still extremely beautiful, which may have further ruffled her would-be interrogator. Clare felt herself turning red and hot, but she admired violent feelings and she admired a show. At last she tried to break into the tirade. 'Perhaps you are more interesting as an artist than as a queen?' But this olive branch was cast aside, and Marie continued, 'And the King of Italy who ought to know better is as bad as you. He has actually received Chicherin.'

Clare tried to butt in with a story against herself, telling how Chicherin had refused to permit her to do his bust. But it was no good.

When Clare returned with Marthe to the Bibesco castle, which was more beautiful though less surprising than the German-Gothic habitations of the royals, she found Jean Duca waiting for her with an expression of amused interrogation. 'So you are a traitor to your class, Madame Sheridan! I knew she would say that.'

'But what *is* my class?' asked Clare. 'What am I but a human being? A widow struggling to support her children!'

Duca's eyebrows rose high, and Marthe stepped forward soothingly. 'One might have guessed there would be trouble between you and the Queen. You are too much the same – thoughtless romantics – how *could* you like each other!'

Those were Marthe Bibesco's words to Clare. Later on she would be exceedingly funny about the two women.

Imaginez – ces deux là – [Marthe used French more than her other languages] the two of them quivering with emotion and that overdose of sex-appeal which got them in and out of so much trouble quite useless. They both had *un tel penchant* for fancy dress but on this occasion the Queen won hands down. And really she was more justly

G

entitled to her Roumanian peasant costume than Clare was to Cossack boots. They were both guileless, passionate, brave and impulsive. We had such a time keeping our faces straight when each gave her own version of this famous 'interview'. *What* a débâcle! What a clash of temperaments. And all for the sake of an American newspaper!

Clare left the country soon after. She had decided that her next 'scoop' *must* be male.

21

Signor Mussolini

AFTER this disconcerting interview with Queen Marie, Clare decided to return to Switzerland to cover an international conference convened to settle Europe's ills. Before she took the train from Bucharest Jean Duca handed her a magnificent sealed document which she imagined must be a diplomatic pass of some kind. She waved it at the frontier officials as they turned her suitcases and her handbag inside out, 'looking for carpets' they said. Finally she inquired in French what her handsome document meant. 'It says you yourself are not to be searched.'

As the Simplon Orient Express rumbled through Yugoslavia, more searchings took place. Clare became cross, refused to lift her cases down from the luggage rack and the train was kept waiting while her diaries were carefully examined by burly, fur-hatted men who understood not a word of English.

The Beau Rivage Hotel in Lausanne might be a haven of clean sheets and flealess mattresses, but she soon realized that the conference was going to be long and dull – not at all like the one at Mudania when she had lived on a battleship and received 'hot' news denied to other journalists. Here, the press were treated like dirt and admitted nowhere. They hung about the foyers of the hotels, trying to waylay any man of importance who walked through.

This was not at all Clare's idea of journalistic activity, but she brightened when Mussolini, spectacular leader of the recent Fascist revolution, arrived on the scene. A natural orator, his pronouncements on the Fascist cure-all gave reporters something to write about. His enthusiasm and the power of his personality took immediate effect. Clare learned that under his control Italy enjoyed no strikes, soaring

trade and the reduction of a huge civil service. She took notes and dutifully cabled articles to New York.

Soon she had collected four Italian beaux among the delegates and secretaries. These gentlemen assured her that a dictatorship was less damaging to personal liberty than a bureaucracy, and each promised to pull a string to obtain her an interview with their great man. Clare saw Mussolini for the first time in the foyer of the hotel, surrounded by his young bodyguard. A flutter of excitement ran through the journalists who were vying with one another to obtain interviews. She waited for a couple of days, entertaining herself with friends of various nationalities and scolding the Turks for wearing top hats and bowlers instead of their own becoming fez.

Clare was, in fact, talking to Kemal's friend, the poet Rouchen Eschref Bey, when a messenger arrived to say that 'Le Président du Conseil' Signor Mussolini would see her immediately. Clare broke away while the Bey asked her why this interview should make her *quite* so excited. Clare combed her hair, powdered her nose, flung a coloured cape around her shoulders, then, pen and paper in hand, proceeded to the landing outside Mussolini's room, which was well guarded by his uniformed Fascists. She was led into a sitting-room in the centre of which stood a large vase of flowers tied with the Italian colours.

There she was left quite alone for ten minutes. Then the door opened and Mussolini strode in. He never just entered, he 'made an entrance'. So bulgy were his eyes that Clare almost laughed. Luckily she didn't, for already something in her candid blue-eyed gaze had aroused antagonism in the *Duce*. Obviously he thought that she was out to get him – all women were. But he liked to dominate. He would see that *he* got *her*. They settled down, speaking in French, to conventional interview routine.

'I know all about you and your connections with the Russians,' said Mussolini.

'Well, what do you think of their efforts? I want to write about your attitudes to the working classes.'

Mussolini waved a big hand. 'The working classes are stupid, dirty, lazy and only need the cinema. They must be taken care of and learn to obey.'

Clare ceased scribbling. She thought she could remember his words. He went on about *le peuple* – '. . . what is this vague herd? I do not

want their applause – I want to touch them and bend them. It is impossible to govern except through a strong minority. There is no such thing as equality – if there were then beauty and individuality would be stamped out – it would be an intolerable world. . . .'

He did not look at Clare as he talked. Gazing across the room, he snapped his jaws at the end of each sentence; occasionally he closed his eyes and sat motionless waiting for her reaction. She showed none, and after several long silences he picked up the threads again on his own. She was trying to memorize everything he said, but at the same time she could not resist the desire to memorize that extraordinary face – and to sculpt it. By nature she was an artist, not a journalist. When he touched the subject of art, Mussolini changed. He talked with passion and Clare warmed to him. She could not tell if he was laughing or scolding her. Then he asked about her sculpture of '*ces gens-là dans le Kremlin*' and she admitted frankly she hoped to do his bust.

He never flicked an eyelid. Maybe he wanted to find out if she was any good. 'Come to Rome with me. Come and see my Fascists in *la gloire de leur jeunesse* – Ah! youth in the abstract – how beautiful it is – and that, if you want to know, is all I really care for – Youth!'

He looked hard at her and added: 'You are an artist and *une révoltée* but you must learn obedience. Catch the midnight train and I will show you my new Rome.'

Where had she heard the words before? 'Catch the train and I will show you my new revolution.' She had not dared to go with Trotsky. The cold made it unbearable. But a sleeper to Milan was a very different story.

She moved to the door, and he kissed her hand coldly: '*A bientôt.*'

It was six o'clock. Secretaries and journalists who knew her were on the landing, their faces alight with curiosity.

Well? How did you get on?'

'He's marvellous,' she replied.

The correspondent of the *Stampa di Torino*, who had known her at Mudania, walked with her down the stairs. 'How can you be taken in? He's just playing with you.'

Clare snorted. 'Who said I was taken in? You're jealous because I'm so good at my job – I'm off on the midnight train to cover his return to Rome. *Il est quelqu'un quand même.*'

A secretary informed her he had been told to purchase her ticket

and accompany her en route. All she had to do was pack her bags and leave the hotel. This she hastened to do and soon she was asleep in her couchette. After the train had passed the frontier she frequently heard singing. Lifting the blind she saw that crowds waited through the night at every station to greet their *Duce* with the Fascist hymn. As the strong clear Italian voices took up the throbbing refrain Clare sleepily registered that they were all male. She thought it very moving and very romantic indeed.

Mussolini halted his triumphal progress at Milan for the day. His wife and a glamorous mistress lived in Milan. He liked to keep his women separate from his political affairs. These domestic arrangements amused his staff. 'The chief is always so tired when he leaves Milan,' they tittered. That night when the train departed for Rome orders were telegraphed ahead that no demonstrations were to take place at stations – Mussolini wished to rest.

On reaching Rome, Clare's escort booked a room for her in the Grand Hotel where Mussolini had installed his temporary headquarters. Clare had no intention of having an affair with Mussolini, she just wanted to sculpt him, interview him, and have an interesting time.

She rang up her Italian sister-in-law, Hugh's wife Mémy, asking her to install herself in the hotel in the next-door room. All that day Clare rested and then went out to dine and dance with an old beau. When she returned her sister-in-law had a message from Mussolini, whom she knew slightly – he had sent for Clare at 9 o'clock and would send again on the following evening. Would 7.30 suit her? Clare accepted the invitation by telephone and went to bed elated.

On the following night she proceeded to his suite as arranged, feeling remarkably pleased with herself. Much as he scorned women, Mussolini was evidently interested in her, and she expected to obtain unique material for her paper. *Another scoop!*

The interviews which followed were indeed unique, but they did not lend themselves to reporting. She wondered on the first occasion if Mussolini would ask her to dinner, but in case he didn't she had her gentleman friend waiting ready to take her dancing again. Clare loved dancing and Rome was full of amusing *boîtes de nuit*. On being ushered into Mussolini's room, she saw that he was just finishing a meal served on a tray. 'I apologize for not asking you to a meal but I eat very lightly – one cannot eat and work, and I am due at the theatre to see Sarah Bernhardt.' He handed her a glass of wine and some fruit.

'Coffee?' His round black eyes stared. Clare felt that she was just the sort of woman he most detested.

'Why don't you bring your wife to Rome?' she asked naïvely.

'Never! Women – children – belongings – luxury – they clutter up – one cannot work with all that round one's neck. Art and literature are different – they lighten, they inspire.'

Clare changed the topic. 'Tell me about your parents. Were they difficult?'

Mussolini's face softened. 'I come of peasant stock. My father was a blacksmith – he gave me strength – ' and he lifted his arm bulging with muscle while his eyes bulged too. 'And my mother – ah, she was sweet and sensitive – a school teacher – a lover of poetry – she feared my tempestuous nature, but she loved me – and I loved her.' This was the only note of gentleness Clare ever perceived in him.

They continued discussing various subjects, until suddenly he asked: 'What age do you suppose I am?' She hesitated, wondering if he was fishing for a compliment, then answered truthfully, 'I could not guess.' He liked that. 'I must go,' she said, 'the theatre waits for you and some-one is waiting for me – but what I would really like...'

He knew it before she spoke the words. 'Is to model my head as you did those fellows in the Kremlin – well, I don't know. It is late and you must be hungry. Go to your friend.'

At the door he kissed her hand as before, unsmiling. 'Never let your enthusiasm rob you of your appetite – keep your heart a desert.'

Certainly Clare was intrigued. Unwisely she went again when he sent for her. And again he was a difficult subject to interview, but his head – so bull-like, so different from other men's – was made to be sculpted.

They talked occasionally about politics and why he had abandoned Socialism and often about power which was all he really cared for (except for youth, but it was youth that gave him the power). The phrases which Clare recorded for her newspaper and her diaries are inconsistent and often platitudinous: 'My love for the people is my love for the springtime,' said Mussolini.

She tried to gather some strands of his philosophy and asked if she could use them in her articles for the *New York World*. He rounded on her. 'I forbid you to publish anything I have told you. I have treated you as a friend not as a journalist – I have spoken openly – said too much. If you ever write anything about me I shall know it. I have agents

[187]

all over the world and you will suffer. There is not a country where my Fascist police cannot penetrate.'

She was disconcerted. Her intention had been to stun her editors with all this material. Why should he object to his views being exposed by a woman? What harm could this outpouring about youth and springtime do him? But Mussolini was relapsing into one of his sullen silent moods. Only her album containing photographs of her sculpture seemed to interest him. 'Curious,' he said, 'I never thought you could do work like that – you a young woman – and beautiful still.' After a pause, he asked coldly. 'Why do you interest yourself in the world's problems? Lead your life and let problems take care of themselves. Don't always be saying "Why?" '

He half promised to let her do his bust, but she felt that the fact that she was a woman embarrassed him. He could not see her outside the restrictions of her sex. In the end he suggested she go to the Senate to hear his speech on the following afternoon. 'You may write up that if you wish.'

'But everyone else will,' she protested. He remained adamant.

She was much impressed by his oratory. There was absolute silence in the Senate. He spoke coldly and calmly for a time, then became wrought up and used the blacksmith's forceful gestures. When he sat down there was a roar of applause which he accepted unsmiling.

Clare did her best to convey the extraordinary atmosphere Mussolini could arouse, in her article for the *New York World*, but she was a little nervous. How much better to mould that fierce mask into bronze for posterity!

That night he sent a messenger for her at 10 o'clock. Mémy, her sister-in-law, urged caution. 'You must not play about with that man.'

'But he's promised I shall do his bust. I'm going to start by making sketches and I have the clay. He likes my work,' she insisted.

On arrival in Mussolini's room she found that a dust sheet had been laid around the model stand and her clay and tools lay ready. With her air of excitement and absolute guilelessness, Clare did not realize how provocative she was. She would never record on paper what occurred on this final visit, but I think she rather enjoyed indignantly recalling the details to me.

The Fascist guards and detectives were accustomed to her now. They bowed her to the landing. That evening she swanned in, swathed as always in floating veils, and set to work on the first sketches. Mussolini

sat staring through her – or so she thought. Her pencil drew the basic lines – it was difficult not to create a caricature for his face was in itself an exaggeration of feature and expression. How contented she felt at getting him to pose at last. What did she care about his politics? It was the power of that mask she must catch. Luckily she did not have to sketch his feet – they were large feet encased in spats and when he stamped about on them she could hardly keep her face straight.

Then suddenly she looked up and saw him advancing – in her own words – 'nostrils flaring – head down like an angry bull'.

'*Vous êtes une femme pour qui on pourrait avoir une grande passion,*' he said breathlessly and seized hold of her.

Confronted with this blonde tigress he thought, of course, that she wished to seduce him. And that would never do. *He* must seduce *her.* Sketch-book and clay flew to the ceiling, slaps, punches, wrestling, gasping cries of amazement (on both sides) filled the room. Clare couldn't believe it true. Neither could Mussolini – she was taller than he, but he was stronger.

'You will not leave till dawn, and then you will be broken in,' were his exact words. He blocked the way to the main door, but grabbing her handbag she made for the side exit. He got there before her and there was, according to her own account, a veritable hand-to-hand struggle for the key. Clare managed to snatch it and open the door. It took a long time, she said. But eventually she managed to wedge it open with her foot. Mussolini threw his whole heavy weight against the door to close it and caught her elbow in the process. Her screams of pain halted him. Purple in the face he stood back for a moment and she was able to wrench herself from his grasp. Then the telephone rang and he glanced towards it. Only a very important call would have been put through.

'Don't go!' he commanded. Then snatching up the receiver, 'Hello – yes – in Greece is it? *All* the ministers murdered . . .!'

Clare escaped. The Fascist guards gaped as she hurried through them dishevelled and crying with rage.

Mémy comforted her not at all. 'Did you get his likeness?'

'Send for a doctor. My arm is broken,' moaned Clare. She was extremely badly bruised.

Next morning a knock sounded on her door. Mémy approached cautiously. There stood two grim-faced Fascist guards with a letter for Signora Sheridan. It read:

[189]

Madame, Je vous prie instamment de vouloir renvoyer ma première pose pour ce buste fameux & que je ne désire pas. J'aime pas les monuments faits aux vivants. Leur résultat est de vieillir. Cordialité sincère, Mussolini.

'Get out of Italy while you can,' advised Mémy. Clare boarded the next train for Switzerland. She seethed with resentment. Beloved Italy had been spoiled by this hateful man.

Christmas lay ahead. She would pay Mussolini back later. For the moment she must concentrate on her much neglected maternal duties.

On reaching London she poured forth her tale of woe to Winston. He was less sympathetic than she expected. In fact, he appeared almost amused. 'But you dear thing. What ever did you expect carrying on like that? Sooner or later it was bound to happen. You've been asking for it, Clare.'

'But I'm bruised. Look at my elbow.'

'Disgraceful. But we can't go to war about *that*. And anyway, my dear, I'm out of office!'

Feeling herself very hardly used, Clare travelled down to Sussex, gathered up Dick from his grandparents and set sail for New York where Margaret had been for two months. During this voyage Clare wrote an article about Mussolini, using the phrase 'a grotesque tyrant in white spats', which was to cause him much displeasure.

The mid-winter seas were grey and gloomy. Italy was virtually banned to her.

And Winston had laughed!

22

More roving commissions

HERBERT SWOPE welcomed Clare back to New York and a number of sculpting commissions were lined up. What she had not envisaged and did not enjoy were the reprimands meted out by Mr Baruch. He had been appalled by Margaret's lonely predicament as an eleven-year-old girl lodged in a cheap hotel with only the amazing little Louise, now called 'a governess', in charge. Every day Margaret would be walked to the school where, indeed, she obtained without fees what was considered the best education in America, but she had no home life and no background, and she was still dressed in 'arty' clothes!

During Clare's absence Barney Baruch had become extremely sensitive to the child's situation. He took her out for treats and at Christmas loaded her with presents. Clare did not like to be told she was a bad mother. This, coming on top of the débâcle in Rome, caused her a bout of melancholy. Rich clients bored her. She wanted to sculpt *extraordinary* people. And she felt that both Winston and Baruch were very unfair.

Suddenly she realized that life in America was not for her. It had all seemed wonderful to start with, but the cost of living reduced her earnings to a joke. Journalistic fees and bonuses had barely sufficed to cover her own extravagant tastes. She had returned to New York with trunks of shimmering Turkish scarves but only ten pounds in her purse. Even after visiting Baltimore and Philadelphia to model people who considered themselves 'swells', Clare found it difficult to pay for her

children's keep. A few thousand dollars had accrued but she knew that it would soon disappear. She must live somewhere *cheap*.

Herbert Swope came to the rescue once again. He offered her a fixed salary for a year to write two articles a week from Germany where the falling mark ought to be making things very cheap indeed. A square meal needed a wheelbarrow of marks to pay for it, and one American dollar could turn into several wheelbarrow loads. It might be a blow to Margaret to whisk her away from Miss Spence's splendid school, but she could learn German and Russian and Modern Politics, instead of the Medieval History in which she was at present absorbed.

On the night before leaving New York Clare threw a party in her studio. Margaret and Dick were dispatched to Coney Island with Louise and Louise's boy friend (there was never a dearth of these). The outing proved even more memorable than Louise intended. Dick sustained a bump on his forehead and a black eye on the Dodgem cars; Margaret had a heavy nose bleed on the scenic railway. Popcorn and hot dogs caused both children to throw up. Louise brought them back at midnight, their coats damp from sponging, and met Clare speeding the last guests into the elevator, some carrying her sculpture as good-bye gifts. Clare actually screamed at the sight of her offspring.

Next day they sailed for Hamburg. The purser informed Clare that the mass of flowers arriving in her cabin could 'sink the ship' and thoughtful old Mrs Vanderbilt sent each child a pogo-stick on which to hop noisily around the decks disturbing people throughout the voyage.

On 4 March 1923, Oswald alerted by cable to come out in a tug from Plymouth and breakfast aboard the steamer, managed to keep the rendez-vous. His diary records: 'Only had an hour on board but Puss is full of vitality and some of it overflowed into me. She is on the 'saving lay' now – (wonder how long it will last!) and is off on a $100 a week contract to Berlin till October. Louise and a large trunk of heavy belongings returned with him to Plymouth on the tug.

In Berlin Vladimir Korestovetz was waiting to escort them to their hotel. Reinstated in Clare's favour he soon became the only one of 'Mama's Russians' the children liked. They did not, however, appreciate the tutorial system he devised. A Professor Edelhaus was employed to teach Russian – a language which neither child had the slightest intention of learning. Dick evaded his lessons by announcing that he wanted to be a violinist 'like that pretty girl in the ship's

orchestra'. Edelhaus leapt into the breach – *he* was a violinist – he could teach music even better than Russian. The hotel rang with the not-so-very-musical Dick's scrapings on his newly purchased violin, while Edelhaus played louder and louder. His glittering eyes puzzled Margaret until Korestovetz explained that the Professor had taken rather too much 'coco'. Russian émigrés in Berlin at that time used cocaine quite naturally as a sedative suitable to their situation.

Clare remained hypnotized by the glamour of all things Russian. As Margaret had, during her days with Lady Wavertree, been taught ballet at Miss Vacani's smart social classes, it was decreed that she should train as a ballerina. Margaret was taken to a dingy attic where the dressing-room 'had to be smelled to be believed' and her tulle ballet skirt and pink satin shoes aroused glances of scorn among perspiring pupils in dirty underwear. Madame Ludmilla placed the new girl at the *barre* and twisted her leg until she yelped. As Margaret has since written: 'This had nothing in common with the Charity Gala at the Hyde Park Hotel where I had done a star turn as the Flower Fairy Daffodil with Miss Vacani's pupils.' Next day Madame Ludmilla telephoned Clare that her daughter had no talent. Margaret eagerly agreed.

Then came a political crisis over Danzig. Troops were said to be massing on the Polish frontier. Clare, with Korestovetz in tow, travelled throughout Germany in search of material. Her articles for the *New York World* were again successful but when the excitement died down, with comic lack of prescience Clare would write: 'In Munich Mr Hitler had raised an army of Fascists and threatened violence to the German Republic. That he fizzled out into a mere nothing could not have been foreseen. At the moment he seemed all-important.'

During these journalistic meanderings Clare and Korestovetz found, near Königsberg, a birch wood carpeted with lilies-of-the-valley, which was for sale. Through the silver stems of the trees shone the Baltic. This was enough for Clare. She purchased the entire wood and told her children that here they would build the home of their dreams. The site presented all the advantages of Russia 'but because it is human nature to *own* something, we would have to own it outside the Russian frontier'. The children understood this at any rate.

On 6 August Oswald arrived and Clare rushed him to Georgens-walde, a summer resort developing near her birch wood. His diary reads:

[193]

Korestovetz is a nice young Russian 'on the staff' (Puss' staff), who is quite invaluable at doing things, and gathering news, although the situaton seems a bit unconventional and certainly Georgenswalde is most pretty. Puss' idea is a wood-surrounded villa with nothing else human *in sight*. She must accordingly *buy everything in sight*, which will be expensive for her and arrest somewhat the growth of the township.

An enthusiastic young architect – a Balt with Russian sparkle – drew up plans and Clare installed her children in a rented villa with a cook (who suffered from that common kitchen complaint, *delirium tremens*) and a German maid. Meanwhile, the mark was falling crazily, fluctuating from three million to nine million to the dollar in a week. Clare found it difficult to assess what she was paying for anything. Her drafts from America brought incalculable sums but prices soared with the same lightning speed. Was this what she meant by living cheaply?

With the infatuated Korestovetz gathering information and helping to write Clare's articles for New York, and Oswald's for the *Daily Telegraph* in London, they gallivanted around Germany trying to assess what on earth was going on. From Danzig they travelled *à trois* to Berlin where the first hotel they tried asked twelve million marks a day per room. They haggled the price down to eight million while seeking to discover how many million the dollar was fetching that *hour*.

Oswald perceived that Korestovetz was beginning to get on Clare's nerves by trying to make himself completely indispensable, which merely maddened her. Oswald's diary recorded the tiffs: how 'K.' made himself useful 'collecting Russian news and material' and then flew into jealous sulks because Clare talked to other men. On 16 August 1923, Oswald heads his page with the caption '*The Fall of Korestovetz*'.

In their Berlin hotel they had all retired early but Clare came to her brother's room to say she was so tired she wanted to go out to listen to tzigane music which alone could revive her. Oswald refused the lure and marched her back to her room. At 1 a.m. Korestovetz knocked and asked if he might come in. 'At sight of me [Oswald] he left a note, with apologies and left. The note was hyper-hysterical and contained his resignation.' At 2 a.m. 'K.' was again tapping at the door ostensibly to ask Oswald for an aspirin and left another note cancelling the first. Oswald wrote: 'If this is the Slav temperament, undependable, unpractical and hysterical, give me the Anglo-Saxon.'

Worse trouble arose on the morrow when Korestovetz insisted on

accompanying them to Freiberg where Clare had obtained an interview with Maxim Gorky. Sitting up in the train all night did not improve tempers. According to her brother, Clare nearly had hysterics

but succeeded in damping down sufficiently to tell K. wearily that she hated Russia and hated him, and could not bear the sight of his face and his silly up-turned nose and how much was he paid to watch her? He merely said his nose wasn't his fault, he was less monarchist than Puss and the Tcheka had killed all his family.

Eventually they reached a Freiberg hotel and next morning Gorky invited Clare and Oswald to lunch.

Korestovetz announced that he also was invited but in view of Clare's bad treatment did not know if he would go. Clare who only spoke French and German and needed K. as a Russian interpreter, yet said she hoped he wouldn't. He came. And he proved himself useful in that Gorky's third wife who usually acted as Interpreter-General, was away and Korestovetz *could* translate quickly.

Oswald just listened.

Clare was dramatically opposed to Gorky's whole occidentation. She wants Russia to face East. She has seen 2 Turks and a Kurd, and imagines a Gilded East pregnant with Golden Births, social, religious and material. She wouldn't even let Korestovetz translate my remarks, but interpreted herself what the answers *should* be, so I gave it up, merely registering a protest, 'I wanted to hear what Gorky thinks, not what *you* think he *ought* to think,' and this remark K. did put into Russian, to the abandoned merriment of the whole room! Gorky told Puss he left Russia because the Govt. were not for Russia but for Internationalism, and *he* was for Russia. Why did he live in Germany? Because he could get visas for nowhere else.

They stayed drinking, laughing and joking until evening when Gorky's son said that his father had never talked so much to anyone as to Clare; he thoroughly approved of her and would they all lunch again next day.

The visit was repeated. Clare obtained enough material for several articles and grew so exhausted with Russian voices arguing and translating that she was too tired even for tzigane music. Gorky informed her that on the whole he thought the peasants better off *after* the Revolution. 'When asked about the attendant miseries, he replied that a rainy day is good for the potatoes.'

Well satisfied, the threesome returned to Berlin. Korestovetz left bunches of roses at Clare's door, but Oswald knew that Korestovetz's day was over. Oswald then returned to London and picked up his mother in his motor cycle for a trip to Paris. Mrs Frewen, in her seventies, had turned 'sporting' – she had done a record run of 175

miles in one day in the side-car, ending up with tea with Winston in Clemmie's bedroom while the dusty Oswald mended a puncture. On this occasion he gave his mother a lift to her favourite city where she could reminisce about her girlhood and balls at the court of Napoleon III. Clare wired that she would join them, leaving her children in Prussia with the 'staff' she had engaged there.

It was now mid-September and on the 16th Oswald wrote: 'Heard there's a Dictator in Spain; Puss says she collects Dictators and wants to add him to her collection; will I come? – Accompanied Puss to the *New York World* office who said no news leaking out of Spain, and so we decided to go.' Mama was left alone in the Hotel d'Iéna lamenting that the district was 'not smart'.

On reaching Madrid, Clare and Oswald discovered that a minor *coup d'état* was taking place. Oswald described his sister's 'scoop' technique: 'Puss has wired Winston who polos with the King of Spain, could he wire her any introductions journalistically useful, but *I* had the brainwave of contacting Merry del Val.' This famous Spanish ambassador to London who had known Clare during her Bohemian days promised to arrange an interview with General Primo de Rivera, the new Dictator. Clare and Oswald were equally impressed with de Rivera who, in bad French, explained the importance of lowering the cost of living. 'We retired to the Hotel to write and pack. We are the *only* correspondents to whom he has granted a special interview, and we're off with our loot. On our return to the Hotel Puss was handed a cable from Winston: "Regret know no one journalistically useful. Good luck." But *we* do (now!).'

They had their 'scoop' and caught the evening train to Paris on which King Alfonso also happened to be travelling. In the morning when Clare went to the restaurant car for her coffee, there sat His Majesty. She had been presented to him years before, and Oswald wondered what his unpredictable sister would do in the circumstances.

'Puss stopped dead in the middle of the swaying compartment to drop a most unbolshevistic curtsey . . . ' Oswald recalled the Duke of Connaught in Aunt Leonie's drawing-room teaching her sons and nephews to 'bow from the shoulders like a courtier and not from the waist like a waiter.' Oswald tried to give a correct shoulder-bow. The King replied with his 'lady smile' to Clare and the paler 'for men' version to Oswald.

In Paris they rejoined their mother. Oswald wrote a long article

Right: Clare and Charlie Chaplin camping in California.

Below: Clare waves from the side-car of 'Satanella' with Oswald in command.

Facing page: Top, Bab-el-M'Cid.
Below: left, Clare in Algiers; right, with author (on leave from French army, 1945).

This page: Top, carving at Oranmore, aided by young Tarka Dick. *Below:* left, Pregnant Madonna in Brede Place Chapel; right, Risen Christ (in the church of St. Catherine, Hoogstraten, Belgium).

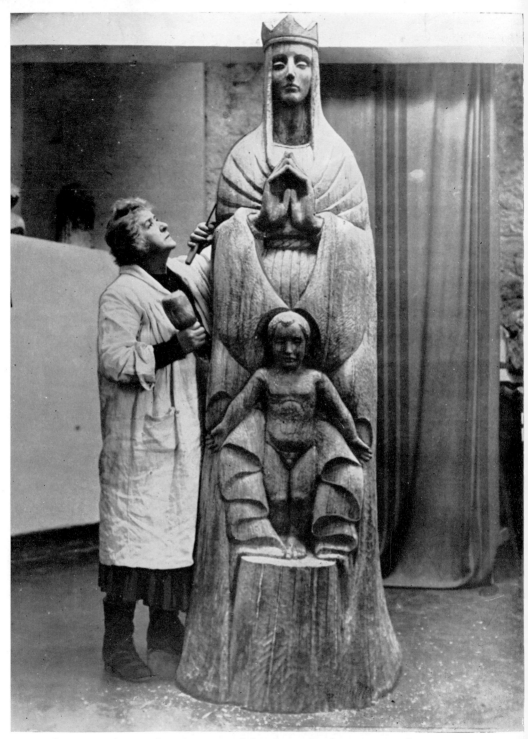

Clare at work in Galway on one of the giant oaks she transported
from Sussex.

headed *Coup d'État in Spain* which occupied nearly a page of the *Daily Telegraph*. After Clare had cabled her 'scoop' to New York, she remembered her children in the rented villa in Prussia and hurried back to Georgenswalde. Margaret and Dick greeted her in floods of tears because Professor Edelhaus had been assuring them that their lovely Mama must shortly be murdered by Red Russians if the Whites did not get her first. She sacked the music master and Korestovetz who had introduced him in one blow. Korestovetz departed leaving a final bunch of roses outside her bedroom door. On 5 October Oswald received a cable: 'Domestic crisis. Exit White Russians. Ask Louise come one month if so send her non-stop Königsberg.'

Oswald found Louise, who was 'on leave with her parents', gave her ten pounds and put her on the boat train. Margaret and Dick rejoiced to see their nurse-maid back and quite approved when the young student now employed to teach them Russian fell in love with her and taught Louise German instead. The dauntless little Cockney girl made brave attempts to manage the·maid and even the drunken cook whom she occasionally found purple-faced and unconscious on the floor.

Well content with the reorganization of her household, Clare departed for Moscow. The second trip to Russia proved disillusioning. Clare had forgotten the antagonism she had aroused in Trotsky's sister and was surprised when Kamenev did not answer her note and Litvinov brusquely informed her: 'You are not the type of newspaper correspondent we are accustomed to.'

Just as London Society had been outraged by Clare's visit to the Kremlin, so the Bolshevik leaders were now disgusted by a person so romantic and useless to their cause as Winston's cousin! Unable to obtain any worthwhile interviews Clare visited Maxim Gorky's first wife. Having posted his letter of introduction, she climbed to an attic to find a grim-faced, middle-aged woman who might well have emerged from The Lower Depths. Mrs Gorky obviously disliked this brightly attired apparition and would only answer Yes or No. Probably, she regarded Clare as some vamp whom Gorky had picked up abroad and sent to her as a final insult.

After two frustrating weeks in Moscow Clare went on to Petrograd, as she still called Leningrad, but she found the city dull. 'What was I to write about this *New* Russia; how circumvent the dreadful anti-climax? I felt as a woman might who, having dreamed of reunion

[197]

with a lover after years of faithful separation, met him and he turned his back upon her.' Her American contract demanded two articles a week and during this October she dutifully produced eight. In England, the *Daily Express* was overjoyed when she offered them her dismal revelations of the Soviet paradise.

Returning to Berlin she visited a restaurant with a Russian prince who played in the tzigane band, and tried his recommended soother of cocaine, but instead of inhaling the powder, she poured it into a cup of coffee, with the result that her hands turned violet and her face green. Horribly wide awake, she sat up for five hours writing in an unrecognizable hand: 'It was certainly foolish and hysterical, but I *had* cared, I *had* believed. My life had been uprooted, my friends lost, my family alienated, all because of my belief in Russia.' At least she learned not to trifle with cocaine again.

23

Across Europe with Satanella

BACK at Georgenswalde Clare found deep snow covering the birch wood. The little house lay in white muffled silence and daylight lasted only five or six hours. The children hated it. They had not minded the long northern summer days, in fact they had found it fun to get up and play in the bright sunlight at 4 a.m. Now they only wished to *go away*. So Clare decided not to build the dream house but to 'liquidate assets on the Baltic'.

At this moment, a cable arrived from Herbert Swope ordering her to London where the first Labour government had come into power. Leaving the children in the snowbound villa she travelled to London. By 10 November Oswald had her ensconced in his flat, and Aunt Leonie was 'inviting all London' to meet her. As Clare's latest articles in the *Daily Express* criticized Russia, her previous infatuation with the Communist régime was forgotten, and Mrs Sheridan found herself *lionized* by London Society. She greatly enjoyed it while continuing to lament bitterly the disillusion of her great love, the Soviet Union.

In the spring she cabled Louise to return to England by cargo ship with the children and 'whatever goods seem impossible to liquidate'. (This unpleasant verb now studded Clare's vocabulary.) Clare met her darlings at the London Docks and they were delighted to be taken off to Brede where they could run wild indulging in activities which had been rendered impossible by depth of snow and degrees of frost on the Baltic. They also revelled in the familiarity of their old surroundings.

In order to save Income Tax, Grandmama Frewen now had to spend six months a year in Paris. While she was away, Oswald or Louise or 'Cookie' from the village, looked after the children. They were, to a certain extent, kept in sober if not obedient form by terror of the ghosts of that beautiful medieval house. It was a repetition of Clare's childhood, but she had forgotten the agony of fear.

For the summer of 1924, an interesting project developed. Oswald's two-year-old motor bicycle Satanella had become the main family mode of transport. Anyone who wanted to go anywhere asked Oswald if he would take them in his side-car. And he loved it. Even Shane and his somewhat luxurious American wife Marjorie were conveyed from county to county when their chauffeur-driven limousine punctured irreparably, as cars did in those days. Oswald noted, however, that Marjorie (a recent Catholic convert) kept making the sign of the Cross.

For a few months the rôle of 'lioness' amused Clare. Then she tired of invitations. Everyone wanted her to *make* their lunch or dinner party by holding forth, and there was a certain smug satisfaction at her revelations of the latest Russian trip. Winston never said 'I told you so' to anyone, but he did whisper to Clare, 'Have done with those Bolshies – they'll do you no good.'

However, the attraction lingered. When Rakovsky, the Soviet Ambassador, who had been Administrator in the Ukraine during the Revolution, wrote to Clare that he had been surprised not to receive a visit, she hastened to his office. He scolded her for the *Daily Express* articles and advised her against 'prokoving Providence' by returning to Moscow, but as he considered himself a force to be reckoned with in the Ukraine, he would give her a visa at any time. Rakovsky possessed Trotsky's trick of appearing to be suddenly overwhelmed by her beauty, and he also murmured poetically about drowning in her golden hair, while offering visa forms.

Clare returned to Brede Place, cast longing eyes at Satanella sitting outside the Tudor porch, and asked Oswald, 'Would she take us to Russia?'

'After those articles!' he exclaimed.

She added hastily: 'Well, South Russia – not Moscow. To the Ukraine and Crimea – across Holland, Germany, Czechoslovakia and Poland.'

Oswald sat down among his flowery shrubs while she repeated Rakovsky's words.

'If that man is really ready to play I'll go with you – ' he began hesitatingly.

On 6 July 1924, Oswald donned his helmet and goggles, fitted their suitcases and Clare, dressed somewhat in the fashion of Boadicea before battle, into the side-car, and they were off.

Leonie, who was giving a rather grand dinner party for the Duke of Connaught, found herself inundated with questions concerning her niece. She answered, correctly, 'Well, actually, the dear thing is just motor-bicycling across Europe with her brother.' Very moral.

Winston rang up peremptorily: 'Is it true?' Aunt Leonie, always the soul of tact, responded airily, 'Of course. Rumours about Clare are always true – she is off with Oswald in his side-car.'

'But he half-killed his poor old mother trying for record runs in that thing – Clemmie had to revive her afterwards. And *how* did she get a visa after those articles? Oh, don't tell me – I know – Rakovsky's fallen for her. They all do. And in the end she'll be shot – ' He paused for breath, then she heard him speaking in a quite different tone of voice. 'How are the tyres? Tell them from me – if you know how to reach them – that I hope at least they bought new tyres!'

When he rang off, Leonie could not tell how much he was laughing. Oswald had attended to triptyques and maps while Clare did the necessary paper work with Rakovsky. There had been no special preparation for Satanella.

Yet Satanella took them bravely across Holland, slices of Germany and the new country called Czechoslovakia. Not until they reached Poland did real discomfort afflict them. This was chiefly caused by bed-bugs – even the cleanest-looking hostels seemed to be infested. Clare wondered how anyone else ever got a wink of sleep. Many nights had to be spent lying on wooden tables or on arm chairs which the bugs had not discovered. Occasionally they slept out in their tent, but neither Clare nor Oswald were practised campers and they found it took hours to get on the move each morning. Crossing the frontier from Poland into Russia was emotionally exciting for them both. Since the war no foreigners had travelled down the grass-grown roads, much less such an unlikely looking couple on a motor bike. Rakovsky's letter of introduction, with its expensively engraved red hammer and sickle, had a magical effect.

'We have been waiting for you for two days,' said the officer in charge waving them on towards the darkening forests. 'All Russia is

yours.' In each town they reached, the Chief of Police would be waiting to lead them to a room of some kind, while the population stood on tiptoe outside trying to catch a glimpse of the 'Angliski' through the windows. Often they were given supper free; always Satanella was washed and overhauled.

Described as 'delegates' they were, of course, really just tourists. From Kiev they jolted their way to Ekaterinoslav on the Dnieper where the iron bar joining the side-car to the motor cycle broke. The local fire brigade offered to mend it, while a newspaper reporter hurried to inform them that he had received a telegram from Moscow (they flinched nervously) saying that *Lord Churchill's brother and sister* were to be expected on a world tour. This inaccuracy seemed reassuring. The President of the Town Soviet drove them around the countryside until Satanella had been repaired sufficiently to set forth across the Steppes.

Oswald and Clare were permitted to rest for six days in the Tsar's summer palace of Livadia, turned into a holiday home for doctors, professors and Red Army generals. They lived on water melons and grapes; the sun shone, and, after waving Rakovsky's letter around, they were shown over a cruiser of the Red Fleet.

In the Crimea Clare admired the fine-looking men in white tunics and high boots and the women in their Sunday muslins. She herself now wore a specially devised costume – a very becoming wide felt hat to shield her fair skin from the sun, a cotton blouse and loose woollen jacket for the cold evenings, and voluminous trousers tucked into Russian boots. In case they had to 'change for dinner', she had packed two pretty dresses and Oswald had an evening jacket and black tie. The heaviest item in their luggage was the pound-and-a-half jar of cold cream without which Clare could not live. 'Lord Churchill', as Oswald had become before reaching Yalta, never had the opportunity to wear his dinner jacket, but Clare lent her dresses to housemaids in the bug-infested inns so that they could copy London fashion.

Conversation remained difficult owing to dictionary discrepancies. When Clare tried to explain the reason for their trip, she found 'just sport' untranslatable into Russian.

They spent a week in Odessa. Rakovsky's letter induced the General in Command of the Roumanian frontier to take them with him on an inspection tour. Oswald kept grumbling that Clare's only breakfast word was Yaïtzu, which produced two soft-boiled eggs to be held

in the hand and sucked. He now learnt an extension to this word – Yaïtznitehoo – which represented *œufs-sur-le-plat*. The inspection took till dusk, then a peasant was turned out of his two-roomed cottage for the night. Oswald records this evening without enthusiasm:

So behold us at 7.30 p.m. with 2 earthen-floored rooms, one oil-lamp and some bread, butter, tea and new-pressed wine, to which the General added half a pint of 90% 'moonshine'. By the time the moonshine had disappeared, the General obliged with a long song, making up the words as he went along, describing today's doings – very oriental. Puss sat in rapt adoration, but finally even that ceased and we sallied forth into the moonlight and roamed the village ... At 1 a.m. we made our dispositions for the night. There were 2 beds. The Russians (the General and his interpreter) took one and a coat, Puss took the other and her coat. *I* slept on the wooden settee around the room without a coat! The General snored and multitudinous insects – fleas, I think, for a change – bit. I later counted 74 bites.

On their return to Odessa they found telegrams to say their father had died in Sussex. Old Moreton Frewen would have to be laid to rest in the family mausoleum attended by his widow and grand-children – Hugh, Oswald and Clare were thousands of miles away.

There was nothing they could do for a week except wander around Odessa and look at 'workers' factories', until allowed to board an Italian ship bound for Constantinople. On the S.S. *Praga* they were joined by W. Norman Ewer, diplomatic correspondent of England's Socialist newspaper, the *Daily Herald*, Mrs Ewen, their eleven-year-old son, and a pretty girl – Rose Cohen who was a dedicated member of the International Communist Party. Before they reached Constanti-nople Oswald had fallen in love. He was tired of Clare's form of Communism, but Rose Cohen had such 'merry brown eyes and such a radiant smile and soft voice' that he could accept her more austere brand.

Clare left the ship at Constantinople with the idea of looking around with a view to settling there. The city seemed even more beautiful than she remembered, and her Turkish friends entertained her lavishly. Oswald and the Ewens sailed on to Venice where he had to say good-bye to Rose Cohen without finding out if she reciprocated his feelings for her.

She has probably been thinking that I was rather in love with her and that unless she kept a trifle aloof I might get a trifle unmanageable. She is old enough anyway for all her childish appearance, to have that amount of worldly wisdom ... Frank, friendly, gentle but aesthetic, unconventional and a communist, I wonder just how I

shall react to her in London. Bare legs and a Tartar dress are her setting. How will she appear in Mount Street?'

Oswald need not have worried; he did not see her again.*

Meanwhile, as the Alpine passes began to block with snow in that autumn of 1924, Oswald, tired of squabbling with his sister over her illogical ideologies, motor-bicycled back to England alone. Clare followed by train. When she reached Brede, she broached her latest plan to Margaret and Dick and Louise. She had found the most beautiful shore on earth. They were off to settle in Turkey – *for ever!*

*Rose Cohen later worked as Foreign Editor of the semi-official *Moscow Daily News*. In 1938 she was arrested and kept for six months in solitary confinement. Lord Chilston, the British Ambassador in Moscow, made strong protests to Litvinov who was by then Soviet Foreign Commissar, but to no avail. At the age of forty-five, Rose (who had according to Oswald's diary 'lost her looks and become fat') was executed for being 'plus communiste que les Communistes'.

24

Turkish idyll

IN London Clare accepted Rakovsky's invitation to stay at the Soviet Embassy. Margaret, now aged thirteen, and tired of her months in the village school at Brede, came with her. An Embassy, even if Communist, makes a comfortable lodging house and there was plenty of caviare for breakfast. This Clare preferred to marmalade. Madame Rakovsky, a huge woman towering above her husband, took a violent dislike to *les invitées*. Clare could not think why, but Margaret's innocent brown eyes did not miss Rakovsky's admiring glances whenever her mother entered the room. It seemed very clear why he had given her visas and smoothed her passage across the Ukraine. Now Rakovsky was arranging for two and a half tons of marble, bronze and books to be transported free to Constantinople on a Russian ship, along with Dick and Louise. Clare and Margaret could remain a week longer at the Embassy and then take the Orient Express.

During the Sheridan visit the Rakovskys held a formal evening reception, which the demure Margaret was allowed to attend dressed in black velvet with a lace collar. Clare appeared in a fantastic gown of purple and gold brocade made from a cape she had acquired in Moscow. Unfortunately, the news spread that she now danced the foxtrot in the vestments of an Orthodox bishop – which was true – but she did not intend sacrilege. She wore what appealed to her without thinking where it might have come from or what it represented.

On the eve of departure for Constantinople, Margaret developed a temperature and swollen glands. Ambassador Rakovsky had previously been a doctor. He registered horror when Clare remarked jauntily, 'Just travel fever. She always does it. Her temperature will disappear on the train.' Off went mother and daughter on the Simplon Orient

Express, attended by Hikmet Pasha, a short-legged, muscular gentle-man returning from his post as Turkish military attaché in London. As her mother had prophesied, during the four-day journey across Europe Margaret recovered. She found the changing scene entrancing and immediately she saw Constantinople Margaret fell in love with the place.

Louise and Dick and the luggage arrived a week later. It took quite a while to get the tons of belongings through suspicious Customs and Louise wept pools of tears, for she had fallen in love with the Russian ship's Captain who spoke French and had courted her throughout the voyage. Clare listened coldly to this story and corrected Louise's grammar: 'He *couldn't* have called you *amourée* – there's no such word.' Life in Constantinople started inauspiciously in a small hotel. But the children adored the markets, the twisting streets and the smell of the Orient. They would be well content if their mother's words proved exact and here they were to live *for ever*.

It was Clare's desire to settle into the most enchanting house on the Bosphorus. The Soviet Ambassador in Turkey, Comrade Potemkin, produced this. For a very small rent he allowed her an indefinite lease of the attaché's house in the tangled, overgrown park of the former Russian summer residence at Thérapia. Renovations were necessary and while these took place, Clare and her children occupied themselves buying antique furniture and other treasures which were flooding into the markets from old palaces. When they moved into their new abode, the two and a half tons of possessions had grown to three and a half.

Louise moped, and found lonesome the terraced garden where her mistress was busily planting lilies and tulips among the old magnolia trees. Dick, watching the endless variety of ships passing by their windows, announced that he intended to 'join the Navy'. He was quickly advised that sons of pacifists may become sailors but *not* join Navies. And Margaret, the imaginative teenager, who had been yanked through so many contradictory modes of education, would escape from the mysterious jungle of overgrown fig and plum and almond trees, to run up the hillside with her dog and look down on the Bosphorus, loving this place with an intensity she had never known before.

Moskoff Yali, the elegant white house designed for diplomatic entertaining, needed a staff. Clare's friend Ismet Pasha who had admired her since he first saw her tackling Kemal Atatürk produced a

Greek maid servant who was terrorized into obedience by Hassan the Moslem former cook of the great Djemal Pasha. Hassan enjoyed producing succulent meals and threatening the Armenian storekeepers with a knife if groceries fell below standard.

The Turkey that Clare had fallen in love with was the vanishing old Turkey. Even in Lausanne she had uttered protests when her Turkish friends donned top hats like Lord Curzon instead of wearing the becoming fez (in which they could kneel at their prayers without breaking a brim). Ismet Pasha's grey astrakhan kalpak made him, she said, the handsomest man on the coast. He appreciated such opinion, wore his kalpak rakishly over one ear, and avowed himself completely at her disposal. Whenever Hassan, the cook, flew into a rage and chased the Greek maid round the kitchen table, Clare would telephone the Pasha who could command in Turkish over the wire and peace would be restored without bloodshed.

Clare was now tired of being a journalist. She resolved to settle here in these idyllic surroundings, to write novels, sculpt when she could and give the children a 'truly cosmopolitan education'. With this in view, a Macedonian of anarchistic persuasion was employed to recommence their Russian studies. Hadji, as the new tutor was called, had deep-set eyes, a black beard and he played the violin with even more abandon than the cocaine-inspired professor of East Prussia. In addition to these virtues (which made him an interesting tentative model when she could find the right clay) Hadji had been a teacher in a Rousseau do-as-you-like school in Paris. According to the Rousseau dictum, children should be taught only what they found interesting. The study of Russian grammar had no appeal whatever to Margaret and Dick; they preferred listening to Hadji playing the violin to the sunset. When he suggested a new subject – 'chemistry' – they enthused and when he added 'bomb-making' to the curriculum, they cheered.

Clare was digging one day amidst her lilies and roses and fragrant-smelling shrubs, when she heard explosions in the wood. On investigation she found her excited offspring throwing what appeared to be small hand grenades. Dick explained gleefully: 'But these are only bomblets for practice.' Hadji was sacked. He tried to creep back into favour by stealing a carved Muslim tomb Clare had once admired and bringing it to her by boat at night. Terrified of reprisals, Clare ordered its return. There was a splash, and the beautiful marble vanished into the Bosphorus.

[207]

The children's subsequent education took place at the Soviet Embassy where Clare imagined that instruction in perfect Russian could be arranged. Margaret and Dick enjoyed the hour's journey each morning by steamer to Constantinople, but their proposed playmate, daughter of the First Secretary, Comrade Mirny, took a strong dislike to them. During the month that Ambassador Potemkin returned to Russia on leave, they were deluged with Communist propaganda and then ordered away as nasty bourgeois children. They returned to Thérapia purple with indignation which their Mama soon shared.

After this, Clare left her offspring to their own devices in her library, until the next educational influence arrived on the scene. This happened to be General Mougin, head of the French Military Mission, who had for six years acted as his country's pre-ambassador and won the respect and affection of the Turks. He came into Clare's life when she was veering towards another disillusion – this one concerning the 'romance of Turkey'. The wonders of Constantinople remained, but Turkish men did not make very good 'pals'. Attractive as they might appear in their own headgear they lost allure (and stature) when they donned bowlers, and most of them were, under Mustapha Kemal's command, doing exactly this. She found them better looking out of doors than in, and a veil had better be passed over their habits when allowed to enter a lady's boudoir. Clare learnt this lesson the hard way.

Just as becoming as the fez or fast-disappearing kalpak was the French képi. There were not many of these around but General Mougin never wore anything else. Clare adored him and was glad when he took control of her household. Hassan stood to attention whenever the General spoke to him; Louise stopped snivelling when his handsome young A.D.C. sympathized about 'homesickness', and the children obediently did their daily lessons as laid down in the standard French school books which the General procured for them. On every visit he coached Margaret and left her strict orders to finish her 'homework'. She blossomed.

It was not just that it was a General who was helping me with my lessons and seriously taking an interest; it was because he was a kind, normal, ordinary man, who spoke the language I loved . . .

But the golden days were drawing to an end. I knew it instinctively, though I would not face up to it. Mama was in a restless mood.

Because she had rented a house from the Soviets, Clare was eyed suspiciously by English residents. Ismet Pasha told her frankly that she was regarded as a spy. General Mougin suggested that she accompany him to Ankara, looking at historic ports and towns along the coast, and sharing the banquets prepared for him under mimosa trees. They reached the new capital on the same train that happened to be carrying Potemkin and members of his Russian staff. Hikmet Pasha, who was now head of Foreign Affairs placed his Ankara house at her disposal, but the British diplomatic corps continued to look askance, and, to Clare's absolute amazement, Latifé Hanum, now the wife of Mustapha Kemal, announced that anyone who received Madame Sheridan would be ostracized by *her set*.

Hikmet came to her as a friend to advise her seriously to abandon spywork. 'You are no good at it,' he said. 'I have been handed a report that on the train you crept into Potemkin's sleeper and recounted to him the contents of General Mougin's valise! Can't you be more discreet?'

It was just too much. And General Mougin agreed. He had now been posted to Algeria as Commander-in-Chief and he said, 'I cannot bear to leave you and those children here. Try Algeria – peace, beauty, desert and material for a hundred books!'

Clare went to Potemkin. 'Do you mind if I give up my lease?'

'Of course not, but you've been here less than a year!'

She broke the news to her children who were heart-broken. They loved the place.

Before departing Clare wrote a book which would be published under the title *Turkish Kaleidoscope*, and in it, in her generous way, she gave praise to Latifé Hanum who had treated her so scurvily. Clare never bore rancour (except against Mussolini).

Mustapha Kemal, whom she had once regarded as a fascinating character, had taken to the bottle and was in this very summer throwing out his wife according to Muhammadan custom, by repeating three times the divorce formula. Clare could not resist rallying to the support of any woman thus treated. She revealed what Potemkin told her, that before his marriage Mustapha Kemal spent his evenings at the Russian Embassy 'revelling in the lack of ceremony, the absence of etiquette, the equality, the freedom and abandon engendered by communistic principles that enabled him to dance and drink with the Embassy housemaids while Turkish communists were being hung in the town outside'.

[209]

Now, in the summer of 1925, Clare wrote of the lady who had sought to snub her: 'Latifé Hanum, his wife, ranked among the few women of character and Occidental culture and education in Turkey. Nor had Kemal anything with which to reproach her, except that she hampered his orgies of drunkenness.'

Influenced by General Mougin and impervious to the misery of Margaret, who was to be torn from the most beautiful home she had ever known and would have to leave behind a beloved dog, Clare rallied her tribe. Once again they were to travel in a Russian cargo ship. It was of the Arcos Line of which Ismet Pasha conveniently happened to be an 'Adviser'. Turkish and Russian acquaintances combined to arrange the free transportation of what had now become four and a half tons of books, busts, and antiques. The destination was, as General Mougin had advised, Algiers.

25
The lure of the Sahara

AFTER the minarets of Constantinople had faded into opalescent evening mist, Clare found Margaret sobbing: 'I can't bear it! Every time I grow to love a place and it becomes home, we go away.' In genuine distress at her daughter's misery, Clare promised that *this* would be the last uprooting, and at the time she believed it. But for her a new country was just a veil to tear down, scenery to move into, and then to forget.

Algiers did not live up to expectations. General Mougin's romantic description of *la ville blanche*, combining French civilization with oriental glamour, seemed inept to those arriving from the beauties of the Golden Horn. And Mougin himself disappeared on military duties in Morocco.

Clare looked around disconsolate and rented a villa in the suburbs within walking distance of an old Moorish palace which housed a girls' *lycée*. Here Margaret could 'continue her studies', and Dick, aged ten, was also accepted. He learnt French easily and liked small girls! Margaret felt thankful that she had been so well grounded by that disciplinarian in his gold-embroidered képi. She was now thirteen, a natural intellectual, astonishingly well read and able to read and write fluently in French and English, while the 'mustard touch' of Russian, German and Turkish had sharpened her perceptions. But her happy spirit had been severely injured by the dissolution of that home on the Bosphorus. She had thought Moskoff Yali was for ever. Susceptibilities can, at this age, be very delicate. And the pain of departure, of finding her bedroom door locked by the furniture removers, the farewell to her dog and goat, had torn open a wound for which she would never really forgive her mother.

While Clare groused about the noise and dirt of 'Alger la blanche', and their guinea-pigs which had been the only pets allowed on the cargo ship, increased in number, and Dick discovered there were sailing boats in the harbour, Louise rather over-enjoyed herself. The battleships of several nations entered Algiers, and ashore there were incessant naval parties. She was kept busy. Even Dick noticed his former nursemaid's successes and cried out, 'You don't love *me* any more!'

Christmas approached and Lady Wavertree, wintering at the Hotel Metropole in Cannes, invited Margaret to spend a few months with her – her former French mademoiselle could resume history lessons, and show places of historical interest on which Margaret would write essays in French. Margaret was happy to board a ship for Marseilles. She found her Aunt Sophie, whom she had not seen for four years, as cool, handsome and exquisitely turned out as ever. She had chosen briefly to be a mistress of King Edward VII in her youth, and her manners remained those of the Edwardian great lady. The manager and staff of the luxurious hotel regarded those who had enjoyed royal intimacy with awe, and Margaret – young, stricken Margaret yearning for Turkey – found herself dressed in unaccustomed fashionable clothes, chatting to the King of Spain and to the tennis champion Suzanne Lenglen, and absorbing painless culture on long motor drives. It was, educationally, very different to bomb-making on the Bosphorus.

Great-aunt Leonie was staying, as usual, with her old beau the Duke of Connaught at his Cap Ferrat villa. She asked Margaret with her governess (who was much impressed, the Duke being Queen Victoria's son) to lunch. After her great-niece had wandered around the garden with H.R.H. making conversation about that little grand-daughter she had frolicked with as a baby (Princess Ingrid of Sweden, later Queen of Denmark), *Ma Tante* in her gentle tactful way put a number of bland questions to Margaret. As a result Clare received a letter which hit hard, for Dick had just come down with typhoid fever.

You dear thing – [this was a favourite opening to my grandmother's letters prior to machine-gunning advice] Your lovely graceful Margaret has rejoiced us. Sophie sent her over to lunch with her Mademoiselle – what a nice woman – and we found the child delightful. What perfect French – and she was so sweet with H.R.H. He showed her all his flowers – I wonder if it might not be a good idea to leave her for a year or so with Sophie? Of course *you* would miss her but one must be unselfish. One

hears of smallpox and cholera at Algiers and health is *so* important, especially at her age. Don't risk it. And isn't she ready for a finishing school? With her erudite tastes so much more developed than other girls' she could shine at Melle Ozannes in Paris – and meet the girls she is going to come out with later . . .

Clare told Sophie Wavertree to keep Margaret until spring. In the meantime she was frantic to get Dick away from Algiers and into the 'fresh air' of the Sahara. Taking the train to its furthest southern point, the oasis of Biskra, she hired camels and set off for a fortnight of convalescence for Dick. Margaret would read her mother's letter aloud to an unsmiling Aunt Sophie: 'He falls from his camel every evening, his lips blue with fatigue . . . but he loves it.'

The health holiday ended uncomfortably on a blazing day when their mineral water ran out, and they could not dare swallow the brackish water of the nomad casks. In Ghardaia, the oasis city of the M'Zab, Clare and Dick kissed their camels good-bye and boarded an Arab omnibus for Laghouat. There Clare briefly permitted a good-looking Englishman to imagine that she might marry him. Major Ronnie Bodley, old Etonian and notorious lady killer, was in sheep-breeding partnership with a local Caïd and had taken to wearing Arab clothes. The Arab headcloth held by its braided or golden ageyl is becoming to any man, even more so than the fez or kalpak or képi, and Clare had an unsurmountable weakness concerning male head-dress. Ronnie made a practice of riding in to the one big hotel on his white stallion when tourists arrived. He would stand there nonchalantly in white bornous, and gold ageyl, knowing that he presented a picture that elicited inquiries.

For a time Clare thought that she liked this Englishman, who was just Arab enough to appeal to her desert sensibilities. They planned to spend the summer driving from oasis to oasis, Clare, Ronnie, Dick and Margaret, who was to be returned from Cannes.

In June, Oswald wrote that *he* wished to come out to inspect the new set-up, and perhaps drive around the desert also. Oswald's letters of this period insinuate that he was having a very difficult time with Mumkin who was 'on the gallivant with Rosa Lewis at the Cavendish'. He gave a detailed description of their widowed mother, now approaching eighty, bored by country life, accepting an invitation to stay at the Ritz with a rich cousin. Then 'Mumkin had moved on to the Cavendish Hotel which has a really bad reputation. It is kept by one Rosa Lewis who in 1889 Ma and Pa employed as cook at the house

they took at Goodwood for Solar Jung of Hyderabad. Ma stays there free as Rosa Lewis' guest!'

Oswald, who was really a very conventional naval officer had been profoundly shocked when he had picked his mother up after dining with Aunt Leonie and transported her back to the Cavendish where Mrs Lewis 'surrounded her with cavalry officers all introduced by their Christian names. "My habitués", said Mrs Lewis.' And Oswald watched with disapproval his Mama 'sipping fizz'. Then Rosa shouted, 'Hello there, Shane. Come in,' and Shane Leslie entered the sitting-room. 'Which was the more shocked – Shane at seeing Ma, or Ma at seeing Shane, I don't know.' Rosa then revealed confidentially that Shane was helping her to write her reminiscences. This in turn shocked Mrs Frewen to the core and she asked Oswald if they should not 'in duty bound' tell Leonie to restrain her son.

Next morning Oswald took his mother to a big lunch prior to the memorial service for Lord Dunraven who had been Moreton's great friend.

Ma turned up toute de noir habillée, a tear trembling on either eyelash. But on receiving an invitation to see Suzanne Lenglen play tennis, she went off to Wimbledon with fresh friends, still in flowing widow's weeds, murmuring 'I don't think they'll miss me at the Dunraven Service & I'm sure this is much better for me . . .'

Clare wrote that Oswald was to leave Mumkin to her 'London Season' and to join her at Algiers in Satanella. Ronnie Bodley would, she said, be able to lead them around the desert where the Arab chiefs were his friends.

Oswald obediently drove Satanella across Europe, embarked at Marseilles and reached Algiers. In the side-car travelled his valet (shared with his London landlord), named Meade, a devoted character speaking broad Cockney and no French or Arabic and thus very dependent upon his master.

Ronnie Bodley proved unable to drive a car, so the onerous work fell on Clare. In her Renault rode Margaret, Dick and Bodley. Oswald followed with his valet in Satanella. 'We travelled west to east and back again, hundreds of miles in the Sahara.' Bodley did indeed introduce them to Caïds and Sheiks, and many a roasted sheep they ate (Dick liked the feasts – where he could keep munching and not be expected to speak a word of Arabic). Margaret absorbed the fantastic Roman ruins and started to learn Arabic diligently.

It was their first taste of summer in the Sahara. There were incidents –

skids, sticking in the sand, exploding dynamos, and so on. Eventually, Clare who was getting furious with Bodley for never being able to take the wheel, developed a temperature from heat and strain. She collapsed delirious, in a caravanserai at Ain al Ibel, and in her delirium imagined she could hear 'the Kremlin bells ringing vespers'. Through her fever she heard Bodley remarking that she had 'no reserve strength' and that Dick ought to go to boarding school. Loudly she desired her affianced one to depart from the caravanserai and hang himself for all she cared. 'Don't marry him, Mummy,' Dick whispered in her ear.

By September they were all back at the oasis of Laghouat and Oswald's diary records with relief the 'official termination of Bod's expectations'. Not at Laghouat, but at M'Cid, an Arab village outside Biskra, would she find an old date tree garden – three gardens in fact – and within them build, at last, the house of all their dreams. It would be called Bab-el-M'Cid – 'At the gate of M'Cid'.

The Ronnie Bodley episode produced repercussions which echoed up to our schoolroom. He happened to be a friend of my father's and as he stayed with us during visits to England, I heard another version of the Saharan trip, in which he, although unable to drive or to dig sand quickly, was the hero. I was, in fact, once foolish enough to speak of him to Margaret as having 'the profile of a Greek god'. I was, of course, echoing my elders whose whispered stories concerning Ronnie's amours never missed my ears. Margaret – so much better educated than any girl I had ever met – snubbed me. 'Since when, may I ask, have Greek gods had tiptilted noses?' I wilted at the rebuke and have never since passed a remark about *any* man's nose.

What Ronnie Bodley *did* do after receiving his marching orders from Clare, was to write a novel called *Opal Fire*, concerning an educated woman, resembling Clare, depicting the Italian who gave her a rough time in a Rome hotel, not as Mussolini, but a waiter! The heroine carried a fictitious name, but the dustcover of *Opal Fire* showed a woman sitting on a pile of luggage, the labels of which bore the initials C.S. Clare herself showed me this jacket muttering about libel, but instead of going to court she sat down and produced a retort in the form of a novel featuring a good-looking cad who cheated on his desert sheep-farm. The writing of *Green Amber*, as this book was called, got a great deal out of her system, and probably made more money than a libel suit.

From then on – that is during the years 1927 to 1931, when she grew tired of the desert and took an apartment in Paris – Clare lived chiefly in her white house overlooking the Wadi of M'Cid, and during their summer visits to Ireland, I became yet more closely linked to this spectacular cousin and her out of the ordinary daughter, and to Dick her son.

After reaching the age of forty, Clare became less interested in men, and more deeply conscious of the joy of making beautiful things – houses, gardens, fountains. She disliked writing 'pot boilers' as she called her novels; even travel books bored her to get on paper. 'While writing I watch the clock to see if it's lunch time, whereas with my hands in the clay I don't know or care if the day has gone.'

Her two autobiographies *Nuda Veritas*, published in 1928, and *To the Four Winds* in 1957, were more amusing for her to write than for others to read, but it was noticeable that Clare's character never revealed itself. Some people thought her selfish, others deliciously stimulating, but the opinionated author who appeared to be passing thoughtless judgement on the countries where she rested, was unrecognizable in the live, scintillating Clare Sheridan.

Of the novels, I recall only the names of two, because they scandalized our family. One, named *The Thirteenth*, described a vamp somewhat resembling herself, whose lovers were grim failures until she reached her lucky number – the thirteenth! This was considered a very shocking theme in the 1920s. Another book, *Stella Defiant*, was most unwise. Her rich brother-in-law, the sporting Lord Wavertree, had worked out a very successful method of breeding his racehorses by casting the horoscopes of the sire and dam. His horses bred by this method won many great races, including the Derby of 1909, with Minoru. Clare, who had been showered with cheques, presents and advice by Willie Wavertree, had no compunction about using him and his horoscope breeding as the theme of a novel. She skimmed over the racing world, which did not interest her, and concentrated on the other aspect in which according to rumour, Lord Wavertree found the juxtaposition of planets aided human procreation. The heroine of *Stella Defiant* was the daughter of a successful race-horse breeder who arranged for a mistress to emulate his mares and produce a daughter according to the stars.

Clare's tit-for-tat on Ronnie Bodley was understandable, but she was quite surprised when kind Uncle Willie and dear disapproving,

childless Aunt Sophie were absolutely furious at the publication of this book. An unexpected comic incident resulted at a Buckingham Palace garden party when Aunt Leonie (who dearly loved an intimate chat with royalty), was taken aside by King George V. Fondly imagining that His Majesty wished for a nice little confidential talk, my grandmother strolled along the gravel path preening herself, and dropping an occasional 'Sir'. When he got her alone, King George suddenly, but apparently in all innocence, turned to her: 'I read two most curious books the other day – by your niece Clare Sheridan – one was called *The Thirteenth* and the other *Stella Defiant* – any truth in them?' My usually suave grandmother found it hard to formulate a quick answer. 'Sir,' she finally gasped, 'who chooses your books for you?' At that moment Queen Mary appeared; there was more brisk curtseying and to my grandmother's relief the subject was dropped. But as he said good-bye, King George remarked casually: 'Very curious books – very interesting. I should like to meet your niece.' My grandmother could not be sure if there really was a twinkle in the eye of that outstandingly moral monarch.

As the Muslim religion forbade the modelling of human faces, Clare produced beautiful fountains, somewhat stylized, of flying birds, and directed her Arab mason to build and unbuild white arches and insert windows of various shapes and sizes. She herself spent two years decorating her own inner walls with a twisting design of orange trees and vines. She had learned that the Persians inset mirrors into their walls, so she inset coloured-glass grapes and oranges backed with tinsel in the plaster. Exotic birds hovered among the blossoms. Every inch of space was filled by a leaf or a tendril, outlined in gold. No furniture could be suitable for such a décor apart from one large orange divan and a Koran stand for the bedside book. Another room had to be built outside in which she could keep her clothes. All this was rather expensive, especially the knocking down when new and better ideas occurred.

Occasionally acquaintances and friends from Clare's early life arrived at Bab-el-M'Cid – Lady Diana Cooper in a huge white felt sun hat rode out on a borrowed stallion, to a smaller oasis, where at Clare's behest, the local Caïd organized a luncheon. Clare carried eiderdowns for her to sit on beneath the palms, and Duff Cooper, disliking stallions prone to fight other stallions, followed in a curtained carriage like an Arab bride.

Lord and Lady Ednam also arrived. Clare introduced them to the

local Arab celebrities and much hospitality was shown. But Lord Ednam *would* advise her to send Dick to Harrow (for which he had no inclination), and when the great admiral Sir Roger Keyes came to Algeria, he tormented Clare by suggesting that her boy might profit from the discipline of the Royal Navy. Then Lord and Lady Louis Mountbatten arrived and were driven across the desert to the most delectable ruins and oases Clare had discovered. And one day Scott Fitzgerald and his wife arrived at the gate of the high mud wall of her garden *on camels*. They did not descend, but sent in a note of introduction from Shane: 'You will be interested in this young man – he knows how to write. He has dedicated *The Beautiful and the Damned* to me. Do something amusing for him.'

Clare went out into the village street with Haafa, her caretaker-factotum, and implored the Fitzgeralds to slide off their camels and enter her garden for coffee. But it was their first camel ride. They had hired two kept specially for tourists, and they would not dismount. 'We just wanted to *see* you. Shane said we must.'

'But you can't see me from up there. Come in. I'm offering coffee as Arabs do. It is rude to refuse.'

'We can't. We've got to get back to New York.'

'Well, really, very strange people,' remarked Clare to Haafa.

Under pressure from Lord Wavertree and various English friends, Clare reluctantly compromised by sending her son to an English boarding school in Switzerland, where my brother Jack was already miserably incarcerated. Wearing a leopardskin toque which greatly impressed the other boys Clare alleviated their existence with cream bun teas. But the melancholy of Dick's letters resulted in a speedy withdrawal. Henceforth he was educated by the delightful English Chaplain in Algiers, Reverend Lucius Fry, a classical scholar. Dick learned to translate Roman inscriptions (which abounded on the desert's edge), to paint a little, and to indulge his passion for sailing. He also learned to write vigorous English prose. Margaret was simply left alone to read and to learn Arabic with all the diligence of her imaginative scholarly nature.

Occasionally Clare took her children camping in the Aurès mountains which lay in veils of exquisite light to the north. The Sheridans were accepted as 'friends of the family' by the Bash Aga, reigning prince of the locality. They appreciated this unusual honour and grew to know all his relatives intimately.

During the summer of 1927 Clare brought Margaret to Ireland and left her at Castle Leslie, where she was well remembered by the tenants, as a little girl playing there during the winter after her father's death. Thus it was that Clare's daughter became my first great friend. My own upbringing had been as unsteady as hers, though in a different and less interesting way. My father never noticed that he had a daughter. My mother regarded schools as convenient kennels in which to leave 'pets' for a short time. With a procession of governesses I learned to read very slowly, and was then tipped into a variety of schools, sometimes being left through the holidays, sometimes taken away in the middle of term. At thirteen my chosen literature consisted of *Tarzan of the Apes* and *Bulldog Drummond*, both of which I accepted as gospel truth.

Margaret with her expressive brown eyes, her smooth sun-gold skin and quick wit, awoke in me the desire to copy her, and to learn something – a hitherto alien sensation. Our rooms adjoined and when the day ended – those sunlit summer days of swimming and fishing and tennis and picnics in the woods – we would sup together while the grown-up house party dined. And although she never mocked me, I could see Margaret's mobile lips moving humorously when she watched me take up my books. Feeling foolish, I stopped reading for a time. Instead, I emulated her by writing a diary. And then, having banished Tarzan and Bulldog to the nursery shelves I began to follow her and read Anatole France (with a dictionary!). We weren't on the same wavelength, for her French was perfect and mine elementary, but I struggled along and eventually I could discuss books and people with her although still on different levels.

All this happened while the slow magical dusk descended on the lake outside and the voices of that other world which we would some day have to join, drifted up from the dining-room. Then, dinner being over, the ladies would come upstairs to 'powder their noses' and look in on us – they in the short evening dresses of the time, we in our schoolgirl dressing-gowns. Sometimes, only half listening to the reply, they asked us what we were reading. My cousin was so knowledgeable on the subject of French literature that she often caused eyebrows to lift. When my very broadminded grandmother found the *whole* of Anatole France in paperback strewn around Margaret's room, even she became thoughtful. 'Of course it is important for a girl to be well read but she mustn't become *too* cynical.' So beloved Aunt Leonie ('Gran' to me)

tried to wean Margaret on to Voltaire – her own favourite brand of cynicism.

That winter we returned to London, and Margaret proceeded to take me to the British Museum – a favourite haunt of hers which I had never heard of. I hoped that she would be allowed to live with us for ever, but suddenly Clare appeared in a spectacular Arab burnous. The effect her presence had on us differed. Margaret wilted and tried to be sarcastic which did not suit her warm, glowing personality, and I felt widely stimulated and desirous of showing off.

For a time Margaret and I stayed at Brede Place where we shared a bedroom (in what was referred to as 'the haunted end of the house') whose door used to slip its own bolt and open after dark! The staff was in slight disarray. Not on account of the ghosts, but because Rosa Lewis had taken to visiting her former employer with hampers of champagne towed on a trailer at the back of her former laundry car. Clare's mother did not like the look of the laundry basket, and Rosa *would* try to inveigle the pretty maids to come to her hotel where they would meet 'a lot of nice young men'.

How cruel it was to see the Sheridan family off to Algiers when winter came! But at least the mail existed. Finding me almost completely illiterate, Margaret had in four months taught me to place a daily record on paper. As I was mad to maintain communication with this exotic bird – so much more *interesting* than other girls of my acquaintance – I strove to summon up my thoughts for her appraisal.

Dick, who was a huge but babyish twelve-year-old, drifted vaguely in and out of the scene. Boys meant nothing at that juncture and young men did not exist in our world. We never saw any. They were being kept for later – when we had lost our 'puppy fat' we would be produced. Dogs, horses and books were all that mattered. The transition from half-witted juvenile to a companion for Margaret Sheridan of the Sahara was quite a leap in one summer, and the intense pleasure of her companionship was the prize.

During the following year Margaret and I corresponded regularly. Her vivid style lured me on to great efforts. I had not her mastery of English nor had I desert experiences to record, but I did my best to hold her attention, and when Major Ronnie Bodley, her mother's arch enemy, came to stay with us, I sent Margaret accounts hardly suitable for grown-up eyes. While these lucky Sheridan cousins enjoyed trips through the Sahara and staying with Caïds in the Aurès mountains, I

knew only ordinary Irish country life. But through her daughter's letters, Clare became very well known to me indeed.

Suddenly, during a pea-soup London fog, my mother, startlingly, decided to take a Saharan trip. Next day we were buying thick felt sun hats and jodhpurs for camel riding and the day after we had tickets on a Dutch steamer. In Algiers we stayed at the elegant St George's Hotel, high above the town.

Lord Wavertree was also there, and while we had meals together he poured forth his dilemma concerning Dick's upbringing. 'I am his godfather and Wilfred would have wished him to go to Harrow. I feel responsible. I gave Clare four thousand pounds specifically to cover that boy's education and do you know what she has done with it . . .?' My mother was riveted. I pretended not to listen. 'She has spent the whole lot on marble columns for that damned house of hers in the river bed – had them hewn out of some quarry and dragged across the desert by camels – *camels!* That alone cost a thousand. And the house is built of mud and the river comes up in flood every year – the whole thing will dissolve. And Dick does nothing but play around the docks and sail a boat – Clare arranged for him to have painting lessons and there he was sketching *from the nude*. Can you beat it?'

All this I lapped up hungrily but when the long train journey to Biskra terminated, the wild excitement of meeting Margaret again was ruined by my own collapse with pleurisy, while Clare, who had hardly ever been ill in her life, suffered her first attack of flu. Through my fever and torment I heard my mother saying, 'Don't speak if Clare comes in. When ill she is like a wounded buffalo – she can only roar.' Margaret, quite rightly, fled from this house of wheezing and roaring, to drive her friends, David Arbuthnot and his sister Patricia on some sightseeing tour.

My mother, a very luxurious American who did not know it was possible to travel without a lady's maid, had brought Sarah from out Irish gate lodge. She cried a bit but was given daily love-tokens by Haafa, the Arab gardener-cook. I lay there gradually recovering, staring at the wonderful orange walls inset with glass grapes – for Clare had generously given me her own room to be ill in, while she fulminated in the outside dressing-room.

The visit was *not* a success. My mother and Clare had never very much liked each other – Clare resented any attractive woman entering the family circle. She also resented Clemmie. Shane and Winston were

hers. By the time I could get out of bed and into the garden I learnt that, terrified of the villainous appearance of the night watchman, my mother had induced the indignant Clare to hire a second man to watch *him.* Also, the fact that all meals had to be eaten sitting cross-legged on the floor around a low, exquisite Turkish table, was causing havoc with my mother's silk stockings and tearing her suspenders off.

The only food was cous-cous, the basic Arab dish of ground millet and rice. We *were* guests, but my mother eventually asked if some form of protein could not be added to the cous-cous. 'Boiled chicken,' she inadvertently remarked 'goes so well with rice.' Clare sat up and shouted, '*Haafa – tuez le coq.*' There was a terrible chase around the sunken garden, squawks and even worse sounds. Then Haafa appeared triumphant and blood-stained, dangling the cock from his hand. We found it difficult to swallow the chicken dish which appeared the next day.

As Margaret had gone off with her older, more interesting friends, I was lonely until Dick arrived from Algiers. Then we rode two lovely grey horses together, out into the desert and towards the hills, and he gave me a new kind of friendship – he was not intellectual but he was so human.

One evening as we rode back together, Dick, who was now an *enormous* thirteen, turned to me and with all the charm of absolute innocence said, 'Do you know I'm not allowed into the women's quarters any more – if a woman unveiled her face to me she would be killed. May I call you my first sweetheart?'

I was flattered. It did not seem ridiculous. We had had our first fights when little, chiefly over picking mushrooms at my Irish home. It was quite suitable to be first sweethearts now. Those brought up in Clare Sheridan's home could express themselves perhaps modestly, but without inhibition. I was to be followed by a very long procession but Dick and I never lost the childish bond.

Then came an emotional earthquake beyond my comprehension. Ronnie Bodley, who had heard we were staying with Clare, wrote asking us to visit him at Laghouat, two hundred miles across the desert. Clare was outraged, but my mother genuinely wanted to see more of Algeria and she hired an Arab car for the two-day trip. We stopped at Bou Saada on the way and saw the Walid Naïl dancing girls – 'most unsuitable for *une jeune fille*' Clare unexpectedly declared. We spent several weeks pleasantly with Ronnie Bodley and his

beautiful new young wife. I had no one of my own age, but riding Ronnie's white stallion made every outing an adventure and I was happy in Laghouat. The desert is famed for sunsets and dawns, but Europeans who go there seem liable to a number of complaints which render difficult the contemplation of beautiful sights. Dick had suffered suppurating sores on his forearms, Margaret had indulged in a mastoid, now once again *I* got sick. My mother diagnosed ptomaine-poisoning and Ronnie, who had a terribly infected forefinger, took me off to the Foreign Legion fort where a French Army doctor pulled my eyelids down, and said, 'Mademoiselle est gourmande', and measured a spoonful of medicine which I swallowed gagging before I quite realized that it was castor oil, the cure-all of the Foreign Legion.

Ronnie was then led aside groaning about blood-poisoning and his hand placed on a table for examination, or so he thought. Within the minute, the doctor had snipped off the finger at the first joint. He gave a great roar of pain and I felt slightly faint. We returned to his flower-covered house in a state of collapse. I recovered from my dose, but Ronnie's finger, naturally, never grew again. At least one had learned it is most unwise to get ill in, or indeed in the proximity of, the Foreign Legion.

26

Frampton

CLARE remained based in her oasis for another two years, but as she grew increasingly restless her summers in Europe became protracted. But Margaret, ever more studious and knowledgeable, found the pattern and traditions of Arab life to be deeply intriguing. Eager for complete acceptance among Muslim friends, she undertook the rigours of the Ramadhan fast, and on one occasion persuaded her mother to join in. The religious observance was far more distressing when it came in mid-summer – the thirsty daylight hours were so long. Margaret would sleep till noon, and then ride her beloved horse until the sunset gun allowed food and water. Clare, who did not ride and could not sleep at will, grew glassy-eyed and bad-tempered, but she liked it when an Arab friend, noticing her pallid countenance, said in the street, 'I see you are one of us.' Dick found more entertaining experiences to try his strength during the holidays.

During the winter of 1930 to 1931, old Mrs Frewen decided to 'have a go' at the desert, and Oswald drove her from London to the Sahara in his little Baby Austin, a journey which she thoroughly enjoyed, including the sea crossings. From Bab-el-M'Cid eighty-year-old Mumkin rode a camel and went for her first aeroplane flight. She had always remained clear-minded and determined to keep up the standards of her youth.

Clare's other guest, David Arbuthnot, a musical young man who spent several months at Bab-el-M'Cid, was most impressed by her power as a *raconteuse*. David has placed his desert diaries at my disposal. As his visit coincided with that of Grandma Frewen and Oswald, it becomes obvious that the white house with its sunken garden (which sank more each winter when torrents descended down the river bed)

was somewhat over-crowded. Haafa, aided only by a twelve-year-old brother, was getting hysterical when scolded by Clare at every meal. She was particularly angry when she discovered that Haafa did not go home at night. He just slept on the kitchen floor surrounded by food. David listened in astonishment when Mrs Frewen had her stories rudely interrupted by the family who were tired of hearing about the Tuileries balls and the Empress Eugénie. He noted Clare's almost daily tantrums while admitting the power of her charm and her art. 'Her bedroom is a real masterpiece – worthy of Pharaoh's burial chamber. She is without doubt a genius, which excuses those moments of anger and depression. She has put a wedge into my life that can never be removed.'

Clare became happier when Dick returned for his holidays, but David Arbuthnot added, 'She is rather distressed about Dick. She had hoped that he would turn out to have an artistic temperament worthy of his Mother. And to aid him towards this she refused to send him to school. The result has been a typical English schoolboy with *no* smattering of art in the whole of his large self.'

All through January and February 1931 it poured with rain – the desert turned into a sea of mud, the road from Bab-el-M'Cid got washed away, and the mud-brick foundations of the house started to sink where not encased in cement. Everyone grew extremely bad-tempered and Clare immensely argumentative. Her guests were employed trying to divert the course of the river which was threatening to sweep away the garden banks, but the evening meal brought all together over the low Turkish table. David wrote:

C.S. has at last decided to throw off all semblance of courtesy and good manners... People who are completely controlled by an artistic temperament are bearable for a fortnight but certainly no longer. For the guests there is but one end – a nervous breakdown. And it is on the borders of such that I have been hovering for the last three weeks.

Clare was tired of her house party. It had lasted rather too long. The climax came after a night spent combating the river floods.

We had been discussing portrait painting and I happened to remark that the late Mr Hardy had brought to a state of perfection the art of painting portraits of persons deceased from their photographs. Mrs Sheridan immediately asserted vehemently that such a man was desecrating the art of portrait painting – an absurd statement to which I took exception. C.S. lost her temper and seizing upon the nearest orange, flung it at my head, shouting, 'Who are you to talk about art!'

As Mr Arbuthnot now realized, the time had definitely come to depart, but he suffered a few more meals at Clare Sheridan's table and restrained his indignation when she read out her latest article entitled 'The Myth of Man's Superiority'. This happened to be among David's own favourite myths, but he kept his mouth shut. Only in his diary did he explode when she took to reading the European newspapers aloud. 'One gathers that the world has yet to produce a man who knows his business. C.S. knows it so much better.'

Clare now made no efforts to be polite to her guest – she made Margaret play the gramophone when he wanted to write, and ordered vegetable broth for everyone as 'a diet to improve our figures'. David noted it did not seem to be improving her temper. Yet he felt sad to pack his bags and leave for Marrakesh. After the rains, the beauty of the dark blue Aurès Mountains lay in shimmering desert light, and above all he was reluctant to leave Margaret who bore with tranquillity her mother's frequent tantrums and who knew so well the history of that part of the Sahara.

Then Oswald packed his ancient Mama back into the Baby Austin and drove off northwards, heading for Algiers and England, and Clare was left fulminating and restless. Margaret recognized the signs and reminded her mother of the promise made on leaving Turkey. Clare had sworn to her daughter that the next home should be *for ever*. But now Clare felt she was wasting her talents. For a sculptor to settle in a Muslim country where the eminently sculpturable faces of the Arab chiefs might not by religious law be portrayed, seemed ridiculous. She was fretting herself into a state of sickness, when suddenly old Mr Sheridan of Frampton died, and Dick became heir to the big house in its 6000 acres, and to the family portraits which included Richard Brinsley Sheridan and his lovely wife Elizabeth Linley, painted by Sir Joshua Reynolds. Dick also inherited the library.

Clare, scenting riches, immediately promised Haafa that she would buy him a wife 'out of the new inheritance'. Then she and Margaret set forth and took the first boat from Algiers.

Clare had not been to Frampton for sixteen years. She arrived there with Margaret whose henna-ed finger tips caused English eyebrows to lift. In vain she kept explaining that she had been preparing herself to attend an Arab wedding in native dress when the news of Grand-father Sheridan's death arrived.

Most of the servants had already been dispersed. Wilfred's three

brothers John, Algy and Maurice, whom Clare hardly knew, were installed, and a great sorting out of inheritances was taking place. This had been rendered complicated by the fact that two of the brothers had been disinherited for 'marrying beneath them' and the old Squire had over the years been illegally selling off heirlooms.★

Dick was the main heir, but his grandfather, disapproving of the way in which he had been brought up, had left everything not directly entailed to his other sons, whom he had now forgiven for making *mésalliances*.

On the morning after her arrival Clare wrote to her mother who was still on the continent,

<div align="right">

Frampton.
25th March 1931
</div>

Darling old Ma,

I reached Brede Sat last with Teeta [Margaret] Oswald met us at Dover with his 'Baby' (which is I should think the most disreputable car in England) . . . On Monday Oswald motored us up to London to catch the 1.30 express train to Dorchester. He started an hour late and so of course we missed it . . . All this to tell you what hellish journey we had. We arrived here at midnight and everyone had gone to bed. A footman in an overcoat, blinking like an owl, opened the door to us at last. We found fires in our bedrooms & went to bed. Early next morning Teeta and I tiptoed around the Hall & landing, deciding which bits of Sèvres & Saxe we would pocket & keep! Then we went into the dining room & saw six places laid for breakfast! I said angrily: 'They'll have to go – I won't stand any Sheridans in the house.' Then they all trooped in! First John who was disinherited because he married what all the family called a 'tart' – Then in came 'the tart'! – a nice-looking, well-dressed, amiable lady who captivated me at once. She is so genuine, so friendly, simple and charming. Impossible to imagine her anything but a 'county lady'!! John nervous and friendly. Then Algy his twin, almost sentimental with pleasure at seeing me again after 15 years. Then Maurice the youngest whose boy would inherit if Dick were not – All I can say is that within a few minutes we were all laughing & joking & as jolly as possible! And I *can't* be disagreeable because they're all so friendly. Marshal [the Frewen family solicitor] is here & Oswald arrived this evening. He will find a happy family, tous d'accord as to the future – all three boys have been left money & the un-entailed property (2000) acres divided between them so they're content . . . Dick gets good acres unencumbered appear to amount to £25000. Marshal advises that the place be sold and the boys agree. They all three say that they would sell it if it had been left to anyone of them. Dick will have something like £3500 a year when he's of age, & tax will reduce that by a further £1000. Therefore he could not live at Frampton which requires at least £6000 and should have £10000. I am so glad that all are agreed about selling and that no one is hurt or shocked.

My great excitement is I've telegraphed Dick to come for Easter. He is required

★By English law declared heirlooms avoid death duties, but must not be sold.

for business purposes as well as pleasure. The estate wll pay his journeys! He was so sad to think he would have to Easter with the Frys at Algiers . . . I had a great thrill seeing a quantity of silver, mostly Georgian, & all heirlooms going to the bank in Dorchester (packing cases full to await Dick's majority!). There is also a very handsome diamond pendant worth £300 that I have a right to wear, but I won't ask for it, as it would only be a responsibility, so that too will go to the bank, but Dickie will have it to give someday to his bride!

Oh darling! You are so sweet . . . We all love you so much . . .

Your Clairette.

The euphoria melted away when Clare found the brothers reluctant to leave their valuations to help her tie up fallen rose trees. And Oswald who arrived on the following day began to assess the situation, astringently recording the 'history of the last decades'. Algy, Wilfred's father, had married Miss Motley, daughter of John L. Motley, author of *The Rise of the Dutch Republic*.

They had five sons and 2 daughters, but from earlyish on I gather she only spoke to her husband to reprove him icily. The sons say that she never spoke a kind word or an untrue one. Her husband comforted himself with the house – and other maids, & lived almost wholly for sport, but continued to sleep in his wife's dressing room, which was also her bathroom, even after her death, on a mingy servant's iron bedstead.

Oswald was lodged in this suite where the Queen Anne semicircular powdering closet had been converted into a w.c. He could not resist taking what he called a census of the room's contents including '9 chamber pots and 7 bibles'.

He agreed with Clare's opinion of John's wife and discovered that, after being ostracized for seventeen years, the couple were invited to a Christmas shoot by the widowed old Squire.

The visit merged into a domicile. At the end it was the woman on whose account John had been disinherited, who was the sole nurse, companion and comfort to the disinheritor, who died practically in her arms, after with true senile selfishness having refused to let her go into Dorchester (4 miles) even to have her hair cut . . . In his dotage he got the cutting mania & cut the creepers on the house at the roots (leaving the dead branches to cling) & the shrubs in the garden leaving the stumps, & this, together with the policy of letting trees lie where they fall, gives an indescribable air of melancholy to the place . . . He sold the heirlooms systematically, till found out, & combed the library for valuable books & gave the valuable drawing-room carpet to his lady-love.

All Clare wanted was to clear out. She brightened considerably when the solicitor phoned from London naming a prospective buyer who was considering the price they asked of £100 000. During the cold rainy

Sunday of 28 March Oswald browsed through the superb library, collected between 1799 and 1840, examining the interesting volumes which had survived the old Squire's piecemeal selling. Dick's inheritance included the manuscript plays of his celebrated ancestor Richard Brinsley Sheridan, annotated with stage directions in his own hand. Margaret who, being a girl, inherited nothing, enjoyed herself among these precious books.

Meanwhile Clare wandered disconsolately in the drizzle. She called Oswald out to gaze at the bridge where she had said good-bye to Wilfred, and in the little church she showed him her memorial plaque for Elizabeth, and 'the cruel marble ones' to Wilfred and his elder brother slain in war. They returned to the house to begin clearing out Wilfred's old rooms where his things had been left untouched. Oswald carried out the collection of Staffordshire china which had been Wilfred's pride and packed the pieces into his trailer. The diary records:

The rest of the day was not so successful, for Margaret went off and royally ordered fires of the 15 year old housemaid. I followed Clare to Margaret's room with a stamp and heard her saying she must have consideration, and *not* ring bells in a lordly way, still less order a fire in her bedroom at 3 when there *is* one in the library.

Margaret saw fit to say sarcastically that 'if we haven't enough money even to have a fire . . .' to which in sudden championship of Puss I furiously & unexpectedly rapped out, 'We haven't . . .'

Oswald's interference triggered off understandable reaction. His diary continues:

As I left the room, an extraordinary noise brought me back – I thought Margaret was *assaulting* her mother! She was however, only standing up to her fullest height, bright pink of cheek, flashing of eye, shiny of nose, stamping of hoof, pouring out incoherencies, culminating in the seizing of her water ewer and the flinging of its entire contents on the offending fire! I mopped up the consequent flood with her face sponge in a stunned silence. . .

Oswald drove off next day to Brede, 'the trailer with Wilfred s china going clankety-clank like a railway coach the whole way'.

Dick reached Frampton for Easter and was taken out rabbit shooting by his uncles. He found the great house surrounded by fallen trees and neglected gardens dismal and when Oswald arrived for a second visit he saw that the family home had no appeal whatever for the sixteen-year-old-boy. Meanwhile Margaret had grown very bored with the county gentry who did not appreciate her intellectual and Arabic attainments; and those henna-ed finger-tips wore off very slowly.

When Oswald departed this time he recorded: 'Dick has found he is eligible for direct entry to the Navy 2 years hence. I think that was why Puss was wistful, & I naturally did not tell lies when asked my opinion. I fear Dicky may reach Heaven, but not the Quarter Deck if his mother can prevent it.'

A week later Oswald received a letter from Clare:

Frampton. April 19th 1931.
. . . I have something on my mind that I will have to write to you and that I hoped I could avoid doing but I did not see my way clear any longer . . . am a funny woman, I know myself. I go a long time in a smouldering state, & one day I burst. I've done it several times . . . It is all the more difficult to write because I do love you.

You may criticise me to myself, or even to my friends if it so move you, but I cannot tolerate your criticising me to my children. Happily nothing you can say about me to Margaret has any effect. She adores me & she's loyal. She has lived with me too long & too intimately not to know and appreciate me. Her love and respect will never waver.

My children are all I live for. I could easily have parked them both years ago on the Wavertrees as you know, but I happen not to be that sort. They are *mine* and I am sole guardian, according to *my* lights I have brought them up and educated them – my ideas may not be yours just as yours are not mine – I dare not bring Dick any more into your orbit – As for the Navy, this new idea is a week old & he thinks it might be a good plan to learn a little about men-of-war in order to know later how to handle his Thames barge! He wants the Sea & he can have the Sea – If he loved the Desert it would be no reason for going into the Foreign Legion – So darling there will be no visit to Brede for Dick this time. I have explained that I am too busy.
Your afft sister
C.

Oswald wrote in his diary, 'I was so stunned by this bolt from a cloudless sky that I just couldn't touch my lunch'. All he could do was 'creep upstairs' and munch the apples and marmalade which Seymour Leslie had luckily arrived with. Then he wrote back to his sister pointing out 'the impossibility of admitting or denying accusations which were not specified', adding as a P.S. '*I* would not have put a son in the Navy if I could have left him £1500 a year, but I *would* have given him a normal education & if Dick went into the Navy for 5 or 6 years it would give him character and cachet.'

There was, Oswald felt, more to her attack than his approval of the Navy could warrant. Several days later another letter from Clare clarified the situation. She, who had driven a Renault magnificently over the Sahara and knew how to charge sand dunes in bottom gear and emerge un-stuck to the applause of the Camel Corps and French

military, was having difficulty with a hired Morris Cowley in English lanes, and her children had been brought up to mock.

Before copying his sister's second letter into his diary, Oswald wrote, 'The trouble with Clare is that she is *so* ingenuous she is hardly worth powder and shot.' Her complaints were now explicit.

Frampton. 23 April 1931

Darling,

I am more sad than I can say. Because you see I do love you, I can't help it . . . Of course my letter came to you as a shock & you don't know what promtped it, but now I will tell you.

Dick wrote you a letter. That is the whole trouble. I intercepted it. A terrible letter! I don't believe he meant it, he thought he was being funny. But he has no right to be funny at his mother's expense. He held me up to ridicule and contumely on account of his opinion of my car driving. I had to take them to Bournemouth to lunch with Sophie [Lady Wavertree] I didn't know the way, it was about the 2nd time I had driven the car. The gears are the *exact opposite* of my old Renault – & I got flustered in the traffic of the town. Incidently Dick exaggerated & said I drove 'five times around the town' which wasn't true. He invented conversations with the petrol pump man & tried to imply the fellow was shrieking with laughter at me – It all sounds rather ridiculous – a tempest in a tea pot – but the fact is the letter was an outrage of disrespect and inaccuracy.

I practically had a nervous breakdown over it & didn't sleep all night. (I discovered it after he went to bed.) I cried my eyes out, I was so deeply hurt . . . However you *have* criticised me and adopted the attitude that I'm 'poor old Zooker' & that I don't know my own mind & you *have* told him that I've botched his life! I've told him he's a very ordinary young boy who is only the least bit interesting because he is my son & brought up oddly – & that he'd be a good deal *more* ordinary if brought up like ordinary little boys! Incidentally I *haven't* botched his life – he's *very* happy, he's never been through the misery you've known & which *wasn't* good for you – & he's going to have a gorgeous life – because happy – & its quite possible to be happy *and* useful . . .

Dick loves you and always will – but I *can't* risk being held up to obloquy. He's too easily influenced, and doesn't know his own mind – So you mustn't mind if for the moment I isolate him. Its a punishment if you like for his letter – But I've promised never to refer to it. He is deeply ashamed, admits it was a cad's letter & that he can't understand how he could have written it – and he wept bitterly –

As for Teeta, she doesn't hate you & has no malice in her, but she does mind your wanting us to sell Biskra, & she minds your not admiring me. She is very secretive and discreet but she *has* told me that when you drove her back from El Oued to Biskra you talked about 'lovers' warning her that 'nice men' were put off by them and insinuating that I had always moved our homes in pursuit of some *man*. This is quite untrue. Never have I cared for any man since Wilfred but the world's interesting men happen to be useful to my career. You should not talk about lovers to a nineteen-year old girl . . .

[231]

Of course I looked wistful the day you were here. I had that dreadful letter of Dick's on my mind. It has hurt me so terribly. How he could think that he could amuse you by writing in such a way. Strange boy. Not very intelligent. Needs guiding.

Don't be sad . . . You'll see Dick because he loves you but you must not allow him to discuss me – *ever*. It's unbecoming, & you mustn't criticise. He's all I've got – he and Teeta – & I am Tigress about them!

<div style="text-align:center">

Goodnight old boy – love –

Puss

</div>

'Whew!' was Oswald's comment. He then proceeded to entertain himself compiling an acid reply,

. . . I note your imperial command that we are to be friends although I am never, never to discuss 'the only thing you live for' which to *my* very ordinary mind would seem to truncate the friendship . . . I also note your command that Caesar's wife is to be above discussion. I had always understood that the original phrase was directed not so much to the People who should have their heads cut off if they mentioned HER name but to the Lady herself that she might comport herself with dignity and discretion.

I hope I may venture these abstractions without trespassing on the forbidden territory?

You are hardly the person to tell *me* I must not mention 'lovers' to Margaret when you have jeered at me for years because I did not keep a mistress. And I have never told Dick you BOTCHED his life – botched is a perfectly good word but it is not one of mine . . . it must be an encrustation of your subconscious'.

Oswald could hardly have intended to soothe his sister with the comment,

this utterly unnecessary row with its far-reaching and serious repercussions appears to be a monument to the maxim that it is dangerous to meddle with other people's letters;

nor by the ending of his eight pages,

Out of the blue you suddenly stab me & leave me stunned by the roadside, gaily say 'don't be sad – we are too old to fall out' & tootle off to Paris. 'Lets be friends' you say; just like Mamma's 'Well give me a kiss, no matter'. But it *does* matter, and a deadly wound like this is not healed by a word – You've got a long way to go to pick up. Love you I do, but the stamped-on snail does not put out its horns & it will be many a long day before my love can be allied to trust, which must be *earned* by you.

It was however, earned with alacrity. Clare dispatched Dick back to Algiers, took Margaret to Aunt Leonie's house in London where she was ordered to 'enjoy the Season', and on 5 July after lunching at Chartwell with Winston, she and Shane arrived to stay at Brede Place. Grandma Clara was running the house and maddening everyone by

instructing the servants to peal a large bronze bell 'when important guests arrive'. This was intended to summon all members of the family in from garden activities to 'mince around and be polite'. It made lesser Frewens extremely hostile.

Margaret refused to come to Brede. She had been needled by her uncle's remark about there being no money for a bedroom fire when Frampton was up for sale at £100000, and she was rather enjoying London where Aunt Leonie took the same pains to reveal the interesting side of Society as she had in the past for Clare.

A coming-out party was given. Margaret drifted in languorously, wearing a white dress, camellias in her hair. *Ma Tante* watched with approval and a little nostalgia – she could remember Margaret's grandmother pinning camellias in *her* hair and Jennie saying, 'Oh darling Clara, we'll swoon with the scent – what a bore that Milan discovered they were your favourite flower!'

The gentlemen soon began to fall for Margaret but to Aunt Leonie's chagrin whenever eligible young gentlemen were invited to dinner Margaret scorned them. The only males in whom Margaret showed any interest were not boys with fortunes but the famed eighty-year-old Egyptologist Sir Wallace Budge who taught her to read hieroglyphics, and of all people Dr Axel Munthe, who had been old if diverting in her mother's day!

Aunt Leonie, although seeing the humour of the situation, was finally moved to comment, 'So good of you to give so much time to these aged creatures but all this will not help you to find the right husband. *And it's never wise to let men see you are clever!*' Margaret smiled and returned to her gruelling hieroglyphic homework.

By the end of the Season Clare had become utterly exasperated with her intransigent daughter. It really was too bad. Margaret was behaving exactly as she had.

27

Dick

No buyer materialized for Frampton. The house was demolished and the lands sold to tenant farmers. Only one acre remained in Dick's possession – the plot by the river where his grandfather had chosen to be buried.

In the autumn Clare allowed Margaret to return to Biskra alone, while she remained at Aunt Leonie's angling for a chance to sculpt Gandhi. Eventually this was arranged and in October she started work. Meeting Gandhi was for Clare a moving experience, and she tried to impact his inner tranquillity into the work. Winston had refused to meet Gandhi. He did not wish to face the complications of a discussion with the Mahatma whose opinions concerning the British rôle in India were diametrically opposed to his own.

Gandhi had found out that Clare was a cousin of Churchill and while peacefully spinning, he suddenly remarked: 'Maybe you thought that because of your relationship I would not welcome you? On the contrary you are most welcome. As he will not see me you can tell Mr Churchill what I am like – not too bad really?'

Clare finished the bust in November. Gandhi invited her to spend the night in Kingsley Hall so as to be able to join in his 3 a.m. roof-top prayer. Clare had to bring her own blankets. As a cold fog was descending Aunt Leonie added her own fur coat to the heap she carried off out of the guest room. The butler, Mr Wells, told me he was terribly impressed as he helped Mrs Sheridan into the taxi and realized that she was going to sleep on a camp bed and get up at 3 a.m. to chant Hindu prayers on a roof-top.

When Clare reappeared next day shaking with cold but elated, her

account intrigued Leonie so much that she wished to accompany her for the evening prayer at a Knightsbridge house – by firelight.

Gandhi took to Leonie, and after she had knelt beside him in prayer for India, he drew her aside for a long talk. Clare fidgeted enviously, but never a word of the discussion would *Ma Tante* divulge. When Clare and Leonie said farewell to Gandhi, he looked at them humorously: 'Tell Mr Churchill who does not want to leave India that I *love* his relatives.'

After Christmas Clare returned briefly to Biskra. She was by now tired of the place but when she drove away one blazing hot day in the following May she never dreamed how many years would elapse before she returned. Dick, now sixteen and having finished his schooling with the Reverend Fry, remained for a time in Algiers with his small boat *Clàpotis* in which he intended to sail back to England. Clare went to Paris where she leased an apartment on the *rive gauche* – I rue Bonaparte – and, having arranged a studio, recommenced serious work.

During this period I paid her several visits, for my own début into London Society had been as uninspiring as her daughter's, and now that Margaret would not leave the Sahara, even in summer when the richer Arabs retreated to the mountains, Clare's company delighted me. She belonged to all generations. She drove around Paris in her Citroën and filled the apartment with white lilac and gave dinner parties which seemed wonderfully exotic compared with those I had attended in London. When she had no sitters she would make me pose for her on a prickly black bear-skin which she insisted kept me warm. I disagreed, but when my hostess cajoled, 'Your long back is so sculptural. Just keep still,' I gritted my teeth and, trying to feel honoured that my vertebrae lent themselves to decorate book-ends, gazed up at her new bronzes of Serge Lifar and the philosopher Keyserling.

Dick's sailing adventure ended catastrophically. When he set forth for England, *Clàpotis* sank in a storm first day out. He swam ashore and was found half-conscious by Arab fishermen. Not only had he lost his boat and all his belongings, but in a moment of childish madness he had snatched the original manuscripts of Richard Brinsley Sheridan's plays from Margaret's locked cupboard at Biskra and taken them on board. These manuscripts – among them *The School for Scandal* – of plays by his famous ancestor annotated in Sheridan's own hand were among England's literary treasures and ought to have been lodged in a

museum. Margaret cared for such heritage and had done her best to preserve the manuscripts at Bab-el-M'Cid, but for some reason Dick determined they should journey back with him. Clare received the news of his survival with joy, but my father, who was with us in Paris at the time, was so angry at the loss of those Sheridan plays that he refused to speak to her for days.

When Dick had recovered from his ordeal and bought a couple of new suits, he set sail once more in a boat belonging to another man. Unfortunately, he fell in love with the skipper's French wife, a very pretty girl and a useful hand at sea. While ready to encourage Dick, she warned him that there could be no question of anything very serious between them. Be that as it may, the husband found his crew in unseamanlike attitudes and he threw Dick overboard off the coast of Majorca. Once again young Sheridan had to swim ashore, and found himself dripping and penniless without clothes or passport.

The British Consul provided these and enough money to reach Paris, where he burst in on his mother reiterating his new ambition: 'Strange as it sounds, *je veux me cultiver!*' With this end in view we all went to the Sorbonne. I also wanted to register for what was called the 'foreigners' course'. But the office proved tiresome – it shut at twelve and did not open until two – and one had to produce educational certificates and such like, which neither Dick nor I possessed. We both felt we might just as well stay at home reading according to our own desire. So we did not return at 2 o'clock to register our names and lay down what seemed a large sum in francs. Instead, we indulged in a long-drawn-out lunch on the boulevard and then drove Clare's Renault exceedingly fast around the Bois de Boulogne causing gendarmes to whistle, and a summons for 'not observing the conventions' to arrive by post.

Soon after this Dick heard that a Finnish windjammer, the *Lawhill*, was loading in the port of London. He hurried over to London to sign on as an apprentice. Clare followed and stayed as usual with Leonie, while the ship was getting ready. Dick invited us all down to drink beer in dockland pubs and to gloat at the beauty of the four-masted barque. It was November, and at night hoar frost made the rigging gleam like unearthly silver. Clare would gaze up and pat the mast murmuring prayers for Dick's survival. Within twenty-four hours of the *Lawhill*'s departure, a 70 m.p.h. gale blew and the windjammer

got into trouble off Deal and had to be towed out to mid-Channel. Unfortunately, Dick's journalistic friends who had been following *Lawhill's* progress, immediately used this event for headlines. Clare received hysterical phone calls of sympathy and condemnation of the venture. But the great ship was soon on her way in the open ocean and Clare resigned herself to a six-month wait during the trip to Australia. She hoped the Frampton curse would not chase her son out under the Southern Cross.

Back in Paris she received a few orders, and then, to her delight, a political upheaval arose and protest marches began against governmental corruption. There were street riots (of which Clare always approved because it gave her the opportunity to become 'our Paris Correspondent' for various publications).

When the *Anciens Combattants*, the *Croix de Feu* and the *Jeunesse Patriote* organized a protest march, she telegraphed Oswald to leave dull Sussex and walk the streets with her to the strains of the *Marseillaise* – most exciting of all national anthems. A few shots were fired and the sight of gendarmes using truncheons added lively material. How indignant Clare became when she had forced her way into the Hotel Crillon to view the Battle of the Place de la Concorde, and there were hardly any charges – just skirmishing with the *flics*! When the violence died away, her journalistic records were not wanted and I can remember her in tears when one newspaper wrote that it no longer required her weekly column. 'Those insular, uneducated English – why don't they want to know what is *brewing* in Paris? France is on the verge of a revolution . . .'

When it became clear that there would be no more bloodshed, Clare, the eye witness of violence and a barometer of French feeling, went to London and dined with Winston. The other guest was Sir Archibald Sinclair, leader of the Liberal Party. She recorded:

Winston as usual at the beginning of dinner was rather silent and thoughtful. I watched his face; one almost felt the machine ticking. Suddenly he launched forth with such emphasis that one might have supposed he had been in Paris with me. He displayed perfect understanding and appreciation of the facts . . . Daladier, he said, had allowed patriots to be shot down, who were spontaneously protesting against a government that was *pourri* (he seemed to like the French word), but that it was not so much the shooting that was to be be deplored as the state of affairs that had been allowed to develop, and which had provoked the patriots into action. He referred to *us*, the English, as 'the children of the French Revolution'. What France fought for we reaped without any of the Terror!

While Clare and Winston held forth emotionally about France, and wine glasses were refilled, Sir Archibald Sinclair, who disapproved of the 'delirium of protest marches' and thought that Daladier's government had been right to shoot in defence of an elected parliament, sat silent. Clare knew how to get Winston going, and on this occasion she was able to keep pace. She enjoyed that dinner.

Later on, when Barney Baruch invited Clare and Margaret to stay as his guests in a grand hotel at Vichy, mother and daughter accepted with curiosity and delight. Possessing iron digestions they had no need to participate in the cure, but while others sipped the waters they added a certain allure to the spa. Clare criticized the décor of the luxurious hotel and could not resist holding forth on the good taste of Communist Russia, which did not amuse Mr Baruch, but Margaret, growing ever more lovely and causing much speculation among the bilious rich as she swept around in her home-made cotton frocks, aroused once more all the kind protective instincts of that great financier.

Baruch thought that Margaret had suffered a rough deal because Clare exhibited unjustifiable favouritism towards her male child and English girls seemed to have no rights to the patrimony. 'The adviser of Presidents' wished to open up life for this dazzling girl. He was a very sensitive man, and he felt deeply moved by what he called 'the poignancy' of Margaret's situation. What was Baruch's surprise therefore when he asked Margaret to say what he could do for her – what gift could embellish her existence – and she answered, thoughtfully, 'A car – a car that can face the desert.'

'Oh Margaret,' he said, 'you're still in love with that old Sahara. But so be it – the car you shall have, and a right one.'

On her return to Biskra she made the most of Mr Baruch's offer. During the following year she was to take part in three expeditions of immense interest among Touareg tribesmen deep in the Sahara – but that is another story. And then, in 1935, she would marry a French Army officer, Comte Guy de Renéville, called by General de Lattre de Tassigny 'the most likeable lunatic in the French Army'. For two years they would vanish from our view into French Equatorial Africa. Eventually she brought Guy to stay at Castle Leslie, where our friendship had first blossomed. Their names are inscribed in the guest book – but I was not there. Margaret had given me so much, I would have found it difficult to share her.

The *Lawhill* reached Australia safely and six months later Dick arrived back in England on this beautiful windjammer. Clare met him rapturously and only then learned that he had very nearly lost his life when, during a storm, he had been sent out on the yard to furl a sail and a footrope broke leaving him dangling 100 feet above the deck. He had been hauled to safety by his mates and the Captain ordered every footrope in the rigging renewed. Clare thought the curse of Frampton must have been shed out there in the ocean, and it was with a lighter heart that she left Paris for London, where Dick now intended to settle. After publishing a book called *Heavenly Hell*, his account of the voyage, he rented a flat and started to try to write plays. We all thought it would be amusing to see the name of Richard Brinsley Sheridan the Second on the theatre boards.

Clare bought the lease of a studio-house in St John's Wood, 25 Woronzow Road, and there she worked away in fresh heart, although a frightening moment was approaching. Dick's twenty-first birthday would fall on 20 September 1936, and until that date passed the faint shadow of the Frampton curse lingered on. No first-born son had ever survived to inherit those lands from which Henry VIII had evicted the monks. By now Dick had sold every acre except that one by the river which contained his grandfather's grave. He went to Dorset to look at the place being broken up, the great trees cut down, the house itself demolished, and he arranged to transfer the riverside plot, but he did not actually sign a transaction.

For his birthday party Clare had made a nine-foot high iron candelabra on which twenty-one candles were lit in thanksgiving for the years of his life. We all attended that joyful party in the big studio, and Clare would write in her diary: 'Tonight my heart is an altar lit with candles . . .' Everyone rejoiced that Dick had 'made it'. The twenty-one candles were still burning when I left at dawn.

Old Clara Frewen had died leaving Brede Place to Oswald. The monies which Dick received from the sale of Frampton he spent on purchasing Brede from his uncle, and on the installation of electric light and plumbing so that the strange exquisite house could be let to an appreciative family. We, the cousins, were a little sad that one could no longer creep timorously to the splendid oak-encased earth-closets holding a candle that threw shadows on the panelled walls, but the Frederick Holts who were most sensitive tenants held other views.

Oswald had already constructed himself a home in the park and

Clare started to plant a bulb garden in a little valley where she could, if she wished, build herself a tiny 'cottage dower house'.

Dick's life in London, now that he had come of age, followed a hectic tempo of motor smashes and girl trouble. He found play-writing more difficult than he had expected and one night he telephoned his mother to say that, after a fist-fight with a husband, he had a black eye and must rescue the lady from the mess he had landed her in. He arrived for breakfast with his eye bandaged and told Clare he wanted to go back to Biskra, taking his lady with him. He was sure he would be able to write in the peace of the desert. Bab-el-M'Cid lay empty now that Margaret had gone to the Congo, and Haafa would welcome him and produce his relations as servants.

Next day Dick departed with a half-written play and his lady. They planned to drive out in a Ford V8 which had already experienced a fair quota of accidents. He telephoned Clare before leaving at dawn. 'I'll give the flat key to the garage owner. You'll find it untidy – goodbye – my love.'

A few weeks later I went to see Clare. She was working at a clay head and casually mentioned that Dick had had an operation for appendicitis: 'They flew him to Constantine – there's a good hospital there.' Next day, a telegram reached her: 'Peritonitis developed, come quickly.'

She left within the hour, travelling all night to reach Paris soon after dawn. It was Sunday and not a train left for Marseilles till evening. There were no planes. Clare deposited her suitcase with the concierge at 1 rue Bonaparte and walked to the Louvre where she sat staring with unseeing eyes at the Greek sculpture till closing time. On returning for her bag, the concierge said, 'Madame, a telegram arrived for you. As you are not resident they would not leave it but you can ring at the back door of the Post Office.'

She took a taxi and found a side door of the closed Post Office. A boy looked through the *dépêches* of the day. He found one for Madame Sheridan and Clare tore it open. She could hardly see to read in the dim light but gradually the words came into focus and a blackness swept over her. When she opened her eyes the Postmaster's wife was holding her head and the taxi driver was saying, 'Quelle est l'adresse de Madame? Can I take madame to a hotel or to friends?' She could only say, 'My son is dead. I don't know where to go.' They were silent then, the strangers, and kind. A cup of hot coffee was brought,

and she remembered a friend's address. The taxi driver took her there and helped her up the stairs. Her friend opened the door and Clare held out the slip of paper unable to speak. They took her in and gave her a sedative and she slept heavily, for there was no longer any hurry or anything to do.

Clare had to adjust her mind to the unbelievable fact that Dick would never come storming through the door again. Two of his young friends arrived from England and escorted her on the train to Port Vendres on the Spanish frontier where she wished to meet the ship bringing his body from Africa. She wrote,

Such a small harbour, just room for one big ship to berth at the quayside. The village consisted of a row of houses and round the bend of the bay a Church seen dimly through a forest of masts of fishing craft. In a matter of minutes I was wandering along the rocky shore, knee deep in wild rosemary and rock cistus. The creeks and inlets were of a deep scintillating aquamarine. I sat and stared into the lovely clear depth. The temptation was immense; a little courage, an instantaneous decision, and there would be an end to the unbearable ache. As I could not swim oblivion would be quick. But would I be with Dick? Was it as simple as that?

The feeling that suicide was not the way to get to her son overwhelmed her.

She buried him there beside the Mediterranean, in a little hilltop cemetery. The grave was covered with flowers by peasants and fishermen who heard that an English boy was to be laid among them.

Then, as a distraction from grief, Dick's friends suggested that they should all three cross the frontier into Spain and see what they could of the Civil War. Clare might find an appeasement of pain when the bullets sang near her. Perhaps she could write for some newspaper. 'I came to Spain in the hope of finding annihilation in the Civil War. But so instinctive is self-preservation that I allowed myself to be led below ground when the wailing sirens gave warnings of German bombers.' She found she had no desire to write. Her journalistic flair had disappeared.

The peace of Biskra might help. Clare returned there and Margaret flew up from French Equatorial Africa – suffering five days of changing planes – to join her. Haafa was waiting – sad, for he had adored Dick, but quiet in deference to the Will of Allah, and accepting as a normal occurrence Dick's ghost whom he met smiling in the garden.

In the silence of her oasis Clare sought to regain her balance. She was determined to seek contact, and to a certain extent she found com-

fort in attempts to reach Dick by automatic writing. She really cared for nothing else except trying to get through.

When she returned to London in the summer she was quite a different person. Many people who had grown accustomed to the other Clare – the romantic tornado of a woman – no longer sought her company. But she had only changed; she had not stopped. A new exciting person would emerge from this anguish.

Winston saw her before she left for the next venture – she was shipping Dick's Ford car across the Atlantic and then driving on alone to an Art Colony attached to a Red Indian Reservation in the Rockies. Her cousin simply embraced her exclaiming: 'There are no words. Just know I love you. And go to those Red Indians. I am sure you will learn something further.'

On 14 May 1937 after a last visit to Brede Place she wrote to Mrs Frederick Holt who was living there on a long lease. The letter was typical of Clare's capacity to mingle joy and sorrow,

Dear Mrs Holt, I was very sensitive to all you felt for me when I was at Brede & so thankful you didn't say anything, Any outspoken sympathy makes me break down, as I expect you surmised. It takes all my strength to keep up a brave front . . .

As for building a tennis court – put it where you please. I personally do *not* think it's an ugly thing, whether its green or red. I don't play, but always think the sound of people playing, the laughter & the score 'love this' & 'love that', is rather a pleasant cheery sound –

I saw her off. Curiously, my little present happened to turn into the most useful of her belongings – as small, thoughtless gifts sometimes do. This was a rug which could roll up into its own pillow covering. She was to sit on it all day by the mountain shore where she learned to carve, and to sleep in it at night.

She would write:

How strange that through losing one child I discovered myself as a modeller, through losing another I found myself a carver. It seemed to me I hadn't been a sculptor until now, for modelling is not sculpting. To tackle wood is a great sensation. Wood lives, comes to life under one's hand, one wrestles with it, humours it, coaxes it, argues with it. The grain gives fight.

She started by carving the soft cottonwood trees fallen beside a lake, into likenesses of her Red Indian friends. She remembered old Grandma Jerome's tale of her own mother being half Red Indian and when she related this it evoked a kind of bond. The prairie, like the desert, gave Clare an inner peace. When she finally returned to England, on a ship

whose hold carried enormous crates of Red Indian faces carved in wood, Clare said, 'But what has happened to England – or is it only that *I* have changed?' It was 1938.

In the spring she held an exhibition, and these extraordinary heads hewn out of trees aroused much interest. The critics did not know quite what to say or how indeed to judge such work. It was unique. Winston, of course, made a superb observation: 'A very curious exhibition my dear – *all heads of Shane!*' And, indeed, one could see that all Red Indians resembled him or rather that he resembled all Red Indians. The high cheek bones and half-closed eyes of every face appeared to be a version of Shane Leslie.

The technical mastery of wood inspired Clare with fresh creative urge. She was over fifty now, but her versatility and power to learn, her freshness of spirit survived.

When the war came she retreated to the cottage she was building beside Brede Park, its little valley already planted with bulbs and flowering shrubs. Margaret returned from Africa, donned the khaki uniform of the Mechanized Transport Corps and proceeded to drive ambulances. She had learned to change a wheel in the desert, now she did it under bombardment.

Occasionally Clare came to London, dressed as ever in brilliant colours – tangerine shawls and flowing violet tweed skirts. She was still glamorous. She still made every party go, whether lunching with Shane's son John and his brother officers of the Irish Guards when on duty at the Tower of London, or spending a hectic half-hour with Winston, who was back in his old job – Lord of the Admiralty.

In general, of course, Clare disapproved of the war – she was a pacifist, and every time a woman she knew who had lost a husband in the other war suffered a second tragedy with a son killed in this one, Clare would admit herself lucky not to have to endure torn feelings – for if Dick had lived he would have joined up.

28
War

CLARE now relied greatly on two people. A woman named Shirley Eshelby wrote to her out of the blue, saying she also had lost a son from appendicitis at the age of twenty-one – his birthday was the same as Dick's. Mrs Eshelby, stone deaf, believed that in her enforced silence she could communicate with her son. It might be more difficult for Clare distracted by sound, but she advised her to try and maybe she would find a link with another world.

The other friend was Dr Walter Stein, an anthropologist prone to intuitions. When, just before war broke out, Stein badgered her to inform Winston that he was about to rise to great power and that France would 'cease to be of use', Clare begged her cousin to meet him. But Winston demurred. 'The world is full of cranks with messages. I haven't time to listen.' Believing passionately in France as an ally he did not want to hear discouraging news of the Maginot Line, and he knew by instinct his own destiny.

On one of the rare occasions when Winston could drive down to Chartwell for the day, he took Clare with him. After lunch they walked around the garden, admiring the black swans and the brick walls he had found such satisfaction in building with his own hands, laughing about her rebelliousness and muttering about the Hitler tyranny. When it was time for her to leave, Winston came to the stairs, hugged her, and as she went down he called out, 'Remember . . . our love is eternal!' She wrote this in her diary adding, 'For a flash he was as near and dear as a brother, but all too quickly he soars away and is lost in a mist of preoccupation.'

Shane wrote to her,

In a way it is consoling to think of you without husband or a boy. You at least cannot be hurt again and you will be a spiritual force for others. I am glad you have settled in your little cottage and have returned to the land. You will find a wonderful peace in the breast of nature . . . I do not think this can be any parallel to the old war. It will take other shape and of course the results will also be other. Surely it is best to refrain from the endless wireless – and go one's way with one's ears listening within rather than without . . .'

Certainly Clare did this. But although she had no boy to fear for, she had a daughter driving in dangerous conditions. It was hard to sleep when overhead she heard flotillas of bomb-laden enemy planes throbbing their way to London. Clare would lie awake thinking of Margaret tin-hatted, driving her ambulance through the darkened demolished streets.

Brede Place, lying eight miles from the coast, was requisitioned by the Army and the Holt family were given two weeks to remove their precious belongings. During the Battle of Britain from her small sanctuary in the park Clare wrote to the Holt daughter on 19 September 1940.

Dear Rae,

I wonder how you are – & whether its several kinds of hell! It seems to get worse in a steady crescendo. Margaret has let herself in for something – She joined the M.T.C. & now drives a lorry with stretcher parties . . . She's been in the very thick of it – & on two occasions was sent to shelters that had received direct hits, a human butcher shop but she wasn't sick. Nothing will induce her to give it up and join me! Last night we had a great scare here about 10 p.m. There was an explosion that blew open my front door although it was locked – a magnetic mine like those at sea, dropped by parachute in Bakers field just down the lane! I can see the crater from my door 16 ft deep. If it had fallen on the village there would have been nothing left.

All night long they pass overhead in waves on their way to London – its almost impossible to sleep – I can stand anything by day but the nights are pure hell . . .

Margaret was not always on duty. On 11 March 1941, after a particularly heavy raid, she wrote:

'Mama darling, Queen Charlotte's Ball [the annual deb charity party] went off well. There were 976 people, quite a blitz going on too; but we heard nothing of it. Most of the Brigade of Guards were there, and I knew lots of them. It was good fun. The Café de Paris got a bomb on its dance floor – which sent the orchestra, still playing, to Heaven and a few couples detached jewelled hands still clasping the stems of shattered champagne glasses. Almost at the same time a pub was demolished in the Essex Road, but no one cares if horny hands were left clutching beer mugs!

We all went on to the Four Hundred [a nightclub] and danced till 5 a.m. Then you woke me up at 9 to ask if I were still alive! I wasn't quite sure . . .

A more unsuitable habitation for the military than Brede Place, a fourteenth-century manor house with its yet earlier chapel, is difficult to imagine, but Clare made full use of the soldiers. While they awaited the invasion that never came, she alleviated their boredom by using them to cut down dead trees in the park and carry them to the studio beside her cottage. Among the trees were two giant oaks. The tallest of these she encouraged ten strong soldiers to set up in her studio, and there she carved it into a Madonna as a memorial to Dick. When, after seven months' work the statue was finished it stood nine feet high and on the base Clare carved her inscription:-

This oak tree from Brede Place was carved by Clare Sheridan in memory of her beloved son Richard Brinsley Sheridan.
September 20, 1915 – January 17, 1937

The old Rector of Brede gladly received this unique work of art into the Lady Chapel of the small medieval church of Brede village. One winter day he watched the ten soldiers struggling with it up the steep lane which leads from Brede Place, and then when it would not stand firmly, the blacksmith came in and forged a strong iron spike which held the Madonna in place. All this was done in days when petrol was unavailable and the guns of England were trained ready over countryside silently waiting for the enemy.

Shane came for the unveiling at evensong and wrote in a letter: 'As the purple veil fell, there was an awed hush. It is an inspired work and could stand beside the wonderful mediaeval statues of Chartres.'

Clare found that her enforced isolation with strong soldiers to lift and carry presented perfect conditions for a carver. During the lonely war years she turned from an able sculptor into a great artist. She had a sense of her own pinioned wings opening out. From now on most of her carving showed a religious character. She did not desire fame, only to hack out works of beauty. She never intended to do a crucifixion but when a friend brought a cherry tree with two outspread branches she knew that it could take no other form. Oswald returned on leave from the Navy and bravely allowed her to hang him up as a model. 'His lithe body revealing muscles and ribs was exactly what I needed the indrawn diaphragm, the curvature of the ribs, the taut muscles of the arms, the strained bare legs, the tortured feet . . . but he could only hold the pose for a few seconds.'

Two letters Clare wrote to me during the war somehow survived

[246]

in the kitbag which for five years I dragged around the Middle East. One of these begins:

12 September 1941. Darling Anita: I hate the Censor – all these things put me off – however I have you so often in my heart that I really must write . . . I hope the adventure of life fulfils all your hopes! It's your turn now. Mine to stay at home – inactive . . . I've given up my London studio for ever and have succeeded in building myself a lovely studio *here*. In spite of difficulties (such is my passion for overcoming obstacles) it's nearly ready – and a huge tree trunk awaits my winter carving. I'm also building my own little kiln so that I can bake my own terracottas. I can get lovely pink clay down from London by the ton, on a lorry that plies to and from London and here, weekly. I shall then be happy and occupied for the rest of my life, or what remains of it! That is if everything isn't blown to smithereens by a bomb!! . . . I'm finishing a book just to prove to myself that I haven't absolutely gone native! It's all very well to live like a peasant, but one *must* retain the last vestiges of intelligence and culture – or at least make a fight for it before we are submerged entirely by the collapse of civilisation. . . . Darling, I've 3 cows, heaps of cream & butter – & my few chickens give me 3 eggs a day and I've 36 geese worth 30/– apiece & quantities of ducks which eat rotten potatoes (the geese live on grass) so I'm doing rather well – & keep Margaret supplied, also Oswald at Scapa Flow – & I supply 11 old people in the village with my surplus milk. So life is very full. I'm quite happy here, & dug in for life. I listen to the news not more than once a week. My friends have orders to ring me up if Leningrad falls or anything catastrophic happens . . . Bless you darling – & all my love – & come back safe to us – to a shattered but a better world – lovingly, Clare.

I can remember reading this letter in the Western Desert and the delicious breeze that was Clare's personality suddenly blew through my ambulance.

The other letter was written a year later when the peasant rôle had worn rather thin.

December 12, 1942 . . . I have been two weeks in London doing the head of our dynamic cousin. I am admitted to his bedroom at 9 a.m. He does not get up till 12. Receives generals etc. there – so essentially Jerome. It must be a surprise to the generals but I suppose they get used to it. He relaxes towards his black persian cat and likes it to play with his toes. He calls her a 'delectable cat' and says she has a great brain. I think the bust is going to be good. He's interested & wants it to be a success – but it's uphill work & very exhausting because he never gives me a chance. Always that blasted cigar in his mouth which twists his face. He's promised however to 'be good' next week & give me a whole half hour's full attention . . . Oswald is King's Harbourmaster in Algiers! Such fun to think of him there & all our friends must be so surprised – I am sure the Arabs of Biskra are telling one another in the cafés, 'Moi je suis sûr – Madame Chéridan, elle a dit à son cousin "il faut prendre l'Algérie" – !' We were always objects of suspicion at Biskra, & now it is quite clear, we were an advance guard!! . . . I've built my kiln & am turning out my own terracottas – very

[247]

exciting – and I carve tree trunks! There'll be so much to show you when you get back – & so much to hear – we'll never get to the end of it. All my love – Dieu te garde – Clare.

Clare has described the sittings Winston gave her in far greater detail. Inviting her to lunch he had stipulated, 'The only time I can give you is when I'm in bed in the mornings – I know you well enough not to mind. Sir Edwin Lutyens is nagging me to let some Academician do a bust – I have promised him photographs and *one hour* for the finishing touch.'

Early on the first morning Clare arrived at the underground shelter which had become the sleeping annexe of 10 Downing Street.

Winston was in bed reading a newspaper. When he lowered it I saw a Hogarthian figure with cigar and spectacles. The light was bad, each side of his bed encumbered by tables laden with papers. When I uncovered my block, into which I had already marked a suggestion of him, he seemed to approve that it was slightly bigger than life.

Then he raised his newspaper and disappeared from view. His secretary, sitting by, pencil in hand ready for sudden dictation, smiled sympathetically. Clare just waited till he finished reading and looked up at her: 'How are you getting on?' She replied, 'I can't even start unless you let me see you.'

'Oh – my dear – my dear! Sorry.' He removed his cigar and gave her unblinking attention for five minutes.

At noon when Mr Attlee or Mr Eden arrived to discuss the war, Clare would depart. Thus it continued for several days. She tried to be grateful and to show interest when news of important sinkings or raids was reported, but it was difficult to switch out of concentration.

One morning Clare arrived along with Winston's breakfast tray.

I was able to study him for a while without his cigar or his glasses. I got on well during that short time, in spite of the vagaries of the black cat, to which he seemed devoted. At the risk of upsetting his tray Winston would waggle his feet about beneath the bedclothes, and the mystified cat extended a paw.

A most delectable cat. With a brain – not to be measured by ours, but a first-class brain of its kind.

That particular morning Winston was feeling well. When he had finished munching toast he said, 'Let me see the head – turn it around slowly. You don't seem to have worked on the mouth.' Clare blazed, 'You're always rolling that cigar around. I'm leaving the mouth for the last.'

'I'll give you a really good chance on the last day.' A little later he suddenly looked up and stared at her. 'Forget Mussolini. Remember you are portraying the servant of the House of Commons.'

'You weren't very sympathetic to me at the time,' said Clare. 'I got the notion you rather admired him.'

He nodded. 'I did – a very able man. He should never have come in against us. In fact this whole war could have been prevented if it had not been for so many bungling statesmen.'

When Saturday came Clare returned to Brede for a rest. Winston had been penitent. 'Next week I'll give you a really good sitting. Look forward to it. I think the head is a fine piece of work. I want it to be a success. We'll call it Prime Minister by Obstreperous Anarchist.'

Back in the country she longed to abandon the effort. Here she had built up her peace. She knew her wood carving represented her final fulfilment as an artist, and that her heads of famous men were in a way just a form of journalism – journalism in bronze.

When she returned to Winston, she found him tense over the Darlan affair. She interrupted his telephoning with, 'I wish I could die in my sleep and then I wouldn't have to keep on trying to catch your expression.'

'All right. I'll be good.'

He leaned back in bed, threw away his cigar and picked up a book which caused him to chuckle with amusement as he turned over the pages. Clare worked in feverish silence until noon. Then suddenly Winston threw back the bedclothes, shuffled into his slippers and pulled on a Chinese dragon-embroidered dressing-gown. 'My dear, I have a Cabinet meeting – I've given you too long.'

'Look!' said Clare, 'it's finished.'

He took her in his arms. 'Good girl,' he said. 'And I didn't smoke for what – two hours? I keep my promises.'

A party of Marines carried the bust upstairs and Clare gathered up her tools and followed triumphantly.

A few days later a note arrived: ' . . . I think you have produced a very fine piece of work. I should certainly like to have a replica of the head in bronze. I will send you a cheque at once. Keep in touch. Yours affectionately, Winston.'*

*The head stands in the hall at Chartwell. Bronze copies were also bought by the cities of Edinburgh, Belfast, Stafford and by Harrow School.

When the nerve strain of trying to model England's war leader ended, Clare admitted that she had enjoyed her visits to his secret sleeping lair. But solitude had now become a necessity and returning to Brede she embarked on two major wood carvings for Brede Chapel. She hewed one great oak into a Resurrecting Christ to hang against the shadow of a cross which she chipped into the wall over the altar. And by the entrance she set up a pregnant Madonna in pine. It was a bold and beautiful theme – 'Before birth and after death', she would explain to the soldiers, and not one of them looked shocked, though few had been reared to appreciate Titian's proudly pregnant Madonnas.

As the German flying bombs fell on southern England Clare grew puzzled at her own terror. She was franker than most, writing to a young friend Marigold Crook:

It doesn't mean that one is paltroon, but some people have nerves that can't stand it. I have never been regarded as a coward – and have on several occasions (in Dublin during the rebellion and in Paris on the night of the famous 6 Février) been where bullets were spattering freely and seen men quite close to me drop dead. Even a cavalry charge (the Garde Mobile in Paris) with sabres brandishing did not do more than accelerate my heart beats and thrill me fearfully!! But bombs simply unbalance me. I hate aerial warfare more than I can find words to express.

In June 1944 she wrote again:

It's been hideously noisy in here, impossible to sleep. After the second night I was so tired I went to bed after breakfast and slept till eleven. Last night was quiet but three of the officers from Brede Place came at 8.30 p.m. and stayed till 2.30 p.m. . . . After they left I cried myself to sleep thinking of that sweet boy, so like Dick, heading towards that hell.

In July 1944, Clare went with Oswald, who was on leave, and Shane, who was enjoying the entire war as a Home Guard in the much bombed areas around Victoria Station, to lunch at 10 Downing Street. The tide had turned and Winston was in splendid form. He enjoyed listening to eye-witness accounts of action and Oswald had seen action on the Normandy beachhead on H.M.S. *Dispatch*. Beside him had lain a Greek-manned ship which with fifteen others was to be sunk to form a breakwater. Possessing no refrigerators and never knowing in this secret enterprise how long they were to remain afloat, the Greek captain suddenly found himself overstocked with mutton on the hoof. 'My sheeps! my sheeps!' he kept shouting. 'They go down.' The Royal Navy thought he was referring to his ships. Of course they

had to go down. Then Oswald tumbled to it. 'It's his *sheep* he wants saved . . .' Seventeen sheep were brought up from the hold and transferred baa-baaing into H.M.S. *Dispatch* where they were later transformed into stew. But the Greek captain, oblivious of the guns, the planes, the dangers of the moment, asked for a *receipt*.

'Did he get one?' asked Winston.

'Well no,' admitted Oswald. 'He'd drawn the sheep as rations – for his Mess . . .'

'We are not pirates,' protested Winston, 'give me the name of that Captain and his ship.'

Shane, being a Greek scholar, translated the name as *The Holy Spirit*. Winston solemnly jotted down the details. 'Our Greek Allies shall be recompensed for rations devoured by the Royal Navy – seventeen sheep from the *Holy Spirit*!'

I remember being told of a small drama that occurred during the final advance into Germany, when Winston and his staff had – to put it mildly – rather a lot to do. Clare grew some specially luscious cherry trees. She gathered a basketful for her cousin and sent them by hand of Colonel Peter Wilson, who ran his bomb-proof, underground map-room. Entrusted with the precious basket Peter carried it to London by train, hired a car, and placed it in what he thought were the appropriate hands. A week later Clare came to London and asked Winston how he had enjoyed her cherries. 'Cherries, my dear? Never had any cherries . . .'

Clare spluttered with rage. 'But these were special cherries; I picked them myself.'

Colonel Wilson who was at this moment employed moving pins denoting the retreat of the German armies across the map found it very difficult to trace that basket of cherries. And Winston, who had always time to laugh at small incidents, told him to desist. 'So many throats they might have gone down in a strategic Headquarters.'

29

The patterns of peace

I HAD not seen Clare for five years. When I returned from the French Army in June 1945, she was living alone in her cottage in Brede Park, surrounded by terracotta madonnas and carvings. She had grown larger – wide rather than fat. The strength which had been her natural inheritance proved of great importance now she had to work with chisel and mallet. And she was intensely happy because, since Dick's death, she cared only for his closeness. This feeling she obtained in the mystical atmosphere of Brede and its park. The ghosts which frightened others had become her friends.

Margaret, scoffing slightly at what she called 'Mama's spooks', led her own busy life in London. Oswald had married, very happily, having found a wife in the WRNS. He and Lena were going to settle in the house he had himself constructed beside a dell of flowering shrubs. Winston came to inspect Oswald's home and pronounced, 'As a bricklayer myself I think the walls are too thin.'

'Oswald has a wonderful circulation. He doesn't feel the cold,' his wife chipped in.

'Lucky fellow,' said Winston. 'The Jerome circulation bypassed me.'

Brede Place was now empty. Clare missed the soldiers. They had cut and carried oak trees and enjoyed her enthusiasm and praise. Clare would always be a woman for whom men liked to work (or at least for whom *strong* men liked to work). When peace settled austerely over the land, she moved into the old house which cruel fate had made hers through Dick's death. All through the spring of 1946 I stayed with her off and on. So did my father, the beloved cousin Shane of her girlhood, but rather less beloved now, because servants were scarce and his habit of walking across Sussex, covering fifteen to

twenty miles in a day, to arrive unexpectedly at the homes of his friends, no longer delighted her. I enjoyed watching them sparring together, for each thought their great talent should permit complete disregard for other people's idiosyncracies.

One night my father arrived unexpectedly at Brede Place and announced that he would like to be 'put up'. All he wanted was supper and a bed. He'd be off in the morning to another friend. Sheets were aired; rations were shared out (coupons for tea, sugar and meat were still needed), and my father enjoyed himself reminiscing about old Moreton. Clare, who also liked to reminisce, hardly got a word in edgeways. Next morning Shane strapped on his haversack and strode off. 'I walk everywhere – I hate cars – the longer petrol is rationed the better.'

He had not been gone long when Clare leaned out of a window angrily shouting at me to come in and 'see what your father has done'. On her desk she had left a big stiff-backed copybook of the kind *she* liked writing her books in. She had just started a story. Shane had sat at the desk doing his morning letters. Twenty pages covered with her handwriting had been torn out and left on the desk and the brand new copybook had vanished. 'He's *your* father and *you* have got to cope,' she fulminated.

'But I thought he was *your* great love?'

So furious was she that I did get on to my father by telephone and asked if he had removed a shiny black copybook from Clare's desk. 'Why yes,' he replied, 'I like those hard covers. I left what she had written!'

That autumn of 1946 Clare found her old home lonely and desolate, despite its beauty. *Too full of ghosts. Too full of memories.* She decided to put it up for sale and move to Ireland where my mother had roofed a romantic Norman keep on the shore of Galway Bay. The moment Brede Place was advertised the press started to telephone Clare. Where was she going? Somewhat over-excited by the prospect of a change she replied – and I can hear her now: 'To Galway Bay where my cousin lives. There are 400 wild swans on the bay outside her castle.'

This was an exaggeration. Wild swans landed from Greenland and elsewhere, but only in time of fearful storm did the number exceed twenty. I was besieged by queries from bird-watching societies – had I counted them myself? Whoopers or the Berwick swan? Or just mutes?

*

During the last days I stayed with Clare at Brede Place, and I was sadder than she was at its approaching sale. I knew now what Margaret must have suffered on the Bosphorus. A blackbird followed us around the empty rooms – beating wings and beak outside the window panes. 'You know what that means,' said Clare. 'A member of the family is going to die – it must be Roger.' Roger was her nephew who had recently suffered a serious operation in Switzerland. Before the week was out we heard of his almost miraculous recovery. By the same mail came a cable. Roger's younger brother Jerome Frewen, who had been a bomber pilot all through the war and then taken up the post of personal pilot to a Maharaja, had been blown to pieces in a sabotaged plane in India.

Soon after this tragedy we left Brede, and Clare shipped several ancient four-poster beds and a quantity of bronzes to Galway. She also consigned to the not inexpensive care of British Rail those tree trunks which she intended to carve for churches in Ireland.

Still hating money and anxious to be treated as artists were in the Middle Ages – not paid but fed and looked after – Clare now steered towards the Catholic Church which had appealed to her for so many years. But for such as she, the way into a disciplined church was not easy. She found it more natural to give than to accept instruction. How indignant she became when Shane – that Catholic convert of long ago – wrote to her coolly after a not very satisfactory visit to the Jesuit Father Martindale who had drawn many famous personages into the fold:

I shouldn't trouble to consult tired, bored priests about legalising yourself Catholic. You cannot change your views, but you can submerge them generally in a wish to belong to the Universal Church. You are probably Catholic as you are . . . I should go on with your mediaeval carving which is as much a symptom of Catholic feeling as any signed document . . . Poor Father Martindale must be very tired and weary after his imprisonment in Denmark. If you can't understand dogmas and creeds you can say you accept Catholicism, as you took the Eton side, or Cambridge versus Oxford or being British. Life is too short to enquire into details affecting eternity.

But details affecting eternity concerned Clare very seriously indeed. While her vast belongings travelled slowly towards the west coast of Ireland, she herself took off by train, boat and bus for Assisi. It was not easy to obtain travel permits and foreign currency so soon after the war, but Clare invoked Winston's aid and he helped her through the formalities.

It was an exceptionally hot August. Clare did not mind a ten-hour bus drive to the hillside city of Saint Francis and her patron Saint Clare, but she did object to the mention of more *instruction*. She did not want to *talk* about the Catholic Church, she simply wanted to enter it, without shedding her personal beliefs in reincarnation and private spiritual contacts. Within five days she had the town on her side, although most of the local people could hardly comprehend why anyone should travel so far to become what everybody already was.

Neither the Bishop nor the priests of Assisi found her easy to deal with. She insisted that she was too old to learn catechism. All she wanted was to be received with open arms. This was not the usual approach of a humble convert. But she won. Within a week she entered the Catholic Church and to her great joy found that she was to have her first confession, her first communion, and her confirmation on the Feast Day of St Clare. And in an ecstasy she discovered that she could enrol as a tertiary in the Order of St Francis.

To Marigold Crook she wrote:

I am now a Roman Catholic! I don't believe anyone has ever been received so quickly . . . This is really a holy city, but the contrast between the Franciscan shrines and the great gaudy churches is a spiritual challenge. I wonder how beloved St Francis was ever able to fit into the Church! But as *he* could, I can . . . it is good discipline for one to have to try to fit in, and maybe it is good for the Church to be interpenetrated with the franciscan spirit, the more the better! . . . I will do my best – but I don't want to be another bigoted convert – I will take the whole magnificent thing in my stride and try to be a worthy addition. I mean always to see it *big*, not small as some do . . . know the *real* thing rises transcendantly [*sic*] above the sillinesses, and I won't deny myself the joy of the main reality, because of – well, shall I say – the carbuncles on the bottom of the ship. I love it, I love it, I love it, I love Italy, I love Assisi. I am happy.

On her return journey Clare stopped off at Geneva to see Winston and his family who were staying by the lakeside in a house lent by the Swiss government. The press had got hold of the news of her conversion. Journalists had telephoned Margaret in the middle of the night to ask if she knew that her mother had become a nun! But Winston, always warm towards the Catholic Church, received her with arms spread wide. 'I know about it; it was all on the Vatican Radio! Bless you. May it give you comfort.'

'I'd never have got there without your help.'

As quick as a flash Winston answered, 'But my help ends here! Don't think I can get you into Heaven too!'

The elation of her new found disciplines kept Clare joyous through all the years that followed. On the slow train journey from Dublin to Galway she couldn't resist telling the ticket collector and the tea waiters how immensely *exciting* it was to become a Catholic. Born and reared in the faith themselves, they were fascinated to learn what it felt like to get it late in life. They ceased clipping and serving, to sit and chat. Some nuns got in – there are always nuns on Irish trains – and she was able to add delight to their journey by describing that most beautiful of all hill towns, Assisi, and what had happened to her there on the Feast of St Clare.

There was one slight disappointment in the drama – and Clare would tell the story with that absolute innocence which to the end of her days made her the most refreshing company in the world. 'I made my affirmation in Italian – the perfect language in which to speak it – but my first confession was to take place in French, and I prepared it very carefully. As you may imagine I had a lot to recount. But hardly had I started than the priest interrupted me with, "My child, I quite understand. It is a long story – *mais on se passera de tout cela*" – and I found that I had been given absolution! I couldn't help feeling a little flat. After all, *my* confession must have been unique – if my sins were many they *were interesting*.'

During the years that Clare lived beside Galway Bay she continued to carve. Still strong enough to chisel not only in wood but in stone, she asked our castle mason to rough out big blocks which she could then hack into form.

She lived in her own house, The Spanish Arch, built into the wall of old Galway, but much of her time was spent at Oranmore Castle five miles along the coast. There are many entries in my guest book, such as, 'June 10th 1950. Hacked in the sun for seven hours at Pomona.' And Pomona, the Roman goddess of gardens, stands six feet high in granite at the Castle gate, unshaken by the wildest gales and highest tides.

The West of Ireland suited Clare and she became a well-known figure floating in her violet-shaded tweed cloaks of ecclesiastical design along what remained of the ancient streets. The old Claddagh-born women in their black shawls loved Mrs Sheridan and brought her their baskets of fresh fish when the boats came in. And the Convent of

Poor Clares on their medieval site, Nuns Island, knew her well. She had the privilege of describing Assisi to them through their grill.

Margaret, who had finally put her talents to writing under the name of Mary Motley, came to stay and remarked: 'Well, I've seen Mama through many different phases and she always dresses the male part – I've seen her as a Cossack, an Arab sheik and now apparently, a monk.'

Clare was disappointed at the dearth of orders for her carved figures. The Bishop of Galway was building a vast cut-stone cathedral and she hoped that the most magnificent of her Sussex oaks, carved into an austere Madonna with the Child at her knee, might be the central piece of a Lady Chapel. But no order came and when she saw that a bright modern mosaic of President Kennedy was to adorn the wall where she had hoped her twelve months of work might find a setting, she railed against the taste of those who had the power to spend. It was not in this manner that Chartres and Rheims had risen!

A yet more damping incident occurred when she offered the statue to a convent guest house. It was pointed out that the Holy Child wore no trousers and some people might be shocked! Clare retorted splendidly: 'The Renaissance did not consider underwear necessary, so why should *you*?'

After this disappointment Clare retreated and we noticed sadly the well-known symptoms. She was over sixty now, but still she was ready to move on. The drive and restlessness remained.

Her visits to the England she had 'left for ever' grew longer and more frequent. In June 1948, she wrote a long account to Margaret of a day she had spent at Chartwell:

Dear Winston, in his dreadful boiler suit was looking pale. He rants, of course, about the inefficient ignorant crowd now in power, who are what he calls 'throwing the British Empire away'. He is almost heartbroken. All his life he has been such a great Imperialist. He is so brilliant, but unless one can make notes in shorthand one cannot recapture all he says. He quotes so aptly, which I envy, having myself no memory. He quoted Hamlet several times which illustrates his spirit of despondency. I said I didn't feel it was any use working physically hard to carve statues, or indeed, do anything creative, for which he admonished me. 'You can't go on strike –' It is true; one can't sit down with folded hands and just wait for the clap of thunder! He has finished three volumes of his new book *The Second World War*, and only the possibility of being called back into politics prevents him going on with it. After lunch he took me into his studio where he is painting a big still-life – this consists of a huge black ebony Buddha inlaid with gold and Winston has it on a table against a sage-green velvet drapery. On the left of the Buddha is a silver vase with a vivid scarlet amaryllis lily – very effective. He removed the picture from the easel and the two of us crawled about on

the floor, struggling to get the canvas into a frame. Then we hammered the nails in place. When I picked it up from the floor to place it back on the easel, he commented: 'How strong you are!' Of course I am strong; however the picture was not heavy. Later we joined the horticultural expert in the garden, and Winston spent some time in a chair on the edge of the pond. When he calls to the big golden carp they come in a shoal to be fed. He told me the tragedy of the black swans who nested on the island. Mother swan had produced a family when a fox killed her. Winston said the father swan behaved so wonderfully to the babies and carried them about on his back! He is wondering what will happen next spring . . . If I can judge of swans by my experience with geese, his daughters will become his wives! After tea Winston led me off to his study. He tried so hard, bless him, to be interested in my concerns, but he can't sustain interest outside himself for more than a few minutes. However, he was very affectionate and I believe he's fonder of me than I know. When we parted, he called to me from the top of the stairs: 'Write whenever you want me to do something for you – remember our relationship is *eternal* – ' I think it was uttered by his subconscious!

The summer of 1949 was particularly happy. My son was born and I called him Tarka, for he looked like a little otter and we expected to rear him on a boat. Clare was to be a godmother and I remember the delight that spread over her face when I told her 'His Christening name will be Richard – he is to be my Dick – Tarka Dick.'

'I'm so glad, so glad – a sort of a grandson,' she said. When the Franciscan friar of her choice christened my son, she was thinking of her own Dick, and I was too. It was a very long ceremony; the young friar had never christened a baby before and he left out no detail. Tarka Dick roared and squirmed while Clare's old women friends stood around in their black shawls and waved gnarled hands in front of his nose. But Clare's expression remained beatific.

As he grew older Tarka Dick would clamber around her stone blocks that lay ready for incising and he would pick up mallets and dig chisels into the ground. She found great solace in her work and in the atmosphere of Western Ireland, but with the lack of orders she eventually tired of the sea and the wild skies and departed.

The guest book of Oranmore Castle (which had lain roofless and uninhabited for a hundred years) opens with the name of Clare Sheridan:

1947, July 17th to 21st. Left England for ever – Brede Place sold – I am a fugitive from world conditions – seeking sanctuary in Eire . . . spent my first night on landing at Oranmore Castle . . . My first night of citizenship . . . Their first guest – may blessings pour down upon this ancient monument – Pax et Bonum.

The same splendid hand makes its final entry in 1952:

September 20th–October 1st. The Spanish Arch sold, and so comes to an end another five year span, of which the pattern of my life is inadvertently composed! (One five-year span after another . . .)

I can see her now, loading up her car with belongings and driving out through the Castle gate. As she passed the stone figure of Pomona she waved bravely without turning her head and a strange feeling hit me. It was as if I was seeing the last of her – as if Clare was driving out of my life.

30
The end

FIVE years did she say? She had only five years left in which to work. Then the passionate Clare we knew would pass into a period of contemplation, and then very quietly she would die.

She became a little eccentric. She had always been surprising but now an Irishman, overpowered by the storm which attended her presence, remarked: 'At first I thought Mrs Sheridan was acting a part. Then I realized that one never acted – she was just being herself.'

Within a week of her departure from Oranmore Castle a letter arrived which filled me with bewilderment and guilt. I had thought that with two small children and a party of hungry sportsmen on my hands I had organized substantial nursery fare for all rather well. We only had local girls to cook and attend to rooms in various turrets, but Clare was entering a new phase and chose to reprimand me. She wrote:

Carving *Daphne Laureoli* out of the laurel tree – those were my finest hours – but also I loved the moments before I fell asleep in that vaulted hall by firelight – Oranmore filled me with conflicting emotions! In a way so beautiful, but at the same time so unbeautiful. I hate disorder . . . and I suppose I should not say so, but I was appalled by the confusion of the kitchen, the inelegant clothless wood table, the potatoes and the carrots!!! I suddenly found myself old-fashioned and conventional! I'd never thought of myself as such – but I care about a certain 'style' in living – it *must* be beautiful . . . but then my impression was clouded further by feeling *so* ill . . . and I got it into my head that I was going to die there – I lay awake in that lovely Wagnerian Hall watching the dancing lights and shadows and the arched window above me which lit up every time anyone went upstairs . . . and my chest felt as though a cat were sitting on it! and I thought that of course I would never go away from Oranmore . . . and then I reflected that after all why not . . . I've had a very full life but now something has come to an end just as though a piece of woven tapestry was finished – the design all fulfilled and ended – how nicely it all worked out, and now I

could depart in peace . . . and may God have mercy on my soul and outside a great gale was raging, sea and wind and rain all jumbled together – but the thought of Daphne obsessed me – Could I not finish her? Would I be given the strength? I cared about Daphne, she was so full of promise. Well, I think Daphne it was who pulled me together – because of Daphne I made an effort – I got up and I climbed those stone stairs and I got very hot hacking at the wood – and there it is! I am not dead, Daphne is not finished, and I am on my slow way by stages towards Africa – heading towards a new life all unplanned.

I accepted Clare's chiding and a year later she was writing to me happily from Bab-el-M'Cid where she finished her last book, entitled *To the Four Winds*. Winston had wished to see the sections about himself before she departed:

I had lunch with them at No 10 before leaving. I sat between Winston and 'Monty'.* Winston said to me, 'You still have your taste for life, you give me the feel of it.' But I was horrified by the conversation that then took place across me and I had to bite my tongue – obviously Monty has no time for a mere woman and the fact that I know and love and understand the Arab world meant nothing to him whatever. Nor did he seem to care for France from which our language and our civilisation springs. I felt like chipping in with 'I suppose you disapprove of the Roman Empire too.' Winston just gave grunts, he was dead tired and his chin sunk down on his chest. No brandy, no champagne, only a little white wine which obviously fails to cheer him – but you know the way he rallies and he isn't done yet.

Two years later, after I had written a life of Leonard Jerome, who was Clare and Winston's American grandfather, she wrote a vivacious criticism from the desert saying that I had underestimated the character of Grandma Jerome.

There was something more in her than just Redskin blood, she was the Grand Roman Matron! You'd have to have known her to realise the dignity of that old woman. You've done your best with Jennie and my mother. Neither of them could write a letter. Mama's letters are lamentable and Jennie's not much better – when you think of the age in which they were young women, and of what they *might* have written. Jennie in a brilliant political-royal set, and my mother knowing all that was interesting and worthwhile – their letters are asinine, like silly schoolgirls – about nothing but frocks and young men – never a record of one intelligent or interesting remark or conversation. Just lists of names which mean nothing. Damn it – what *did* Lord Salisbury say? What *did* Arthur Balfour say? What *did* the Duchess of Edinburgh [daughter of the Tzar] say besides playing the piano à quatre mains? Oh, what silly letters! And those two, my mother and Jennie, had the opportunity of writing and thereby recording a *most* interesting epoch.

*Fieldmarshal Viscount Montgomery of Alamein.

[261]

English summers spent near Brede and Algerian winters were the pattern Clare chose for three years. She wrote in 1956:

I couldn't care less about England. Thank heavens we were brought up in France. All the same, I am filled with horror and indignation at the way the Americans and Egyptians are treating us – what *has* happened? are we finished . . . ? Do we count for *nothing* – ? But the English are so slow, so unpredictable we may suddenly find ourselves perking up and surprising the world!

Occasionally, on visits to Greece, she stayed at the British Embassy from which she lured the Ambassadress, Lady Norton, and others to visit distant ruins in the Corps Diplomatique car. Eventually she heard of a quarry of pink marble and this caught her imagination. That night at dinner she sat next to King Paul. She told him that she must have a portion of rosy-pink marble to carve. She knew exactly what she would turn it into. The King said that he would see to it. Greece would ship her a block of its pinkest marble as a gift. 'But the matter is urgent,' Clare went on with shining eyes. 'I can't wait to get to work before the ideal leaves me. Please, please, don't send it by sea; get it on my plane next week.' King Paul, infected by her enthusiasm, 'attended to the matter'. And Clare's plane carried home a sizeable block of marble – an offering from immortal Greece at mortal expense.

She was always interested in the new generation. When Roger Frewen's second son, Robert, was born she wrote her nephew a typical letter, which young Robert and other Frewen children would frame and enjoy at examination time.

September 17, 1957. Dear Roger: I have come across the following by a Chinese poet:

> On the birth of his son,
> by Su Tung-po: A.D. 1036

Families, when a child is born, want it to be intelligent – I, through intelligence, having wrecked my whole life, only hope the babe will prove ignorant and stupid. Then he will crown a tranquil life by becoming a Cabinet Minister.

With all good wishes for the nouveau-né – love, Clare.

Although she no longer worked for renown, but carved as her heart bade her and for the love of God, it proved difficult to find the right surroundings. Clare had set her heart on settling in some monastic establishment where she could carve without interruption or financial bother in return for bread and board. For a time she experienced fulfil-

ment living in a House of Retreat in Kent. 'Here I can dwell *for ever* – they feed me . . . I donate my work . . .' How often one had heard those words *for ever*!

It was not long before a wonderfully uninhibited letter explained that she had departed, leaving as payment Our Lady carved from a black pear tree and adorned with an ancient silver Spanish crown – an object of great beauty which remains on view today. Clare's explanation to me was, 'I thought there would be uplifting talk as at Abbots' tables in the past, but I was expected to eat with the goat-herd and I can't talk about goats.'

She went to London and saw Winston, without knowing it was for the last time. He was unwell and she thought he looked very sad. Instead of fluffing her feathers and arguing she found herself trying to cheer him. 'At least *you* must feel your battles have been worthwhile.' But he gave her the distant look which was so often his in old age and said, 'In the end it has all been for nothing.'

'How can you!' she riposted. 'You beat the Nazis – even *I* have come around to seeing *that* had to be done – I am a pacifist but you are the great war leader who *won* – if Hitler had conquered England not only would he have shot you – he'd have put *me* in a gas oven!' She tried in vain to make him smile. 'I'm not a Communist any more. Horrible Stalin murdered my friends. I love the Russians – their music, their golden domes – those vast stretches of land – but the system is dull as a boarding school!'

Winston remained sunk in gloom. 'If the Dardanelles had come off it might have been a different story for the whole world.'

'You can't go on mourning the Dardanelles – it's too long ago.'

'I can and do,' said Winston. 'So many brave men have died since through stupidity. We could have ended the whole thing back in 1915. Yes, my dear, we had to fight those Nazis – it would have been too terrible had we failed. But in the end you have your art. The Empire *I* believed in has gone.'

She didn't know what to say. Kissing him good-bye she murmured, 'Stop thinking of the Dardanelles.'

'Can't,' he said. This was his final word to her.

The last letter we received from Clare came in 1959. She had spent a few months in Biskra retrieving her old diaries for the *Daily Telegraph* which had commissioned a series of articles based on the material in them. On 4 May she wrote:

I got back on Saturday. Biskra is just an armed camp with barbed wire shutting off the main streets – soldiers in queer uniforms to look like trees and bushes! Soldiers in my garden – being awful to Haafa and his family.

I was ill nearly the whole 2 months with dysentery – managed to get my sculptures and 36 vols of diary all packed up and sent off – but in between I collapsed into bed for days. Haafa and his family wonderfully devoted and loyal – Margaret made over the place to them – but I can go back whenever I like – they keep my rooms for me.

I came back on the cargo boat belonging to the *Echo d'Alger* newspaper, a lovely 8 days and I the only passenger from Algiers to Rouen, which did me good. But I'm weak and dead tired and thankful to be in bed and no more trying. Blessings – Clare.

She did not recover. The bug she had caught affected her bloodstream and a terrible lethargy fell over the vital Clare, she who with her praise or anger had always made one feel so *alive*, now admitted that she was too tired to write, too tired to think. She found the effort of reading through her own vast diaries onerous and the *Daily Telegraph* had to go without the series commissioned. There was a poignant moment when Clare took her carving tools, her chisels and mallets to Brede Place and handed them to Xandra, the beautiful young wife of her nephew Roger Frewen. 'I shall never need these again. Perhaps you could use them . . .?'

She was not sorry for herself – she simply recognized her span was ending. For a time she returned to Ireland – not to Galway but to a Convent near to Castle Leslie in County Monaghan, and sometimes she came over to see us. She had become quiet. 'I wonder what the nuns think of me. I have a Madonna *and* a Buddha in my room!'

She returned to England to die, and being Clare, she chose a blossoming spring for that final exercise. It had been her wish to be buried beside the fourteenth-century church of Brede village and we all attended the ecumenical service. The Rector who had watched her first great oak Madonna carried into the church by soldiers during the war, spoke movingly of that far-off day – of the ten struggling men and the blacksmith coming to help. This was Clare's funeral oration before a Catholic priest took over for the committal. Oswald and Winston had already died, but in the front pew were Shane whom she had loved and quarrelled with over so many years, and her nephew Roger, now the owner of Brede Place. Beside me sat Tarka Dick and my daughter Leonie, named for *Ma Tante* who had guided Clare in trouble. Half Sussex seemed to have heard of her going, and the church was heaped with the flowers she had asked for – nothing bought – only picked from garden or hedgerow.

During the service I grew ever more aware of the tranquil smiling Madonna which was her memorial to Dick. I began to grasp a reality which the passionate exuberant Clare had always sought to express – beauty outlasts pain – beauty does not age. The wooden face which she had carved in sorrow looking down on the coffin told us this.

Index

compiled by Patricia Utechin

[267]